The Birth and Rebirth of Pictorial Space

by

JOHN WHITE

ICON EDITIONS

HARPER & ROW, PUBLISHERS

New York, Evanston, San Francisco,

London

STANDARD BOOK NUMBER: 06 430027 7

To
XENIA WHITE

Acknowledgements

Of the many people who have helped me in this work, I owe a most especial debt of gratitude to Professor Johannes Wilde who has, at every stage, been prodigal of his knowledge and his friendship. The necessary research would probably never have been carried out but for the initial encouragement of Professor Sir Anthony Blunt, and I am also particularly grateful to Professor Erwin Panofsky for the warm generosity with which he has encouraged me to venture into a field that he himself has so largely pioneered. Unstinted help has been given to me by Professor Martin Robertson, and I owe much to Professor John Pope-Hennessy, to Sir Kenneth Clark, to Dr. Margaret Whinney, and to Dr. Leopold Ettlinger, as well as to Mr. Philip Troutman who has gone to endless trouble in obtaining reproductions for me. I would also like to thank all those connected with the actual processes of publication for their unfailing kindness and personal interest.

This book is based in part upon work carried out whilst a Junior Research Fellow of the Warburg Institute and leading, in 1952, to the award of a doctorate by the University of London.

Financial help in the early stages of research was given by the Central Research Fund of the University of London, and the present publication has been made possible through the assistance of a grant from the Courtauld Institute of Art.

Thanks are due for permission to reproduce photographs to the directors of the following Authorities, Galleries, Museums, and Libraries:

The British Museum; The National Gallery, London; The Victoria and Albert Museum, London; Soprintendenza alle Antichità della Campania; Soprintendenza alle Gallerie di Firenze; Museo Civico, Padova; Museo dell' Opera del Duomo, Siena; Biblioteca Apostolica Vaticana; Bibliothèque Nationale, Paris; Musée du Louvre, Paris; Ecole Française d'Athènes; National Museum, Athens; Antikensammlungen, München; Bayerische Staatsgemäldesammlungen, München; Staatliche Museen, Berlin; John G. Johnson Collection, Philadelphia; Cleveland Museum of Art; Metropolitan Museum of Art, New York; Museum of Fine Arts, Boston; Archives Centrales Iconographiques d'Art National, Bruxelles.

Acknowledgements are also due to the following photographic firms: Messrs. Anderson, Alinari, Bencini and Sansoni, Brogi, Giraudon.

9

Introduction to the Second Edition

The reproductive process which has made the Second Edition possible has also made it desirable to keep the alterations to the main text down to the essential minimum. Fortunately, although a number of points have aroused a good deal of discussion, no very extensive emendation seems to have been made necessary by advances in knowledge which have occurred in the period following the preparation of the First Edition. The most significant change in emphasis has been the new importance accorded to the distance point construction in Italian painting in the Fourteenth and Fifteenth Centuries. Numerous amendments and additions of material, and extensions of the original bibliography, will be found in the notes. In the great majority of cases their presence is signalled by references to publications appearing in or after 1956.

Contents

Perspective Diagrams

Illustrations

between pages 66 and 67.

13

Illustrations

Illustrations

16

Illustrations

Introduction

The main purpose of this book is to clarify the story of the introduction of pictorial space into Italian art during the thirteenth, fourteenth, and fifteenth centuries. An understanding of this historical process is essential to any full appreciation of the innumerable masterpieces of the Renaissance.

It is only by venturing beyond the limits which seem at first to be implied by such a study that some of the most fundamental questions can be answered with any degree of confidence. Comparative material has therefore been sought, first of all in the closely related field of contemporary French illumination, and secondly in the painting and sculpture of antiquity, as well as to some extent in Chinese and Islamic art.

As the chronological sequence of development has been preserved as far as possible, so as to simplify the relation of each work of art to the full historical setting in which alone its beauty and significance can be completely grasped, it would seem natural to begin by looking at the parent art of antiquity. On the other hand there is no escaping the fact that Greek pictorial art has almost vanished, while a relatively large proportion of the paintings and reliefs of the Renaissance has survived. It is possible to speak with certainty about many aspects of perspective theory in the fifteenth century. In antiquity its very existence must be proved. It seems, consequently, to be more sensible to begin where the evidence is plentiful and every aspect of the subject can be broached in the course of an uninterrupted historical survey. In this way a wide area of reasonable certainty can be consolidated. The more fragmentary evidence of antiquity can then be analysed with profit, and effective use made of it in solving problems which remain in doubt after the more closely documented field has been investigated. It is for these reasons that the art of antiquity is considered at the end, instead of at the beginning of the book.

The adoption of a strictly historical approach, based on careful analysis of the individual works, seems to be the soundest way of revealing the living pattern of development formed by the interaction of the artist's growing desire to portray the world of space about him and of his feeling for the individuality and essential flatness of the surface upon which he works. Such an approach is rendered still more necessary by the existing state of knowledge. It is only by close attention to historical detail, and the careful testing of each link in a chain of reasoning strictly based upon the visual and literary documents, that

any advance seems to be possible. There is already a sufficiency of attractive but conflicting general theory. Until its foundations have been examined in detail there is little prospect of escaping from a Wimbledon of assertion and counter-assertion in which no game is ever won, and all the balls remain unchanged.

The need for detailed examination of a wide and often controversial field means that all unnecessary entanglements must be shunned if the central pattern is to keep its clarity. All specifically mathematical arguments and controversies are reduced to the essential minimum, and the same is true of the discussion of dates and attributions. No attempt is made to prove more than is absolutely necessary to the immediate purpose. The artist responsible for the frescoes in the nave of the upper church of San Francesco is, for example, referred to as the Master of The Legend of St. Francis only because this name reflects most clearly the existence of an unfinished controversy. In this, and in the other similar cases, nearly all the detailed analyses and many of the more general conclusions are such that they must be taken into account in any final, as well as in any interim conclusions on the subject of authorship.

The existing state of knowledge is equally responsible for the decision to deal most fully with those problems which have previously proved the most intractable. Similarly those developments which have not been observed before, or if observed, not fully understood, are also given special emphasis. Where conclusions have already been reached and generally accepted upon reasonable grounds, they are merely sketched in so as to balance the overall pattern of development. The detailed arguments establishing their validity are not repeated. By way of compensation every effort has been made to see that the great preponderance in the space devoted to establishing certain conclusions does not imply that the latter are necessarily more important than others which are merely stated as accepted and acceptable facts.

It is in order to establish a balanced picture that the subject of perspective and pictorial space is considered both in its theoretical and in its practical aspects. Pictorial space is discussed in terms of the varying degrees of realism which were attempted or achieved by means of the different spatial systems throughout their evolution, and also in terms of the compositional problems and solutions to which each gave rise. The several perspective theories are similarly treated, and the relation of each to contemporary or to subsequent artistic practice is made clear as it emerges.

It is hoped that this approach will prevent the discussion of a potentially highly theoretical subject from losing contact with the reality represented by the individual work of art. It is there alone that the abstraction leaps to life. On the other hand discussion of the theoretical systems both establishes the background of ideas against which every work stands out, and provides the indispensable points of reference and control.

The discussion of compositional problems is always liable to lead to the

over-exercise of personal bias. The tendency to impose subjective rationaliza-tions upon the works, rather than to reveal the purposes of their creators, is exceptionally strong. The dividing line between what is measurable and what is not is apt to be uncertain. What seems easily demonstrable to some appears to be impossible of rational proof to others. As a result, the area over which it is possible to make universally meaningful statements about artistic pro-cesses and their effects is still surprisingly small. The documentation and physical properties of a painting can be enumerated with generally acceptable accuracy, but the more closely it is examined as a work of art the less likely is it that any given statement will survive for long un-contradicted.

It is this situation that prompts the decision to base all arguments as far as possible upon an analysis of the treatment of rectangular solid objects, and to accept the limitations which this implies. The immediate, compensatory advantages are obvious. Clarity and simplicity in shape and setting are characteristic of such objects. The distortion of all angles and surfaces can be measured exactly, and the accuracy of construction in relation to vanishing points and the like can be assessed in detail. It is also possible to measure the relative size and diminution of objects with similar accuracy, since a measur-ing rod is often provided by the repetition of identical elements. If enough care is taken, the visual facts to be discussed and interpreted can be very largely placed outside the sphere of argument. Upon such a foundation composi-tional problems can often be considered in surprising detail without undue entanglement in matters of opinion.

Finally, the degree of certainty attainable through the acceptance of such limitations is particularly valuable in the present connection. Whenever space is represented, the same fundamental problems of the relationship between the two-dimensional surface and the three-dimensional world inevitably recur beneath the iconographic surface. Any valid generalizations which arise from the attempt to illuminate the individual work of art tend, as a result, to be revealing over a wide field. It is not hard to see the relevance of conclusions reached during a study of spatial design in antiquity, and in renaissance Italy and France, to later developments such as those in seventeenth-century Holland or in nineteenth-century France.

The particular form taken by this book arises, therefore, out of an attempt to reconcile the dictates of three things. These are, respectively, the limitations of the evidence available, the existing state of knowledge, and the nature of the subject.

CHAPTER I

The Upper Church of San Francesco at Assisi

Cimabue is the artist with whom Vasari begins his story of the resurrection of Italian art from the depths of barbarism. The modern historian, shy of aesthetic value judgements, born in a world of relativity, and eager to see art and history through the eyes of its creators, tends to alter the emphasis in many ways. Nevertheless, the Upper Church of San Francesco at Assisi remains the most satisfactory starting point for a discussion of the develop' ments in the representation of space and the organization of the picture surface that lead up to the High Renaissance. This is partly a question of survival. Only a fraction of the great decorative schemes painted in Italy between 1250 and 1350 still exists, and unfortunately the losses are most serious in number and importance at the very point which is the key to the whole story, namely Rome. In the case of the two Basilicas of San Pietro and San Paolo fuori le Mura, it is possible to reconstruct a major part of what has been lost. The reconstruction is, however, dependent upon complex arguments concerning not so much the works themselves as the precise value of various kinds of secondary evidence, and upon theories about what has been irrevocably lost. Consequently it seems wiser to begin where the ground is relatively firm because the subject matter of the enquiry still exists, and exists in its entirety.

A sense of decorative unity is one of the first and most exciting impressions gained on walking round the Upper Church at Assisi. This is, in itself, good reason for considering it as a single work of art, growing towards its own completion and perfection. Such an approach yields results of the widest historical significance. These can be attained in no other way, and are essential, not only for an understanding of the church itself and of its creators, but also for that of the whole Italian development.

CIMABUE

The stylistic unity of the frescoes of the choir and transepts of the Upper Church at Assisi, attributed to Cimabue and his immediate assistants, is generally accepted. The question of execution, which is more debatable, and rendered increasingly difficult by the ruined state of the frescoes, need not be discussed here, since it does not bear directly on the present problem. The

general coherence of style is, indeed, only the beginning of the matter. It is the way in which the artist in charge has enhanced and developed this primary unity within the architectural forms at his disposal that is truly exciting, and which provides the firm basis for the apocalyptic vision and narrative drama of the individual scenes.

The most striking feature of the decorative arrangement is the repetition of the Crucifixion scene in either transept. In each case the entire wall is taken up. In each, the main masses of the composition are symmetrically balanced, although the dramatic S-curve of the crucified figure, the sweep of the drapery, the violent gestures of the crowd below, and the threshing circle of tormented angels, allow no static feeling to result. The repetition of this scene has deep religious meaning, since the placing of the stalls means that the monks in choir would have the central moment of the Passion constantly before their eyes.[1] It takes on compositional significance as well, however, when it is seen that all the remaining scenes on the lower walls are also symmetrically designed. The individual compositions, furthermore, are so varied and repeated that every wall is likewise balanced in strict symmetry.

The spectator beginning on the choir side of the north transept with the scenes of 'St. Peter Healing the Lame' (Pl. 1, *a*) and 'St. Peter Healing the Possessed' is immediately faced with what is essentially the repetition of a single composition. In each case there is a central structure flanked on either side by groups of smaller buildings which unite to form receding wings. This division of the architectural masses harmonizes with the tripartite disposition of the figures.

The end wall of the transept carries the three scenes of 'The Fall of Simon Magus', 'The Crucifixion of St. Peter' (Pl. 1, *b*) and 'The Execution of St. Paul'. Here, symmetry is obtained by balancing two similarly designed wing scenes about a central composition which is in itself symmetrical. The fulcrum is the figure of the crucified Apostle, flanked by the two pyramidal structures and by corresponding figure groups. On either side, like the level scales of a balance, are compositions which are again divided evenly by three main accents. On the left two slender architectural verticals, rising behind groups of figures, run the whole height of the scene, and flank the tall trestle tower above which hangs for a moment the doomed figure of Simon Magus. On the right the composition is divided by three rocky mountains which climb to the upper border and add weight to the figures and architecture in the foreground.

The Apocalyptic scenes on the corresponding walls of the opposite, south transept repeat essentially the same scheme. The two scenes on the choir side are those of 'St. John on Patmos' and 'The Fall of Babylon', which in their original state cannot have formed such a strict pair as the first two scenes from the life of St. Peter.[2] Nevertheless the artist has gone a long way towards coupling these two episodes, so widely dissimilar in content. In the 'St. John

on Patmos' the two figures are surrounded by a swirling waste of waters which seem to sweep diagonally down, teeming with leaping fish and com/ pletely covering the composition. This gives the scene a dramatic movement that is the counterpart of the collapsing city which likewise fills the whole of the next fresco. Here, however, a castellated wall provides a firm horizontal lower strip that has no counterpart in the preceding scene.

On the end wall (Pl. 2) there is a return to the rigid symmetries of the North transept. The two flanking scenes of 'Christ the Judge' and 'The Adoration of the Lamb' repeat each other almost exactly. In each the com/ position is based on a central mandorla with a surrounding crowd of saints and angels. Between these twin compositions the tree/topped background hills of the scene of 'The Four Angels at the Four Corners' repeat the V/shape in 'The Crucifixion of St. Peter' (Pl. 1, *b*) in the opposite transept, while a castellated wall forms a dark band across the bottom of the fresco. In front of it stand the four angels in hieratic repetition, so that the whole scene forms a central link tying together the repeated compositions of the wings.

Finally, in the shallow choir itself are four scenes from 'The Life of the Virgin'. On the left 'The Last Hours' (Pl. 3, *a*) and 'The Dormition' are each enclosed by a wide and heavy, rounded trilobate arch, supported by Corinthian columns. The repetition of this massive framing is a dominant factor in the design of these two frescoes, and weighs more heavily than the variations on a single theme which occur within the figure patterns. On the opposite side of the choir the figure/crowded scenes of 'The Assumption' and 'The Coronation of the Virgin' (Pl. 3, *b*), each disposed about their central axis, form a similar, but not rigidly repetitive pair. It is immediately apparent, however, that while each side of the choir is composed of two similarly designed frescoes, there is no question of balancing the larger units against one another, since the heavy architectural framing in the left/hand scenes effectively disposes of any visual equation.

This fact might seem at first to militate against the idea of a single, sym/ metrical design embracing the whole of the main range of frescoes in the choir and transepts. In reality, it does not. This one point, at which the compositional balancing of wall areas is discarded, is the very point on which the architectural symmetry of the church inexorably concentrates. It is the one place at which the physical awareness of symmetry is so strong that no pictorial emphasis is needed, and at which it might indeed, if it were intro/ duced, become oppressive.

The system created by this repetition of individually symmetrical composi/ tions is historically most important, as it is seemingly unique. It is not a question of parallelism of subject matter, which is extremely common.[3] Nor is it a matter of those subtle compositional harmonies which form a visual undercurrent in almost any great cycle designed by sensitive artists. Whilst there are occasional cases of the symmetrical possibilities of a pair of scenes

being seized upon and emphasized, there are no earlier examples of a complete pictorial series undergoing such a rigid discipline. In particular, the arrangement seems to be entirely foreign to native Italian decorative schemes.[4]

Cimabue's intention at Assisi, clearly witnessed by the histories themselves, is just as emphatically shown by his handling of the painted architecture framing the scheme. The scenes are separated by broad, flat strips of putto-inhabited acanthus pattern. Above the main series the wall is set back, allowing a broad ledge, or walk, to run unbroken round the entire church, passing behind the arcading of the transepts (Pl. 4, a) and the columns of the main vaulting (Pl. 8). This real setting back of the upper surface is, however, partially painted away by the artist. He sees the passageway not as cutting into the wall, but as jutting out from it, revealing a coffered under-surface resting on voluted brackets (Pl. 1, a). It is this painted architectural feature which underlines Cimabue's conception of the choir and transepts, and probably of the entire church, as a single unified space.[5]

In the first place, the illusionistic brackets run continuously round the whole area of the crossing, effectively uniting the individual scenes. In the second, instead of receding towards the end of the choir, they run in parallel recession outwards from it, just as the histories themselves flow outwards from this centre, rounding either transept to culminate, in each case, in a monumental Crucifixion.[6]

The only other architectural illusionism embraces the decoration above the arcading of the transepts. On the north side this consists of Gothic pinnacles and figure roundels, and on the south of rounded trilobe arches, supported by Corinthian pillars and enclosing half-length angels, only the latter scheme reflecting Cimabue's personal style, if not his actual touch (Pl. 4, a). Here there is no question of a sequence amongst the figures, and it is possible to see, despite the severe damage on the nave side of the south transept, that all its architecture is seen from the right, receding towards, and not away from the end of the choir. Again, as in the history scenes, this concentration on the centre diminishes in the choir itself, where it is already sufficiently asserted by the actual shape of the building.[7]

The understanding of the unifying function of the perspective of the painted brackets supporting the passageway broaches the question of the constructions used by Cimabue in his narrative compositions. This necessitates a glance at the general problem of the representation of solid objects, and at some of the historical antecedents of Cimabue's methods, which, after all, appear relatively late in the history of the representation of space and solidity.

In all primitive arts the first stage in the representation of any cubic object is invariably to show only a single side of it. The latter lies completely undistorted on, or parallel to the representational surface; that is to say in frontal setting (Fig. 1, a). When this is considered insufficiently informative the next stage is marked by a tendency to bring a second side into view by swinging it

round until it too lies undistorted in the plane. This method of representing a solid object will be referred to as a complex frontal setting (Fig. 1, *b*). In both settings the conflict between the three-dimensional world surrounding the artist and the two-dimensional surface on which he wishes to represent it is therefore resolved entirely in favour of the latter. All the concessions are made by the solid objects.[8]

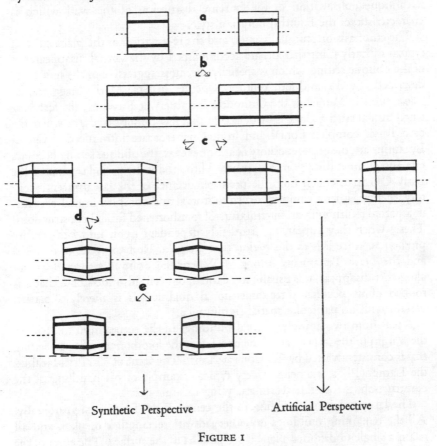

Synthetic Perspective Artificial Perspective

FIGURE I

a. Frontal *c.* Foreshortened Frontal
b. Complex Frontal *d.* Oblique (Extreme)
e. Softened Oblique

The artists of antiquity went on from these beginnings to constructions in which the solidity of the object is not completely sacrificed to the flat reality of the wall. The first of these later developments was what will be called the foreshortened frontal setting. In this case one side is still left undistorted in the plane, thereby stressing the representational surface. But when a second

or third side is shown, each of these appears foreshortened, and recedes as it were into, or through, the representational surface (Fig. 1, *c*). Finally all the visible faces of the object were emancipated from the domination of the plane, and shown in recession, the object then being seen in an oblique setting (Fig. 1, *d*). This evolution was accompanied by an equal, but slower invasion of the flat surface by three-dimensional interiors. This whole process reached its antique culmination in the extreme disruption of the wall which is characteristic of the Fourth Pompeian style.

The emphasis on spiritual values, and the re-assertion of the plane surface, typical of Early Christian art, are accompanied by the virtual disappearance of the oblique setting which is spatially the most aggressive of the four types described. By the mid-fifth century, whether in Sta. Maria Maggiore, S. Paolo fuori le Mura,[9] or the Orthodox Baptistery at Ravenna, the foreshortened frontal setting alone is used, except in a few minor details, or where the even flatter complex frontal and frontal patterns are introduced. Even in Byzantine art, the great repository of antique ideas, the oblique setting becomes rare and at times disappears altogether. Throughout the period separating the Early Christian epoch from the proto-renaissance of the late thirteenth century, there is either a complete return to frontal and complex frontal patterns, or a partial return with an intermixture of foreshortened frontal constructions. These, when they appear, are frequently dependent upon mid-fifth-century prototypes, since it is to this period that the great Roman cycles of the Old and the New Testaments belong.[10] Where the oblique setting does not altogether disappear, it is usually so adapted, or even misunderstood, that it is robbed of its peculiar three-dimensional qualities. It is merely a pattern variant with no particular spatial significance.[11]

Apart from two complex frontal buildings in the scenes from the Life of the Virgin in the upper part of the choir, it is the foreshortened frontal setting that is consistently used by Cimabue at Assisi. The scene of 'St. Peter Healing the Lame' (Pl. 1, *a*), being a very typical example of his handling of the construction, is therefore worth analysing in some detail.

The large polygonal building in the centre of the fresco is seen frontally. All the remaining buildings on either side are rectangular in plan, and all retain a single undistorted plane lying parallel to the surface. The effect of the receding faces is, however, softened by the bird's-eye view employed for the whole scene. As a result all the planes running into depth and establishing the solidity of the architecture also run sharply upwards. The in-running eye is at the same time allowed to continue the upward movement implied by the repeated verticals of the composition without any interruption. In this way the conflict between surface and solidity is reduced to a minimum.[12]

Another important feature of the 'St. Peter Healing the Lame' is the way in which the buildings recede, not towards the centre, but away from it. This has three main consequences. The first is that the eye, instead of being urged

towards the middle of the composition by the orthogonals, or receding lines, is held there by the verticals lying parallel to the surface. The tendency is to read the design in the opposite way to that of a typical renaissance picture which draws attention inwards from all sides. Instead, the gaze moves from the centre outwards, much as the real world is scanned by turning the head from side to side away from the norm, or central axis, represented by a direct glance straight ahead. The tendency to organize his compositions consistently

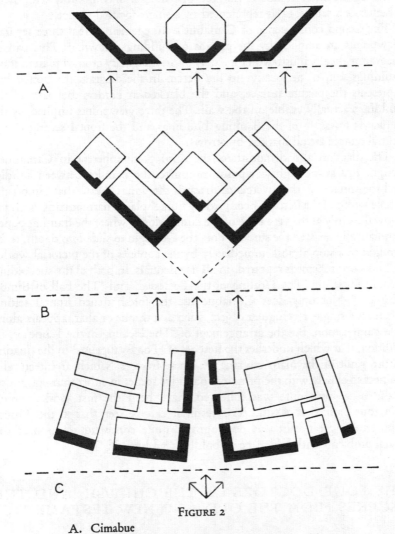

FIGURE 2

A. Cimabue
B. Late thirteenth- and early fourteenth-century painters
C. Ambrogio Lorenzetti

in this way marks one of Cimabue's major contributions to the development of space representation. It is principally this factor of organization which dis-tinguishes his designs from those of many of his contemporaries whose build-ings, while individually constructed on similar principles, recede hap-hazardly to left or right, regardless of their position in the picture. Cimabue's composition is, however, only in harmony with the physiological facts insofar as the eye is led to scan the scene from the centre. There is no question of a scientific interpretation of the facts of vision, or of conformity with them, whether as a whole, or as represented by a single focused glance.

The second consequence of Cimabue's arrangement is that three separate viewpoints are implied by the groups of buildings shown.[13] This can be diagrammatically illustrated (Fig. 2, *a*) by an imaginary ground plan of those buildings seen in perspective in the fresco. In the diagram the dotted line represents the picture surface, and the blacked-in borders the parts of the buildings actually visible on the wall. The three viewpoints implied by the outwards recession of the flanking buildings and the frontal setting of the central temple are all marked by arrows.

The diagram also demonstrates the third point inherent in Cimabue's design. Just as the high viewpoint minimizes the conflict between solidity and the surface, so the divergence towards the wings means that almost the whole width of the fresco is occupied by frontal planes harmonizing with the flat wall. Only at the very edge of the composition, where the framing bands emphatically re-assert the surface, does the eye begin to slide into depth, to be brought to a stop almost immediately by the confines of the pictorial world.

This same scheme is repeated, in all its essentials, in both of the succeeding scenes. These are 'The Healing of the Possessed' and 'The Fall of Simon Magus'.[14] Not only does Cimabue use the foreshortened frontal setting wherever a single, rectangular object, such as a throne or altar, appears alone in a composition, but the arrangement of 'The Healing of the Lame' is, in addition, that which underlies the frescoes of 'The Evangelists' in the quadri-partite vault of the main crossing.[15] These frescoes, which architecturally connect so closely with the principal narrative scenes in either transept, must, if the usual procedure was followed, have been the first works which Cimabue painted at Assisi. As a result it can be seen that in the Upper Church this great artist was developing a quite consistent solution of the visual problems with which he so boldly faced himself.

THE FOUR DOCTORS OF THE CHURCH, AND THE SCENES FROM THE OLD AND NEW TESTAMENTS

The stage in the development of architectural space represented by the frescoes of 'The Doctors of the Church' in the vaulting of the entrance bay

of the nave is so closely related to that embodied in Cimabue's work as a whole, and in 'The Four Evangelists' in particular, that it seems to be worth while to turn to them immediately.

In each of the four frescoes (Pl. 4, *b*) the saint and his scribe are placed in a complex architectural setting that almost fills the awkwardly shaped triangular field. As in Cimabue's 'St. Mark' the various objects do not recede inwards to the centre, but outwards to the wings. Here, however, no definite caesura separates the two halves of the scene, since the various archi-tectural elements stand upon a single unbroken base. The ends of this marble platform, emphasized by bold Cosmati work, are plainly visible as they recede outwards to left and right.[16]

A further link with Cimabue's method of composition is that nearly all the complicated array of desks, thrones, and lecterns is seen from above. Nearly, but not quite all, for, except in the case of the 'St. Gregory', the tops of the scribes' niches, which are the tallest architectural features, do not run upwards like the remaining orthogonals. Instead, they recede downwards. With this change the bird's-eye view is superseded.

In the case of 'The Doctors of the Church', it might be argued that the combination of normal viewpoint and divergent recession is connected with the curvature of the vaults. The fresco of 'The Brothers Interceding with Joseph' (Pl. 5, *b*) on the north side-wall of the same bay shows, however, that this is not the explanation. Here, on a flat surface, the same phenomenon occurs. Despite the damaged state of the painting, it is evident that, on the left, the wall behind the figures, and the balconies of the building above and behind it recede outwards to the left. On the right, the recession of the throne and of the background house is again outwards, this time to the right. Finally, the orthogonals of the bases of both wall and throne recede upwards, whilst the top of the wall, together with all the orthogonals of the background build-ings, recedes downwards.

The effect of this change in the direction of the upper orthogonals is to increase the depth-creating qualities of all the receding lines in the composi-tion. The eye can no longer use the orthogonals as an easy way of skating upwards over the surface. As soon as it begins to do so, it is caught, and forced into depth by the opposing, downwards receding lines. In fact, whether the eye moves up or down, it is equally trapped and funnelled into depth. The realism of the architecture is, as a result, greatly increased. Nevertheless the composition is essentially a more solid repetition of that used by Cimabue. It is only at its very edges that the frontal bulk of the architec-ture allows the movement into space to begin, whilst the conflict between the different viewpoints is, if anything, increased by the lack of any break in the composition.

The lowering of the viewpoint, besides increasing the impression of soli-dity and depth, has the second important effect of immediately making a con-

vincing interior possible. Several stages of this development are already to be seen in the Old and New Testament cycles at Assisi. The process begins with the early master who painted the two bays nearest to the crossing. These include the story of 'The Feast at Cana' (Pl. 4, c).

The conflict between the various viewpoints is much more noticeable in this scene than in any of those already discussed. In Cimabue's type of composition the different points of view are consistently distributed across the picture surface, whilst here a table seen from the left is placed inside a building seen from the right. The footstool on the left conforms with the table, and the now invisible throne on which the figure of Christ is sitting probably also receded to the left. It is as if the two halves of a Cimabue composition had been pressed together and telescoped in the process.

The placing of the servitors and the wine jars in front of the foremost columns of the architectural canopy greatly limits the sense of enclosure. The relatively early stage in the transition from a true exterior to a true interior, represented by this building, is further underlined by the foreshortened frontal setting. The latter allows its whole right end as well as its forward surfaces to be seen from the outside. On the other hand the receding beams and the coffering of the ceiling are clearly shown, and despite the rather sharp tilting of the table to display the plentiful feast, there is a definite sense of looking into a spatial enclosure.

The feeling for the interior increases greatly in the scenes of 'Isaac and Jacob' (Pl. 5, a) and 'Isaac and Esau' in the second bay from the entrance. The building is still seen in a foreshortened frontal setting that allows the exterior of the right wall and the outer boundaries of the open forward wall to be inspected. The scale in relation to the picture space as a whole is completely changed, however, and the edges of the building squeeze against the frame on all sides. There is no longer room for figures to move between the room-space and the spectator, whilst the avoidance of conflicting viewpoints and the more naturalistic foreshortening of the upper surface of the bed combine to increase the reality of the enclosure.

In the last example, the 'Pentecost' (Pl. 5, c) on the end wall of the entrance bay, the beginnings of a centrally viewed interior are seen for the first time at Assisi.[17] Here the rectangle of figures, those seated nearest to the onlooker facing inwards with their backs completely turned, gives an impressive sense of reality to the space which they enclose.[18] The rather shrunken quality of the half Roman, half Gothic triple vaulted building, which scarcely seems to overhang the figure space at all, is at least partly explained by the difficult L-shaped field. In spite of this the solidity of the architecture and the strongly emphasized, if disparate figure room, together with the centralized setting which places the perspective emphasis within the space enclosed, mark an important step towards the many fine interiors of 'The Legend of St. Francis', which completes the decoration of the nave.

In the two bays dominated by the Isaac Master, the links with the St. Francis cycle are in many respects far closer than those with the frescoes by Cimabue and his assistants. This is shown not only by the increasing solidity of the buildings and the emergence of the interior, but also by the actual style of the architecture and by the disposition and treatment of the figures. In all these ways, the frescoes just discussed, whilst retaining certain features from the past, are a fitting prelude to the work which crowns the achievement of the decorators of the Upper Church.

THE LEGEND OF ST. FRANCIS

The clearest evidence that the master responsible for the main body of 'The Legend of St. Francis' starts from that vision of reality shared by the painters of the middle register and vaults of the two entrance bays is to be seen in 'The Vision of the Thrones'. The design is entirely composed of foreshortened frontal objects, their forward surfaces emphasizing the smooth plane of the wall, and the heavenly thrones are all seen from the left, whilst the altar and its canopy recede towards the right. There is even a good deal of structural uncertainty in the latter, since the verticals supporting the roof-brackets have their bases set at widely different depths, although their tops lie in a single plane. It is, perhaps, interesting that the only other fresco in which the orthogonals diverge towards the edges of the composition is the next-door 'Vision of the Fiery Chariot'. In both cases the radical change in viewpoint is accompanied by a change from one reality to another, from a material to a visionary world. This may easily be no coincidence, as these are also the only two frescoes in which objects placed in the upper part of the picture are seen from above, in contradiction of the normal viewpoint of the buildings below. The distinction between the way in which earthly and heavenly realities are seen is therefore made in the vertical, as well as in the horizontal sense.[19]

Although divergence only occurs upon these two occasions throughout the entire series, the foreshortened frontal setting is consistently used in a further seven scenes.[20] All the buildings represented in the cycle are now, without exception, seen from a normal viewpoint, and most convincingly constructed. The rising and falling orthogonals tend to converge quite sharply, as they did in the frescoes of the upper parts of the nave. It is, on the other hand, characteristic of the early stages of empirical perspective that orthogonals which recede in the same sense, either upwards or downwards, usually remain more or less parallel to each other.[21]

A fine example of a building seen from a normal viewpoint with its sides foreshortened and the frontal surface held firmly in the plane, occurs on the right of 'The Dream of Innocent III', the final fresco in the second bay (Pl. 8). The sloping lines of the Lateran supported by St. Francis, on the left

of this same scene, do not reflect a different type of spatial setting, but the tilting of the entire body of the collapsing church. In the fresco of 'St. Francis before the Crucifix' in the same bay (Pl. 8), there is no question of a toppling movement, since the similarly sloping lines are not accompanied by tilted verticals. This time a perfectly steady if rather ruined building is represented. But instead of being shown with one of its outer walls receding, and one left undistorted parallel to the surface, both sides are foreshortened, lying at an angle to the representational plane. This introduction of an oblique setting marks the opening of an entirely new phase in the development of empirical perspective as it is reflected in S. Francesco.

The change is not fortuitous, based merely on a desire to introduce a new decorative pattern and vary the monotony of repeated frontal and fore-shortened frontal settings. It is, instead, one of the many symptoms of the growing excitement aroused by the direct observation and imitation of the natural world.

It is a simple optical truth that as soon as it is possible to see more than one side of any cubic object, all the visible surfaces will recede from the observer and will be foreshortened. This is equally true whether the visible surfaces be two or three, as in a solid cube, or as many as all six, in one that is transparent. The convention, considered up to now, which allows one face to remain unforeshortened, parallel to the representational plane, was, for a time, progressively discarded by those artists who were inquiring most acutely into what it was that they could actually see, who were looking most intensely at the individual objects in the world about them, and who were trying to represent these objects more faithfully than their predecessors.[22]

In the extreme and most characteristic case of the oblique setting, all the visible surfaces of a cube recede with equal sharpness at forty-five degrees to the observer's line of sight. In pictorial terms, this means that all the visible faces of the object will also be receding as sharply as possible from the picture plane. This situation is diagrammatically represented in Fig. 2, *b* (p. 29). If, in this drawing, the rectangular group of buildings shown in plan and continued in the converging dotted lines is considered as a solid block, it is essentially a representation of the ground plan of a building such as the ruined church in the fresco under discussion (Pl. 8). If, on the other hand, the exten-sion is ignored and the buildings in plan are considered as separate units, then the rectangular inlet with its jutting wings shows in essence the position of the houses on either side of the fresco of 'St. Francis Giving Away his Cloak' (Pl. 6, *a*), or of 'St. Francis Repudiating his Father' (Pl. 8). In either inter-pretation the extreme nature of the conflict between the individual solid object and the picture plane against which it thrusts its wedge-like shape is dramatically emphasized.

The diagram, besides stressing the intensification of the element of conflict between the real and the pictorial worlds, also reveals a certain connection

between the new representational method and the earlier artistic solution found by Cimabue. The two flanking buildings shown in Figure 2, *a*, have been retained in Figure 2, *b*. All that has happened is that the short, forward surfaces in the first drawing have been pulled back into steep recession in the second, making them correspond with what would actually be seen by look-ing at such buildings. The inference is not that the second solution is a correction of the first, from which it derives. This is historically unlikely, as the Cimabue stage does not always precede the development of the second visual pattern.[23] The comparison does, however, underline the conclusion, reached when discussing Cimabue's painting, that his compositions repre-sent a first, tentative move towards the recognition of those same visual facts which also underlie the later development.

It is noticeable that, to begin with, it is very largely the extreme version of the oblique pattern which is used by progressive painters. It seems as if, in the first excitement of discovery, it was impossible for the adventurous late thirteenth-century artist to resist making every object just as solid as it could be whenever he used the new construction.[24] This is particularly interesting, since it is generally agreed that both in primitive art and in the reviving naturalism of the period leading up to the Renaissance an interest in the object itself precedes any interest in space as such. The interval, or nothing-ness, which separates one solid from the next, is relatively unimportant.[25] Such abstract statements take on concrete form when the essential qualities of the oblique construction are investigated.

The dominating feature of any building shown obliquely is the vertical of the forward jutting corner. Just as it is upon this main axis that the observer focuses his attention in reality, since it enables him to judge at a glance the apparent slope of the evenly receding pairs of horizontals, so it is this central axis that holds the spectator's attention in the pictorial world.

In any focused system of perspective, such as that invented in the Renais-sance, the vanishing point provides the all-important centre of attention. In such a system the most important architectural elements are the orthogonals, or receding lines, which lead the eye towards the focal point lying in space beyond the confines of the buildings themselves.[26]

In the empirical system based on the oblique setting the situation is radically different. It is clear that the main accent in the building of the 'St. Francis Before the Crucifix' (Pl. 8) is indeed the vertical of the forward corner, softened though it is by the crumbling of the masonry. It is equally significant that not only at this point, but throughout the composition, attention is controlled by the verticals rather than by the receding horizontals. These merely move the eye outwards to either side of the central axis. It is stopped, and concentrated on the important elements in the story by the verticals which frame both saint and crucifix. It is, moreover, the magnetic force of the building's forward jutting axis which holds back the eye, returning it to the

centre, and preventing it from following the receding lines out into nothing-
ness beyond the confines of the composition.

The fundamental quality of the extreme oblique construction, the control
of attention by the feature which epitomizes its aggressive solidity, can be
tested in any of the innumerable examples which occur throughout Italian
fourteenth-century painting, or in the art of any other period in which it
appears. It is inherent in the construction, and quite independent of the
individual composition. Reduced to diagrammatic essentials, the effect is
shown by the two cubes in Fig. 1, *d* (p. 27). If the rest of the diagram is
covered up, it is very noticeable that attention tends to centre on the two
cubes themselves rather than on the intervening space. If the foreshortened
frontal cubes in Fig. 1, *c*, on the other hand, are isolated, it is on the space
between, and not upon the solid objects that the eye is chiefly concentrated.
This is particularly interesting as the diagram does not illustrate a focused
system which would greatly increase the effect.

The tendency of the extreme oblique construction to concentrate attention
on the isolated solid object is accentuated by the fact, illustrated in Fig. 2, *b*
(p. 29), that the use of an extreme oblique setting for a number of buildings
in a design entails the retention of the multiple viewpoints of the older system
(Fig. 2, *a*).

In the frescoes of 'St. Francis Repudiating his Father' (Pl. 8), 'St. Francis
Giving Away his Cloak' (Pl. 6, *a*), or 'St. Francis and the Demons at
Arezzo' (Pl. 6, *b*), the tendency of each architectural block to isolate itself
from the other similar elements of the composition is clearly shown. But if
the onlooker capitulates, and allows himself to concentrate for a moment on
either of the two towns shown in the last two frescoes, an additional fact
immediately becomes apparent. In either case, the spaces separating the houses
have completely disappeared. Once again, this is not peculiar to these par-
ticular compositions. It is inherent in the construction itself. There is no
possibility, no matter how logically a town may be organized, of looking
down a street, of letting the eye rove through the houses directly into depth,
as in a typical renaissance picture.[27] All the streets veer away diagonally,
hidden by the houses. These congeal into a single, wedge-shaped mass, as
solid as the individual buildings which compose it.

This same phenomenon accentuates the tendency to isolation noticed
already, which is partly a direct result of the constructional dominance of
verticals that, by their nature, cannot lead the eye across from one part of a
composition to another. In any of the three examples chosen from 'The
Legend of St. Francis' it is very difficult indeed to associate the two halves of
the design as far as the architecture is concerned.

This quality of emphatic, self-isolating solidity, which restricts the
creation of space to the dimensions of the block-like objects trying to force
their way through the flat surface of the wall, underlies many of the

characteristic achievements and limitations of these frescoes of the story of St. Francis.

The interest in direct observation shown by the increasing use of the oblique setting; by the portrait quality of so many of the buildings;[28] by the descriptive naturalism and spatial grouping of the figures; and finally by the multiplicity of carefully reported detail, is equally visible in the representation of interiors. Centrally seen interiors are now more numerous than foreshortened frontal compromises. The increased authority with which the problem is tackled can be seen in 'The Approval of the Rule' (Pl. 6, c). The audience chamber extends almost to the full height of the design, and only at the top are the forward surfaces of the bracketed vaulting of the side wall left in view. Below this point the side walls are cut by the frame. The figure on the extreme right, standing within the room-space, is only partly visible, whilst the lower border cuts across a floor which does not stop within the confines of the scene. The realism of this limited space is further stressed by the double line of figures ranged in depth upon the right, although the spatial content of the left-hand group is less convincingly described. In the upper part of the fresco a wealth of firmly constructed vaults and distinctively coloured orthogonals make both the plastic and the spatial content of the architecture absolutely plain. Nowhere is there confusion between lines leading firmly into depth, and transverse, horizontal cornices. There is no doubt about the growing conquest of the enclosed space of the interior, as there is none about that of the solid object limited space which, for these artists, lay outside it.

The placing of the figures within this new, interior space is of particular interest throughout 'The Legend of St. Francis'. Their relation to the architecture in 'The Apparition at Arles' (Pl. 9, b) is a direct extension of the idea already present in 'The Pentecost' (Pl. 5, c) on the upper wall. It is this same close union of figures and architecture in the definition of space which is continued in the Arena Chapel at Padua.[29] There, no place is found, amongst the narrative scenes, for the Gothic realism of 'The Preaching of St. Francis before Honorius III', but the space defining semi-circle of the figures is re-stated in still more magisterial terms.[30] Two of the remaining interiors at Assisi, however, present a different problem.

In the fresco of 'The Crib at Greccio' (Pl. 7, a) the interior of the church consists of part of a choir screen and pulpit, sharply cut at either end by the frame, and seen from the choir itself, so that only the back of the large crucifix is visible together with a free-standing, canopied altar, and a lectern on a table base. There is nothing else. Above, undifferentiated blue spreads out a seeming sky. Nowhere is any trace of the enclosing architectural shell apparent.

In 'The Funeral of St. Francis' (Pl. 10) the view is taken looking from the nave towards the choir. A rood beam, surmounted by a crucifix and thirteenth-century panels, runs across the scene. Its end supports, just visible

on the extreme left and right, implicitly reveal the architectural limits. This is confirmed by a low wall, of the same height as the rood beam, receding gently on the left, its top line dipping only very slightly below the horizontal. This leads to a small apse surmounted by a semi-dome that shows its blue coffering above the level of the beam. Overhead, and to either side, undifferentiated blue once more takes over. But although no attempt is made to show the roof or upper walls of the church, the artist has tried to suggest their presence by hopefully hanging panels, crucifix, and even the sanctuary lamps from the amorphous blue of the sky.[31]

These two scenes, and especially 'The Crib at Greccio,' (Pl. 7, *a*) have been put forward as convincing evidence that the frescoes at Assisi must at least be later in date than those in the Arena Chapel. This conclusion, based on the argument that the 'slice of life' impression, the sense of spatial continuity beyond the confines of the frame, is far in advance of anything to be seen in the late thirteenth century, is by no means generally accepted.[32] The fallacy in the argument itself is not so clear, however. The sense of space is indeed remarkable, particularly in the more coherent Christmas scene, which gives less indication of the architectural entity of the church itself. The modern imagination is left free, and the mind's eye sees visions far beyond the descriptive scope of the men who painted at Assisi.

The description of the structure of the two scenes shows that the starting point is not the church as a whole, but its internal furniture. In each case the artist stops short at the point beyond which it seemed impossible for him to carry conviction. In 'The Crib at Greccio' (Pl. 7, *a*) no effort is made to indicate the enclosing body, and in the funeral scene (Pl. 10) the attempt is made, but perforce abandoned halfway with results that are less, not more convincing, since the imagination is brought down to earth with something of a bump. This is a completely different approach to the problem of the interior from that in which the building, however ill-equipped to contain the figures, is the essential starting point. It is, moreover, historically the more primitive of the two.[33]

Two tenth-century illustrations from the Menologion of Basil II[34] are particularly revealing in the present context, as they provide a remarkably close parallel to the late thirteenth-century compositions. In the one (Pl. 7, *b*) a large ambo, surmounted by a canopy and pierced by an arch, fills up the greater part of the scene, whilst in the background stand two column-supported architraves. Above shines a golden sky, and there is nowhere any indication of the enclosing church. In the other (Pl. 7, *c*), a similar ambo, this time with no canopy, occupies the centre of the scene. An apse and semi-dome appear behind it, and on either side of them are the walls and applied columns of a great basilica, again cut short by the gold sky above, and with no indication of enclosure in the foreground.

These two scenes occur on widely separated pages within a great body of

illustrations which reveals quite clearly that the artists concerned had little or no feeling for the closed interior. In countless cases it is quite impossible to say whether the inside or the outside of a building is intended. Symmetrical designs of columns and arches, hung with draperies, seemingly part of an interior, stand behind a foreground strip with stones and vegetation, and are often spatially less convincing than similar features carrying apparently unambiguous external detail.

With the Menologion in mind, the significance of the two frescoes at Assisi is less difficult to grasp. They represent the furthest point of develop' ment of a very old idea, not the beginning of a new conception. They belong, in type, to the group of works including all the early and mid-thirteenth century scenes of churches indicated only by the presence of an altar or some other part of the internal furnishings.[35] This compositional type, the influence of which survives throughout the fourteenth century, precedes the already partially described process of constructing an interior by means of a clearly defined building that gradually moves forward, expanding until its borders run beyond the confines of the frame and all the figures are contained.

The realization that 'The Crib at Greccio' (Pl. 7, *a*) and 'The Funeral of St. Francis' (Pl. 10) reflect an application of the new sense of spatial composi' tion to an old scheme based on the individual interior object is, perhaps, con' firmed by the fact that they lead nowhere. No further development of the idea occurs in the succeeding years, and it is clear that it did not have the same effect upon the contemporary artists and their public as upon the modern observer. Already at Assisi, the conception of the interior as an enclosed, and enclosing box is well enough advanced to carry full conviction, and it is this idea which is not merely echoed, but continuously developed throughout the fourteenth century. The placing of these two outstanding compositions at the end, instead of at the start of a long development, does nothing to detract from this remarkable achievement. It only shows that they cannot be used as evidence in an evolutionary, date-determining argument which ignores their historical antecedents and their subsequent influence or lack of it.

The analyses that preceded consideration of the problem of interior space show that the re-conquest of the visible world, which opens up such seem' ingly limitless possibilities for the narrative scene, contains a number of essentially disruptive elements. It was noted then that the increase in natural' ism and in spatial realism in Cimabue's frescoes in the choir and transepts was accompanied by an unprecedented effort to tie the whole ensemble together, thereby reasserting the inherent unity of the wall, and of the archi' tectural enclosure. It is, therefore, interesting to see to what extent a similar attempt has been made in the nave, where the aggressive qualities of the spatial pattern are so much more clearly marked. The term aggressive is no colourful exaggeration. The new spatial effects must have seemed quite startling to eyes unschooled by the centuries of far more radical attacks upon

the picture surface that separate the modern observer from the late thirteenth century.

The articulation of the decorative cycles in the Gothic nave of the Upper Church is conditioned by the latter's division into four vaulted bays (Pl. 8). The clustered columns, supporting the vaults, mark the boundaries of strong divisions in the side walls which, below the level of the encircling passage, are otherwise uninterrupted. This lower space was that reserved for the great fresco series of 'The Legend of St. Francis'.

The base of the wall is again covered by painted hangings, as in the choir and transepts. Above this level, however, the relatively flat, decorative framing, surmounted by a single painted architectural cornice, is replaced by a magnificent monumental colonnade. The massive, twisted columns stand above rich mouldings and support a coffered architrave topped by painted brackets. The latter, in their turn, hold up the real moulding forming the upper boundary of the field. This superb invention, its unbroken horizontals set off by the majestic verticals of the columns, is the key to the whole formal concept of the cycle.[36]

The division of the wall-space into bays is not merely accepted by the artist. It is actually emphasized by means of the perspective construction which, instead of treating the whole nave as a single unit, makes the centre of each bay an individual focal point. In every bay the orthogonals of the bases and capitals of the columns, of the coffering, and of the projecting elements of the mouldings above and below, all recede in parallel towards the centre. This construction marks a fundamental change from the outwards receding orthogonals used by Cimabue. The centre is now indicated by the space between two plastic elements, and not by a solid bracket with both sides receding in full view. Realism is further increased by showing the whole scheme as if it were seen from below, in conformity with the observer's actual position. The spectator is even told approximately how far away from the wall to stand in order to obtain the best effect. This interval is less than the width of an entire bay, but over twice that of an individual scene. A compromise is therefore reached between the distance which allows the bay to be seen as a unit, and the best distance for seeing both the whole and the parts of the individual fresco.[37] Apart from its aesthetic quality, the scheme is a revelation of how much can be achieved by the simplest means, and without the aid of any theoretical system.

The perspective construction used for the architectural framework at Assisi, at the very outset of the renaissance story, was indeed still used by artists such as Piero della Francesca and Mantegna, two of the main protagonists of theoretical perspective.[38] The method survives throughout this long period of violent change because it is both simple and sufficient. To do more than is done on the walls of S. Francesco is very often wasted effort, and was recognized as such.

The full significance of the new element of concentration on the individual bay only emerges if the artist's own intentions are respected. The onlooker must not merely read the story and enter into the formal play of every fresco. He must look at each bay as a whole, considering it both in itself, as a larger decorative unit, and also in its relation to its neighbours on the wall and to their counterparts across the free space of the nave.[39]

The story opens, in the first bay, with the three scenes of 'St. Francis Honoured by the Madman', 'St. Francis Giving Away his Cloak' (Pl. 6, *a*), and finally 'The Vision of the Palace'. It is almost as if the story of St. Peter and St. Paul, filling the north transept end, were repeated once again to smooth the passage from one narrative to another, from one visual world into the next, even as the spatial complex of the choir and transepts resolves itself in the smooth-flowing nave. The centre of the three compositions is not now the crucified St. Peter (Pl. 1, *b*), but the young St. Francis. The V-shape of the Roman monuments fades into Umbrian hills which no less firmly run the eye towards the focal point, the haloed head of the young saint. The patterns of the falling hillsides are caught and echoed in the falling folds of the cloak. The balanced masses of the background are the natural counter-part of the balanced foreground figures, with the cloak and the poor noble-man on one side, and the ass upon the other, evenly weighted round the axial figure of St. Francis. Once again, as in the transept-ends, the flanking scenes poise evenly about the central composition. Both are similarly weighted by the architectural complexes which almost entirely fill them; and this despite the heavy, stone bracket that juts out high up in the middle of the left-hand fresco, limiting the compositional possibilities. The greater number of figures in the first scene does something to redress the balance, although in the church itself the major contrast is always between the rich blue of the sky and the pinks, and creams, and greys of the solid masses as a whole. Whether the latter are composed of landscape, architecture, or plain figures, singly or in combination, makes small difference in comparison. It is, however, no exaggeration to say that this opening bay is composed in quite firm sym-metry about the central figure of St. Francis.

There are almost certainly two personalities involved in the actual execu-tion of the opening bay, the first fresco of which is usually ascribed to the St. Cecilia Master. It might at first seem likely, therefore, that such a balancing of scenes was rather the unconscious harmonizing of artists united by a single, well-established tradition of apprenticeship and of artistic practice, than due to any conscious planning. Such a position soon becomes untenable, how-ever, in front of the three frescoes in the second bay (Pl. 8). Here the com-bination of the scenes of 'St. Francis Before the Crucifix', 'St. Francis Repudiating his Father', and 'The Dream of Innocent III', gives even stronger meaning to the unity of the bay, stressed as it is by the perspective of the architectural framing.

In the central fresco both figures and architecture are evenly balanced, this time not on the figure of St. Francis, but about the dramatic hiatus which gives visual form to the tension of the story. As in the opening bay, the scenes on either side are dominated by the architecture, now more massive still. But here, the artist's desire to form a single, balanced composition out of the whole bay is also underlined by the very structure of the dissimilar buildings making up the wings of his design. The church of S. Damiano is obliquely set with both of its main faces running into depth. The tilting Lateran on the right is differently constructed, like the foreshortened frontal building which contains the sleeping figure of the Pope. It is, moreover, intended to be a portrait of the actual basilica.[40] Yet the fact that the building in the left-hand fresco is meant to be seen, within the symmetrical framework of the whole bay, as the formal counterpart of that in the right, is unequivocally emphasized by the heavy, rich, red bands that stress the base lines of the two buildings. These run in towards the centre at an identical angle to the lower border. Even in photographs the effect is so striking that it seems impossible to deny that the formal elements of the three scenes have been carefully manipulated to create a single, balanced pattern on the wall.

Now that the identity of the complete bay, as a decorative unit, has been clearly stated in the repeated strict symmetries of the opening pair, the pattern is softened and varied in the next two which complete one side-wall of the nave.

In the frescoes of 'The Approval of the Rule', and of the visions of 'The Fiery Chariot' and of 'The Heavenly Thrones', it is impossible to balance the main masses of the three individual compositions. The barrel vaulting filling the upper third of 'The Approval of the Rule' forms, it is true, a clear decorative counterpart to the five thrones in the third fresco, whilst the formal separation of the upper area is also present in the central scene. Nevertheless, there can be no question of arguing that any strict symmetry is intended in the general disposition of these three frescoes as a group. In reproduction the similarities are emphasized by the lack of colour. In reality, the heavy, figure-filled interior of 'The Approval of the Rule' can in no way be called the counterpart of the isolated forms and sparse figures of 'The Vision of the Heavenly Thrones'. There the bright creams of the architectural elements stand out like islands in the blue seas of sky. There are elements of symmetry amongst the figures, particularly in the 'Vision of the Fiery Chariot', and in the tendency in all three scenes to accelerate upwards to the right. But these again cannot be carried through to form strict symmetry within the whole. Instead of single, firm chords, there is a contrapuntal rhythm full of contrasts, similarities, and echoes. The unity of the bay is recognized, but it is not asserted with such clear urgency as in the opening scenes.

The same is also true of the large, four-frescoed bay which occupies the rest of the north wall of the nave. This time, although there is a tendency for

each scene to be divided vertically into two roughly even parts, the con-
tinuous choir screen and crowded figures of the fresco of 'The Crib at
Greccio' on the right preclude the possibility of overall symmetry in the main
compositional masses. As far as the figures are concerned, the division of the
compositions, and the movement of interest diagonally upwards, link the
'St. Francis and the Demons of Arezzo' and the 'St. Francis in Glory'. The
threefold grouping and hesitant leftwards movement of 'The Ordeal by
Fire' are similarly balanced by a tendency to threefold articulation and con-
centration of attention on the right in 'The Crib at Greccio'. This complex
interweaving of formal patterns could be followed into further detail, but it
suffices for the present purpose if the fluid nature of the design of the final bay
has been established.

If this is so, not only the individual compositions and the bays in which
they are grouped, but the whole wall can be seen to have a definite organiza-
tion, with two rigidly centralized and symmetrical bays, followed by two
with a more open, more complex, less assertive pattern. This does not mean
that in the larger unit of the wall a state of self-sufficiency is reached. The full
significance of the new design can only show itself in the still greater whole
of the full cycle that encloses the nave in its entirety.

The dispersed composition of the fourth bay is succeeded by concentration
on the particular problems posed by the end wall. The latter is, for the in-
quirer following the unfolding legend step by step, a connecting link between
the two main walls of the nave. It is also a static frame for the great centrally
placed main doors, the last thing seen on leaving the church.

The two episodes flanking the doors are 'The Miracle of the Spring'
(Pl. 9, a) and 'The Sermon to the Birds'. Their subject matter ensures that
the last impression on the minds of the faithful as they leave is that of two of
the most popular Franciscan stories.[41] Formally, as country scenes, and the
only landscapes with no trace of architecture, they make a pair as nicely
balanced as it is distinctive. Finally, this static composition of the doors and
framing frescoes is stressed by the perspective of the single cornice. The latter
forms a flattened arch across the wall, all its orthogonals running down in
parallel towards the centre.

The linking function of the entrance bay is admirably expressed by the
actual composition of the two scenes. Even as the cornice rises to surmount
the doors, so, in 'The Miracle of the Spring' (Pl. 9, a) the figures enter on the
left, the mule still only half in sight, and then the eye sweeps upwards with
the upturned face of the praying saint and the up-rushing mountain, ready
to glide, in one smooth movement, up and out over the doors. Once on the
other side it floats down softly as St. Francis, standing on the left, leans
forward, looking down to bless the birds that flock upon the ground beneath
the thick-boled tree that closes in the composition. As this gentle, falling
movement draws to its close in the very bottom right-hand corner of the

fresco, the transition is completed, and the dual problem offered by the entrance wall triumphantly resolved.

It is significant that whilst the previous thirteen frescoes, composing the decoration of the long wall, follow one another without deviating from the order laid down in the Legenda Prima, these two scenes are widely separated from their place in this, the authoritative literary source. There is, indeed, in the entire cycle, only one other case in which the order given in St. Bonaventure's text is not respected.[42]

The four scenes in the following bay, the sixth from the beginning of the series, are those of 'The Death of the Knight of Celano', 'The Preaching of St. Francis before Honorius III', 'The Apparition at Arles' (Pl. 9, b), and lastly 'The Stigmatization'.

The most striking formal element in the whole bay is the great architectural block uniting the two middle scenes. The possible monotony inherent in a total repetition is avoided by a change of viewpoint, the building in one being seen centrally, and in the other in foreshortened frontal setting. Otherwise these two scenes mark the designer of the cycle's nearest approach to a solution in the style of Cimabue. Three equal Gothic arches, similarly emphasized by their decoration, constitute in either case the major architectural accents. In either case one of the two principal figures stands facing inwards on the very left of the interior, linked by the drama of the action to the other, who creates an even stronger formal accent slightly to the right of the composition's centre. The concave disposition of the seated figures facing the spectator in the first scene, and the convex, back-turned spatial closure in the second, stop the repetition from becoming overpowering. Yet the determination to create a single, firmly knit, and generally symmetrical centre out of these two frescoes is in no way overlaid. The flat roofs given to each building, and the way in which their individually unbroken cornices are made to coincide, and to run through from one scene to the other, interrupted only by the framing column, is sign manual of the artist's purpose.

Despite the fact that of the two remaining frescoes, one contains a vestigial interior, and the other a landscape with much smaller buildings, the master has contrived, by limiting the architecture in the left-hand scene and stressing the identity of the double, central block, to bring the bay as close as possible to a symmetry consisting of two lighter wings depending from a solid architectural centre. The use of blue for the curved ceiling of the left-hand building is a further help in establishing the equation of the flanking scenes. Moreover, whilst the general L-shaped disposition of the masses is the same in both, the movement of attention is down and to the right, towards the centre of the bay in one, and up and outwards from it in the other. The very real success achieved in building up a centralized and symmetrical bay design from these disparate elements can easily be seen by looking at the diffused arrangement of the composition on the opposite wall.[43]

The Upper Church of San Francesco at Assisi

At this point, with its spiritually important, as well as chronologically accurate culmination in 'The Stigmatization', the active life of St. Francis comes to an end.

The next bay, despite a clear change of hand, is again symmetrically grouped about the centre (Pl. 10). In the middle fresco of 'The Visions of Augustine and of Bishop Guido' the right aisle of the church, forming one of the three architectural accents that frame the separate incidents, falls at the centre of the fresco, isolating a figure in the very foreground. The even stress about this central axis is completed by the balancing of the bell-tower of the church against its high-pitched roof, thereby neutralizing the displacement of the latter to the left.

On the wings, 'The Death and Reception of St. Francis' is balanced by 'The Funeral of St. Francis, and Conversion of Jerome'. In both, the top third of the design is marked off by a strong horizontal, formed in one case by the solid line of heads, and in the other by the rood beam. Above this line the triple accent of the angels and the rising Saint in one, is repeated in the cross and panels and interior detail of the other. Below the identically placed horizontal caesurae, the two scenes are the same in all essentials. In both, the body of the Saint, which lies in a rectangular, figure-enclosed space, provides a second horizontal stress. In both, a single figure interposes itself between the spectator and the prostrate Saint, whilst at either corner others, turning inwards, show their backs. It is perhaps significant that the ofter-noticed way in which both lamps and cross are apparently hooked to the sky in fact helps the equaton of the two wing scenes. There is, therefore, a certain logic in the very illogicality of the composition; an illogicality increased by the fading even of those architectural elements which the artist had intended to be visible. The balance with the open sky of the scene on the left is almost perfect, and provides a fine example of the successful exploitation of a limitation.[44]

The frescoes of 'The Mourning of the Clares', 'The Canonization of St. Francis' and 'The Dream of Gregory IX', which fill the eighth bay, return, in contrast, from the centralized, strongly symmetrical type of composition to the looser unity. The façade of S. Damiano on the left is echoed by the hanging canopy upon the right, and a horizontal accent runs across the bottom of all three scenes. On the other hand the mass of the interior on the right is not to be equated with the bright blue sky that sets off the brilliant marbles of the diagonally seen façade upon the left. Similarly, whilst the tall bulk of the building filling the left half of the centre composition does something to redress the balance and increase the architectural weighting of the left half of the bay, it makes the canonization scene strongly asymmetrical in itself, without, however, restoring symmetry to the composition of the bay as a whole.

Finally, in the ninth, and last bay of the series, in which another change of

hand takes place, the same compositional methods are brought to bear upon the problem of a satisfactory ending. The figures in the three scenes of 'The Healing of the Man of Ilerda', 'The Confession of the Resuscitated Woman', and 'The Deliverance from Prison of Peter the Heretic' are symmetrically grouped. A static element is therefore introduced as far as the figure design is concerned. In either of the flanking scenes two groups divide the composition. In the middle fresco, figures clustered at the sides look in towards the isolated pair who form the point of concentration of the miracle, so that the single scene again epitomizes in itself the symmetry which draws the bay together. The main compositional masses, on the other hand, make up an asymmetric group. Instead of being balanced round the centre, the architecture forms a steady decrescendo. The heavy, centralized interior on the left is followed by a lighter, foreshortened frontal structure which lacks, in its coffered ceiling, the same dramatic thrust straight into depth, and leaves room for a scene of heavenly supplication. In the third and last fresco the single solid building has fragmented into two light variations on a Roman theme, and, as in the preceding scene, the falling movement of the architecture is accompanied by a slowing of the natural progression to the right by means of flying figures. These sweep back against the flow, upwards, and to the left. So, in this final detail, the last rallentando of the dying music is completed.

It is now possible, for the first time, to see in the finished pattern the full sweep of the artist's conception. The relatively rigid symmetries, characterizing the formal pattern in the first two sections of the wall, assert the reality of the bay as a decorative unit. The point once made, the next two bays present a softer and more lively grouping. The frescoes on the entrance wall are in close harmony with it, both in its own essential symmetry and in its linking function. Then, on the second side wall, two strong symmetries are once more followed by two looser groupings, with a closing motif in the final bay to bring the story to an end. In this way the walls are varied evenly by two quite different types of composition without resorting to an actual alternation bay by bay.

It is not merely on the individual wall, however, that this scheme has meaning. It has a spatial interest as well, for the pattern variation also balances wall with wall across the nave, involving its whole volume in the decorative unity. Under each of the four quadripartite vaults the strict symmetry on one wall balances a freely composed group on the other. The patterns alternate in couples across the greater, threedimensional units of the architectural bays, so that the two halves of the nave are also balanced against each other, and out of the variety of parts is born the final symmetry of the whole.

This analysis leads inescapably to the conclusion that a single artist must have been in close control of the general design of all the frescoes in the entire series. Two different personalities are involved in the execution of the strictly symmetrical first bay, and there is no break in the compositional rules which

govern the work of the three main artists involved in the series as a whole. These three are the St. Cecilia Master; the artist of the principal group, comprising frescoes two to nineteen; and the painter of bays seven and eight.[45] One of the hall-marks of the latter's style is his delight in crowd scenes. In the Canonization, for example, about ninety figures are in some way indicated, and all his crowds are far more populous than those painted by the master of the main group. This does not, however, materially affect the question of the degree of control exercised over the individual executants. The main lines and divisions of a crowd scene can be roughed out with a dozen figures, and the subsequent increase in the number of heads, and so forth, need make no difference to the general compositional structure. The very fact that this particular master, whatever his personal inclinations and abilities, does conform so closely to the general plan, painting one symmetrically centralized, and one loosely organized bay, is, if anything, a strong argument for the idea of a compositional scheme for the whole nave.

There is, unfortunately, no indication of the precise method by which the ideas of the leading artist were passed on. Lacking other evidence, it seems most in conformity with early practice to suppose that he sketched out the composition of each fresco on the under-plaster, leaving the remaining processes, where necessary, to the individuals under his control.[46]

The decoration in the nave, conceived by this great but controversial personality, is, as a whole, a close development of Cimabue's earlier conception in the choir and transepts. In the less complex space the symmetries have greater suppleness. Actual repetition is avoided, but the softer harmony creates a no less all-embracing unity. The increasing three-dimensionality of the individual scene, and the new, self-isolating, and disruptive tendencies of the ever more important oblique setting are offset by intense preoccupation with the two-dimensional values of the pictorial surface. The unity of the whole restores the balance that may, at times, be lost within the parts. It seems to be significant that this desire to balance and counterbalance single compositions within the divisions of the wall, and walls within the architectural volume of the building as a whole, should reach its peak at just this moment.

It is not merely in its state of preservation, or even in the continuity of development upon its walls, that San Francesco is unique. It is unique above all in its artistic unity; in the exciting interplay of part and part within that single whole by which the visitor is enfolded, no matter where he stands in nave or choir, or where his gaze falls on the work of two great masters.

CAVALLINI AND ROME

The striking coherence of the developments in the representation of space at Assisi raises an immediate question as to whether this is an isolated pheno-

menon, deceptive in its orderliness, or a true reflection of the main stages in the growth of spatial realism in thirteenth-century Italian art. The answer lies in Rome, and, more especially, in the art of Pietro Cavallini.[47]

Cavallini's greatest series of frescoes, and also his earliest recorded works, were the huge cycles of scenes from the Old Testament and from the life of St. Paul on the walls of the main nave of the old basilica of S. Paolo fuori le Mura. Fortunately it is still possible, despite the destruction of the basilica by fire in 1823, to learn much about these lost designs through water-colour copies made for Cardinal Francesco Barberini in 1634.[48] These copies form one part of a series of similar records by various artists. The collection includes, amongst others, the mosaics of Sta. Maria Maggiore and Sta. Maria in Trastevere, and the frescoes of St. Urbano all'Caffarella and S. Lorenzo fuori le Mura. Comparison with the existing works establishes the all-important fact that the seventeenth-century artists are usually extremely reliable as regards general layout of the compositions and the distribution and structure of the architectural features.[49]

A series of inscriptions dates the frescoes of 'The Life of St. Paul', formerly on the wall to the left of the nave on entry, to the years 1277–9. The Old Testament scenes, once on the opposite wall, can similarly be placed, with a high degree of probability, but without the same certainty, in the period between 1282 and 1290. In the latter case, the work was commissioned by the same Abbot Bartholomew who also ordered, as part of the general renovation, the new ciborium signed by Arnolfo di Cambio in 1285.

The general impression left by the forty-two drawings recording the frescoes of 'The Life of St. Paul' is one of considerable stylistic variation from one design to the next. This impression is not due to the fact that several draughtsmen were concerned in the copying. Even amongst the drawings by one hand, the kinds of variation visible in the series as a whole remain apparent. The inter-relationships of the figures themselves are, nevertheless, fairly constant. The latter are nearly always ranged across the surface as if confined to a shallow relief plane. In this respect there is little distinction between designs containing large numbers of figures and those with only three or four. The pattern is only varied to any extent in some eight compositions, quite haphazardly grouped within the series, and involving at least three different copyists. This group appears to reflect a number of tentative efforts at design in space, rather than a steady development of any kind.

The overall uniformity in the spatial character of the figure disposition is accompanied by a much greater variation in the depth of the composition as a whole, in the position of the relief plane of figures within this space, and in the latter's relation to the architecture. It is, however, the very great variation in architectural style, rather than the differences in the spatial setting of the architecture, that is responsible for the heterogeneous impression left by the series as a whole. There are designs which seem to be directly dependent upon

the late antique and early Christian art of the mid-fifth century A.D. There are others in which some Byzantine intermediary seems to be apparent, and yet more in which such mediation is quite certain. Finally, there is a small group which can be quite closely connected with work carried out in Rome during the late thirteenth century itself. The costume of the figures shows a comparable range, the different groups into which it falls being likewise independent of the several stylistic variations introduced by the copyists.

The wording of the inscriptions, and their wide spacing on the wall, appear to make it certain that the entire cycle was repainted in the late thirteenth century. The variations in style and iconography therefore seem to stem from the fact that Cavallini was both faced with, and influenced by, the patchwork presented by a fifth-century cycle already heavily overlaid by subsequent alterations. It is even likely that he himself at times did little more than restore or reproduce the existing designs. The one thing that seems to emerge very clearly is that Cavallini was not, at this stage, completely in command of his own personal style.

This uncertainty is strongly reflected in the architectural constructions. Nearly half the scenes show only frontal and complex frontal buildings, often of uneasy structure. In the remainder the foreshortened frontal construction occurs, either by itself or in conjunction with one of the other two. Only in one composition, 'The Conversion of St. Paul' (Pl. 11, *b*) is there a determined attempt to create a building seen obliquely. This building is, moreover, unique in scale as well as in setting. In style it points forwards more clearly than any of its companions in the direction of Cavallini's personal manner. The latter begins to develop firmly for the first time in the Old Testament cycle on the opposite wall of the nave.

Here, the echoes of fifth-century art, which appeared to occur amongst the earlier compositions, are confirmed. A block of ten fifth-century designs seem clearly to have been left untouched by Cavallini and his predecessors.[50] These scenes are distinguished by their very simple, but firmly constructed foreshortened frontal architecture, with its characteristic tendency to a high viewpoint (Pl. 11, *a*). The perspective of these simple buildings is less confused, and more advanced in terms of structural realism, than that of the often more complex designs already discussed. But if Cavallini, by 1277–9, had not, in perspective matters, reached the level of his fifth-century forebears, although frequently outstripping them in ambition, he has, by the mid-eighties, passed beyond them.

The increased confidence is noticeable in the distribution of the figures. There is more spatial play between the individuals, and crowds take on impressive bulk in depth. In the fresco of 'The Plague of Serpents' (Pl. 12, *b*) the shallow movement and reluctant bending inwards of the figure relief occasionally to be seen on the opposite wall is replaced by a complete circle of figures extending into space in intimate connection with the architecture.

All attention focuses across the hollow centre on the serpents writhing in the foreground.

All the compositions in this series, excluding the ten fifth-century scenes, belong to a coherent group, the unity of which transcends the variety of influence that has been absorbed. This new unity is visible in the costume, in the landscape, and above all in the architecture. The latter, stripped of only partially digested late antique detail, has a simplicity and certainty of structure that points towards Cavallini's later work. Only one purely frontal structure, and no complex frontal buildings at all, can be found in the whole cycle.

The foreshortened frontal construction, handled with a new sureness, is used in nine of the fifteen scenes containing houses and thrones. In the remaining six the oblique construction is attempted with a confidence that reveals itself most strikingly in the extreme oblique setting of the scene of 'Joseph and the Wife of Potiphar' (Pl. 11, *c*). The increased scale of the architecture in relation to the figures, another feature which develops in the Old Testament series, is also vividly illustrated in this design. A single building, showing its interior, almost fills the pictorial field. The jutting architecture sets the whole composition in motion. It reinforces the powerful diagonal movement of the figures expressed in the sudden sweep of Joseph's cloak as the wife of Potiphar tears it from his shoulders. Although there is still uncertainty in the relation between the floor and the left-hand wall, the spatial forcefulness of the design speaks for itself when compared with the church in the 'Conversion of St. Paul' (Pl. 11, *b*). The continued development of the normal viewpoint already visible in the earlier composition emphasizes the observation of nature that underlies these changes in design, just as it underlay the similar development amongst the frescoes at Assisi.

Despite the oblique setting, which stresses the same growing awareness of external appearances, there is a powerful feeling for enclosure in the scene. The relation between the figures and the floor is clear, and the volume of the interior is defined with a new force. Nevertheless, it is not surprising that the most complete conquest of interior space is to be seen amongst the foreshortened frontal compositions. This development culminates in the clarity of structure and uncompromising enclosure of the scene of 'Joseph in Prison' (Pl. 12, *a*).

The next landmark in Cavallini's career is the mosaic decoration in the apse of Sta. Maria in Trastevere, dating from 1291. These few surviving compositions reveal his continued movement in the direction seemingly established by the drawings of the frescoes in S. Paolo, thereby providing further confirmation of the copyists' accuracy.

Out of the ten major cubic structures shown in the mosaics, six are foreshortened frontal in setting and four are oblique. The latter now possess a solidity of construction which previously characterized only the fore-

shortened frontal buildings. It is, however, significant that the tall edifice on the left of 'The Presentation' (Pl. 12, *c*), which accompanies two foreshortened frontal structures, reflects precisely the stage in the transition towards realism revealed by 'The Plague of Serpents' (Pl. 12, *b*) in the Old Testament cycle in S. Paolo. In both scenes the architecture is so constructed that the base is in the extreme oblique setting, whilst the horizontal main line of the top appears to reflect a compromise with the foreshortened frontal type.

The frescoes in Sta. Cecilia are usually considered to be Cavallini's next known task.[51] Unfortunately, it is impossible to tell if he continued to divide his architectural designs more or less evenly between oblique and foreshortened frontal patterns in a manner reminiscent of the main St. Francis cycle at Assisi. In the few surviving fragments only the foreshortened frontal setting is visible, although it is interesting to notice the divergent arrangement of the thrones in 'The Last Judgement'. This compositional feature was already present in the two wing structures in 'The Dormition' in Sta. Maria in Trastevere. It is also interesting that the important detail of the lower part of the fresco of 'Isaac and Jacob', so closely connected with the similar scene at Assisi, is structurally less advanced than the finest interiors in S. Paolo. The interior to be seen in 'The Birth of the Virgin' in Sta. Maria in Trastevere is likewise considerably shrunken in relation to the most advanced designs reflected in the S. Paolo copies. This may, however, partly stem from a desire to balance the visual effect of the whole sequence of mosaics in the apse. This little 'interior', despite being placed behind, rather than around the figures, is the first of Cavallini's buildings to show the receding coffered ceiling so prominent in late thirteenth and early fourteenthcentury Italian art and already observed in 'The Feast at Cana' at Assisi (Pl. 4, *c*).[52] This mosaic is nevertheless a further warning that it is unwise to expect the absolute consistency which seems to be the basis of certain theories about the evolution of the interior.[53]

This survey of Cavallini's known work, from the mid'seventies to the mid'nineties, confirms the fact that the sequence of development so clearly visible at Assisi is not fortuitous. The stages represented by the work of the various masters who painted the nave of the Upper Church correspond with the development in Cavallini's art between the cycle of 'The Life of St. Paul' in the late seventies and the work in Sta. Maria in Trastevere in 1291. Such a development fits in coherently with the most probable dating of 'The Legend of St. Francis' in the middle or late 'nineties. There, the coexistent foreshortened frontal and extreme oblique designs, seen slightly earlier in Cavallini's work, set the stage for the patterns which emerge in the Arena Chapel at Padua. It must also be remembered that the entire decorative framework of the St. Francis cycle derives from Roman prototypes, S. Paolo amongst them,[54] whilst Cimabue's frescoes of 'The Lives of Sts. Peter and

Paul' depend, in all probability, on the lost series in the portico of Old St. Peter's.[55] The crucial part played by the vanished late thirteenth-century Roman cycles then begins to appear in its true light.

It was in Rome that Italian painters first rediscovered nature through the art of late antiquity. It is against this background that the history of the fourteenth century is unfolded in the great twin centres of Tuscany, in Florence and Siena.[56]

NOTES

1. For St. Francis's stress on the passion, see A. Nicholson, *Cimabue*, Princeton, 1932, p. 4 ff., and, W Schöne, 'Studien zur Oberkirche von Assisi' in *Festschrift Kurt Bauch*, Munich, 1957, pp. 50 ff.

2. Fading of the colour and complete reversal of the light have increased the impression of chaotic movement in both scenes. The difficulty of deciphering the 'St. John on Patmos' minimizes those elements which would have distinguished it from its companion.

3. The dissimilarity of subject in these frescoes is as striking as the formal balance which they create. The conception differs completely from that of the many examples, as in old St. Peter's, of the equation of the Old Testament on one wall of the nave with the New Testament on the other, or, as in S. Angelo in Formis, of a similar division of subject between nave and aisles. Such didactic parallelism is never accompanied by close formal interplay between the opposing decorative surfaces.

4. The interplay of subject matter and complex repetition of single figures in middle byzantine art are similar in theory, but far removed in visual effect. O. Demus, *The Mosaics of Norman Sicily*, London, 1949, pp. 418 ff., describes the late Comnenian method of balancing the internal compositional features of narrative scenes and sometimes of entire walls. The latter is seen on the end wall of the nave at Monreale, illus. E. W. Anthony, *A History of Mosaics*, Boston, 1935, Pl. L, No. 176, but the lack of late twelfth-century comparative material from Constantinople makes it impossible to say if any of these relatively fluid symmetries became more rigid. The development was, in any case, cut short by the Latin conquest of 1204. The Venetian mosaics are closer geographically, but stylistically less likely as a prototype for Cimabue, although this source seems certainly to lie within the sphere of Byzantine rather than of purely Italian art.

5. The illusion does not account for the full depth of the passage, and the designer of the 'Legend of St. Francis' improves on Cimabue in this respect by greatly increasing the penetration of the painted architecture. The aesthetic principles involved have been stressed by J. Wilde in a series of unpublished lectures on Assisi. The word 'illusion' is not taken to imply a complete or systematically thorough attempt to deceive, but is used wherever a definite effort to counterfeit three-dimensional reality occurs. Here, the solidity of the painted cornice clearly represents an intention differing from that revealed in the flat framing of the narrative scenes below it.

6. The situation is complicated in the south transept, but it seems to be certain that the scene of 'St. John on Patmos', with the angel pointing out the visions, comes at the beginning of the sequence, and not at the end. The order in which the remaining scenes occur in the text of the Apocalypse, however, implies a movement from nave to choir which is continued in the visually almost interchangeable scenes from the Life of the Virgin. On the other hand, the series of scenes from the Old and New Testaments on either side of the nave both run away from the transepts towards the end of the nave.

The final effect, therefore, is to create a movement from the choir round either transept and on along the upper levels of either side of the nave. But in the South transept, in which the narrative element is weakest, the textual order supports the normal order of reading, which runs from left to right.

7. The painted trilobes in the choir are shown in pure elevation, and stand on columns. The Gothic ornament on the choir side of the north transept is similarly unforeshortened. That on the nave side is in part seen from the right, probably in imitation of the south transept decoration. The contradiction of the general scheme possibly stems from Cimabue's less tight control over the executants of the minor detail in this section.

8. These patterns are found in Egyptian and in early Middle Eastern art generally, as well as in Greek vase painting. They dominate those medieval periods and localities in which interest in the representation of space is least evident, and are common in twelfth- and early thirteenth-century Italian art.

9. Known from copies considered on pp. 48 ff.

10. The earlier tendency to place these cycles in the fourth century appears to be unsound. J. Garber, *Wirkungen der Frühchristlichen Gemäldezyklen*, Berlin, 1918, gives a mid fifth-century date. Demus, op. cit., p. 238, note 26, supports this. A. C. Soper, 'Italo-Gallic Christian Art', *Art Bull. XX*, 1938, pp. 190 ff., advances the most powerful arguments against the earlier date.

Where Byzantine artists go directly to the Hellenistic sources, they also tend to re-interpret them in such a way that complex frontal and foreshortened frontal structures again predominate. Late Comnenian art presents a singularly vigorous example of the revival of foreshortened frontal settings with late antique and early Christian associations clearly visible.

11. Demus, op. cit., in considering the mosaics at Monreale, recognizes that the oblique pattern represents a more developed stage in spatial construction, and one with a tendency to break up the wall surface.

12. The one important exception to the general rule of a high viewpoint is 'The Fall of Baby-lon' in which the downsloping lines of the city wall harmonize with the falling movement of the houses.

13. Lines only begin to recede into vanishing points at a later date. But the fact that things are seen from one side or another, or from straight ahead, can be indicated without such focusing.

14. The only alteration is the replacement of the centrally seen building by a foreshortened frontal structure receding upwards to the right.

15. The similarity is made less obvious by the shape of the field and by the caesurae between the leftwards receding thrones and desks of the evangelists and the buildings of the cities running predominantly to the right.

16. The connection with Cimabue's methods is maintained in the arch and beam decoration of the ribs of this bay and also of the third bay from the entrance.

17. It is also the first surviving example of such a highly developed form in Italian art as a whole. The number of lost works is, however, very great. For the whole subject of the development of the interior, see F. Horb, *Das Innenraumbild des Späten Mittelalters*, Zurich, 1938, which, nevertheless, over-emphasizes Pompeian as opposed to intermediate prototypes. The derivation of the vaulting in the present fresco is discussed loc. cit. pp. 35–6.

18. Inwards turned figures were common in Pompeian art, but tend to disappear with the decrease of emphasis on naturalism. Similar single figures occur earlier in Italian thirteenth-century painting, but there is never, as here, a row of such figures with a semi-architectural func-tion. It must be remembered, however, that Cavallini's work in Rome is largely lost.

19. The fall of light remains constant.

20. In one of these, 'The Ordeal by Fire', the oblique setting also occurs.

21. This was also noticeable in Cimabue's work.

22. This convention has a firm geometrical basis, however, and later becomes one of the princi-pal features of artificial perspective.

23. There is, for example, no closely comparable stage in the development of spatial design on Greek vases, nor in the Second and Third Pompeian styles.

24. In the frescoes of the main group, comprising numbers 2–19, there are six oblique, six foreshortened frontal, one combined, three centralized, and two pure landscape compositions.

In the cycle as a whole there are nine oblique, eight foreshortened frontal, one combined, seven centralized, and three non-architectural designs.

25. See E. Panofsky, 'Die Perspektive als "symbolische Form",' *Vorträge der Bibliothek Warburg*, 1924-5, pp. 268 ff. This principle is also a basic factor in some modern theories of visual perception.

26. This is true, of course, only for external views of buildings.

27. Masolino's 'Feast of Herod' (Pl. 33, *b*) is a fine early example of this type of composition.

28. A similar portrait quality is particularly noticeable in Cimabue's fresco of 'St. Mark', and evidently also occurred in Cavallini's work, as in the church shown in 'The Conversion of St. Paul' copied in Cod. Barb. Lat. 4406, fol. 91. (Pl. 11, *b*.)

29. 'The Last Supper' (Pl. 14, *c*) provides the finest Paduan example of this arrangement.

30. See 'Christ Teaching in the Temple' (Pl. 15, *b*).

31. The compositional exploitation of this blue sky is discussed below, p. 45.

32. F. Rintelen, *Giotto und die Giotto-Apokryphen*, Basle, 1923, p. 159, uses this argument to support his late dating. P. Murray, 'Notes on Some Early Giotto Sources', *Journal of the Warburg & Courtauld Institutes*, vol. 16, 1953, pp. 53-80, throws new light on the general question of dating the cycle. J. White, 'The Date of "The Legend of St. Francis" at Assisi', *The Burlington Magazine*, October 1956, shows that the 'Stigmatization of St. Francis' in the panel by Giuliano da Rimini, signed and dated 1307, derives directly from the composition at Assisi, so that the frescoes are at latest more or less contemporary with Giotto's work in the Arena Chapel.

33. This is borne out by the development of Greek vase painting, discussed in chapter XVI below.

34. Cod. Vat. Grec. 1613. Facsimile Publication, *Il Menologio di Basil II*, Turin, 1907.

35. Examples occur in the frescoes of S. Lorenzo fuori le Mura, in Cavallini's mosaics in Sta. Maria in Trastevere (Pl. 12, *c*), and in those by Torriti in Sta. Maria Maggiore.

36. The scheme is closely related to that in S. Paolo fuori le Mura, with its superimposed layers of fictive twisted columns, illus. W. Paeseler, 'Der Ruckgriff der Römischen Spätdugentomalerei auf die Christliche Spätantike', *Beiträge zu Kunst des Mittelalters*, Berlin, 1950, pp. 157-74, Pl. XV, 2, which reproduces a drawing in A. Uggeri, *Della Basilica di S. Paolo sulla Via Ostiense*, Roma, 1829. It is also similar to the pilastered decoration in Old St. Peter's, illus. J. Wilpert, *Römische Mosaiken und Malereien*, Frieburg, 1917, vol. i, pp. 276-7. For dating, see note 10 above. The latter scheme especially may have undergone some alteration, particularly in the ninth century.

Elements of the decoration of S. Francesco already occur in the marble inlay of the early fourth-century Temple of Junius Bassus, recorded in drawings by Sangallo (illus. A. Venturi, *Storia dell' Arte Italiana*, Milano, 1901, vol. i, pp. 53 and 55), and itself connected with Pompeian fresco decorations. Certain features of this scheme recur, only twenty years later, in the lost decoration of Sta. Costanza (drawings illus. Wilpert, op. cit., pp. 276-7), and also in late thir-teenth-century schemes such as those in S. Saba and in the basilicas of Sta. Maria Maggiore in Rome and at Tivoli. The decoration of S. Francesco is foreshadowed as a whole in the tenth-century scheme of S. Crisogono, illus. Wilpert, op. cit., vol. iv, p. 223. (For the similar scheme in S. Urbano alla Caffarella, see op. cit., vol. iv, p. 230, and vol. ii, pp. 290 ff.)

37. The distance can be estimated because an applied column runs down to a plain corbel, ending within the fields of 'The Crib at Greccio' (Pl. 7, *a*) and of 'St. Francis and the Knight of Celano'. The painted architectural border is so curved that it forms an unbroken straight line when a spectator of average height is at a distance of 9·5 metres in the first case, and of 7·5 metres in the second, which seems to be more damaged and less reliable. The approximate width of a single scene, measured from the centre lines of the framing columns, is 3·75 metres. The general significance of this phenomenon was noted by J. Wilde in an unpublished series of lectures.

38. The significance of this, and of other similar facts is considered below, pp. 192 ff.

39. A Schmarsow, *Kompositionsgesetze in der Kunst des Mittelalters*, Leipzig, 1922, Band iii, p. 155, recognizes the necessity for this type of approach, but both here and in his *Kompositions-gesetze der Franzlegende der Oberkirche zu Assisi*, Leipzig, 1918, the detailed analyses do not seem

to be sufficiently acute. Many of the present analyses elaborate those subsequently given in E. Cecchi, *Giotto*, Milano, 1942, and in M. Florizoone, *Giotto*, Paris, 1950.

40. The portico was constructed under Nicholas IV, *c.* 1290, and is fully discussed by P. Murray, op. cit., pp. 70 ff.

41. The importance of this fact was pointed out to me by J. Wilde.

42. 'The Crib at Greccio' illustrates the story told in chapter X, 7. 'The Miracle of the Spring' occurs in chapter VII, 12, and 'St. Francis Preaching to the Birds' appears in chapter XII, 3. 'St. Francis and the Knight of Celano', in the following fresco, belongs to Chapter XI, 4. The only other displacement is that of 'The Apparition at Arles' (chapter IV, 10), which should occur between 'The Vision of the Fiery Chariot' and 'The Vision of the Heavenly Thrones'.

43. The extreme displacement of 'The Apparition at Arles', mentioned in the preceding note, is certainly intentional. The only alternative, the original exclusion of the scene, and a late change of plan, is inconceivable where so important a subject is concerned. There are no good grounds, historical or aesthetic, for asserting that the scene was to have followed that of 'The Stigmatization', thereby justifying the attribution of a three-and-one division to the bay in partial accordance with the distribution of the architectural elements of the vaulting and the entrance arch, as in A. Schmarsow, *Kompositionsgesetze der Franzlegende der Oberkirche zu Assisi*, Leipzig, 1918, p. 50.

44. The receding side wall on the left, connecting rood beam and apse, has become extremely difficult to see, so that the degree of coherence originally obtained is substantially weakened.

45. For a summary of the extensive literature, see R. Salvini, *Giotto*, Roma, 1938. The main group, as given here, represents the usually accepted opinion given in Rintelen, op. cit. The first, and last three frescoes, form the group given to the St. Cecilia Master in R. Offner, *A Corpus of Florentine Painting*, section III, vol. i, 1931.

46. No underdrawings have, however, been discovered so far. The problem of the procedures followed by fourteenth- and fifteenth-century fresco painters is dealt with in R. Oertel, 'Wandmalerei und Zeichnung in Italien', *Mitteilungen des Kunsthistorischen Instituts in Florenz*, 5 Band, Heft iv–v, Marz, 1940, pp. 217–314, and in L. Tintori and M. Meiss, *The Painting of the Life of St. Francis in Assisi*, New York, 1962, who argue strongly for the importance of small preparatory drawings.

47. The analyses included in this section are given in greater detail in J. White, 'Cavallini and the Lost Frescoes in S. Paolo', *The Journal of the Warburg and Courtauld Institutes*. 19, 1956. The seventeenth century copies of lost frescoes and mosaics are published in full in S. Waetzoldt, *Die Kopien des 17 Jahrhunderts nach Mosaiken and Wandmalereien in Rom*, Vienna, 1964.

48. Vat. Cod. Barb. Lat. 4406. The fundamentals of the problem are fully set out for the first time in J. Garber, *Wirkungen der Frühchristlichen Gemäldezyklen der alten Peters-und Pauls Basiliken in Rom*, Berlin, 1918. Many further reproductions are given in Wilpert, op. cit., vol. ii, and useful additional material occurs in Paeseler, op. cit., note 36 above.

49. The copies of the S. Urbano all' Caffarella frescoes in Cod. Barb. Lat. 4402 are a notable exception in which the unique weakness of execution is often accompanied by serious compositional distortions. It is significant that this whole set is repeated in Cod. Barb. Lat. 4408, in which every effort is made to reproduce the originals faithfully down to the proportions of the figures and the folds of the draperies.

50. Garber, op. cit., pp. 57 ff., discusses the ten drawings in detail.

51. This belief, usually supported by the fact that Arnolfo was working on the new ciborium in 1293, fits well stylistically.

52. The Old Testament cycle at Assisi derives directly from those which existed in Old St. Peter's and in S. Paolo. It is therefore likely that the New Testament frescoes also derive from the similar cycle formerly in St. Peter's, and that the thirteenth-century coffered ceiling depends, like so much else, on the great, originally fifth-century, basilican cycles which were being restored at this very time. The probability is further supported by the existence of such interiors in the

Vatican Virgil, which also provides parallels for certain frescoes from S. Paolo. See White, op. cit.

53. Horb, op. cit. (note 17 above), pp. 35 ff., seems to use detailed arguments which assume a perfect chain of progression, making no allowance for variations, either within one artist's work, or as a result of parallel progress at slightly different speeds by various artists.

54. See note 36 above.

55. The Roman cycle was complete, and to judge by the derivative cycle in S. Piero a Grado (see P. D'Achiardi, *Gli Affreschi di S. Piero a Grado Presso Pisa*, Roma, 1905, and Venturi, op. cit., vol. v, p. 206) contained some thirty scenes. It is unlikely that the major complete cycle of the lives of SS. Peter and Paul, actually in St. Peter's at Rome, was iconographically dependent on five isolated scenes which also occur at Assisi. Moreover, whilst Cimabue's frescoes are greatly influenced by Roman art, there is no reflection of Cimabue's particular brand of Italo-Byzantin-ism in the Roman series. In this respect, ignoring comparisons of quality, the relation of the Roman frescoes to their counterparts at Assisi is exactly the same as that between them and their admitted copies in S. Piero a Grado.

56. A survey of the general art historical background to the particular phenomena considered in the present study is contained in J. White, *Art and Architecture in Italy 1250–1400*, Harmonds-worth, 1966.

CHAPTER II

Giotto—the Arena Chapel

The frescoes painted by Giotto in the Arena Chapel at Padua, about the year 1305, mark an entirely new stage in the development of empirical perspective, as in that of every other aspect of pictorial art. In his depiction of the human figure the emphasis on weight and volume is as striking as his concentration, as a story-teller, upon the dramatic essentials. The discursive interest in the haphazard detail of the visible world, characteristic of Assisi, is noticeably lacking here. It is therefore no surprise that the treatment of space betrays the same severe concentration. Out of this penetrating interest in the essentials both of nature and of art, a new relationship between pictorial space and the flat surface of the wall rapidly emerges. Giotto's conception of what this relationship should be is vividly shown at Padua by the framework which surrounds the history scenes, uniting them to the architectural reality of the chapel.

Within this modest, barrel-vaulted rectangle, complicated only by the addition of the simplest of Gothic choirs, everything is planned for painting (Pl. 13). There are no cornices, no raised mouldings. Six plain, unrimmed window openings are the only interruption in one otherwise unbroken side wall. Nothing interrupts the other. There are no columns, no pilasters,[1] no ribs running in the vault. Without the painter there is nothing but the inarti-culate, bare wall. This total bareness has the effect of giving the ambitious artist the maximum area of ideal painting surface whilst removing the element of competition. There is no need, and no temptation, to try to equate painted architecture with the natural volume and solidity of structural stone and marble. The lack of any wish to create a binding, over-all illusion is categori-cally stated by means of the plain red band which separates the marbled decoration of the walls at all four corners.[2] The painted framework on each wall is a floating, decorative unit on the existing surface, and not a counterfeit wall in itself.

The flatness of the painted architecture is most striking, particularly when compared with the heavy columns and projecting beams of S. Francesco. Flat, painted, marble panelling lines the bases of the walls. Thin, flat mouldings, and cosmati work frame the individual scenes and form the horizontal and vertical divisions of the walls. The same flat bands of painted marble decoration run on up and over the blue barrel vault to stress the ends

and central axis of the room-space. The crispness and clarity of this imitation marbling, its competent realism and strictly limited depth, are as remarkable as its firm subordination to the needs of the narrative paintings which it frames.

The light falls on the painted architecture throughout the chapel as if its source lay in the window on the entrance wall. Everywhere, the marble of the decorative bands and subsidiary figure fields is seen as if from normal head height.[3]

The marble framing of the main upper row of frescoes showing 'The Life of the Virgin' conforms to the pattern of the subsidiary fields. The roll mouldings, which actually enclose the scenes, are foreshortened from below (Pl. 14, *a* and *b*). In the lower registers, however, a flat, decorative band is interposed between the edge of the imitation marbling and the scene itself (Pl. 14, *c*). Instead of roll mouldings, a flat marble rim, with none of its receding surfaces in sight, forms the actual framework. This is therefore seen frontally, and not foreshortened at all.

The immediate framing, both of the main narrative frescoes and of the subsidiary pictorial fields on the two side walls, also emphasizes that each scene has its own intrinsic value. Each is viewed from its own centre line. Each has its own completeness. The perspective of the framing nowhere tries to draw the eye away to left or right towards some other centre that lies outside the immediate focus of attention.

The two end walls are treated consistently in this respect. The 'Last Judgement' fills the one with a single composition, and the top half of the other is similarly unified by 'The Annunciation' (Pl. 13). Both are framed by tall pilasters, which recede towards the middle and thus stress the centre of the chapel as a whole. Despite the jealously guarded rights of the individual scene, the ordering of the decoration round a spectator standing at the centre seems to have become increasingly important to the artist.

This centralizing tendency becomes apparent in some of the framing detail of the side walls. In the vault, and in the uppermost register, it is frontally seen. In the lower registers, however, the detail of each separate part reveals a tendency to recede towards the centre of the wall as a whole. Complete consistency is finally achieved in the complex moulding which divides the main scenes from the allegorical figures at the bottom of the walls. These small perspective pointers only underline the fact made clear by the whole decorative scheme. The spectator's place at the centre of the chapel is already stressed by the articulation of the vault, and by the progress of the narrative as it circles lower and lower on the walls around him.

The most exciting development of all in the conception of the chapel as a single whole is the emergence of a tendency to adapt the viewpoints in the scenes themselves to that of a spectator standing at the centre of the building. This new conception is not reflected at all in the frescoes of 'The Life of the

Virgin'. These are seen haphazardly from left and right, regardless of their place upon the wall. In the scenes from the 'Life of Christ', however, the compositions themselves belie the neutrality of their frames. Apart from the 'Noli Me Tangere' and the 'Pentecost', they are all constructed so as to emphasize the centre of their respective walls. Even in the interiors the axis is displaced to left or right in harmony with the position of the middle of the wall to one side or the other. At Assisi the scenes were united by balancing their surface patterns one against the other. Here, although innumerable correspondences can be found between one row of frescoes and another, as well as between individual scenes, there seems to be no attempt at direct formal balance. The simplicity of the problem at Assisi, where only a single row of scenes needs organization, lends itself to such a solution, whereas the more complicated situation at Padua does not. Instead, the unification is achieved by perspective means.[4]

The interplay between part and whole, and the relation of both to the onlooker are at once more tentative and more complex than at Assisi. There is an air of a new beginning, of an idea expanding while it is being carried out. The character of 'The St. Francis Legend', on the other hand, is rather that of the firm development of an earlier idea, clear and complete in general conception, and unwavering in execution. At Assisi a team of wayward individuals is held to a master's plan. At Padua a single artist grapples with a problem as he works upon the wall. There is the same fertile inconsistency, the same shifting, mobile attack of expanding genius which, two centuries later, leaves its mark upon the Sistine Ceiling.

Turning from the conception of the whole to the construction of the single compositions, the first point of interest is that nearly all the buildings are obliquely set within the picture space. In the St. Francis cycle, and in Cavallini's work in the 'nineties, the foreshortened frontal setting was used in fully half the scenes. At Padua it only appears four times in all. And this includes one special case and the relatively minor example of the sarco-phagus in the 'Noli Me Tangere'.

The special case is that of the 'Annunciation', which takes place across the top of the triumphal arch (Pl. 13). The two small buildings, one on either side, are painted with their forward surfaces parallel to the wall. The ortho-gonals, instead of running in towards the centre of the arch, diverge towards the outer walls. This return to Cimabue's usage keeps the overhanging balconies in harmony with the curve of the connecting arch. The architec-tural divergence also, paradoxically, encourages communication of the figures across the central space. Their glances, and the gaze of the spectator, can slip easily across the sloping inner walls, instead of being hemmed in by the jutting balconies. The same effect is noticeable in the thrones of the Apostles in Cavallini's 'Last Judgement' in Sta. Cecilia, where the out-wards recession helps to turn the figures slightly in towards the centre.

The great fourteenth-century painters were always ready to sacrifice the demands of external logic to the particular compositional problem with which they were faced. There was no fixed theory of perspective construction. There were no set rules to be obeyed or broken. Methods were empirical, based upon inherited skills, on personal observation, and upon the craftsman's sense of what would give the best results in practice. In Giotto's case, there is no doubt that the divergence seen in 'The Annunciation' is a matter of deliberate choice, and not of ignorance, or of indifference to a distinction which seemed unimportant to him. Lower down on the same wall are painted the upper parts of two small Gothic chapels, perfect in every detail of their vaulting (Pl. 13). These are seen as if from the centre of the arch, in contrast to the buildings immediately above. Here there is no story to be told. No figures dominate the scene and influence the architectural construction through their paramount demands. What is desired is the illusion of two chapels flanking the existing choir, and everything is ordered for the benefit of an observer standing in the centre of the church. Here, where realism is supreme, the result is quite astounding, and the extreme importance of weigh-ing the artist's own intentions in attempting to assess the significance of his constructions gains due emphasis.

Apart from the 'Annunciation', the only scenes with large buildings shown in a foreshortened frontal setting are 'The Annunciation to St. Anne' and 'The Birth of the Virgin' in the uppermost row of frescoes running round the two main walls. It is exactly the same building which appears in both these frescoes, since throughout his work in the Arena Chapel Giotto care-fully maintains the unity of place. It is, therefore, no exaggeration to say that the foreshortened frontal scheme is very rare indeed. The extreme oblique construction is also far less common than it was before. It likewise only appears at all amongst the scenes in the topmost row on either wall, so that it is once more seen side by side with the foreshortened frontal setting.

'The Refusal of Joachim's Offering' (Pl. 14, *a*), the opening fresco of the cycle, shows the extreme oblique construction at its most aggressive. The architectural mass is solidly constructed, although the receding lines in several places tend to diverge, instead of running parallel to each other or converging. Seen from a normal viewpoint, emphasizing its solidity, the building is as full of jutting angles as possible. Everything advances and recedes, and nothing is in harmony with the plane. Yet at the potential point of greatest conflict the thrusting knife-edge of the figure platform is suddenly blunted, as if sheared off by the flat surface of the wall just as it was about to burst beyond the confines of the marble frame. This shows, perhaps, that Giotto was himself aware of the element of conflict in this type of composi-tion.[5]

'The Presentation of the Virgin' seems to confirm the supposition. Its architecture is again set at forty-five degrees to the plane, and this time figures

intervene to subdue the conflict. On the right, where the architecture juts most fiercely forwards, half the receding lines are covered by two onlookers, who face inwards, holding back the forward thrust and softening the hard edge of the block. On the left, the figures, climbing the steps and standing on the ground behind them, stop the plunge on into depth along the main lines of recession. The oblique construction of the architecture shows no sign of compromise. Yet the resulting wedge-shaped mass is not allowed to burst the wall asunder.

The next three frescoes are equally valuable in helping to chart the direction in which the artist's mind is moving. These scenes of 'The Wooers Bringing the Rods to the Temple', 'The Wooers' Praying', and finally 'The Marriage of the Virgin' each contain a repetition of a building which is peculiarly interesting in construction.

At first glance the temple in 'The Wooers Praying' (Pl. 15, *a*) seems to be a normally constructed 'interior' seen from straight ahead. A closer look shows that the roof, and in particular its forward edge, slopes very slightly downwards to the left, whilst the altar-front runs softly, but quite definitely upwards in the same direction. Moreover, the receding lines of the coffered ceiling run with a considerable bias to the right, instead of evenly towards the centre, whilst the two inner walls clearly reveal a similar distinction. The left-hand wall is demonstrably less foreshortened than that on the right. Its forward edge all but encloses the small subsidiary semi-dome, the counterpart of which upon the other side is almost evenly cut in two. All these small distinctions lead to one conclusion. The seemingly frontal surfaces of the building are, in fact, softly, but quite consistently receding to the left, as if away from an observer standing a little to the right of its centre line. The construction is coherent in itself. Its repetition in the scenes on either side precludes the possibility that these slight variations are due to accident and not intention. The buildings are, all three of them, not frontal, but oblique. The same minimal recession of surfaces which seem to lie completely in the wall plane also appears in the balcony seen in 'The Wedding Procession of the Virgin'. This time it is an apparently foreshortened frontal building which turns out to be obliquely set.

Between the two poles of the very sharp and of the very soft oblique constructions lies the middle way adopted by Giotto in the fresco of 'The Golden Gate'. In this scene an architectural composition of the first importance is experimented with, only to be developed in a very different manner in the subsequent fresco of 'The Presentation of the Virgin' (Pl. 14, *b*), which has already been considered in some aspects. The composition of both scenes is similar in essence to that of 'The Mourning of the Clares' in S. Francesco at Assisi. There, however, both the faces of the church recede quite steeply, and its disposition as a whole stands in contrast to the firm horizontal of the bier, which lies parallel to the fresco surface.[6] This slight weakness of connec-

tion in the parts is gone. At Padua the two elements of the composition are finely co-ordinated in both scenes. In both, the figures move convincingly over the bridge, or up the steps, at right angles to the main architectural mass. There is nothing to confuse the clarity of space or motion. Beyond these basic similarities of composition the two Paduan frescoes differ fairly widely. The recession of the main face of the architecture in 'The Meeting at the Golden Gate' is softer than in either of the other scenes. The continuous vertical of the right-hand tower, which forms the principal spatial accent, is so close to the border that long lines running downwards to the right, like those in the upper part of the Assisi fresco, are avoided. No devices are required, as in 'The Presentation of the Virgin' (Pl. 14, *b*), to soften a too strongly thrust-ing spatial block. The association with the surface accent of the frame is close enough to render them unnecessary. At the same time the fact that 'The Meet-ing at the Golden Gate' lacks the complexity of jutting shapes, which characterize both 'The Presentation of the Virgin' and the opening fresco of 'The Refusal of Joachim's Offering' (Pl. 14, *a*), gives it a correspondingly calmer spatial quality.

It is worthwhile to pause at this point, and take stock. So far only those frescoes, containing the prologue to the life of Christ, which occupy the upper row on the side walls and on the linking choir arch, have been considered. Within these limits Giotto's architectural compositions can be divided into four main groups.

The first is made up of foreshortened frontal compositions. In these the earliest method of creating space whilst stressing the flat surface is still used.

The second is composed of the extreme oblique constructions. These also appeared alongside the earlier foreshortened frontal type at Rome and at Assisi, marking a new departure, a new emphasis on realism. At Padua, however, there are indications that the inherent compositional conflict, which grows step by step with the increasingly successful counterfeiting of solidity, has become something of a problem to the artist.

The third group is that in which it seems as if the artist wishes to retain the surface-stressing harmony of a frontal setting without entirely sacrificing the realistic connotations of the oblique construction. The outcome is a make-believe foreshortened frontal, a minimal oblique setting, which has the formal qualities of the first group, yet recognizes the conception of the realities of vision which is the basis of the second.[7] The extreme delicacy of the four times repeated construction, noticed only by a minute fraction of the thou-sands who pass through the chapel, is alone strong confirmation that Giotto was himself actually conscious of both the formal and the realistic qualities of the new perspective patterns.

Finally, in the single fresco of 'The Meeting at the Golden Gate' the artist makes use of a moderate oblique construction. This becomes the basis of the

system used throughout the remaining frescoes of the chapel for all buildings seen from the outside.

The new compromise, which represents a genuine middle ground in the tug-of-war between the demands of realism and of surface pattern, is well represented by 'The Last Supper' (Pl. 14, *c*). This not only becomes a standard pattern in the scenes from 'The Life of Christ' in the lower registers at Padua, but is still used for the later work in the Peruzzi Chapel of Sta. Croce which marks the peak of Giotto's achievement in those frescoes that survive.

The essential features of 'The Last Supper' (Pl. 14, *c*), which are so often repeated both by Giotto and his followers, are twofold. In the first place there is no ambiguity; no doubt that the whole building is obliquely set. The down-slope of the roof-ridge and the gutter-board, and the upwards recession of the bench on which the figures sit, backs turned to the beholder, are as clear as they are gentle. In the second, the building is now brought into the closest possible association with the surface of the wall, to which it is so nearly parallel, that is compatible with clarity.

The same desire for spatial realism in harmony with the flat surface, which seems to underlie the growth of a clear preference for architecture set obliquely in the picture space just at the moment when the formally aggressive tendencies of such a setting were being smoothed away, leads Giotto, at the same time, to important modifications in the structure of interiors.

In the fresco of 'Christ Teaching in the Temple' (Pl. 15, *b*) the internal spaciousness is greater than in any of its precursors. There is abundant headroom for the figures, and the outer limits of the sides and ceiling of the main space only just remain within the borders of the fresco frame. The latter actually cuts short the vaulted side aisles that appear to left and right beyond the arches closing in the central room. The scene is an exceptional achievement even for Giotto. It is seen from a position slightly to the right of its mathematical centre, in conformity with the placing of the most important figure, that of the young Christ. The firm arc of seated priests and elders curving back into the space, carves out the reality of enclosure and defines it in a single movement. Nothing more is needed. Overhead, across the whole top of the scene, are hung two green festoons. They lie in the most forward plane, caught at the ends and centre of the foremost edge of the ceiling. The swinging curves, living completely in the plane, are echoed by the hanging top line of the arches running into depth. The very architecture of the room-space mediates between these green catenaries upon the surface and the spatial figure curve which it encloses. This interplay of pattern on the surface and in space grows more exciting still when it is seen that the festoon upon the left hangs right across the principal three-dimensional join, where ceiling, back, and side walls meet. It is completely hidden. The same thing happens on the other side, and although the crucial point is lost beneath an area of damage,

a continuation of the lines of wall and ceiling shows that the small, lost part of the festoon would have completely masked the spatial accent. The rectilinear coffered ceiling has its purpose in the definition of the architectural structure, but it is not allowed to add a harsh, unwanted emphasis to the sufficiently emphatic space created by the figures and by the softer double curve of arches. Instead a purely surface accent softens the spatial pattern of the ceiling, and ties the whole design together. The interplay, and actual visual equation, of curves lying on the surface and curves set in space lead to a full appreciation of their dual function as essential elements both in the three-dimensional realism, which gives immediacy to the story, and in the creation of the decorative pattern which transmutes the dead face of the wall into a living thing of beauty.

The scene of 'Christ Before the High Priests' (Pl. 16, *b*) shows the achievement of essentially the same result by opposite means. The space enclosed is principally defined by the repeated, unbroken orthogonals of the ceiling beams. As compensation, the figures are aligned much more across the surface than in the previous scene. A different device is this time used to stress the unity of space and plane. The central moulding, which runs across the back wall just below the windows, then turns round both corners and runs forwards on the side walls to enclose the entire spatial content of the room. This cornice, stressed by a colour change, is almost a single, mathematically straight line. Potentially a major spatial accent, it is used to emphasize the surface qualities of the design. In addition, it gives formal being to the dramatic unity and tension of the scene. It becomes a bar linking the heads together in its grip, vibrating under strain.

These ambivalent elements in Giotto's designs are distinguished from the occasional, chance occurrences of similar features in the work of other artists by their consistent use, their compositional prominence, and their close association with emphatic space. It is the strongly three-dimensional quality of the compositions in which they play an important part that gives them their particular significance.

Another fine variant of this newly evolved compositional method is 'The Wedding Feast at Cana' (Pl. 16, *a*). The depth is very calmly indicated by the L-shaped table, since its angle is filled in, masked by the figures, whilst a line of wine jars lies across the surface on the right. The canopy that crowns the walls reiterates the spatial content of the scene, although here again the effect is modified. The finials and the ornamental vase, which decorate the upper edge, are made to form a constant link between the architectural design in depth and the flat band that frames the scene. Between these areas of controlled spatial definition above and below, the fresco is divided horizontally at the top of the striped wall-hanging. The sharpness of the colour contrast makes this demarcation line a striking feature of the composition. Once again it is a case of emphasized ambivalence. The line, which as before encloses the

whole room space, turning through a right angle at each corner of the wall, is shown as being practically straight, repeating the near horizontal disposition of the heads below. The slight depression in the wings, almost invisible in reproduction, is, however, balanced by the soft, but noticeable upturn of the diaper moulding higher on the wall. This forms a visual transition to the firmly space defining angles which distinguish the orthogonals and transversals of the ceiling canopy.

The mention of the transversals of the ceiling canopy leads to an interesting and historically important point. The banqueting hall definitely appears to be rectangular in plan. The two sections of the L-shaped table are parallel to the walls, and it seems reasonable to suppose that these arms are set at right angles in the normal way. The canopy above is so disposed, however, that the forward edges of the wings are shown receding softly downwards to the left and right.

In the 'Christ Before the High Priests' (Pl. 16, *b*) it is noticeable that the throne is set obliquely, whilst its back shows that it is conceived as running parallel to the side wall, if not actually attached to it. The same phenomenon is visible in the 'The Approval of the Rule' at Assisi (Pl. 6, *c*) and occurs quite frequently both there and elsewhere. The ceiling canopy of 'The Feast at Cana' (Pl. 16, *a*) is, however, the first clear-cut example of this tendency to apply to architectural details the rules of natural vision based upon the turning of eye and head to look directly at the various separate objects in the field of vision.[8] There is no other case of it in Giotto's extant work. But when the story is continued in the paintings of Giotto's followers, this detail will emerge as the first signal of a long, significant, and historically important development. It is a tentative beginning, and in itself may, or may not be a deliberate experiment. About the subsequent growth of the idea there can be no doubt.

The foregoing analyses of Giotto's Paduan frescoes fall into a definite pattern. If they are individually correct, and are, which is even more important, truly representative of the forty or so required for complete coverage, the pattern will help to build up the larger picture both of Giotto's own life's work and of the history of art in Italy as a whole. In doing this it will confirm the validity of its own line of growth.

The general configuration in Giotto's case is that of a steadily increasing harmony between the flat wall and an ever more ambitious spatial realism. This pattern is supported by the presence of a similar concern in the arrangement of the figure design. It has often been remarked that the position of the figures on the surface in relation to each other and to the compositional diagonals and other lines and subdivisions, which express the inherent geometrical properties of the pictorial rectangle, is as important as their individual solidity and their interaction across convincingly described pictorial space.[9] The trend of Giotto's ideas is equally stressed by the flat

marbling and low relief of the architectural framework, which combines with the reality of the wall in a way that is entirely new. Realism is intensified, and at the same time an attempt is made to avoid the destruction of those qualities which the less realistic decorative art of earlier centuries possessed in such abundance.

This pattern of development reflects the fact, confirmed by recent technical investigations, that work in the Arena Chapel was started at the top and steadily continued downwards. This was the usual course, for purely practical reasons, and the non-existence of cartoons in the fourteenth century makes it unlikely that the order of conception was reversed in execution.[10] Finally there is the fact that the perspective constructions grow increasingly consistent as the lower registers are reached.[11]

When all these observations are considered in relation to the later frescoes of the Bardi and Peruzzi Chapels it becomes clear that the direction of development at Padua cannot be reversed.

The history of the emergence of the oblique construction in the final quarter of the thirteenth century, and the characteristics of the artists using it, led to the conclusion that its basis lay in natural observation. The fact that it later comes to be the standard pattern used by Giotto seems to increase the validity of this conclusion. The oblique construction is, indeed, used by him in fully seventy-five per cent of the architectural compositions at Padua. That is to say, three times as often as all other settings put together. In his approach to narrative and to the human figure Giotto concentrates all his attention upon fundamentals. The probability is, therefore, very strong that this predominance of one particular spatial pattern is not a mere coincidence. It is rather a reflection of his passionate interest in reality as a foundation for the ideally ordered world that is his art.

The close connection of the two phenomena is witnessed by the singular lack of pattern prototypes available to the artists who espoused the new construction. It is not a question of the increasing use of an already common pattern. Amongst the hundred or so Italian panels painted before 1300 in which architecture appears, there are no examples of a normally seen oblique construction.[12] There does not seem to be a single one in which even the most emasculated form of the oblique setting appears alone, or as a dominant feature of the architecture. Indeed it only appears at all in any form, and as one element amongst many, in less than twenty per cent of the panels. In this same group, frontal and complex frontal settings are to be seen alone in about thirty per cent of the total number, and foreshortened frontal constructions appear by themselves in almost half.

The situation is no different in the manuscripts or fresco cycles of the centuries which precede the period of Cavallini's work. If anything, the avoidance of the oblique construction is still more complete. It is equally conspicuous for its absence in the Byzantine mosaics of the thirteenth, as of

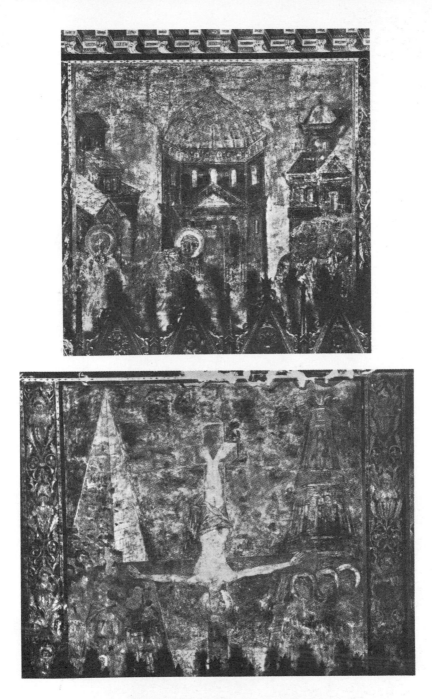

1*a*. CIMABUE. St. Peter Healing the Lame
b. The Crucifixion of St. Peter
S. Francesco, Assisi

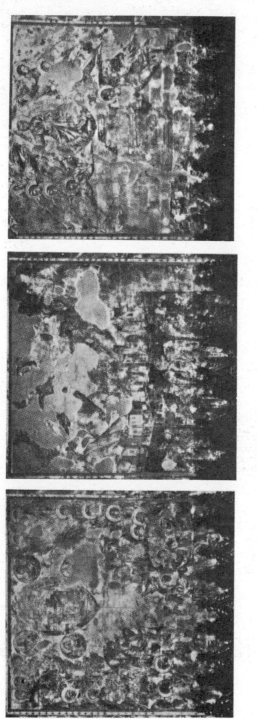

2. CIMABUE. The Adoration of the Lamb, The Four Angels at the Four Corners, Christ the Judge

S. Francesco, Assisi

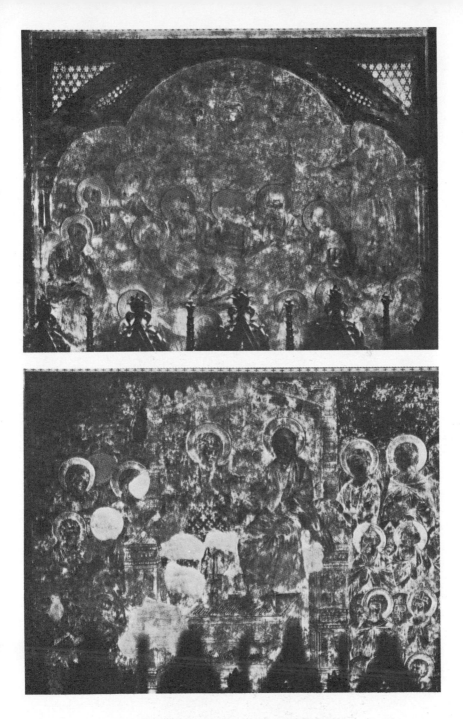

3 *a*. CIMABUE. The Last Hours of the Virgin
b. The Coronation of the Virgin
S. Francesco, Assisi

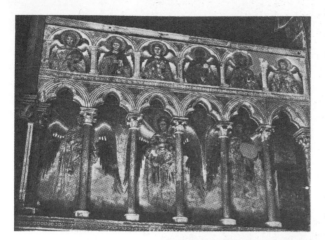

4 *a*. CIMABUE
Angels and Archangels

4 *b*.
THE ISAAC MASTER
St. Augustine

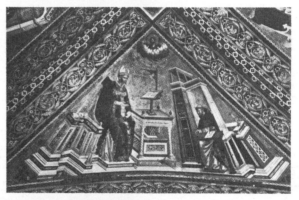

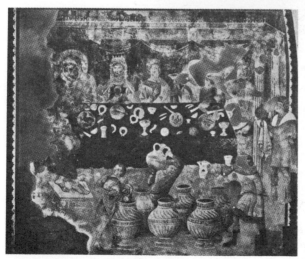

4 *c*. ROMAN SCHOOL
The Feast at Cana
S. Francesco, Assisi

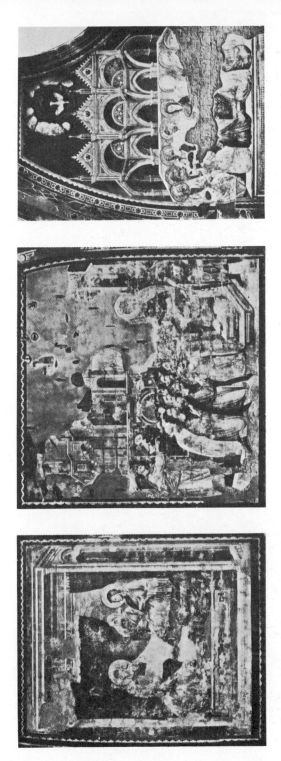

5. THE ISAAC MASTER

a. Isaac and Jacob. *b.* The Brothers Interceding with Joseph. *c.* The Pentecost

S. Francesco, Assisi

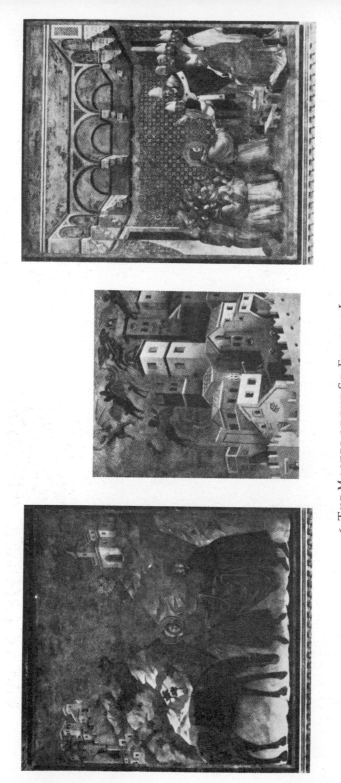

6. THE MASTER OF THE ST. FRANCIS LEGEND
a. St. Francis Giving Away his Cloak. *b.* St. Francis and the Demons at Arezzo (Detail). *c.* The Approval of the Rule
S. Francesco, Assisi

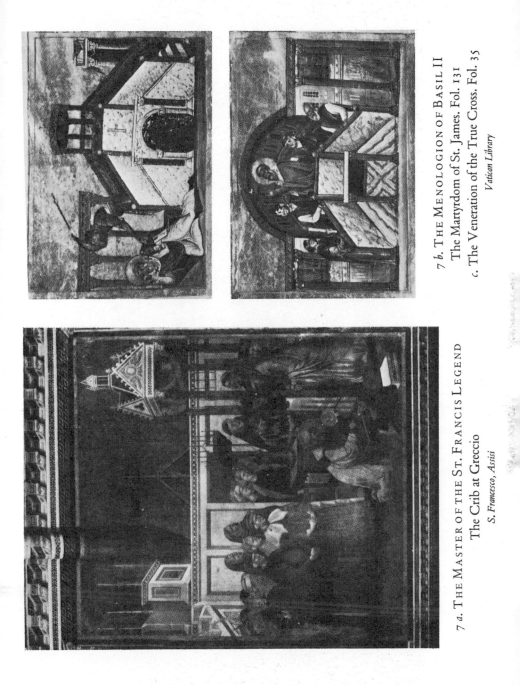

7 b. THE MENOLOGION OF BASIL II
The Martyrdom of St. James. Fol. 131
c. The Veneration of the True Cross. Fol. 35
Vatican Library

7 a. THE MASTER OF THE ST. FRANCIS LEGEND
The Crib at Greccio
S. Francesco, Assisi

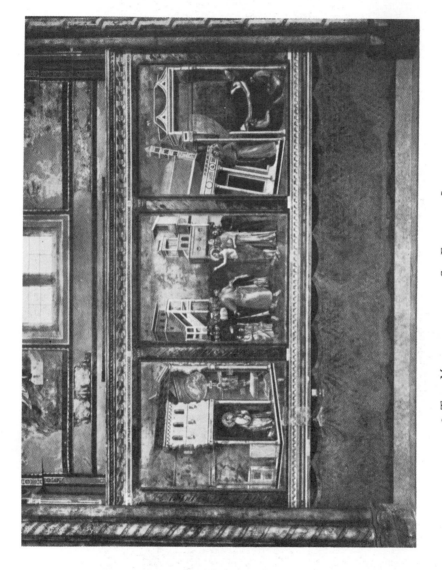

8. THE MASTER OF THE ST. FRANCIS LEGEND

St. Francis Before the Crucifix, St. Francis Repudiating his Father, The Dream of Innocent III

S. Francesco, Assisi

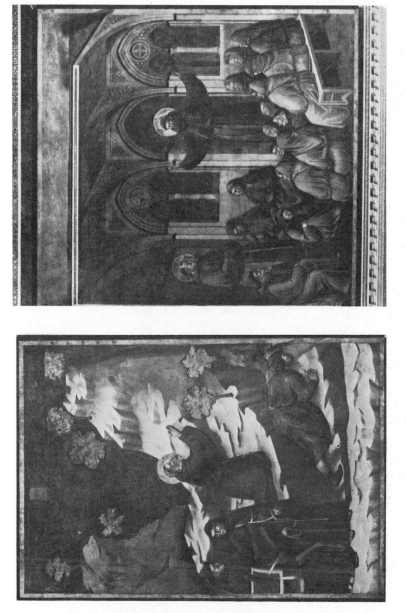

9. The Master of the St. Francis Legend
a. The Miracle of the Spring. *b.* The Apparition at Arles
S. Francesco, Assisi

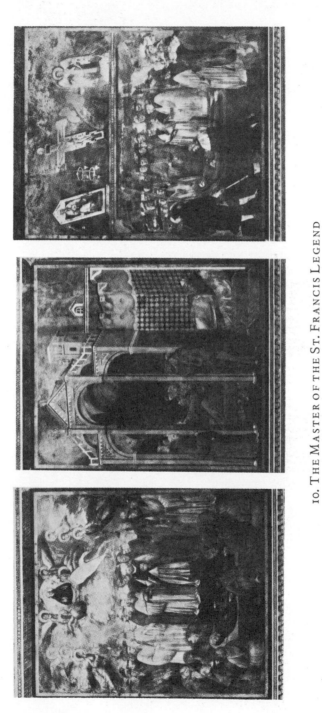

10. THE MASTER OF THE ST. FRANCIS LEGEND
The Death and Reception of St. Francis, The Visions of Br. Augustine and of Bishop Guido,
The Funeral of St. Francis and Conversion of Jerome

S. Francesco, Assisi

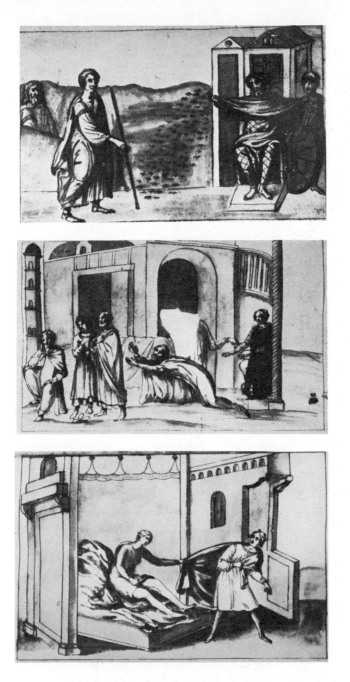

11 *a*. The Plague of Locusts. Cod. Barb. Lat. 4406. Fol. 56
b. The Conversion of St. Paul. Fol. 91
c. Joseph and the Wife of Potiphar. Fol. 40

Vatican Library

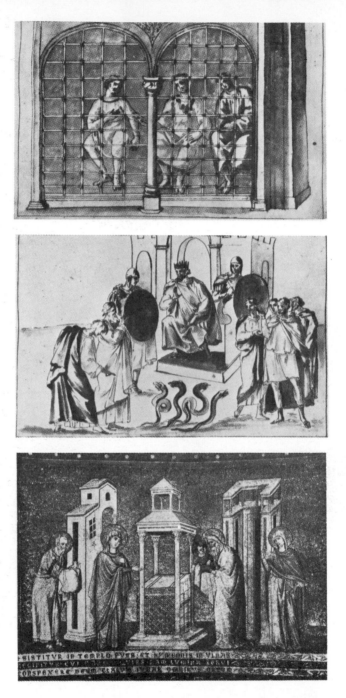

12 *a*. Joseph in Prison. Cod. Barb. Lat. 4406. Fol. 47
b. The Plague of Serpents. Fol. 53
Vatican Library
c. CAVALLINI. The Presentation
Sta. Maria in Trastevere, Rome

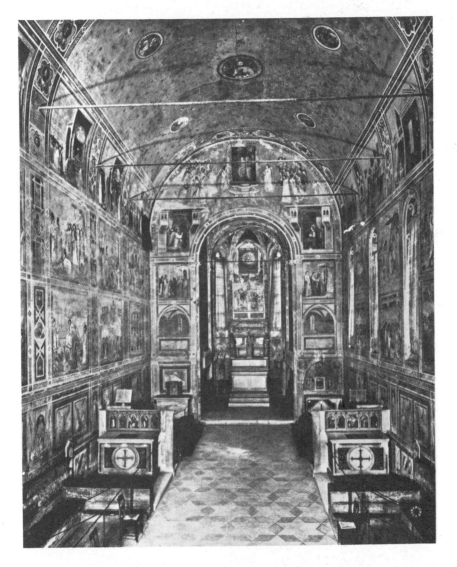

13. GIOTTO. The Interior of the Arena Chapel

Padua

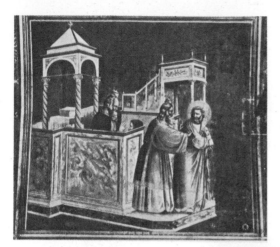

14 *a*. GIOTTO
The Refusal of Joachim's Offering

14 *b*. GIOTTO
The Presentation of the Virgin

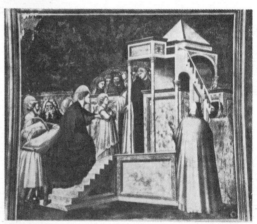

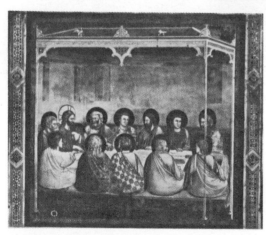

14 *c*. GIOTTO
The Last Supper
Arena Chapel, Padua

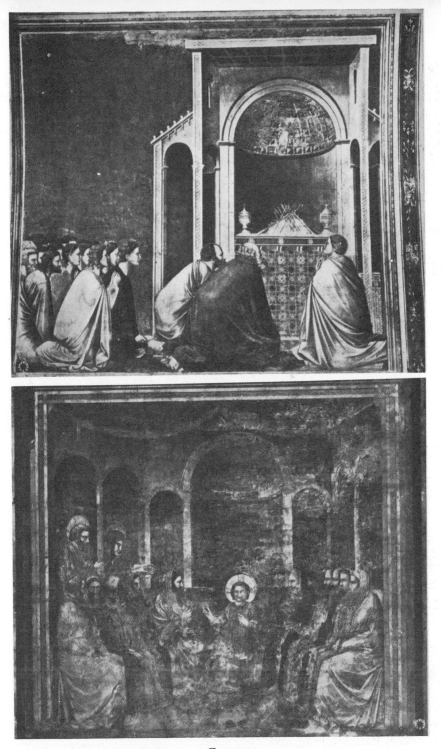

15. GIOTTO

a. The Wooers Praying. *b.* Christ Teaching in the Temple

Arena Chapel, Padua

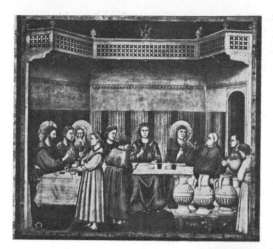

16 *a.* GIOTTO
The Wedding Feast at Cana
Arena Chapel, Padua

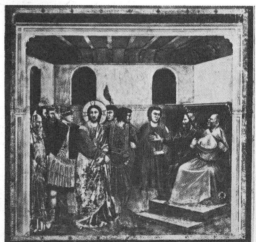

16 *b.* GIOTTO
Christ before the High Priests
Arena Chapel, Padua

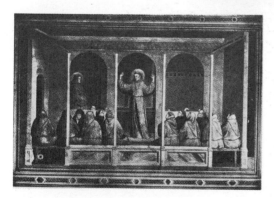

16 *c.* GIOTTO
The Apparition at Arles
Sta. Croce, Florence

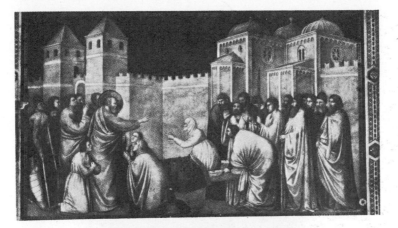

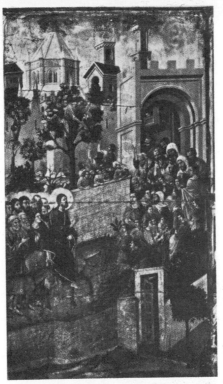

17 *a*. GIOTTO. The Resurrection of Drusiana
Sta. Croce, Florence
b. DUCCIO. The Entry into Jerusalem
Mus. dell' Opera, Siena

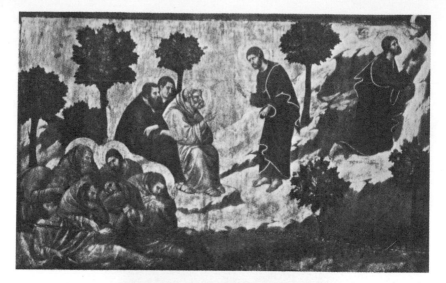

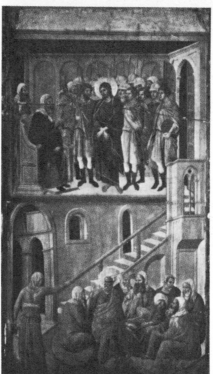

18. DUCCIO
a. The Agony in the Garden
b. The Denial by St. Peter, Christ before Annas
Mus. dell' Opera, Siena

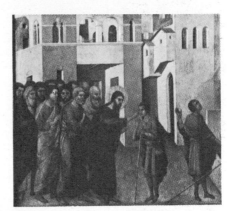

19 *a*. DUCCIO
The Healing of the Blind
Man
National Gallery, London

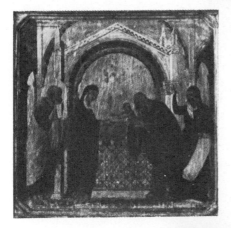

19 *b*. DUCCIO
The Presentation
Mus. dell' Opera, Siena

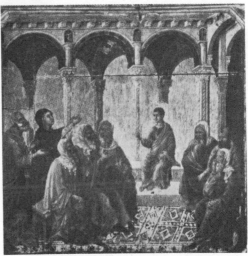

19 *c*. DUCCIO
Christ Teaching in the
Temple
Mus. dell' Opera, Siena

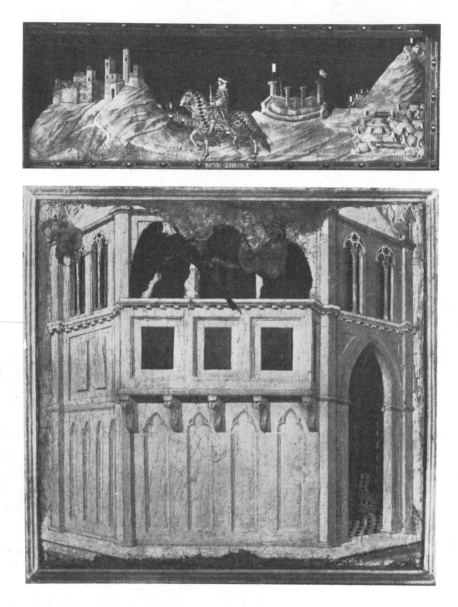

20 *a.* SIMONE MARTINI. Guidoriccio da Fogliano
Pal. Pubblico, Siena
b. DUCCIO. Christ's Temptation on the Temple
Mus. dell' Opera, Siena

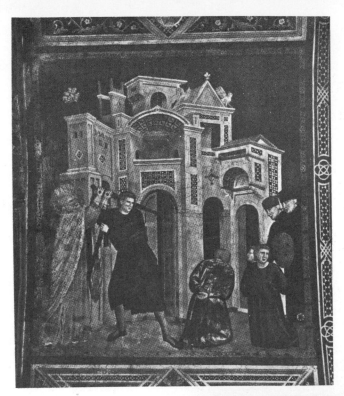

21 *a*. St. Nicholas
Prevents an Execution

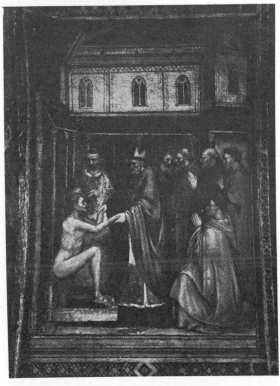

21 *b*. St. Stanislaus
Raising a Youth
Lower Church, Assisi

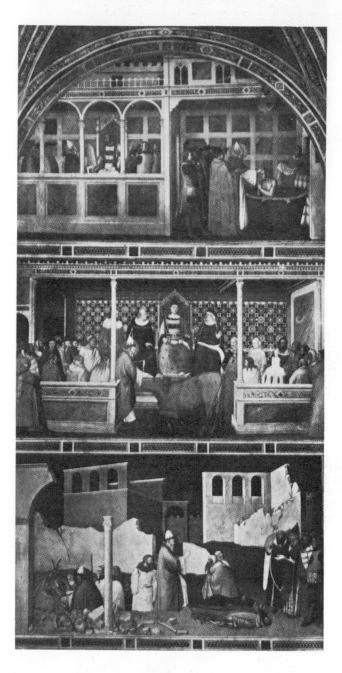

22. MASO
a. St. Sylvester Showing the Pictures of the Apostles and Baptizing the Emperor
b. St. Sylvester and the Bull
c. St. Sylvester and the Dragon
Sta. Croce, Florence

23. AMBROGIO LORENZETTI. Allegory and Town of Bad Government

Pal. Pubblico, Siena

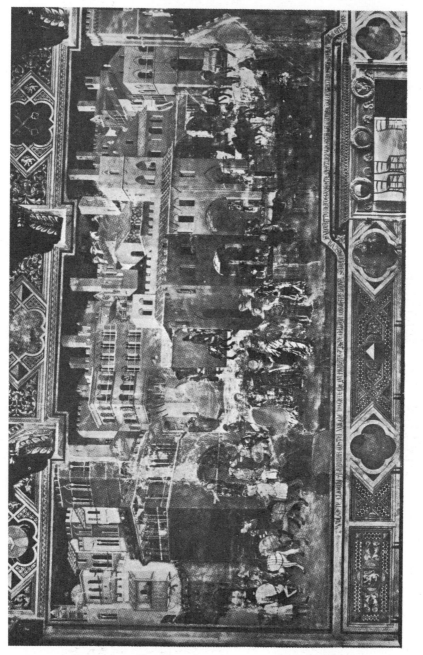

24. AMBROGIO LORENZETTI. The City of Good Government
Pal. Pubblico, Siena

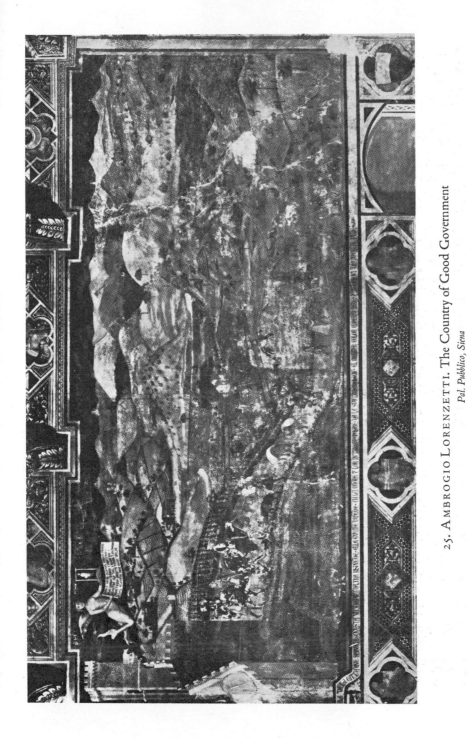

25. AMBROGIO LORENZETTI. The Country of Good Government

Pal. Pubblico, Siena

26 a. AMBROGIO
LORENZETTI
The Presentation
Uffizi, Florence

26 b. PIETRO
LORENZETTI
The Birth of the
Virgin
Mus. dell' Opera, Siena

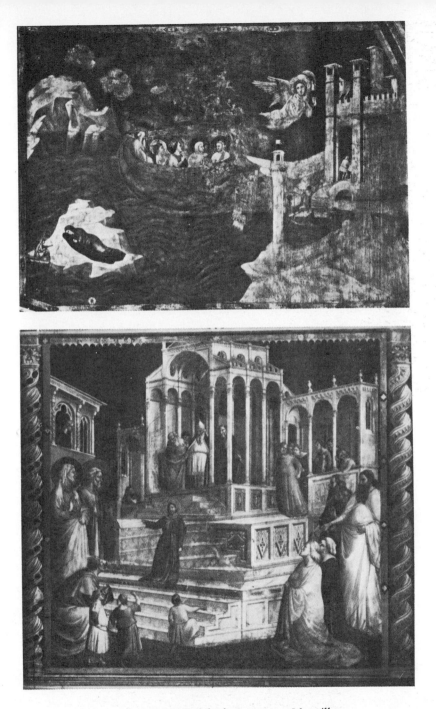

27 *a*. St. Mary Magdalen's Journey to Marseilles
Lower Church, Assisi
b. TADDEO GADDI. The Presentation of the Virgin
Sta. Croce, Florence

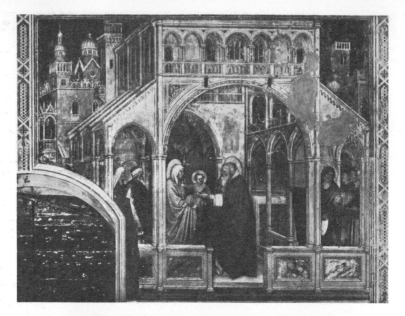

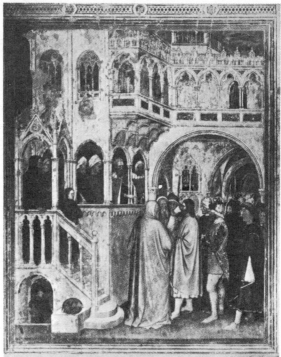

28. AVANZO
a. The Presentation
b. St. George Drinking the Poison

S. Giorgio, Padua

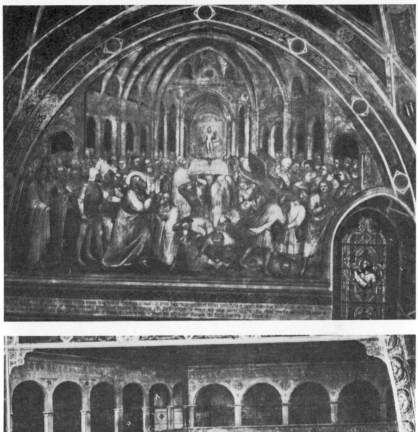

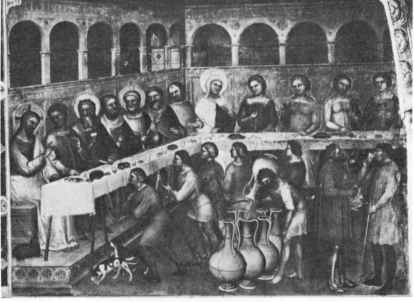

29. GIUSTO DE' MENABUOI

a. St. Philip Exorcizing a Devil

St. Antonio, Padua

b. The Wedding at Cana

Baptistry, Padua

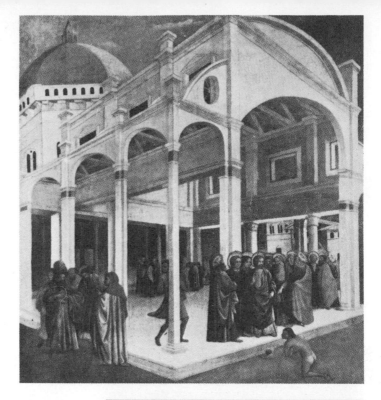

30 *a*. ANDREA
DI GIUSTO?
Christ and the Apostles
in the Temple
Johnson Coll. Philadelphia

b. MASACCIO
The Trinity
Sta. Maria Novella, Florence

31 *a*. MASOLINO
The Assumption

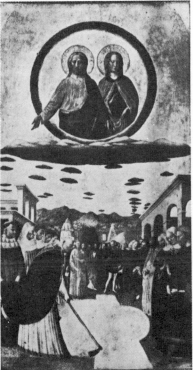

31 *b*. MASOLINO
The Foundation of Sta.
Maria Maggiore
National Museum, Naples

32 *a*. MASOLINO
The Dispute of St.
Catherine

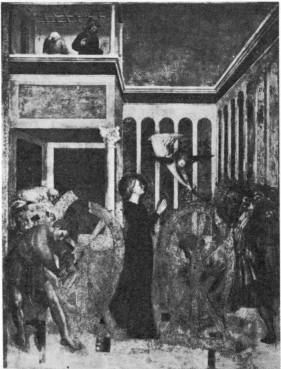

32 *b*. MASOLINO
The Liberation of St.
Catherine
S. Clemente, Rome

earlier centuries, whether in Italy or elsewhere. Finally, it is not a feature of fifth-century mosaics in particular, nor of the frescoes of that period, as far as can be judged from copies, contemporary manuscripts, and other evidence. Cavallini was not confronted by a series of oblique constructions in his labours in S. Paolo. It is a feature which he gradually introduced himself as his personal style matured. In all the surviving work of the preceding cen-turies, it is only in the Fourth Pompeian style that the oblique construction can be said to predominate. It also appears in a fair proportion of late Third Style compositions, but is non-existent in those of the Second. It is only by looking outside the pictorial world that the explanation of the sudden popularity of a hitherto rare perspective pattern can be found.[13]

In discussing the work of the great late thirteenth and early fourteenth century artists the conflict with the plane surface, which emerges as the com-ponent parts of the pictorial world take on increased solidity, has been treated as a problem not merely in retrospect, but as one which existed for the artists themselves. At Assisi the balance was restored by an extension of traditional ways of building up a decorative surface pattern. At Padua the manipulation of perspective itself was the means by which the troubles which resulted from its use were remedied. It is always difficult, however, to make the jump from the visible records of achievement to the sometimes conscious, and often unconscious mental processes behind them. There is always the danger that the mental process belongs to the modern analyst, and not to the long-dead artist. It may, consequently, prove revealing to move for a moment right out-side the stream of Western art.[14]

It is generally agreed that in Islamic, and in Chinese art the decorative surface is of paramount importance throughout all the periods of highest and most characteristic achievement. That is, until the imitation of western models finally changed the direction of the traditional currents.[15] In both arts the representation of certain aspects of the natural world is nevertheless carried to dazzling perfection. The formal problem, if it is not simply a contemporary one, should therefore be reflected in these arts, and the solutions found may throw some light upon the history of art in Italy from the late thirteenth century onwards.

In Islamic miniatures the surface stress is positive.[16] Flat areas of brilliant colour are left sometimes unadorned, and sometimes sprinkled evenly with delicate designs of flowers or with the carpet-makers' geometric patterns. The gorgeous butterfly designs of text and illustrations are the formal outlet for that same burning directness which is characteristic of the Mohammedan religion and of so many of its middle eastern variants and forerunners.

In Chinese art, on the other hand, the surface emphasis is negative rather than positive. It is in close accordance with the calm acceptance, the con-templative natural mysticism, which reached its highest flowering in Taoism. The surface is left undisturbed. Colours are few, and soft. Ink, and delicate

monotone washes are the characteristic media. Spiritual and decorative qualities are valued high above imitative naturalism, the evocative above the representational. Art stops short long before the plane can be disrupted by geometric space or obtrusive solids. The unmarked silk, or paper, is at once the atmosphere, the space, and the inviolate decorative surface. Only in certain Buddhist works such as the great series of paintings in the distant caves of Tun Huang, which depend, with Indian mediation, upon patterns which originated in the Hellenistic world; only in these relatively few examples is there any radical departure from the general rule.

Poles apart as Chinese and Islamic art may be in many ways, they are alike in carefully eschewing just those patterns which, it has been suggested, are spatially the most aggressive of those used in western art. The box interior, with its too insistent recession of floor, ceiling, and side walls, is avoided equally by both.

In Persian, and in Moghul art there is a predilection for polygonal patterns, whether for interiors, or for objects such as thrones and daises, or for the ends of houses. They have the incidental advantage that they allow diagonally receding lines and surfaces to be shown with the least possible distortion of the actual shape of the space, or solid object, that is represented. Furthermore, orthogonals are avoided. There is also a consistent tendency to avoid foreshortening as far as possible. The floor often lies undistorted and completely parallel to the surface, a polygonal plan allowing adequate recession in the side walls. Where a more definite spatial organization is attempted the result is nearly always an approximation to a bird's-eye view which softens the relationship of space and plane. In interiors, the ceiling is very seldom shown, and any focusing down a spatial tunnel is avoided.

In Chinese art the polygon is seldom used. The box effect is avoided by showing only parts of rooms, or more often by evading the whole problem and showing the outside of the building with a strictly limited view of its contents. The box-like focusing by means of numerous orthogonals, which is a feature of the western interior, finds no place in Chinese art.[17]

The oblique setting, which is the corresponding pattern for the solid object, is similarly shunned. It occurs both in Islamic and in Chinese art to some extent, but only as a carpet, or a table, seen from above and usually tilted very sharply upwards. The bird's-eye foreshortened frontal setting is for both arts the standard pattern for small objects and buildings alike, and remains so until the incursion of the West. The special effectiveness of this particular pattern in stressing the plane surface whilst creating space has been emphasized already, and need not be described again.[18] The normal viewpoint for architecture is, indeed, even more generally avoided than the oblique setting. Like the box interior it leads straight into depth.[19]

The intrinsic qualities of a given perspective pattern are not the only formal factors which control its use. Another important consideration is the size of

the object represented, both in itself and in relation to that of the whole pictorial field. In western art, before the development of perspective theory, obliquely disposed objects are often found in foreshortened frontal buildings. One reason is that small things, such as chairs and stools, cannot appreciably break into the surface, whatever their setting may be. Consequently in western, middle eastern, and Chinese art alike, objects which are small in relation to the picture as a whole are more often seen obliquely, whilst relatively larger elements, such as houses, are either only very softly oblique, or actually foreshortened frontal in setting. This is almost invariably the case in Islamic art, in which the architecture usually consists of a townscape, or of a house or interior in the foreground of the scene. In Chinese art the townscape is replaced by the landscape with distant buildings. In the latter it is very noticeable that, whereas large foreground buildings are almost invariably foreshortened frontal in construction, the tiny, isolated cottages and distant farms are very often obliquely set. The same type of distinction also occurs between objects of different shapes, though not of greatly differing sizes. Things such as chairs, with approximately square faces, are much more readily placed in an oblique setting than the long rectangles of objects such as benches. This particular phenomenon is, however, more easily appreciated in Greek than in Chinese art. The restricted fields of the vases, with their surface stressing ground lines, make the difference in treatment stand out very clearly.

The preference for certain patterns and constructional methods is often based on intellectual, philosophical, even mystical or poetic grounds, which may be more important than the merely formal qualities of the design in question. In Chinese art the preference for a bird's-eye view of houses is an instance.[20] In other cases, such as the relative popularity and selective use of oblique and foreshortened frontal settings, the questions of realism and of formal characteristics seem to grow increasingly important. In some instances the latter may be paramount, and it is likely that they play a part in all of them. Certainly it is only the basic formal considerations which connect the whole wide range of visually similar phenomena. In every case it is, moreover, a matter of choice, and not of ignorance or inability.[21]

It is at least interesting to discover that it is precisely the new forms, associated with the burgeoning naturalism of the late thirteenth-century Italian painting, that are avoided both by Islamic and by Chinese artists. These aggressive patterns are also the very ones which Giotto modifies so rapidly, and this may well be a significant coincidence. The progressive nature of the change in Giotto's work seems, with all the other evidence, to show that it reflects the growth of an idea within the mind of an artist who was sensitive to the disruptive forces being unleashed by the reconquest of pictorial space. His purpose was to re-establish harmony without in any way renouncing that new visual world still in the process of creation at his hands.

Giotto—the Arena Chapel

NOTES

1. Except for extremely lightly moulded pilasters framing the choir arch.

2. This, and many, though not all, of the succeeding observations on framing are noted by C. A. Isermeyer, *Rhamengleiderung und Bildfolge in der Wandmalerei bei Giotto und den Florentiner Malern des 14 Jahrhunderts*, Wurzburg, 1937, who treats of the matter in great detail. The question is here considered more fully on pp. 105–7 below, where conclusions are reached which differ substantially at certain points from those of Isermeyer.

3. The word 'viewpoint' does not here denote an accurately focused construction.
In the articulating bands across the vaults, the central lozenges are seen frontally, as they are parallel to the floor. The rest are seen with mouldings foreshortened from below, until the framing of the allegorical figures is reached. These are seen from a low central viewpoint corresponding to normal head height.

4. Apart from subtle formal linkages, there are careful connections in subject matter, such as those considered by M. Alpatoff, 'The Parallelism of Giotto's Paduan Frescoes', *Art. Bull.* xxix, 1947, pp. 149–54.

5. Rintelen, op. cit., p. 19, suggests that a figure on the extreme right has been destroyed. There are good reasons for believing this supposition to be incorrect. But whilst the existence of such a figure, instead of blue sky, would soften the spatial clash at that point, it would not affect the significance of the architectural construction used.

6. The slight weakness of connection within the individual fresco may partly stem from a wish to create a continuous lower horizontal accent across the three scenes of a unified bay (see p. 45 above).

7. Such very slight, and yet consistent deviations from the normal require more care and clarity of purpose in execution than do bolder designs in which small variations are of relatively little importance.

8. In 'The Vision of Brother Augustine, and of Bishop Guido' at Assisi (Pl. 10), the structure of the room on the right, in which the bishop lies, is parallel to the surface, whilst the church on the left is in recession towards the left. This produces a bowing effect which seems, in this case, to be purely incidental. The change of viewpoint is rather clumsily managed, and in neighbouring frescoes the artist concerned reveals no great appreciation of visual subtleties. The bending there-fore seems probably to be a reflection of contemporary trends or a chance effect, rather than the result of personal experiment.

9. Rintelen, op. cit., brings this out effectively. It is treated in a more specialized way in W. Ueberwasser, *Von Mass und Macht in der Alten Kunst*, Strassburg, 1933, where the relation of the figures to the geometric subdivisions of the pictorial field is discussed and compared with that in Egyptian, Syrian, and other arts. The ground plans implied in the scenes of the Legend of St. Francis at Assisi and in Giotto's frescoes in the Arena Chapel and in Sta. Croce are worked out in J. Pešina, *Tektonický Prostor a Architektura u Giotta*, Prague, 1945.

10. See R. Oertel, 'Wandmalerei und Zeichnung', *Mitt. Kunst. Inst. Florenz*, 5 Band, Heft iv–v, Marz, 1940, pp. 217–314. L. Tintori and M. Meiss, *The Painting of the Life of St. Francis in Assisi*, New York, 1962, use the overlapping of successive areas of plaster, each representing one day's work, to prove the downwards progress at Padua. It is also used to determine that at Assisi the order of execution follows the narrative sequence, except that the opening scene was painted later than the second.

11. It is only in the upper scenes, for instance, that orthogonals can be found to diverge.

12. These statistics are based on a careful survey of the works listed in E. B. Garrison, *Italian Romanesque Panel Painting*, Florence 1949. The fact that byzantinizing artists are not covered by it does not materially affect the issue, as these were, if anything, more conservative in the matter of

settings. The fields of fresco painting and of manuscript illumination have also been covered, though in the latter case with nothing like the same completeness. Nevertheless, enough represen/ tative examples have been seen to support the generalizations which refer to them.

13. Even if Roman frescoes contemporary with the Pompeian Fourth Style were seen by artists such as Cavallini, they must still have been uncommon, and consistency in the construc/ tions used does not, in any case, extend beyond examples of the finest quality. It is highly doubtful if the designs on Greek and Italiote vases were noticed at this time, and oblique settings are, moreover, relatively rare upon them.

14. It is, of course, almost impossible to escape Western, and particularly Hellenistic influences completely either in India or in China. None the less, in the latter case especially, any immediate dependence was very restricted, and the native development was so rich and strong that Chinese art may, for the present purpose, be considered, with certain clear exceptions such as the cave paintings at Tun Huang, as being fully independent. In Islamic art there is, similarly, sufficient individuality to give value to comparisons with the main body of western art.

15. The fresh impact of modern western art on Moghul illumination becomes very strong in the early seventeenth century. In Chinese art the influx of western ideas occurs in the Ch'ing dynasty at the end of the seventeenth century.

16. The reference is to Persian and Moghul miniatures.

17. These statements are made by G. Rowley, *The Principles of Chinese Painting*, Princeton, 1947, p. 62, and lend authority to personal observations.

18. See above, p. 28.

19. The normal viewpoint occurs in the paintings at Tun Huang, usually in the topmost fea/ tures of very tall, complex designs. Similarly there are numerous literary references to the 'unsuccess/ ful' or undesirable use of the device in early times. (See O. Siren, *The Chinese on the Art of Painting*, Peiping, 1936). The oblique setting likewise occurs in the Han relief of 'The Eastern Gate of the Chien/Ku Pass' in the Boston Museum of Fine Arts. The relief has been doubted on insecure grounds by W. H. Wells in his highly misleading work, *Perspective in Early Chinese Painting*, London, 1935. The transference of a number of the fundamental propositions there advanced to precisely similar phenomena in western art would lead, for example, to the conclusion that there was no spatial significance at all in a great part of Giotto's architecture. The attempt to show that Chinese art differs from western art, which is undeniable, leads in this case to nonsense. Far more reliable, are Rowley, op. cit., and B. March, 'Linear Perspective in Chinese Painting', *Eastern Art*, vol. iii, 1939, pp. 113–39.

The evidence of the early works, and of the Chinese literary sources, shows that the later pattern preferences were not based upon ignorance of the other possibilities, but upon distaste for them.

20. Shen Kua (A.D. 1030–93) says of Li Ch'eng: '. . . whenever he put kiosques, pagodas, or other buildings, on the mountains of his landscapes (he), painted them with cocked up eaves, so that the spectator looked upwards and saw the inner part; because, he said, the point of view was below the object, just as a man standing beneath a pagoda sees above him the rafters of the eaves. This reasoning is faulty. For in landscape there is a method of looking at big things as if they were small. If people looked at imitation hills in the same way that they look at real hills, that is, looking from the base up to the summit, it would only be possible to see one range at a time, and not range behind range; neither would the ravines and valleys in the mountains be visible. Similarly you ought not to see the middle court of a house, nor what is going on in the back premises . . .; under such conditions no picture could possibly be painted.' March, op. cit., p. 121.

21. Reasons for this statement are given in note 19 above. In later times, when evidence is more plentiful, the distinction between coeval patterns, of which one remains rare, and another becomes extremely popular, grows even more noticeable.

CHAPTER III

Giotto—the Bardi and Peruzzi Chapels

The paintings in the Bardi and Peruzzi chapels in Sta. Croce are all that remains of the rich catalogue of frescoes completed by Giotto after his triumph in the Arena Chapel. It is most exciting that these two fresco series, preserved by chance, and separated by well over a decade from the work of Padua, should, despite their highly individual qualities, reveal in full the striding steadiness of development and intensity of purpose which are charac- teristic of the greatest artists.

The painted architectural framework of both chapels has the same wall- hugging crispness, the same restrained authority as at Padua.[1] There is the same constant faring forwards. Cosmati work embellishes and enriches the pale marbling in the Bardi, just as it completes the colour pattern in the Arena Chapel. The treatment is even simpler in the Peruzzi Chapel, where the wide, calm, marble surfaces are broken only by classical portrait medal- lions. There is a Roman grandeur and severity throughout the whole concep- tion. This does not mean that the realities of the great Italian Gothic edifice of Sta. Croce are ignored. There is no escaping the architectural domination of the chapel structures, and no attempt to do so. The Gothic niches of the Saints are recognition in themselves, and, in the corners, painted columns now run up to give support to the plastic ribbing of the vaults. The negative colour bands which gave a floating quality to the Paduan scheme are gone, replaced by positive, centralized enclosure of the chapel space, pictorial realism harmonized with architectural fact.

The lighting within the scenes falls on figures and on architecture as if from the windows which, in both chapels, create a unified source of outside light.[2] Furthermore, the internal architectural perspective is co-ordinated with the viewpoint of the observer as he enters. The tentative experiments of Padua are perfected and complete coherence finally attained.

In all but one of the six frescoes in the Bardi Chapel, interiors or near interiors are represented. In all of them the visual axis lies not in the geometric centre of the composition, but slightly towards the entrance of the chapel. The perspective, as in the lower registers at Padua, goes halfway to meet the spectator, now no longer in the centre of the chapel, but upon its threshold.

The rectangular lower scenes are almost completely filled by the calm planes and clear verticals and horizontals of the interiors. In 'The Apparition

72

at Arles' (Pl. 16, *c*) the strictly limited depth is enclosed by the unbroken back wall, characteristic of all four of the scenes below the lunettes. The effect of this is reinforced by the low socle and slim columns which mark the forward boundary of the building and strengthen the already powerful net-work of forms maintaining the surface tension of the wall. Furthermore the smoothly sloping roof is so designed that the eye runs up its outer surface, instead of being forced downwards into depth by the orthogonals of an enclosed ceiling.

It is significant that the only true interiors in the Bardi Chapel are those of 'The Confirmation of the Rule', and of 'The Visions of Augustine and of Bishop Guido'. 'The Apparition at Arles' is actually an intermediary be-tween the latter and the even less strongly enclosed constructions of 'The Ordeal by Fire', and 'The Death of St. Francis'. In these the roof has disap-peared, and something half interior, half courtyard is brought into being. Giotto is, in fact, experimenting with an architectural pattern used for cen-turies by artists in whose work the true interior finds no place.[3]

The figure disposition completes the picture of Giotto's efforts to create a convincing space which itself stresses the flat reality of the wall. It is the planar distribution of the figures that prevents the one obliquely set exterior from bursting through the composition of 'St. Francis Repudiating his Father' in which it occurs. The knife edge of the solid block simultaneously centres all attention on the figure of the Saint and is blunted, and held back by it. On either side the line of figures holds the plane against the spatial pull of the receding cornices. These same cornices fit ideally into the curved frame of the lunette, allowing the decorative surface to be filled completely. This probably provides a partial explanation of this isolated use of the extreme oblique construction.[4]

In the Peruzzi Chapel the pictorial architecture within the centralized framing is much more strongly controlled by a supposedly fixed position of the observer than at Padua, or even in the Bardi Chapel. This is done by giving four of the five architectural scenes a similar, softened oblique setting, whilst the fifth, 'The Assumption of St. John' makes use of the foreshortened frontal setting. In this fresco there is evidence of a change in the composition of the architecture after the original drawing-in of its main lines. This may have some connection with the solitary reappearance of the construction.[5]

Whether or not this is true, the surprising thing is not that the foreshor-tened frontal setting appears at all, but that it appears so seldom. Even those artists who most consistently used the oblique setting because of its relation to the actual appearance of solid objects were necessarily also constant users of the foreshortened frontal construction for all the architectural framework of their frescoes. The reason for this dualism lies in the respective qualities of the two systems, and in the double task facing any artist who represents the real world on a limited, flat surface. So far this duality has been expressed as the

interplay between the creation of depth and the emphasis of the surface. It might equally be expressed as the tension between realism and pictorial organization.

The framing of a series of frescoes covering one, or several walls, is primarily a problem of organization; of co-ordinating a number of rectangular fields within the greater rectangle of the wall. The foreshortened frontal setting clearly serves this organizational demand. One of its principal characteristics is that it does not distort at least one of the surfaces of a rectangular solid, this undistorted rectangle remaining parallel to the all-embracing rectangle of the wall. The oblique setting, on the other hand, whatever its merits in the realm of detailed realism, is not only opposed to the plane surface in those very details, but is inherently unsuitable as a means of organization for a wall. Used consistently on a long wall its essential quality of foreshortening to either side of a central point would mean that only at that point would there be any semblance of conformity to the limits of the field. The framing would pull away from the upper and lower boundaries of the wall like the outlines of a building set obliquely in an individual scene. Large blank areas would stretch beyond the borders of a so-called framing architecture deprived of any structural connection with the building which contains it. If the main construction were allowed to remain rectangular in harmony with the normal wall shape, and only the projecting detail were obliquely set, the sole result would be the generation of uncomfortable internal conflicts. The foreshortened frontal types of perspective are therefore almost invariably used for fresco framing. Their organizational qualities in a world of rectilinear architecture make them indispensable even to those artists who eschew them in their narrative compositions. In the latter, the abbreviated, self-sufficient nature of each scene, and the additional compositional factors, such as the figure disposition, can be used to offset basic organizational defects. As a result of these considerations, it is clear that the occasional appearance of the foreshortened frontal setting in the work of any fresco painter is much less remarkable than its almost complete exclusion from the work of some. The pressures in its favour are always present, and Giotto's extremely limited use of it is testimony to the strength of his desire for a faithful interpretation of what seemed to be the fundamental facts of natural observation.

The keen awareness of naturál appearances, underlying Giotto's art, results in no unifying theory. Instead, it produces a number of fairly systematic ways of solving the various constructional problems which the artist faced.

The obliquely set structures tend, from the beginning, to obey the most important rule of later, theoretical systems in which the twin vanishing points are set upon the same horizon line. Receding lines, instead of converging towards single points, run up or down in parallel, or else converge slightly. They therefore correspond with a vanishing axis (Fig. 3, *a*) rather than with a vanishing point construction (Fig. 6) (p. 123).[6] The lines at the

tops and bottoms of the buildings, and any other similar pairs, cut approximately on a unified horizon.[7]

In the interiors of such obliquely set buildings, the ceiling beams and the lines of the coffering tend to run in parallel. In frontally set interiors, however, the orthogonals of the ceilings run sometimes towards a vanishing area, and sometimes almost to a single vanishing point.[8] There is no development from the one type to the other. The distinction seems to be dependent on the delicacy of the details involved, rather than upon any systematic refinement of technique. The system for a single plane nowhere extends to the adjoining surfaces which lie at right angles to it,[9] so that apart from the fact that in

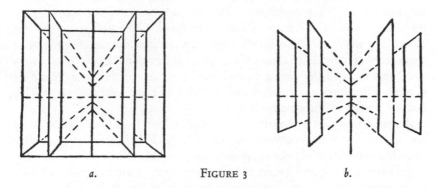

a. FIGURE 3 b.

most cases the figures cover a large proportion of the orthogonals, there is no approach to the idea of a complete interior focusing upon a single point. Nevertheless, interiors in Giotto's paintings do represent a step towards the artificial perspective of the fifteenth century. At the same time the oblique constructions used in the majority of his designs reveal a movement in a different direction. The dualism of construction in framing and in narrative compositions extends into the technical organization of the scenes themselves.

There are, apart from the constant use of the Paduan softened oblique setting, two other interesting features in the architecture of the scenes in the Peruzzi Chapel. The first is the strong cutting of the buildings by the upper border of the frame in both the 'Zacharias in the Temple' and in the 'Birth and Naming of the Baptist'. At Padua there is occasional, less forceful cutting. Here, however, the main architectural lines become involved.[10] This movement away from the formality of construction and the complete enclosure which are generally characteristic of the Paduan compositional style, is also noticeable in the second feature to be mentioned.

One of the most remarkable things about the frescoes in the Arena Chapel is that 'The Massacre of the Innocents' is the one and only composition in which more than one building is shown.[11] The self-isolating properties of the oblique construction, and particularly of its extreme form, are never

allowed to result in a compositional conflict such as occurs in some of the frescoes at Assisi. The single block creates a single, sufficient space for itself. There is no problem of the co-ordination of a number of space-forming solids, heavy nuclei, each enveloped in its own small spatial universe. In 'The Resurrection of Drusiana' (Pl. 17; *a*), however, Giotto tries, for the first time, to emancipate the idea of space from the tyranny of the solid object.[12]

In this fresco a varied, but unbroken wall stretches continuously, in soft recession to the left, from one side of the composition to the other. At neither side is there any indication that the wall comes to a stop, or that its ends lie just outside the frame. Space is no longer extended beyond the limits of the composition only by the movement or the cutting of the figures, or by the amputation of a few protuberances from a central architectural mass. Space no longer comes to an abrupt end with the block-like building to which it clings. No one can tell how far the wall runs on. It is also significant that its softly receding continuity allows the domed basilica and the twin gate-towers to resume the spatially strong extreme oblique construction with complete success. Their interconnection is established, and their potentially aggressive quality calmed by the continuity of the wall.

A similar maturity is present in the crowds which flank the miracle. They are, for the first time, composed of individuals. Like the architecture they have been co-ordinated, not congealed into a block.

For these reasons, and because of the other signs in the Florentine chapels of an internal process of development away from the Paduan experience, there seems to be little reasonable doubt that, of the two, the Bardi Chapel represents the earlier stage.[13] All the definite internal evidence points towards its precedence. There is also some external confirmation in the fact that Giotto's own followers carry on, however uncertainly at times, the ideas of the later Paduan and Peruzzi compositions, rather than those which are typical of the frescoes of the story of St. Francis. The experiment in the Bardi Chapel seems indeed to be a phase in Giotto's search for a method of creating a pictorial space in harmony with the pictorial surface, and not the first sign of a late style only matured in works that have been lost.

The question of precedence at Florence does not affect the fact that the compositions on the walls of both the Bardi and Peruzzi chapels help to confirm the general pattern of development extending from the early scenes upon the upper walls at Padua. The work in Sta. Croce similarly leads towards the future. But before going further, it is necessary to turn for a moment from the Florentine stream in order to consider the great upsurge of pictorial invention in Siena.

NOTES

1. Most of the following observations on framing repeat those in Isermeyer, op. cit.

2. J. Wilde has pointed out to me that in Giotto's work the unified fall of light is always modi-fied by the individual demands of figure plasticity. This, naturally, does not affect the architecture.

3. See above, pp. 37-9, and M. S. Bunim, *Space in Mediaeval Painting and the Forerunners of Perspective*, New York, 1940, p. 141. This volume gives a useful survey of the technical develop-ments from the earliest times, together with a first-class bibliography.

4. It also enhances the dramatic quality of the story.

5. There are large numbers of red compositional lines beneath the surface of the final design, showing, amongst other things, that a centrally seen arch was originally intended to bridge the middle of the building. Unfortunately none of these lines are visible on the right of the fresco, so that a complete reconstruction of the original design is impossible.

6. For diagrams of the system in centrally viewed objects, see Bunim, op. cit., p. 238.

7. Bunim, op. cit., p. 141.

8. Bunim, op. cit., pp. 142—3. D. Gioseffi, *Perspectiva Artificialis*, Trieste, 1957, pp. 60–73, has observed that both a vanishing point and a correct diminution of the intervals between trans-versals occur in the coffering of the ceiling in 'The Healing of the Man of Ilerda' in the Upper Church of San Francesco at Assisi, attributed to the St. Cecilia Master, and also in the three remarkable scenes of 'The Wooers Bringing the rods to the Temple', 'The Wooers Praying', and 'The Marriage of the Virgin' in the Arena Chapel, Padua, painted by Giotto, and discussed on p. 61 above. In the latter, however, the vanishing point appears to be very approximate, and the coffered ceilings are only two squares deep. The system is not consistently used in subsequent frescoes, and Bunim's assessment therefore seems to remain substantially valid as far as Giotto himself is concerned.

At a rather later date, there is, however, no doubt about the convergence to vanishing and distance points in the floors and ceilings respectively of the frescoes of 'The Presentation in the Temple' and 'Christ amongst the Doctors', painted on slightly curving surfaces in the Lower Church at Assisi by a Master strongly influenced by Ambrogio Lorenzetti. See also R. Klein, 'Pomponius Gauricus on Perspective', *Art Bulletin* XLIII, 1961, p. 221.

9. Panofsky, op. cit., pp. 278-9; Bunim, op. cit., p. 142.

10. Similar cutting occurs in Cavallini's work. See J. White, 'Cavallini and the Lost Frescoes in S. Paolo', *Journ. Warburg and Courtauld Inst.* 19, 1956.

11. The Annunciation spanning the choir arch is a special case, as it is not confined within a simple rectangle or semicircle.

12. This is also achieved in the land- or sea-scape of the 'St. John on Patmos', despite the dotting of figures over the surface.

13. This is convincingly shown by J. Gy.-Wilde, 'Giotto Studien', *Wiener Jahrbuch für Kunstgeschichte*, Band vii, pp. 46–94, who clearly distinguishes the faulty nineteenth-century restorations which have since been removed. These wider arguments are supported by the analyses of the framing in Isermeyer, op. cit., pp. 21 ff. The order of the frescoes does not, however, provide a further argument. The even alternation in the Bardi, and wall by wall treatment in the Peruzzi Chapel depend on the unity of subject in the first and its parallelism in the second. The alternation in the Bardi Chapel puts the scenes in the order given by St. Bonaventure. The sequence is different at Assisi because there 'The Apparition at Arles' was considerably displaced. Isermeyer, op. cit., is therefore wrong in thinking that the order in the Bardi Chapel is peculiar, and therefore significant for dating. Similarly, the main sign of Gothic tendencies in this chapel lies in the drapery forms on the left of 'The Ordeal by Fire'. These may as well be experiments with new patterns later applied to their full figure-moulding task in 'The Birth and Naming of the Baptist' as the first signs of a move towards a generally Gothic style.

CHAPTER IV

The Early Sienese Masters

DUCCIO DI BUONINSEGNA

The panel painting of the Maestà, which Duccio completed in the years between 1308 and 1311, is the masterpiece that marks the first full flowering of the new school of Siena. The flowing line, and the glowing colour unattainable in fresco, form an unforgettable contrast with the works so far discussed. It is an art in which the harmony of the decorative surface is never disturbed, and never has to be restored.

The emphasis on the picture plane is shown in the structure and interconnection of the figures. In architectural terms this characteristic attitude is expressed by the virtually complete absence of the oblique setting. In almost every case a centralized, or a foreshortened frontal setting is used. This does not mean a lack of interest in the development of space. It only shows that the development takes place within a framework which is more strictly regulated by the flatness of the picture surface.

The size of even the largest altarpiece is relatively restricted. It follows that the problem involved in creating a decorative unity out of a large number of narrative scenes is far less acute than in fresco painting, where the area covered by the decoration is so much greater. Apart from the strong central accent of 'The Betrayal of Christ', 'The Agony in the Garden', and 'The Crucifixion' there is no attempt to balance the scenes on the back of the Maestà symmetrically about the middle.[1] The framing is, as in most panel paintings, neutral. The often repeated foreshortened frontal, and centralized interiors are freely intermingled without optical relation to each other. Since all the foreshortened frontal interiors are seen from the left, however, there is no extreme conflict of viewpoints. The most important unifying elements may, in fact, be summarized as the colour; the consistent compositional style; the light, which always falls upon the architecture from the left;[2] and, finally, the careful observation of the unity of place, which is not, however, visual in its impact.

The observation of nature in the individual composition has, in many ways, more affinities with Assisi than with Giotto's work at Padua and Florence.[3] The same descriptive qualities, which appear in S. Francesco, are to be seen again in the rocks, and trees, and plant life of Duccio's 'Noli Me

78

The Early Sienese Masters

Tangere'. 'The Agony in the Garden' (Pl. 18, *a*) is, however, his supreme essay in the creation of pure landscape forms. The inclusion of two episodes within a single scene does not detract from the way in which the rocky land/ scape provides a convincing, and fairly deep, natural platform for a number of figures. It is a more thoroughgoing representation of figures in landscape than any of Giotto's Paduan compositions, in which it is normally a question rather of landscape enhancing figures. The only comparable scene is the early 'Sacrifice of Joachim' which only serves to emphasize the distinction. Duccio's descriptive conception is approached more closely in the Assisi 'Miracle of the Spring' (Pl. 9, *a*), which does not equal it despite the spatial advantage of the blue, fresco sky over the gold leaf of the panel painter. The Byzantine rock convention is much more softly and more naturalistically conceived by Duccio, and almost all the space is inhabitable by the figures.

Duccio is, moreover, alone amongst the painters discussed so far in trying to present a near view of a scene that takes place in a town. He does more than show the figures set against one or two isolated buildings, or uncertainly connected with a town that is presented as a whole and seen from the outside. In 'The Healing of the Blind Man' (Pl. 19, *a*) it is true that all the houses are behind the figures, and only the well upon the right reaches the very fore/ ground of the scene. Nevertheless, the low viewpoint, and the large figures, reasonably in scale with the clearly co/ordinated buildings, bring the idea of a town much closer than it has ever been before. How greatly the achieve/ ment of this result is assisted by the foreshortened frontal construction of the buildings can, perhaps, be gauged by glancing at the fresco of 'St Francis Repudiating his Father' at Assisi (Pl. 8).

The most ambitious of all Duccio's designs in terms of space, and naturalism in general, is that of 'The Entry into Jerusalem' (Pl. 17, *b*). The low viewpoint of the buildings makes it perfectly possible to accept the composition climbing the surface of the tall pictorial rectangle as a road winding steeply upwards into the hill/city of a Sienese Jerusalem. Only the small, obliquely set gate in the foreground introduces a slight note of con/ flict.[4] The scale of the city gate, and of the buildings in the distance beyond it; the relation of the trees to the children crowded under them; all these are quite remarkable. The spatial continuity, and the distance travelled into depth as the eye moves steeply upwards, round, and inwards, levelling out as the even rooftops mark the summit of the hill, are astonishing, especially when the date of the Maestà is brought to mind. Only amongst the figures crowded at the city gate is there some difficulty and a slight loss of conviction. Not least remarkable is the lack of any of that sense of strain which might be expected to accompany so daring a pictorial leap. The iconography goes back to the Byzantine prototypes.[5] The composition as a living organism is Duccio's own.

The achievement represented by 'The Entry into Jerusalem' (Pl. 17, *b*) is

underlined by the realization that the only comparable fresco at Assisi is the 'St. Francis and the Demons of Arezzo', in which an attempt is made by means of a change of scale to create diagonal movement into space. At Padua the background, but not the figure disposition of 'The Massacre of the Innocents' represents a similar endeavour. The same limitation is also present in the disciplined magnificence of 'Resurrection of Drusiana' (Pl. 17, *a*).

In interiors Duccio's starting point lies in centralized and foreshortened frontal buildings, such as those in 'The Last Supper' and 'The Flagellation'. In the former the receding lines of the central section of the coffered ceiling vanish approximately to a single point, whilst those on either wing produce a vanishing axis pattern (Fig. 3, a) (p. 75).[6] There is therefore only a ten- dency to converge to a point in part of a single plane. The side walls run, however, to the very edge of the composition, and only the thinnest line of gold ground intervenes between roof and frame, so that the building is almost a true interior. In foreshortened frontal buildings, amongst which the sense of enclosure increases in such compositions as that of 'Christ at the House of Caiaphas', the rule is generally for parallel recession in the ceilings, and for slight convergence in the orthogonals of the side walls. The buildings in the three scenes mentioned are each repeated several times, and form the com- positional foundation on which Duccio builds.

The linking of the courtyard scene of 'The Denial by St. Peter' with that of 'Christ in Front of Annas' immediately above it (Pl. 18, *b*), by means of a diagonally climbing staircase, creates quite a strong impression of a two- storey building with its upper wall laid open for inspection. The courtyard at the bottom lets out through the archway on the left, giving a feeling not only of extension to the side of the main space, as in a number of examples both at Padua and Assisi, but also of moving inwards from the enclosed court into the depths of an extensive building, only a fraction of the wall of which is shown. The spatial relationship of the two levels is, however, rather shifting.[7] There are also minor difficulties, such as the precise relationship between the two uprights of the left-hand arch, and between the serving maid, who stands in the left foreground, and the bannister beyond her. Actual contradictions, particularly those involving the relation of the figures to the architecture, are quite frequent amongst the compositions in the main body of the altarpiece.[8] The recurring lack of co-ordination between the view- points of architectural details and the buildings as a whole, or in the relation of objects such as thrones to the interiors which contain them, is illustrative of the same approach.[9] All these things reveal a lack of interest in the funda- mental realism which was typical of Giotto. In spite of this, the nascent qualities of the courtyard are developed further still in two of the subsequently isolated panels.

The first of these exceptional designs is 'The Presentation in the Temple' (Pl. 19, *b*). The scene is centrally arranged, and the action is shown taking

place before a sturdily constructed, arched ciborium. This is itself framed by a wide Gothic arch, cut by the upper border, and looking out into the gold-leaf distance. On either side a smaller arch springs forward to enclose the entire scene, and is cut short almost immediately by the verticals of the frame. Through these narrow openings aisles are seen extending outwards to the left and right beyond the confines of the picture space. A thin strip of gold above the spandrels of the main containing arch shows that the central space is not roofed in by vaulting like the aisles or cloisters flanking it. Despite the representation of an encircling courtyard rather than of an interior, properly so called, the attempt at a complete spatial enclosure is far more radical than any that have previously been considered. The bold truncation of the main space both at top and bottom, and on either side, aims at an inclusion of the spectator that is rarely found again before the fifteenth century. No forward surface, no exterior faces of the principal structure can be seen at all. The main space, as well as the subsidiary enclosures beyond, stretches out and round, outside the confines of the frame. Helped by the scale of the arches soaring above the figures, the doll's house world of the one room building is left far behind.

The same breadth of conception is found in the panel of 'Christ Teaching in the Temple' (Pl. 19, *c*). Here the immediate impression of depth is, perhaps, increased by the open foreground that is only partly filled with figures, all of which are ranged into the picture space. Once again a court-yard, rather than a true interior is shown. But the distinction is reduced to a minimum by the nearness of the frame to the upper line of the architecture. The scene is asymmetrically viewed, and despite a number of internal con-flicts caused by the recession of different architectural features impartially to left and right, the breadth of the conception remains unaffected. The vaulted arcade is cut short by the left-hand border, whilst on the right the arches springing forward to enclose the central space are similarly cut. Enclosure of the onlooker is once again implied.

These two compositions create for the first time the impression of a slice of life, a view into a small part of a clearly indicated and extensive architec-tural space through which the mind is free to wander. This partial view of an extensive whole is an idea which Duccio also develops in his treatment of the exterior in at least one of his compositions.

The scene in question is 'Christ's Temptation on the Temple' (Pl. 20, *b*). The action unfolds on the balcony of a great, centrally planned Gothic structure. Two whole storeys are shown on a convincing scale, views of the interior opening into each. Above, the building soars beyond the boundary of the upper frame.[10] This new scale of representation matches the advance in the conception of enclosure. It completes the picture of the development of pictorial space within the confines of the single work which is the Maestà.

The estimate of Duccio's achievement implied by these analyses might

81

seem at first to nullify, at least in part, the arguments establishing a close connection between the observation of nature and the emergence of the oblique setting in the work of Cavallini, of the Assisi painters, and of Giotto. The apparent contradiction disappears, however, on consideration of the fundamental qualities of the different styles.

The extent of Duccio's achievement is partly due to the very fact of his conservatism; to his willingness to retain conventions questioned by Cavallini and Giotto. To these artists the fundamental reality of the ground is its flatness, its absolute contrast to the vertical of the human figure. Giotto was never prepared to climb the surface of a composition and use the sloping instability of a hill in order to achieve depth. To him depth was valuable only if it could be created at eye level on the flat earth. Duccio, on the other hand, was willing to accept the convention of the surface climbing composition, and, combining it with natural observation, achieved 'The Entry into Jerusalem' (Pl. 17, *b*).

This design would still have been impossible without Duccio's equal willingness to accept the older figure canons to a greater extent than had either Cavallini or Giotto, or even the artists of the St. Francis cycle at Assisi. He did not see plasticity as the fundamental quality of the human body. In his art a more natural articulation and a limited solidity were combined with a dominant, linear, surface pattern strengthened by exquisite colour. Only the more limited realism of his conception of the human figure allows the crowds to gather on the road that leads up to the Holy City.

In the same scene of 'The Entry into Jerusalem' (Pl. 17, *b*), it is the acceptance of the foreshortened frontal setting from Duccio's Byzantine sources which allows the buildings to fit with such harmonious unobtrusiveness in the background of the composition. He does not abandon the convention, as did Cavallini and the painters of Assisi at least in part, and Giotto almost entirely. Instead, as with his figures, Duccio inflated it a little; blew in enough reality to give it life, and was content to work within the limits it imposed. As a result he was neither controlled, like the artists at Assisi, by the too powerful spatial effects of the oblique setting, nor did he have to concentrate considerable energy upon the restoration of a pictorial balance disturbed by the fundamental realism of an artist such as Giotto. Duccio's concentration upon the bases of individual phenomena was less intense. Consequently he was free to try for more daring representational effects than the Roman and Florentine artists without setting up uncontrollable internal conflicts in designs not yet sufficiently evolved to contain such intense realism.

The foreshortened frontal convention, which Duccio accepted and developed, created little of that tension between the representation of interior and exterior which was experienced by the artists who espoused the oblique construction. There is no inherent dualism in Duccio's art. The rapidity of his expansion of the interior, and the magnitude of the final achievement, reflect

the greatness of his genius. They also reflect the fact that the very limitations of his figure style and the inherent qualities of surface harmony in his perspec﹐tive constructions, together with the brilliance of his colour combinations, the strength of his linear patterns, and the non﹐naturalistic gold ground of the panel painter, all helped to relieve him of concern for the integrity of his decorative surface, enabling him to develop a more and more complete con﹐ception of internal space, and a greater complexity of grouping in architec﹐tural landscapes and exteriors. There is never too abrupt a spatial pattern in Duccio's painting, never any need for the ambivalent architectural features used by Giotto. Orthogonals and transversals are always clearly distinguished. This positive approach to spatial questions was also characteristic of the frescoes at Assisi. But here a more inherently harmonious architectural result is obtained through the accented frontal elements that appear in every con﹐struction. The readiness with which the basic organizational qualities of the foreshortened frontal setting lend themselves to the creation of unified com﹐positional groups is underlined by the subsequent career of Simone Martini. At the same time it becomes even clearer how much the rapidity of Duccio's advance was assisted by the compositional docility of this convention.

SIMONE MARTINI

The first surviving example of the perspective grouping of several scenes about a clearly defined central axis occurs in the predella of the altarpiece of 'St. Louis of Toulouse Crowning Robert of Anjou', which Simone Martini painted in 1317. The idea was adumbrated in the Paduan frescoes, and developed in the single, vertical ranges of the Bardi and Peruzzi chapels. It is in the work of Simone Martini, however, that the new relationship between the spectator and the narrative composition is defined most clearly.[11]

The central scene of the predella shows 'St. Louis Serving at the Table of the Poor'. The perspective pattern is now hardened into a rigid vanishing axis system (Fig. 3, *a*) (p. 75). Uniform parallel recession replaces Duccio's tentative advance towards the focusing of receding lines upon a single point. The vanishing axis system is standardized by Simone to such an extent that, in the later 'The Death of St. Martin' in the Lower Church at Assisi, part of the axis itself is visible in the ceiling pattern. The orthogonals run together in an even herring﹐bone within the boundaries of the architecture, instead of only meeting invisibly when extended in the mind. In the predella scene, however, the art of Duccio is still reflected in the composition as a whole, as well as in the contradictory foreshortened frontal setting of the table which fills the centrally composed room.

The four flanking scenes of the predella are all foreshortened frontal in construction. Their orthogonals recede in parallel towards its centre. In con﹐

trast to the table in the central composition, the various cubic objects shown conform completely to the architectural setting of the interiors which contain them. The steep recession of the parallel orthogonals of the floors and ceilings precludes the possibility of any mathematical construction based upon a single axis valid for the entire group of five compositions. The continuity of the recession towards the middle of the predella, and the way in which the scenes run into one another, nonetheless create a powerful pull towards the centre about which they balance.

The same ideas are carried out with even more assurance in the Chapel of St. Martin at Assisi. Here the ten narrative scenes are ranged above each other on the side walls immediately to left and right of the chapel entrance. The two lowest registers on either wall contain a pair of frescoes each, whilst on either side a single fresco, which adjoins the entrance wall, carries the scheme into the vault. The three interiors in the frescoes nearest to the entrance wall are all centrally seen, establishing the onlooker's position immediately in front of them. This position is confirmed by the foreshortened frontal setting of the four buildings in the frescoes nearer to the altar. Their ortho-gonals, and those of all the cubic objects they contain, recede towards the chapel entrance. The problem of co-ordination is more complex at Assisi than it is in the Bardi and Peruzzi chapels, but the solution is essentially an extension of the same idea.

The different treatment accorded to panel and fresco, in recognition of the different problems that are posed, seems to show that the new organization is not simply a device for compositional co-ordination. Its implications as regards the position to be taken up by the spectator are intentional. This is confirmed at Assisi by the perspective structure of the niches in the embrasures of the windows, which are all presented as if seen from the body of the chapel. Further evidence is supplied by the increasingly complex realism with which the pattern is developed in such panels as that of 'Beato Agostino Novello' in the church of S. Agostino in Siena. In this work the centralization of the flanking panels covers a far more complicated range of architectural designs. At the same time the sense of depth is increased by the extension of the ground plane, and by the representation of a street scene in one composition, whilst in another the eye runs on into the golden distance through an archway set between two houses.[12]

It is interesting to notice that, in their consistent use of centralized and foreshortened frontal settings, both Duccio and Simone Martini come closer than either Giotto or his immediate followers to that unity of construction which is one of the fundamental characteristics of fifteenth-century artificial perspective. The contrast between the early stages of development in these two artistic streams throws further light upon the interaction between the observation of nature and the organization of the flat surface. Each feeds, and is dependent on the other. Each creates, and is created by, the form the other

takes. The forces which contributed to the wide scope and structural weak-
nesses evident in Duccio's descriptive naturalism are still operative in
Simone's art.

The imaginative sweep of the Sienese approach to the natural world, and
its conservative base, are epitomized in the bold spatial and decorative contrasts
of the fresco of Guidoriccio da Fogliano (Pl. 20, *a*) which Simone painted
in the Palazzo Pubblico in Siena in 1328. Horse and rider, blended into one
by the flowing curves of the compelling diamond pattern, parade, capari-
soned in gold, across the foreground. The splendid golden silhouette swells
and gleams against the blue backcloth of the sky. A characteristic medieval
ground strip fills the lower third of the wide proscenium rectangle. There is
the usual uncertainty in the relation of the figures to the ground plane, the
usual abruptness in the change of scale between figures and surroundings.
It is impossible to say if the charger walks across the landscape or upon the
picture frame. There is no knowing its relation to the foreground palisade,
under, behind, or in front of the high-stepping hooves. Yet the result is no
mere archaism, but a new, and vivid evocation of reality. Each of the inherent
contrasts is intensified. The landscape detail is more widely scattered, smaller,
and more distant, the figure more boldly in the foreground than in the
miniatures and panel paintings the characteristics of which are here seen
exploited on a monumental scale and with dramatic consequences. In the
Palazzo Pubblico, as in the Peruzzi Chapel, space, no matter by what widely
disparate means, is taking on new meaning both for artist and for onlooker
alike.

NOTES

1. The 'Entry into Jerusalem' on the extreme left effectively disposes of any balancing of the
whole design.

2. In the figures the individual demands of plasticity and pattern are more important than the
observation of strict unity of lighting.

3. This is shown by the analyses contained in Rintelen, op. cit., and in C. H. Weigelt,
Duccio di Buoninsegna, Leipzig, 1911.

4. It is seen from a low viewpoint that divorces it from the buildings far above it. Duccio's only
other use of the oblique setting occurs in the small building to the left of the main gate.

5. Weigelt, op. cit., pp. 230-59.

6. Panofsky, 'Perspektive als "symbolische Form",' loc. cit., pp. 278-9. Bunim, op. cit.,
p. 138.

7. The best examples of sideways extension at Assisi and Padua are respectively 'The Approval
of the Order' (Pl. 6, *c*), in which doors lead out through either wall, and 'Christ Teaching in the
Temple' (Pl. 15, *b*), in which extensive side-aisles are suggested. Here, the upper room appears to
reach much further forward in space than the lower wall, which presumably supports it, because
the side walls run right to the edge of the pictorial field.

8. Good examples occur in 'The Flagellation' and 'The Washing of Hands', in which Pilate's
relationship to the column in the foreground is uncertain. Here, however, Duccio has merely
exploited the servant's pointing gesture to emphasize the connection with the scene above.

9. The bench in 'The Washing of the Feet', the table in 'The Last Supper', the detail of floor and cornice in 'Christ Teaching in the Temple' (Pl. 19, *c*) illustrate this tendency.

10. The building is a domed baptistery, or centrally planned church, similar to that in 'The Entry into Jerusalem' (Pl. 17, *b*).

The richness and variety of those compositions in subsidiary fields painted by Duccio himself seem to show that they were only planned and executed when the work on the main panel was nearly or even completely finished.

11. The significance of Simone's organization of compositions on panel is noted by Bunim, op. cit., p. 143.

12. These ideas are developed in later works, such as the panel of 'The Beata Umiltà' which are not discussed here because they do not seem to be as advanced as other, contemporary, and more important paintings.

CHAPTER V

Maso di Banco

The starting point for all the later evolution of Giottesque perspective lies in the single composition of 'The Wedding Feast at Cana' (Pl. 16, *a*) in the Arena Chapel. In that scene the visual experience underlying the oblique disposition of all isolated solid objects seems to be applied for the first time to a centrally viewed interior. In discussing the composition it was seen that the two seemingly frontal surfaces of the wings of the ceiling canopy were actually in soft recession.[1] On formal evidence alone this could be taken either as a deliberate experiment based on observation or as merely the unconscious carrying over of an established pattern into an unusual context.

The rule-of-thumb application to a single complex building of the general rule that any cubic object of which more than one face is visible must be seen obliquely, is well demonstrated by the Master who painted the chapel of St. Nicholas in the Lower Church at Assisi. In the scene in which the Saint prevents an execution (Pl. 21, *a*), a large, and complicated building fills the background. The central barrel vault above the main doorway shows that the structure represents a building which is rectangular in plan. Nevertheless, each of its numerous projections is obliquely seen. The forward surfaces run sharply downwards to either side in all the upper parts, and recede upwards in the base. As a result, the whole structure is completely bowed, as if it were indeed an expression of the successive visual images recorded by an artist standing in front of a large architectural mass, and turning his head and eyes to left and right so as to scan the detail. It is, however, most unlikely that this is the true meaning of the construction as far as this particular painter is concerned. The jumble of forms borrowed from this place and that, and thrown together with little regard for their relationship or significance, which occurs in the remaining scenes that decorate the chapel, shows him to be a minor and derivative artist. It is, therefore, improbable that this one composition is the outcome of a scrupulous, personal analysis of the realities of vision. The abruptness of the recession in the details, and the unrealistic extremes to which the bowing of the whole façade is consequently taken, seem to indicate a painter who is either applying a rule based on observation without himself referring back to nature, or else copying and exaggerating a pattern established with more truth and subtlety by some more perceptive artist.

Maso di Banco

The small fresco of 'St. Stanislaus Raising a Youth' (Pl. 21, *b*), also in the Lower Church, presents a more interesting problem. The artist responsible for this scene and its companion pieces is notably more forceful and more individual, both as a colourist and as a figure painter. The immediate point of interest is the church which forms the background to the scene. The main body of the building, consisting of the nave, is seen frontally, and lies more or less parallel to the upper border of the fresco. The transept end upon the right, however, is softly, but definitely foreshortened. All the architectural horizontals of the transept end itself, and of the cloister which backs onto it, run gently downwards to the right. This time the subtlety of the differentiation of nave and transept brings the artistic expression very close indeed to the soft changes that take place as the eye swings, and the head turns, shifting the point of focus to take in the totality that lies beyond the narrow beam of stationary vision. The probability that the distortions in the structural pattern reflect deliberate purpose is increased by the fact that the building is a church of standard Latin Cross design, and not an architectural fantasy.

Unfortunately the little set of damaged frescoes in the Lower Church are not the acknowledged work of a known master. Various names have been put forward. Various small groups of works have been associated on stylistic grounds. But no certainties have been established.[2] It is therefore impossible to assess the perceptivity, and the artistic powers, of the painter, with any degree of assurance. It is, in any case, unlikely that they are actually by Maso, to whom they have often been attributed. Even so, there is some stylistic connection with the frescoes of the Bardi di Vernio chapel in Sta. Croce, which are Maso di Banco's chief surviving monument. It may be significant that it is in these scenes from 'The Life of St. Sylvester' that it appears to be possible, for the first time, to find enough evidence to form the basis for a reasonable judgement.

In the 'St. Sylvester and the Dragon' (Pl. 22, *c*), on the bottom of the right wall of the chapel, all the architectural features lie softly at an angle to the surface. There is a strong, direct recession at the centre, and a soft slipping inwards and away as the eye moves from the centre to the left or right across the composition. This gentle recession to the sides is not confined to the main architectural masses of the two buildings in the background. The broken arch that closes the left foreground, and the capital of the isolated column also fall softly away from the surface. The gentle curve of the composition shows the same sensitivity as Giotto's handling of the delicate recessions of the canopy in 'The Wedding Feast at Cana' (Pl. 16, *a*). There is, in addition, a harmonious, controlled complexity which is Maso di Banco's personal achievement.

The artist's own distinctive qualities are visible not only in the structure of the composition, but also in its colour. The clear, cream whites, the calm, flat pinks and greys and yellows cannot be found at Padua or Assisi, and

are equally distinct from all the peacock brilliance of Siena by which the painter may have been inspired.[3] At the same time there is a realism, both in detail and in the relation of the figures to the architectural desolation which surrounds them, that intensifies, and is itself heightened by the effect of the artist's powers as a colourist. The archaism of the representation of two separate actions taking place successively within a single scene, and involving the twofold depiction of all the most important figures, is matched by the compositional skill with which the problem has been solved.

The two episodes, although separated in time, are visually interwoven in an interesting way. The earlier action of the two is compositionally dissipated. While St. Sylvester quietens the dragon on the left, the stupefied magicians lie upon their backs before the emperor and his retinue, who close the composition on the right. In the succeeding moment the whole action concentrates. The saint comes to the centre. The magicians rise. The two wings of the scene are drawn together. The divided interest is focused at the nodal point of the entire design and at the apex of the formal triangle created by the principal actors in the drama.[4] The architectural recession at the centre reinforces the concentration at this point in front of which the onlooker is placed; at which he is brought closest to the action, both in time and space; and, finally, from which the soft recession to the wings floats his attention out to left and right, so that the self-perpetuating cycle may begin once more.

Within this major circulation to and from the centre there is also a supremely skilful handling of incidental detail. An arch casually frames the figure of the saint as he raises the magicians from the dead. The figure just behind stands as an intermediary between the two events, a temporal connection and a formal bridge. Still turning from the first dramatic happening, he is already fully a participant in the second. On the left, the column in the foreground draws the eye firmly, but not too insistently out from the centre, and the broken arch completes a framing for the action which is, nonetheless, not isolated by it. This fresco, which is Maso's surviving masterpiece, shows that he is an artist of considerable stature. He is no mere follower of Giotto, a minor painter watering down and misunderstanding the legacy of genius. It is in the light of his own major talent that any further analysis of his approach to visual fundamentals must be seen.

The fresco of 'St. Sylvester and the Dragon' (Pl. 22, *c*) is no isolated phenomenon. The compositional principles which underlie the gently bowed disposition of the architecture as a whole are also given expression in the 'St. Sylvester and the Bull' (Pl. 22, *b*) immediately above it on the wall. In this case it is a unified interior, not a group of separate buildings, which is represented. In it the orthogonals of the ceiling recede towards a central vanishing axis, as in so many similar fourteenth-century compositions. The unusual feature is that the parapets enclosing the floor-space do not lie with their main faces parallel to the surface of the fresco and its painted marble

frame. Instead they recede softly outwards to left and right until, at the outer edges of the scene, there is sufficient room between parapet and frame for figures to appear, closing the composition. The entire base of the hall, but not the unbroken cornice of the roof, is therefore treated in the same way as the isolated architectural features of the scene below.

In this particular fresco it could be argued that the figures in the foreground do not fill a space already made, but actually create their own space, like the figures in Giotto's early landscapes in the upper registers at Padua. In that case the oblique setting of the architectural detail has no significance in rela-tion to the observation of nature. It is merely a rather crude device to make room for some extra figures. This argument is, however, nullified by the fresco immediately above. The latter fills the space beneath the arching of the vault, and represents 'St. Sylvester Showing The Pictures of the Apostles, and the Baptism of the Emperor' (Pl. 22, *a*).

This fresco, which must have been executed first, since it is the highest on the wall, is filled by a single, large, frontally set building. This is subdivided into two rooms, one of them enclosed and one left open. On the extreme right, the lower line of the front wall is only separated from the framing by the very narrowest strip of ground, and recedes very slightly upwards to the right.[5] On the other side of the scene, the main wall of the building runs quite definitely upwards to the left. The building as a whole is therefore con-structed in the same way as that in the fresco underneath. But here there are no figures to provide an explanation.

The three scenes on the right wall of the Bardi Chapel show an increasing mastery and complexity of composition. That is certain. They also seem to reveal a consistent, and ever more clearly expressed tendency to make the painted scene conform to the appearance of the real world as both head and eye are turned to focus on its multifarious contents. The application of this system to the interiors implies that the buildings in the scene of 'St. Sylvester and the Dragon' (Pl. 22, *c*) are only set in an apparent curve, and in reality would lie upon the straight line marked by the castellated wall that links them.

The total effect in this small chapel is quite startling, since its narrowness accentuates the great height of the walls. The painted foreshortenings into and across the picture plane are accompanied by sharply apparent vertical fore-shortenings as the visitor cranes his neck to see the upper scenes. The end effect is of completely curvilinear compositions, painted as if on the surface of a hemisphere. The eye supplies the curves the artist has implied, and which in later generations would themselves be painted.

The recessions in the frescoes of the Bardi di Vernio Chapel are noticeable for their lack of crudity and for their consistency. In this they reveal a close community of spirit with the work of Giotto himself which increases the probability that they are based on observation and are not just pattern-weaving.

This thesis is confirmed by 'The Dream of Constantine' upon the opposite wall. Here an apparently foreshortened frontal building has its forward surface actually in the softest possible recession. The lines of the roof run delicately downwards to the right. The forward bases of the side walls show a corres/pondingly fine upwards movement. This fresco, with its minimal oblique construction, seems to show precisely that concern for realism, and for the flat pictorial surface, which Giotto demonstrates in several compositions.

The essential qualities of the new perspective scheme developed by Maso are of some significance. The method marks a definite attempt to break down the cleavage in the treatment of interior and exterior space which was observed when dealing with the work of Giotto.[6] The same rules are applied to both, though somewhat tentatively in the case of the interiors. The bases of these rules are in each case the central position and the moving eyes of artist and spectator. This unification of constructional method also betrays a further stage in a fundamental change of attitude that is historically most important. The concentration on the solid object, which previously dominated the growing awareness of the natural world, is giving way to the idea of space itself, of the void within which objects are contained. The new conception does not triumph until the fifteenth century. It is, however, symptomatic of the beginning of a shift in emphasis that, for the first time, a construction has been evolved which, without abandoning the oblique view of the individual object, contains the possibility of a vista down a street that runs directly into depth. This new potential, not yet realized by Maso, is diagrammatically illustrated in Fig. 2, *c* (p. 29).

The diagram also indicates a third essential point about the new construc/tion. Whilst the compromise with the plane surface, developed by Giotto, is still retained, a large group of objects can now be represented without forcing on the artist the attendant problem of an equal number of emphatically separate viewpoints. True to the empirical nature of fourteenth/century per/spective Maso does not achieve a methodically developed single viewpoint in the scene of 'St. Sylvester and the Dragon' (Pl. 22, *c*). Even so, there is a definite move in that direction. The impression, if not the technical reality, of a single viewpoint is almost achieved.

During the first quarter of the fourteenth century the single object, in its realistically oblique setting, gradually regained, as far as possible, the com/positional and formal qualities of the foreshortened frontal setting, which was, for the moment, largely superseded. With Maso the reconquest is extended to the group. The oblique setting is incorporated in a system which assimi/lates some of the most desirable formal qualities of its rival without sacrificing its own identity. The artistic frontiers opened by this evolution are, signifi/cantly, exploited only by one great contemporary of Maso. This artist is Ambrogio Lorenzetti, in whom the Sienese and Florentine traditions are united.

Maso di Banco

NOTES

1. See above, pp. 64–5.

2. See E. Zocca, *Catalogo delle Cose d'Arte e di Antichita d'Italia, Assisi*, Roma, 1936, p. 69, for bibliography. An interesting discussion of the textual evidence is given by P. Murray, 'Notes on Some Early Giotto Sources', *Journal of the Warburg and Courtauld Institutes*, vol. 16, 1953, p. 80.

3. Ambrogio Lorenzetti was probably in Florence in the late 'twenties and early 'thirties (see G. Sinibaldi, *I Lorenzetti*, Siena, 1933, pp. 190 ff., and G. Rowley, *Ambrogio Lorenzetti*, Princeton, 1958, pp. 137 ff.) and he may then have felt the impact of the Giottesque oblique settings reflected in his later works. Isermeyer, op. cit., pp. 52 ff., summarizes the arguments about the dating and attribution of the frescoes of St. Sylvester's life, and the conclusion that they belong to the late thirties seems to be sound, as compared with attempts to put them later. This leads to the conclusion that in colour Maso was partially dependent on Siena, but that in the matter of perspective structure Ambrogio learnt from Florence, whether actually from Maso, or from other sources.

4. This follows the order of events given in the Golden Legend, in which the heretics are overcome whilst St. Sylvester is with the dragon, and he then returns to resuscitate them. See, Beato Jacopo da Varagine, *Leggenda Aurea, Volgarizzamento Toscano del Trecento a cura di A. Levasti*, Firenze, 1924, cap. XII, pp. 156–7.

5. Even if this short section is taken as being parallel to the frame, the argument, and the general structure of the composition are not affected.

6. See above, pp. 73–5 ff.

CHAPTER VI

Ambrogio Lorenzetti

The perceptions of the natural world, and the idea of visual reality, which underlie Ambrogio Lorenzetti's 'City of Good Government' (Pl. 24), painted in the Palazzo Pubblico in Siena in 1339 and the years immediately following,[1] are precisely those which are the well-springs of Maso's achieve-ment in the scene of 'St. Sylvester and the Dragon' (Pl. 22, *c*). Here, these insights are clothed in a new richness and complexity. The Florentine abstrac-tion of essentials and constructional approach to composition underline the garrulous, descriptive sweep, the all-embracing quality of the Sienese ap-proach to nature.

The dancing serpentine of gaily costumed maidens marks the centre of the scene. At this point a wide inlet opens into the packed houses, giving a sense of spaciousness found in no earlier townscape. To either side of this wide centre emphasized by space and movement, the architectural horizon-tals of the houses all run down to left and right in soft recession. Every building is obliquely set. Each recedes from this one centre, the dividing line of which is marked by the street that runs upward through the houses beyond the left-hand boundary of the foreground inlet. This unity of construction spreads beyond the city into its dependent countryside (Pl. 25). There, castles, houses, bridges are all seen from the direction of the town. All the architectural features of the countryside diminish in proportion to their dis-tance from the city, and not merely in proportion to their distance from the foreground. A group of farm buildings is placed in the middle-ground almost at the centre of the country scene. Further to the right on the hills that form the left-hand border of the lake, but at an almost equal distance from the foreground, castles and walled villages or towns appear on a far smaller scale. The centre of the city is the point from which all architectural diminu-tion runs.[2]

In the city of Good Government itself (Pl. 24) no mathematical construc-tion is involved. Yet the whole town curves backwards from the centre, as if receding softly from the observer's shifting gaze. The casually jumbled houses, welded into unity by his eye as it roves slowly outwards from the centre, are further tied together by accented horizontal features. The most noticeable of these is the long line which starts from the roof above the head of the man on horseback who rides to the right out of the central space and

is about to disappear behind the foreground building. This line is carried through continuously from house to house, right to the city gate, and is only the most striking feature of many. Within the greater unity each building has its fully individual character, conforming closely through its softened oblique construction to the visual experience of the onlooker in his own three-dimensional world.

The down-sloping roofs express the normal viewpoint. The piling of the houses tier on tier does not denote a bird's-eye view. This is a steep, hill-hugging town, as is Siena itself. The plunging road beyond the city gate confirms the fact. And if the artist has not taken care, either in town or country, to run the receding lines together on a single, strict horizon, other means are used to seal the unity implied by the perspective in its broad conception, although not in any mathematical precision. Like all Giottesque empirical perspective, the construction presupposes radiation from the centre.[3] It is the pictorial counterpart of the spectator's situation, always looking outwards from himself, the centre of his world. It is the reverse of the frozen stare of fifteenth-century perspective in which the composition is sucked in towards a single point by centring orthogonals. This outwards radiation, already noted as inherent in the structure of each building, is also expressed by figures, and by movement, and by light.

In both town (Pl. 24) and country of Good Government (Pl. 25) the figures, like the houses, are diminished from the single centre where the young girls dance. This diminution is again not merely in depth, supposedly at right angles to the pictorial surface, but over it to left and right as well. The riders, and the figures shopping at the stalls that line the inner boundary of the central space, are all smaller than the dancers in the foreground. But so are the knights and ladies riding outwards to the left and situated in the same plane as the dancing figures. This lateral diminution extends also to the right throughout the figures in the town, whilst at every stage those in the background are likewise diminished in relation to the corresponding figures in the foreground.[4] The process is continued on the road beyond the gates. As it runs down and across the landscape foreground the figures steadily grow smaller. The same is true wherever the eye wanders down the roads, or out over the fields, away from the city into the deep countryside. Full rein is given to the new sense of space apparent in the structure of the town. A panoramic vision of the countryside unfolds for the first time, diminishing into the distance with the continuity of natural space.

The five peasants working amongst the vines within the shadow of the city walls are the only contradictions in this remarkably consistent pattern. They are definitely smaller than the figures on the road beyond them. The fact that in this single instance the compositional demand for concentration at the point of greatest interest has come into conflict with, and been allowed to override, strict naturalism, does not destroy the unity of the composition as

a whole. At all other points the continuity of diminution, both laterally, and directly into depth, is steadily maintained. The break in logic is liable to seem far more important to the analyst than to the artist, and particularly to the analyst who is only prepared to recognize the single diminution into depth from front to rear. In lateral diminution there is very little inconsis, tency.[5]

Recognition of the unified interpretation of reality visible in the descending architectural and figure scale does not entail the supposition that an absolute naturalism of any kind has been attempted. Even in the town the figures are a little large for their surroundings, and the disparity increases as the eye moves over the more distant reaches of the countryside. The figure diminution is maintained in step with the diminution of the landscape. It is not tied to it by laws of photographic naturalism. If it were, the figures would be ants, mere dots, alive only beneath the magnifying glass of analytic scrutiny.[6]

The dimunition both of figures and of architecture has been seen as radia, ting from the centre of the city. From this it was deduced that the composition is constructed, like an individual building in an oblique setting, to be read outwards from the centre, and not inwards to it. The truth of this hypothesis is confirmed by the directions which the artist stresses through the movement of the figures. Riders travel outwards from the centre to the left, and empha, size the flow against the natural movement of the eye.[7] In the central space the further inlets are stressed by townsfolk, and by horsemen moving out of sight. The three foremost dancers, moving to the right, start the eye outwards. The movement, which is easier in this direction, is assisted by the architec, tural recession. Consequently less encouragement is needed from the figures. These move impartially to left and right until, as the eye is held and taken upwards by the steeply climbing castellated wall, laden donkeys carry it on with them into the narrow street that climbs yet further into depth. Outside the gate the movement of the foreground riders encourages the eye to venture onwards. On the hill itself a contrary movement prevents an unwanted, comic toboggan slide from being generated by the slope. As soon as the flat is reached, the outward movement is continued until the figures strug, gling to pull their mules across the bridge reverse the trend once more, this time to slow the eye, and stop it running out beyond the frame. Similarly, the smaller roads that run out from the city past the isolated farms, and curl towards the distant hills, have figures moving outwards with them, pointing the essential structure of the composition with their quiet motion. In move, ment, as in scale, the figures therefore play a fundamental part in the creation of a unified design, for all their seeming casualness of grouping. The appar, ently conflicting and disruptive qualities, which have been observed in them by some, are due, not to their own inherent properties, but to a misunderstanding of the compositional unity which they are so carefully calculated to support.[8]

The final seal is set upon this total radiation from the heart of the city of Good Government by the way in which the light itself flows from the glow^ing centre. The pictorial lighting takes no notice of the single natural light source in the window lying to the extreme right in the adjoining wall beyond the furthest boundary of the landscape. It shines instead to left and right out of the city's centre. As in the case of the perspective, it is the road leading inwards from the wide space behind the dancers that forms the demarcation line. The right^hand surfaces of all the buildings to its left are lighted. The red tower which rises up above the main polygonal building in the fore^ground constitutes the sole exception. This, however, is the fault of clumsy restoration.[9] To the right of the dividing line, light floods outwards over every house, and on over the countryside, flowing like a tide against the real light from the window of the room.[10] The lighting from the window side in the whole triangle extending from the bottom right^hand corner diagonally upwards to the ceiling beam is the result of damage and of restoration, as are other minor contradictions. The degree of interference suffered by the entire area is visible even in a photograph.

It is an exciting experience finally to stand in front of this great fresco, and to see the way in which the perspective of figures and architecture, the lighting, and the movement, are all used by Ambrogio Lorenzetti both to give reality to the pictorial world and to create a composition with sufficient unity to contain an unprecedented wealth of natural detail.

The enjoyment of this fresco for itself is not the final goal, however, for the decoration of the room is not confined to this one wall. The full sweep of Ambrogio's invention only emerges when the remaining compositions are appreciated in relation to the artist's purpose.

The unity which binds the town and country of Good Government to^gether has been emphasized enough. It is also clear that the whole wall may be considered in another way. Whilst the main centre of attention is placed in the left half of the city, the countryside may be thought of as a secondary centre. When the wall is looked at in this light, it is seen that the division of the composition corresponds exactly to that on both the other walls.

The allegorical figures of the virtues which support Good Government occupy the whole of the end wall of the room, directly opposite the window. The figure of Good Government itself sits at the centre of a long, bench^like throne, which extends for two^thirds of the entire width of the wall. On the left a smaller, individual throne is occupied by the figure of Justice, and surrounded by her attendant virtues. In each case the thrones are centrally constructed, so that the composition as a whole is organized about a well^defined pair of primary and subsidiary centres.

The side of the room opposite the fresco of the consequences of good government (Plates 24 and 25) is occupied first by the 'Allegory of Bad Government' itself, and secondly by its effects on town and country (Pl. 23).

Ambrogio Lorenzetti

The composition is distributed in such a way that the horned figure of Bad Government is placed exactly opposite the compositional centre of the city of Good Government. Since the throne on which the figures of the vices of Bad Government are seated is, at the same time, the perspective focus of the entire fresco, the spectator's principal standpoint is the same for either side wall.

Within this unifying framework Ambrogio Lorenzetti does not confine the dramatic contrast to the subject matter of the medieval allegory which it is his task to illustrate. It is extended also to the fundamental formal structure of his compositions.

The focusing of the entire wall on the centralized construction of the throne of Bad Government calls attention to the fact that on this wall no place is found for the oblique setting. Ambrogio is now drawing for his own particular purposes upon the Sienese, instead of on the Florentine tradition of perspective. All the buildings in the crumbling city are foreshortened frontal in construction. The receding lines all run the eye towards the enthroned allegorical figures on the right. There is no centre for the town itself; no point of rest or concentration as the eye searches the ruins; no radiating harmony corresponding to the centralized oblique constructions exploited by Ambrogio on the opposite wall. The eye of the observer looking at this scene of desolation is always trying to escape—a futile occupation in a composition cleverly contrived to foil so simple a solution.

On the right of the town the buildings jut far down into the foreground. The full effects of this arrangement are now lost through damage, but enough is left for a quite accurate assessment of intention. In the first place it provides a demarcation line between the representation of the 'Allegory of Bad Government' itself and the illustration of its consequences. Formally, it increases the difficulty of transferring attention leftwards from the central allegory to the city. A steady leftwards movement is always more difficult than the reading to the right which is habitual in the West. Here this inherent difficulty is increased by the presence of the forward-jutting wall of houses and by the uncertain movement of the figures placed in front of them.[11] In the well-governed city everything was done to help the movement on the left. Steeper recession of the architecture and determined figure motion were combined to help the leftwards flow from the pictorial centre. Here everything is done to make it harder.

The same retaining wall renders the leaving of the town an equally painful process once it has been entered. It shuts in a spatial box that stands in front of the main line of houses, its other side closed by the wall which separates the town and country. The figures, instead of harmonizing with this spatial pattern, are in conflict with it, running down the sides of the enclosure and across its open front. Running is not, however, the appropriate word. There is no circulation round this vacuum. There is no explanation and enrich-

97

Ambrogio Lorenzetti

ment of the compositional movement through a flow of figures similar to that upon the opposite wall. Here little knots of struggling figures stand in shrivelled isolation, pointing no direction, building up no formal harmony. Nor is this greater unity provided by the disposition of the architecture in the background. Streets are indicated leading inwards, but no movement up them is encouraged, or indeed allowed at all. The wide road that passes upwards from the city gate is cut from view by the outer wall which runs into an area of damage that obscures the composition at this point. It does not obscure the fact that no circulation from the main space to the street was ever possible.

Finally, the light itself is treated in a way that differs from the method used in town and country on the opposite wall. Instead of radiating from the centre in harmony with a composition built entirely in this way, it falls upon the devastated country and decaying town as if from the real source of light, the window on the left. The compositional centre and the source of light are set at opposite poles. As a result, light falls onto the flat frontal surfaces of all the houses, whilst the receding sides are left in shadow.[12] In terms of com-position this produces an effect of constant jarring as the eye moves over a succession of strongly lighted, variously coloured, flat, vertical strips. The difficulty of lateral movement through the composition, which was noted earlier, and which the light accentuates, is further increased by the broken quality of the horizontal accents. In the city of Good Government (Pl. 24) there was a tendency for the architectural cornices and mouldings and the lines of the windows to be run together at important points. In this way buildings were linked together, and horizontal movement was made easy. In the ill-governed town there is none of this. Nothing fits. Nothing con-tinues from one building to the next. Nothing is made easy.

The light-fall, which accentuates the mounting compositional unease, also leaves in shadow all the receding right-hand surfaces of the houses.[13] Bad Government blazes darkness and not light out over the dying town and the dead countryside. At every step throughout the illustration of the conse-quences of mis-rule, or of good government, Ambrogio Lorezentti uses compositional means to give visual reality to intellectual concepts, and to accentuate by formal harmony and discord the emotions which their con-templation should arouse in the spectator.

Whatever final judgement may be given as to Ambrogio's success or failure, it can only be reached on the basis of a thorough understanding of his purpose, and of the methods used for its achievement. It is clear, at least, that he attempted far more than a careless mixture of the incompatibles of medieval allegory and modern naturalism. On one wall allegory is supreme. On one it shares the field with the new world of illustrative naturalism. On the third it slips away into the background. Everywhere in town and country, form and content are an indissoluble unity. The Sienese artist fully understands the

inherent qualities of the foreshortened frontal setting handed down by Duccio and Simone, paradoxical as the use to which he puts them may appear. On the other hand, the centralized oblique constructions of the city of Good Government mark a new development of that clear vision of the world which is typically Florentine. Here, for the first time, the two streams intermingle fully. The multiplicity of nature is approached with a new confidence justified by Ambrogio's growing power to exercise control by compositional means. Here Florence and Siena meet, and medieval allegory gives, and is given meaning by the first full vision of the landscape which still lies un' changed beyond the windows of the room.

The feeling for space, and for the organization of natural detail, so abun' dantly revealed in the frescoes of the Palazzo Pubblico, is equally present in the two panels of interiors painted, the one by Ambrogio Lorenzetti, and the other by his brother Pietro, during the year 1342.

In Ambrogio's large'scale panel of 'The Presentation' (Pl. 26, *a*) the increased complexity of the architectural detail is matched by a new depth of recession. The usual Sienese or Florentine interior of the first half of the four' teenth century is one or, at most, two bays deep. The width of the room space also normally exceeds its depth. In Ambrogio's high, narrow format this relationship is decisively reversed. The movement into depth continues for at least six bays, and the impression of space, particularly in the foreground, is intensified by the strong diminution of the successive rows of squaring on the floor. This represents a definite technical advance,[14] the effect of which is further strengthened by the disposition of the figures. The rapid diminution of the squaring is accompanied by a fairly accurate, single, vanishing point, which is, however, valid only for the central area of the floor. The outer orthogonals to the left and right converge upon a point which lies much higher up the picture plane. The construction as a whole is therefore that of the vanishing axis, combined with a single vanishing point for one part only of the most important horizontal plane. Technically the construction is therefore a more systematic version of the one which Duccio had developed. The conception of the interior as a whole, on the other hand, is not advanced by the retention of the older pattern, which shows both the outside and the forward surfaces, as well as the inside of the building.

In both conception and technique Pietro Lorenzetti's 'Birth of the Virgin' (Pl. 26, *b*) is, perhaps, the most remarkable interior created by the brothers. In this painting the whole surface of a Gothic triptych has been welded together by an indoor scene. The latter covers it entirely except for minor areas in the apexes of the arches. The room, occupying two of the three bays, is unified to a considerable extent. The orthogonals of the floor, the covering of the bed, its foot and head rests, and the upper mouldings of the walls, all run together in a series of vanishing points that lie within a more restricted area than usual.[15] The left'hand bay, however, is not included in this system. Even

in those features, such as the coverlet of the bed, which are completely within its influence, the single vanishing point construction never appears to be entirely valid for a whole plane. Nevertheless, the new degree of co-ordination, and the completeness of the enclosure, flowing over and absorbing even the frame, are evidence of the growing tendency to move from the idea of 'things' surrounded by space towards that of space enclosing and uniting things.[16]

During the rest of the fourteenth century this change of emphasis, whether in landscapes or interiors, was never carried substantially beyond the points reached by Ambrogio and Pietro Lorenzetti. The tentative nature of the shift in mental attitude need not be stressed, since it is emphasized enough by the whole history of late fourteenth-century painting.[17]

In Ambrogio's case the impact of the art of Giotto and his followers during his stay in Florence in the 1330's seems to have been sufficient not only to influence his style, but to force him to that fresh scrutiny of the visible world which flowered in 'The Allegory of Good and Bad Government' (Pls. 23–5). This appears, in general, to have resulted in sensitive working approximations to experience, rather than in the creation of strict geometric systems. There is evidence, however, in the panel of 'The Annunciation', which is dated 1344, that in his later years Ambrogio was working on problems of perspective in the more restricted meaning of the term.

In this panel all the orthogonals, except the fractional line behind the angel's back, run roughly to a single vanishing point in the central column.[18] Although the succeeding rows of patterning on the floor are rapidly diminished, it is still not possible to join the squares diagonally by straight lines. If such diagonals could be drawn, it would mean that the law of diminution characteristic of fifteenth-century artificial perspective was already being used. It is interesting, and also baffling, to see that underneath the final pattern of the floor a totally different system of squaring was originally drawn out. What is more, at least five diagonals, three running to the left and two towards the right, were drawn in at the same time.[19] Unfortunately for historical neatness, they do not converge consistently to single points at all, let alone to points that lie on one horizon. All the same, they are extremely finely executed, and Ambrogio clearly drew them for some purpose. The warping of the panel and the difficulty of making accurate observations of such delicate under-drawings add to the general uncertainty. It is only possible to say at present that they seem to show that underneath the present painting there lies an experiment which Ambrogio was unable to bring to a satisfactory conclusion, and which he discontinued, at least for the time being. Possibly he was merely trying to see what actually did happen to the diagonals of his foreshortened squares. This in itself is interesting, since there is evidence by this date of the occasional use in coffered ceilings and squared pavements of the distance point construction which was the northern counterpart and seemingly the southern forerunner of Italian artificial perspective.[20]

Ambrogio Lorenzetti

It is, perhaps, not altogether wrong to end the story of so much achieve-ment on a tentative note. The Lorenzetti brothers, Ambrogio, in particular, mark the wave-crest of early fourteenth-century naturalism. This is followed by the trough of hesitation, and of recapitulation, of uncertain movement, sudden advances and sharp changes of direction, that precedes the great surge of the early fifteenth century. It is this moment of small certainties, and of large indecision, which prepares the way.

NOTES

1. C. Brandi, 'Chiarimenti sul 'Buon Governo' di Ambrogio Lorenzetti', *Boll. D'Arte*, anno XL, serie iv, no. ii, 1955, pp. 119-23, shows, following the recent cleaning, that the area on the right of the 'Good Government Allegory' and on the left of 'The City of Good Govern-ment' was probably damaged, and then repainted on the original lines by an unknown artist, within ten or fifteen years of its creation. All the evidence seems to point to there having been no changes of a kind which would substantially affect the analyses which follow in the present study. The article also contains useful documentary information.

An important prologue to the development considered here exists in two small landscape panels, Nos. 70 and 71, in the Siena gallery, which are often attributed to Ambrogio.

2. Beyond the large crack, which runs diagonally upwards from the bottom right-hand corner, the damage and subsequent alterations suffered by the fresco make any analysis of detail impossible.

3. As the softened oblique construction takes on the surface stressing qualities of the fore-shortened frontal setting, the grip of the main vertical, which was the principal feature of the extreme oblique construction, is correspondingly weakened without being entirely superseded by the centralizing tendencies of the foreshortened frontal system.

4. The woman on the extreme right, above the figure carrying a basket on her head, has been altered. Her dress has two distinct hem-lines, of which the upper corresponds better with the position of her knees. The lower one increases her height, making her proportions rather uncertain, as well as very different from those of the other figures. The shortening may well be an original pentimento subsequently nullified by damage and deterioration.

5. The figures to the right of them on the road, where it levels out, are smaller than the fore-ground peasants themselves.

6. Where figures are brought into immediate relationship with buildings, the landscape and figure diminutions coincide, and the figures are on the right scale for the houses, as in the distant farmhouse on the road below and to the right of the flying allegorical figure.

7. This, in conformity with western methods of writing, is normally from left to right where no other pull is stronger.

8. Sinibaldi, op. cit., pp. 102-6, is the most important of those who seem to have radically misunderstood the design.

9. Not only does the texture of the paint, and its very colour, differ from that at any other point, but the direction of the horizontal mouldings of the architecture has also been changed. The place at which this happens is clearly visible in photographs such as Anderson 21321. The upwards slope of all the mouldings on the right-hand wall makes nonsense of the perspective structure of the tower, and emphasizes the contradiction in the otherwise consistent lighting. This fault is clearly distinct from the restorations referred to in note 1 above.

The only other inconsistency, that in the detailed drawing of the gateway in the bottom left-hand corner, the inner surfaces of which are seen from the left instead of from the right, is, however, probably attributable to the fourteenth-century restorer.

10. In the farmhouse underneath and to the right of the flying figure the dark upper paint layer on the forward surfaces has largely flaked away, allowing a light underpaint to show through. The balcony and its supporting columns prove that the light originally fell from the left.

11. If there is any general trend at all, it is to the right. Whatever the physiological basis of the general tendency, the most important factor to be considered in discussing the compositional predilections of late mediaeval artists and onlookers is that by this time a strong, iconographically based expectation had been established. An enormously high percentage of all Annunciations, to take the most obvious example, are based on a left-to-right movement.

12. The castellations and other architectural details to the right of the throne of Bad Government are naturally an exception to a rule valid for all other elements.

13. The damage and flaking of the pigment of some of the houses, especially on the left of the street leading up from the town gate, accounts for a number of apparent contradictions in the distribution of light and shade. In each case traces of the darker pigment remain on the now-bright walls.

14. Bunim, op. cit., p. 146 and Pl. 56.

15. Bunim, op. cit., p. 149 and Pl. 59.

16. Panofsky, op. cit., p. 314, note 47, and Pl. 24, draws attention to the small 'Madonna Enthroned with Angels and Saints', in the Siena Gallery, as an example of a change of viewpoint between floor and carpet which signifies that the idea of 'carpet' is stronger than that of 'plane-as-a-whole'. The changes of viewpoint illustrated are not the only ones that occur in this panel. Each step is accompanied by a sometimes more and sometimes less definite alteration, and in these cases a distinction of a different kind must be in operation. On the other hand, the panel is too damaged, too small, and too free in its handling to permit the conclusion that a definite intention to shift the viewpoint every time a break in the pattern allowed it to be done unobtrusively actually existed in the artist's mind, creating a pattern of recession very similar to that achieved in the curves of various empirical approximations to synthetic perspective. The argument that this panel dates from the fifteenth century or later, put forward by Rowley, op. cit., pp. 66 ff., and considered in J. White, *Art and Architecture in Italy 1250–1400*, Harmondsworth, 1966, p. 254, does not seem to be convincing.

17. See F. Antal, *Florentine Painting and its Social Background*, London, 1948, and M. Meiss, *Painting in Florence and Siena after the Black Death*, Princeton, 1951.

18. Panofsky, op. cit., p. 279 and Pl. 22; Bunim, op. cit., p. 145 and Pl. 57.

19. The under-drawing differs greatly from that accompanying a normal change of plan such as can be seen in the flooring of Pietro Lorenzetti's 'Birth of the Virgin'. It is unusual both in delicacy and consistency.

20. For the early examples see above, p. 75, note 8. For the relation to artificial perspective, see also Panofsky, op. cit., p. 319, note 60, and also *The Codex Huygens and Leonardo da Vinci's Art Theory*, London, 1940, p. 96.

CHAPTER VII

Late Fourteenth-century Painting and the Meaning of the Picture

One of the most important developments in recent surveys dealing with minor artists, and particularly with those working in the late fourteenth century, has been the replacement of a largely negative attitude by one that is thoroughly positive.[1] Unfortunately for the present study, the varied interests and achievements of these painters lie predominantly in fields other than those of spatial realism and perspective innovation. At times they have, indeed, been credited with inventions which do not exist.

The most intriguing of these mythical monsters, inverted perspective, largely deriving from such scenes as that of 'St. Mary Magdalen's Journey to Marseilles' (Pl. 27, a) in the Lower Church at Assisi, is based on the idea of systematic diminution towards, instead of away from the spectator. The difficulty is that the variations in figure scale are neither dependent on any spatial relationship within the composition nor upon the relationship of the scene as a whole to the observer. The deciding factor is invariably the importance which, for one reason or another, is attached to each particular figure.[2] The impossibility of finding any systematic diminution away from the principal figure in the composition is of some importance. It illustrates the general truth that in Italian art all deviations from a naturalistic diminution away from the spectator, other than for purely decorative reasons, are due to the intervention of a hierarchic scale based on the importance of the person or object represented, and not upon any principle of optical inversion.[3]

The painter of this unusual fresco, the Master of Magdalen Chapel, is, nevertheless, one of the three closest followers of Giotto, the other two being the Master of the Early Life of Christ, working in the north transept of the Lower Church, and, last but not least, Taddeo Gaddi. It is a significant confirmation of the position the oblique setting held in Giotto's art, and in his vision of nature, that it is used consistently by all three artists. With a couple of minor exceptions, the foreshortened frontal setting does not appear at all. The many variations on the oblique construction are, however, indiscriminately used for compositional purposes and do not reveal a pattern of development in any new direction, except, perhaps, in the case of the extreme oblique design of Taddeo Gaddi's 'Presentation of the Virgin' (Pl. 27, b).

In this fresco a tall-columned temple, standing on a high, complex base containing several flights of steps, juts forwards from a spatial inlet formed by similarly constructed flanking buildings. But although the only structure architecturally isolated from the main mass is the small building on the left, the impression given is rather of a series of co-ordinated solids than of a single heavy block.

The reappearance of this design in the work of Pol de Limbourg under-lines the fact that both the northern miniaturists and the countless minor Italian painters turned to sophisticated, yet not too monumentally inclined artists such as Taddeo Gaddi; to men who combined structural conservatism with ever-increasing naturalism of detail.[4] The extreme oblique setting, as the most obviously powerful and direct way of achieving architectural realism, remained, throughout the century, one of the stock patterns for artists unable to understand, or simply disinterested in, its later transformations and refinements.

The concentration on a single pattern, that of the oblique setting, which was seen in the work of Giotto and his most important followers, was never a feature of the output of minor, provincial, or derivative artists. It is likewise foreign to the majority of painters working in the second half of the fourteenth century. The return to a mixture of patterns, similar to that found at Assisi and in Rome during the earliest stages of the late thirteenth-century revolu-tion, is, at the later date, a reflection of a less intense observation of nature, as well as of the confluence of the Sienese and Florentine artistic streams during the thirteen-forties.[5]

By the end of the century, an artist such as Lorenzo Monaco, although largely uninterested in the problems of pure naturalism or of spatial realism, is among the most important in these very respects because of his technical power and high aesthetic sensitivity. It is this sensitivity that leads Lorenzo Monaco to a differentiation in his use of patterns which, though more abrupt, is reminiscent of the Chinese practice. All the distant towns and buildings, necessarily small in relation to the picture surface, are seen in the sharpest of extreme oblique settings and usually have a doll's-house delicacy and cer-tainty of structure. On the other hand, those buildings which fill the frame, particularly in fresco painting, are presented in foreshortened frontal setting.

The slackening, and even reversal of the acceleration towards realism, which are characteristic of the painting of the last half of the fourteenth century, are reflected not only in the individual scenes, but also in the architectural framework which surrounds them. The framing of a panel or a fresco is amongst the most important factors in establishing the relationship between real and painted space. It may serve to magnify their separation, or to blend them yet more closely into one another. It is therefore worthwhile to consider for a moment what has happened to this framework within which so much had been achieved during a century and a half of turbulent activity.

Late Fourteenth-century Painting and the Meaning of the Picture

The first steps towards the conquest of the barriers between reality and art were already taken by Cimabue in the heavy cornice, with coffered under-side and supporting consoles (Pl. 1, *a*), used to emphasize the spatial unity of choir and transepts at Assisi. The plasticity of this painted architecture is in noticeable contrast to the tapestry-like framing of the individual frescoes. Like the similar features used to support the massive ribbing of several of the vaults, it is intimately connected with the real architecture of the church. In the latter case there is the obvious supporting function. In the other an attempt is made to nullify the break caused by the encircling passage, and to push back the lower wall, so that the whole surface may appear to run on upwards, broken only by a bold, projecting ledge. Both in Cimabue's work and in the subsequent framing of the St. Francis cycle in the nave (Pl. 8), it is quite difficult to tell where painted mouldings give way to the real stonework of the diaper-patterned cornice which lies just below the passage. Even more striking is the clear equation, in the southern transept, of monumental, painted archangels, who stand behind an actual arcade (Pl. 4, *a*), and angelic half-length figures above them, framed by an arcade which is this time only painted.[6]

The element of architectural illusionism is intensified in the nave (Pl. 8), despite the bay-by-bay perspective. The monumentality and plasticity of the architecture grows. The added depth of the colonnade makes the pushing back of the pictorial surface of the lower wall more thoroughgoing than before. Spatial illusionism is cut short, however, before it reaches the pic-torial scene of action. The immediate framing of each composition is a pair of flat, patterned colour bands. The latter separate the narrative from the architectural illusion. They at once assert the flat reality of the wall, proclaim-ing the depicted scene to be indeed a picture and no more. These separation bands make every scene appear as a flat tapestry stretched out between the solid-seeming architectural forms. As yet pictorial space itself has no illusion-istic quality.

The purposeful nature of the coloured separation bands seems to be shown already at Assisi by the selective way in which they are applied.[7] All the narrative scenes, both in the transepts and in the St. Francis Legend, are surrounded by them. In the niches of the angels in the transepts (Pl. 4, *a*), and of the saints upon the soffit of the entrance arch, however, nothing inter-venes between the painted figure and the painted architectural frame. It seems as if a higher degree of illusionism was considered possible for the single figures of the saints or angels in their niches than for complex scenes contain-ing architectural and landscape features, and carrying associations both of time and place. In the single figures, whether considered as real presences or as lifelike statuary, there is no element of contradiction in their appearance all together in a single building.

In the work of Giotto and his immediate followers the situation is more

complicated, and its interpretation more exciting. The conclusions reached carry a new conviction, since there is more evidence that bears on the elucida- tion of the artist's purpose and ideas.

At Padua (Pl. 13) the architectural framework of each wall is surrounded by a plain red band. This functions as a neutral strip, drawing attention to the fact that this is painted architecture on a flat wall, and not solid marble.[8] A similar, neutral, surrounding strip occurs already in the entrance arch of S. Francesco, where the tiers of niches 'float' between the ribs of the real architectural structure. The differential use of separation bands in the Paduan architectural framework elaborates exactly those distinctions visible in the different parts of the Assisi decorative scheme. The frescoes of 'The Life of Christ' (Pl. 16, *a*, *b*) in the middle and bottom registers are all surrounded by the twofold decorative bands. These do not appear, on the other hand, in the niches of the grisaille figures of Virtues and Vices, nor in the realistic painted chapels flanking the entrance to the choir (Pl. 13). They are similarly dis- pensed with in 'The Last Judgement', which fills the entrance wall, and in the scenes of 'The Early Life of the Virgin' forming the uppermost row of frescoes on the side walls (Pl. 14, *a*, *b*). Nor are they present in 'The Annunciation' which occupies the entire upper part of the triumphal arch. All these scenes are therefore framed essentially in the manner which became the rule in the succeeding century. The distinction in degree of realism has been extended into the area of the history compositions themselves. Now, scenes which stand alone or occupy the entire area of a wall, and scenes placed at the top of a surface shared by several compositions are given a degree of realism formerly confined to single figures in their individual niches. The flatness of the pictured scene is no longer emphasized in the same way, and, whenever the position of the fresco allows the conflict with its neighbours to be minimized, the absence of the separation bands permits the architecture to become a window looking out into a new reality. It is no longer a picture frame, bounding an impenetrable decorative surface.

In an earlier chapter it was seen that in the individual frescoes Giotto was changing and developing his pictorial method as he worked. The present analysis of the function of the frame in the Arena Chapel shows that his conception of the relation between picture and spectator, together with his whole idea of the significance of the pictorial surface, was also in a state of flux. The flatness and non-reality of the decorative scheme as a whole is asserted by the neutral bands which isolate its major units. The onlooker sees before him painted walls. Yet this indication of the actual nature of the decoration is not in any way obtrusive. Only the most observant notice it at all, and as the spectator focuses his attention on the individual scene the illusion of a marble framing is allowed to work upon him. He is, in fact, free to see the entire decoration of the chapel now as space, and now as plane. And when he chooses to see space, he is allowed, according to the logic of

the situation, to see sometimes a painted scene on a flat surface emphasized by coloured separation bands that run within the marble frame, and sometimes a new world that opens out beyond the wall—a world partly dependent on his own, but not as yet a mere extension of it.

In Sta. Croce, under the influence, possibly, of the more assertive forms of the real architecture, Giotto makes a firm choice between the possibilities implicit in the Paduan scheme. Here are no floating panels, no flat, neutral bands. The painted architecture now supports the plastic elements of the actual structure of the church. The realism of the painted marble surrounds the onlooker completely. There is no labouring of the structural logic. Neither is there the assertion that what looks like·marble is but paint. The onlooker is now completely free to think of the appearance as the actual thing. Within this 'marble' framework there is here the same distinction as at Padua between the pictures with their separation bands, which occupy the lower surfaces (Pl. 17, *a*), and the realities which are seen through the architectural framing of the large lunettes that top the walls. Similarly, no separation bands insist on the non-plastic, pictorial nature of the saints within their niches.[9] The same distinction is systematically applied throughout the frescoes by Taddeo Gaddi in the Baroncelli Chapel, and by the Master of the Magdalen Chapel at Assisi, as well as in the transepts of the Lower Church.[10] In Gaddi's case the illusionist intention of the architectural framework is confirmed by the small, realistically lighted inlets in the marble socle, which, with their simple, still-life objects, are the forerunners of the fifteenth-century intarsia cupboards.

This developing conception of the picture is accompanied, as has been seen, by the increasing use of oblique settings within the individual composition. There is, at the same time, a firmer placing of the onlooker on whose position the appearance of the contents of the scenes, as well as of their framing, is now definitely dependent. At this point the blending of the real and the pictorial worlds is already far advanced.

The final stage before the advent of perspective theory can be seen in Maso's frescoes in Sta. Croce (Pl. 22) in which the separation bands have completely disappeared. The solidity of the representational surface is no longer emphasized at any point.[11] As yet there is no mathematical exactitude. Nonetheless the onlooker's position is quite firmly indicated. He looks out beyond the architectural frame into pictorial space in much the same way as the visitor to Masaccio's Brancacci Chapel, or to any of its fifteenth-century progeny. The only difference is of degree. In the later works, by virtue of the new perspective theory, the pictorial space is, in many cases, much more closely identified with the space in which he stands. The development of the new conception of the picture takes place, therefore, half a century before a precise mathematical basis was arrived at to invest it with the aura of scientific validity. This increasingly close identification of pictorial

and three-dimensional reality does not indicate a search for undiluted illusionism, a carnival of the '*trompe l'oeil*'. Even as the new conception is developed, more and more thought is given to the harmonization of the composition with the flat surface which it has, in a sense, replaced. On the other hand, the illusionistic qualities now lost to us, for whom fourteenth-century figure art must often seem far removed from reality, should not be underrated. To Ghiberti these same figures could still seem to stand out from the wall like sculpture.[12]

A similarly complete conception of the picture frame as a window into space is to be seen in Jan van Eyck's Van der Paele altarpiece. The contemporary frame is foreshortened so as to form a plastic window ledge with its orthogonals continued inwards by the foreshortened pavement of the actual picture space.[13] Although the panel dates from 1436, the construction of pictorial space is still a matter for empirical approximation, not the application of a unified system.[14] In the north, as well as in Italy, the new idea of pictorial reality is expressed in practice well before the evolution of a mathematical theory. The fundamental change is carried forward hand in hand with the developments within the composition which were previously discussed. The same great artists were responsible both for the detailed growth and for the general change in values.

It is no contradiction that the new ideas remained restricted to a relatively narrow circle. The existence of Giotto's figure style is not disproved because its meaning was not understood for a full hundred years. There can be no doubt that the majority of craftsmen and minor artists still painted on wall and panel, and still thought of their artefacts in the same way as their medieval forbears. There is a similar contrast between the ideas of the artistic leaders and those of their minor and provincial followers in first-century Pompeii and in fifteenth-century Italy. Cennino Cennini throws little or no light on the meaning of the fourteenth-century picture surface. His silence has no positive value, for he shows a similar backwardness in his advice about perspective.[15]

'And always use this method for buildings: that the cornices which you make at the top of the building fall down towards the shadow below; the cornices in the middle of the building, half-way up the surface are even and level; the moulding of the base of the building runs upwards from below, in the opposite way to the upper cornices which hang down.'

Such instructions do scant justice to the perspective subtleties of Giotto and Maso and the Lorenzettis.

Turning from the question of pictorial framing back to that of compositional content, it is on three artists working in North Italy during the last quarter of the fourteenth century, namely Altichiero, Avanzo, and Giusto de' Menabuoi, that attention must be focused in order to discover the most interesting developments in spatial design. It seems to be unlikely that these three artists, the one a Veronese, the second Paduan, and the last a Florentine

who settled in the North, have any of them a direct historical connection with events in Florence in the early fifteenth century. The analysis of their achieve-ment does, however, help towards an understanding of the explosion in spatial realism which was touched off by the invention of artificial perspective.

Altichiero's great fresco of 'The Crucifixion' in the chapel of S. Felice in the Santo at Padua was probably painted by 1379.[16] This scene marks the highest achievement of this group of artists in the realm of landscape. The spreading of the unified design across three column-separated bays recalls the similar treatment of the tripartite Gothic panel in Pietro Lorenzetti's 'Birth of the Virgin' (Pl. 26, *b*). Although the conventional, constructed rock forms show that it is not a landscape in the new Sienese manner, the variety of grouping and movement, and the skilful use of horsemen to increase the crowd's extension into depth and also to carry the design well up the surface of the wall, combine to give a real feeling of outdoor space. The impression is increased by the deep, and unusually realistic architectural coulisses which run far into the distance upon either wing. Finally, the oblique construction of the architecture accommodates the scene to the roving eye of the spectator as it moves across the three bays of the wall, whilst a culvert in the foreground confirms the impression that the painted world continues forwards and down-wards beyond the lower border, as well as out to either side.

The non-naturalistic landscape detail and the contrasting realism of the buildings reveal the essentially architectural basis of Altichiero's sense of space. A similar foundation is even more apparent in the work of Avanzo and of Giusto de' Menabuoi.[17]

The fresco of 'The Presentation in The Temple' (Pl. 28, *a*), in which Avanzo elaborates the architectural design of his signed 'Funeral of St. Lucy', also in the Chapel of St. George beside the Santo, reveals the essential qualities of his approach to spatial realism. The characteristic elaboration of imitative architectural detail is here accompanied by a determined inwards thrust, particularly on the left. The sense of nearness, and of the onlooker's inclusion in the event is, on the other hand, less emphasized than in the scenes such as that of 'St. George Drinking the Poison', (Pl. 28, *b*) which takes place in a small, and only partly visible courtyard opening out from an elaborate Gothic cloister. In spite of this relatively self-contained quality, the scene of 'The Presentation' (Pl. 28, *a*) still appears to be seen from close at hand. In the degree of realism, and the extent of the spatial movement, there is no parallel for such a composition in Tuscan art before the coming of theoretical perspective. The only comparable designs are the work of the last member of the northern trio, Giusto de' Menabuoi, who was working during the seventies on the decoration of the cathedral baptistery.[18]

The artist's forceful approach to architectural space is witnessed by the fresco of 'The Feast at Cana' (Pl. 29, *b*) in which the depth of the interior is reiterated time and again by the orthogonals on the left. Its precise extent is

measured out by the monotonous sevenfold accent of the seated figures ranged in depth. The limits of the cluttered central floor space are shown through the careful disposition of the gaps that open up between the figures of the servitors. In some scenes, such as 'The Massacre of the Innocents', the whole interior is filled by a seething crowd. But even then, a row of heads, as if of soldiers on parade, runs down the side wall to ensure that the spatial content is not lost on the beholder.[19] In other frescoes, grandiose, vaulted architectural schemes, cut short by the intervention of the frame, are used to create impressive space. In 'The Feast at Cana' (Pl. 29, *b*) itself, only the left-hand wall and a small part of the back wall can be seen before the room is cut from view. The considerable depth of the pictorial space is established by the emphasis on recession, and the sideways extension of the banqueting hall is left to the imagination.

Menabuoi's obvious weaknesses as a landscape painter, and his tendency to abrupt transitions into the realm of popular imagery, are thrown into increased relief by the growing control of internal and external architectural space revealed in the Belludi Chapel in the Santo, which he decorated in 1383.[20]

The vast crowd filling the piazza in 'The Martyrdom of St. James' is convincing in the extreme. There is no piling up of heads over the surface, and the imagination is free to accept the continuation of the mass of figures far into the distance. The portrait quality of the architecture is enhanced by its convincing scale.[21] The sense of recession, conveyed by the orthogonals receding arch on arch into the distance, particularly in the magnificent edifice on the left, is more typical of the 1430's than the 1380's. The perspective remains empirical, and there are still uncertainties in detail.[22] But in what has been attempted the artist reveals precisely that spirit which was to flourish to the full under the impact of a systematic method of creating space.

The same spirit shows itself in the great Gothic interior, crowded with figures, which contains the scene of 'St. Philip Exorcising a Devil' (Pl. 29, *a*). The huge central hall extends above, and out to either side beyond, the boundaries of the frame with which its wide Gothic arches are in such close harmony. The alignment of the figures carries the spatial play of the architecture into the crowd which it encloses. The sense of a great, echoing space, teeming with life, is achieved as never before.

The fact that such explosions of originality in the creation of pictorial space could occur in the Italy of the 1370's and 1380's is highly significant. In a period generally characterized by economic and political tension, and by artistic uncertainty and even stagnation, there was a slow combustion of ideas, which finally burst into flame, fanned by the favourable conspiracy of events in Florence in the early fifteenth century.

NOTES

1. See M. Meiss, op. cit.

2. The angels are much larger than the largest figures in the main ship. The sleeping figure on the island is the same size or larger, and certainly not smaller, than the bearded figure in the same boat. The miniscule sailor on the island is no nearer to the foreground than the sleeping figure, and about the same size as the more distant figures working in the port on the right. These are consequently nearer to the angels and the main boat, and further from the spectator than the sleeping figure on the island, and also much smaller than it. There is, therefore, no consistent diminution in any direction at all.

3. J. Pope-Hennessy, *Giovanni di Paolo*, London, 1937, p. 85, advances the idea of a perspective inversion from front to back on the right of the panel of 'St. John the Baptist Entering the Wilderness' in the Art Institute, Chicago. But both in this panel and in the similar scene in the National Gallery, London, it is noticeable that within the area of the fields in the foreground, all of them small in relation to the distant figure and its immediate surroundings, the lines of roads and fields converge normally towards the distance. In other words, the further scene represents the interruption of normal diminution in the interests of the subject matter, but not a continuous inversion of it.

A principale of empathetic inversion put forward in O. Wulff, 'Die umgekehrte Perspektive und die Niedersicht', *Festschrift Schmarsow*, Leipzig, 1907, appears to be more unsound because more generalized, as is noted by Bunim, op. cit., p. 7.

4. Experiments such as that of the night lighting in the fresco of 'The Annunciation to the Shepherds' appear to mark real advances in natural observation. The various copies of 'The Presentation of the Virgin' show the confusion in the structure of the steps is entirely due to faulty restoration.

5. The conventional rock landscape formula, which has a long subsequent history in Tuscany and North Italy, is as much a sign of this conservatism as are the architectural constructions. Fra Angelico, Benozzo Gozzoli, and Filippo Lippi are, perhaps, the principal Florentine artists who carried the use of this convention well into the fourteen-sixties. Its importance, in combination with the Italian oblique setting, for the evolution of French landscape art does not alter the fact that no fundamental developments in architectural or landscape space are achieved by artists such as Agnolo Gaddi and Spinello Aretino. G. Gombosi, *Spinello Aretino*, Budapest, 1926, gives an excellent analysis of the latter's work which leads, however, to over-enthusiastic claims as to his originality.

6. There is no attempt to carry illusion to its logical conclusion, as the whereabouts of the lower parts of the figures is unexplained.

7. The separation bands derive from the earlier traditions of fresco bordering. But where there are no contrasting plastic elements they have no special significance as decorative features.

8. Isermeyer, op. cit., p. 10. The analysis which follows, leads, however, to different conclusions.

9. The sole exception to the differential use of separation bands is in 'The Stigmatization of St. Francis' on the wall above the arch leading into the Bardi Chapel.

10. The only exceptions in the lower church occur in the paintings of 'The Five Franciscans' and of 'The Virgin, St. John Baptist, Donor, and Crucifixion', but in both cases the separation bands can be seen to be crude later additions. In the one, they run impartially over blue ground and lettering alike. In the other, a complex marble frame can be traced beneath the bands.

11. Certain late fourteenth-century schemes, such as Agnolo Gaddi's Sta. Croce frescoes, in which the separation bands along the lower borders disappear, as if dropping out of sight behind the painted marble frame, have been claimed as representing a new conception of the picture

Late Fourteenth-century Painting and the Meaning of the Picture

(Isermeyer, op. cit., pp. 59 ff.). This device occurs, however, in Simone Martini's 'Guidoriccio da Foliagno' of 1328 (Pl. 20, *b*).

Similarly, the new ideas find their reflection, but not their origin, in Giovanni da Milano's frescoes in Sta. Croce in which framing columns, separation bands and all, stand on the ground within the picture space, like flats projecting onto a stage.

12. Isermeyer, op. cit., p. 73. J. von Schlosser, *Ghiberti's Denkwürdigkeiten*, Berlin, 1912, p. 55. The increasing boldness of the artists and receptivity of the public as regards certain kinds of perspectival adventure can be seen, after the mid-century in Taddeo Gaddi's 'Last Supper' in the refectory of Sta. Croce, discussed in J. White, *Art and Architecture in Italy 1250–1400*, Harmondsworth, 1966, pp. 268–9. Often the most elaborate feats of illusion were carried off by artists whose other works show that their interest in the fundamentals of spatial design was limited. For Lippo Vanni's frescoed illusions, see E. Borsook, 'The Frescoes at San Leonardo al Lago', *The Burlington Magazine*, xcviii, 1956, pp. 351 ff., and *The Mural Painters of Tuscanny*, London, 1960, p. 137 and Pl. 30, the latter illustrating his counterfeit polyptych in the Seminary at Siena.

13. Illus. L. Baldass, *Jan van Eyck*, London, 1952, and A. Janssens de Bisthoven and R. A. Parmentier, *Les Primitifs Flamands, Fasc. 1 to 4, Le Musée Communal de Bruges*, Anvers, 1951, Pl. to No. 9.

14. Panofsky, 'Perspective als "symbolische Form",' loc. cit., pp. 281–2.

15. Cennino Cennini, *Il Libro dell' Arte*, ed. D. V. Thompson, London, 1933, cap. 87.

16. A document of 1379 shows payment to Altichiero 'per ogni raxon ch'aveva a fare'.

17. S. Bettini, *Giusto de' Menabuoi e l'Arte del Trecento*, Padova, 1944, gives a good bibliography for all three artists, besides dealing thoroughly with Giusto himself.

18. Bettini, op. cit., pp. 77 ff.

19. A similar space-defining line of heads is to be seen in other crowd compositions, such as that of 'St. Philip Exorcizing a devil' (Pl. 29 *a*) in the Belludi Chapel.

20. The background hills in 'The Crucifixion of St. Philip' are a notable exception, but show little connection with the foreground.

21. The buildings are clearly based on the great Paduan monuments, and accurately reflect their architectural style, if not their actual forms.

22. The mouldings on the pillars supporting the arches in the building on the right run upwards far too steeply, while the crowns of the arches and the line of windows above are almost horizontal, so that there is little co-ordination with the falling recession of the building on the left.

CHAPTER VIII

The Development of the Theory of Artificial Perspective

FILIPPO BRUNELLESCHI

It is a vivid reminder of the continuity of historical processes that the invention of a mathematically based perspective system during the early years of the fifteenth century was heralded, not by the publication of a treatise, but by the painting of a pair of panels. It is also characteristic of the ever-increasing unity of the arts and sciences in the Renaissance that it was Filippo Brunelleschi, firstly an architect and secondly a sculptor, who chose to publicize his new discovery in this way. The importance of the contents of these pictorial manifestos can hardly be overestimated. Although they themselves are lost, it is fortunately possible to reconstruct all their essential compositional features with unusual accuracy.

Antonio Manetti, in his *Life of Brunelleschi*, which was probably written only a few decades after the latter's death, states quite firmly that the new perspective was the master's own creation.[1]

'Thus in those days, he himself proposed and practised what painters today call perspective; for it is part of that science, which is in effect to put down well and with reason the diminutions and enlargements which appear to the eyes of men from things far away or close at hand: buildings, plains and mountains and countrysides of every kind and in every part, the figures and the other objects, in that measurement which corresponds to that distance away which they show themselves to be: and from him is born the rule, which is the basis of all that has been done of that kind from that day to this.'

Manetti immediately points out that the new invention contained the rule for the proportional diminution of painted objects which was later codified in treatises such as Alberti's, and which was one of the basic features of artificial perspective. The writer's sense of history is emphasized by his subsequent discussion of the possible existence of a rational perspective system in antiquity, and by his carefully reasoned conclusion that this could not, in any case, affect the stature of Brunelleschi's achievement, as any knowledge of the nature of such a system had undoubtedly since been lost. It is therefore interesting to see, for reasons which will appear later, that before going on to describe the practical applications of the new method, he inserts

113

a long passage insisting how thoroughly modest his hero was, and strongly implying that he was shamefully treated by contemporaries who were not.

Having relieved himself of this outburst of feeling, Manetti describes the painting of 'S. Giovanni and the Piazza del Duomo', which was the first of Brunelleschi's demonstration pieces. He records it in these words:[2]

'And this matter of perspective, in the first thing in which he showed it, was in a small panel about half a braccio[3] square, on which he made an exact picture (from outside) of the church of Santo Giovanni di Firenze, and of that church he portrayed, as much as can be seen, at a glance from the outside: and it seems that in order to portray it he placed himself inside the middle door of Santa Maria del Fiore, some three braccia, done with such care and delicacy, and with such accuracy in the colours of the white and black marbles, that there is not a miniaturist who could have done it better; picturing before one's face that part of the piazza which the eye takes in, and so towards the side over against the Misericordia as far as the arch and corner of the Pecori, and so of the side of the column of the miracle of Santo Zenobio as far as the Canto alla Paglia; and as much of that place as is seen in the distance, and for as much of the sky as he had to show, that is where the walls in the picture vanish into the air, he put burnished silver, so that the air and the natural skies might be reflected in it; and thus also the clouds, which are seen in that silver are moved by the wind, when it blows.'

The position of all the buildings mentioned, and indeed the whole dis/position of the Piazza del Duomo before its westwards extension, is well known. The latter enlargement is the only important alteration of shape which has occurred. The key to the accurate reconstruction of Brunelleschi's picture of it lies, however, in Manetti's detailed description of the viewpoint from which it was seen. This is given as some three braccia inside the main, central door of the Duomo. This distance is approximately 1·75 metres. In comparison, the width of the present doorway is about 3·80 metres, a little more than double the previous distance.[4] An actual two to one ratio would mean that anyone standing at the point described by Manetti, and looking out towards the piazza, could swing his eye through an angle of ninety degrees before his view was cut off by the uprights of the door.[5] The fact that the doorway is narrowed slightly by its nineteenth/century marble facing does not affect the matter appreciably, since in Brunelleschi's day the similar incrustation of Talenti's portal was still standing. The sixteenth/century drawing of the latter in the Opera del Duomo seems to reveal a slight splaying of the deep, inner walls of the porch.[6] On the other hand, the simi/larly accurate representation of it in Poccetti's fresco in the cloister of S. Marco, which shows the façade from a nearly central viewpoint, definitely shows no splaying at all.[7] It therefore seems safe to conclude that the entrance space was either rectangular or, at most, only very slightly splayed. Since the design of Brunelleschi's panel would only be altered materially by an increase

of about thirty degrees in the angle of vision, there is no necessity to modify the original conclusion that he retreated inwards about half the width of the doorway in order to design his picture.[8] This distance must be taken from the front of the tunnel-like entrance as a whole, and not from the doorway

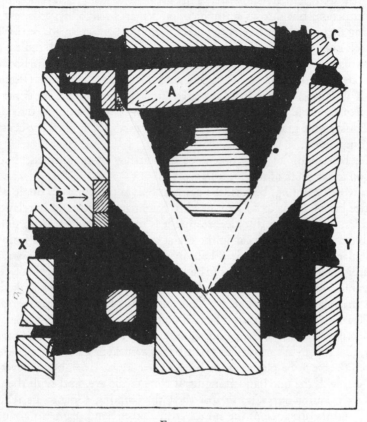

FIGURE 4

A. Volta dei Pecori X. Via de' Calzaioli
B. Misericordia Y. Via de' Martelli
C. Canto alla Paglia

itself. Otherwise, allowing even the most improbably small depth for Talenti's porch, Brunelleschi's view would have been so restricted that the sides of the Piazza del Duomo would have disappeared completely.[9]

By drawing in Brunelleschi's ninety-degree visual cone on a plan of the piazza as it was in the fifteenth century, it is possible to see how much of it he could have included in his painting. This is done in Fig. 4,[10] which shows that both the Volta de' Pecori and the Canto alla Paglia, mentioned

by Manetti, would indeed have been visible from the main door of the Duomo. Manetti himself does not say that either the Misericordia or the column of S. Zenobius was included in the picture. He merely uses them to identify the left- and right-hand sides of the square. Vasari, however, says that they were actually shown.[11] This fits in with what is revealed by the reconstruction, but throws no light upon Vasari's reliability. His text says nothing that could not have been taken from the passage in Manetti. What is much more interesting is that both to left and right only the receding sides of the piazza are visible. The corners, and forward surfaces of the houses of what are now the Via de' Calzaioli and the Via de' Martelli (Points X and Y in Fig. 4) cannot have appeared in the picture at all. On either side the picture must have begun immediately with a coulisse running into depth and flanking the graceful octagon of the Baptistery which filled the centre of the composition.

The description of the content of the picture being finished, Manetti goes on to say more of its construction.[12]

'In which painting, because the painter needs to presuppose a single place, whence his picture is to be seen, fixed in height and depth and in relation to the sides, as well as in distance, so that it is impossible to get distortions in looking at it, such as appear in the eye at any place which differs from that particular one, he had made a hole in the panel on which there was this painting, which came to be situated in the part of the church of Santo Giovanni, where the eye struck, directly opposite anyone who looked out from that place inside the central door of Santa Maria del Fiore, where he would have been positioned, if he had portrayed it; which hole was as small as a lentil on the side of the painting, and on the back it opened out pyrami-dally, like a woman's straw hat, to the size of a ducat or a little more. And he wished the eye to be placed at the back, where it was large, by whoever had it to see, with the one hand bringing it close to the eye, and with the other holding a mirror opposite, so that there the painting came to be reflected back; and the distance of the mirror in the other hand, came to about the length of a small braccio; up to that of a true braccio, from the place where he showed that he had been to paint it, as far as the church of Santo Giovanni, which on being seen, with the other circumstances already mentioned of the burnished silver and of the piazza etc. and of the perforation, it seemed as if the real thing was seen: and I have had it in my hand, and I can give testimony.'

This passage confirms that, besides showing all of the Piazza del Duomo that was visible from a carefully chosen position, the construction of the picture was dependent upon its being seen from a single viewpoint set at a particular distance from the picture surface. In this case the viewing distance was about twice the width of the painting. There must, therefore, have been a true vanishing point system, with the mathematically controlled rate of

diminution which was implied in Manetti's opening remarks on the new discovery.[13]

Manetti's insistence on his familiarity with the work is important from the historian's point of view. His assertion is confirmed by the confidence with which he handles the details of measurement, of construction, and of content, without becoming involved in even venial contradictions. Unfortunately in describing Brunelleschi's second panel, showing the Piazza della Signoria, Manetti says much less about the buildings represented. He makes up for this by being just as definite about the general description of the picture, and about the exact position from which the view was taken. The whole passage runs:[14]

'He made in perspective the piazza of the palace of the Signori of Florence, with everything on it and round about it, as much as can be seen, standing outside the piazza or really on a level with it, along the façade of the church of Santo Romolo, past the corner of the Calimala Francesca, which rises on the aforesaid piazza, a few braccia towards Orto Santo Michele, whence is seen the palace of the Signori, in such a way, that two faces are seen completely, that which is turned towards the West and that which is turned towards the North: so that it is a wonderful thing to see what appears, together with all the things that the view includes in that place. Afterwards Paolo Uccello and other painters did it, who wished to counterfeit and imitate it; of which I have seen more than one, and it was not as well done as that. Here it might be said: why did he not make this picture, being of perspective, with that hole for the eye, like the little panel from the Duomo towards Santo Giovanni? This arose, because the panel of so great a piazza, needed to be so big to put in it so many different things, that it could not, like the Santo Giovanni, be held up to the face with one hand, nor the mirror with the other; for the arm of a man is not of sufficient length that with the mirror in his hand he could hold it at its distance opposite the point, nor so strong, that he could support it. He left it to the discretion of the onlooker as happens in all the other paintings of all the other painters, although the onlooker may not always be discerning. And in the place where he put the burnished silver in that of Santo Giovanni, here he left a void, which he made from the buildings up: and betook himself with it to look at it in a place, where the natural air showed itself from the buildings upwards.'

Once again the nature of the focused perspective system is underlined. The painting, whilst approaching the normal practice in dispensing with the eye-hole and the mirror, still reveals, in its silhouetted upper border, the unusual interest in pure illusionism to be expected in a perspective manifesto demonstrating a new system in the most forceful terms possible.

Manetti makes it clear that, to paint this second panel, Brunelleschi stood in the extreme north-west corner of the Piazza della Signoria (see Fig. 5).[15] Entering the piazza at this point the natural impulse is to look immediately

towards the great mass of the Palazzo della Signoria. Flanked, as it is, by lower buildings, it dominates the whole wide expanse of the square, thrust, ing, corner onwards, almost directly at the observer, who sees it with the two visible faces violently foreshortened.[16] The Palazzo is the natural centre of the scene, and Manetti's description implies that it was also the centre of Brunelleschi's panel. It is the only building which he gives by name. His actual words, 'donde si guarda'l palagio de'Signori, in modo, che due faccie si veggono intere', imply that it is the principal focus of interest, and the

FIGURE 5

A. S. Romolo D. Loggia dei Lanzi
B. Canto, Calimala Francesca E. Signoria
C. Tetto dei Pisani F. Mercanzia

compositional and perspective centre of the picture. They also stress the distinctive characteristic of the extreme oblique setting, its equal emphasis on both the visible, evenly receding surfaces of a building. There seems to be no other reason for his labouring of the point that the two sides shown in their entirety are 'quello che'e volta verso ponente e quella ch'e volta verso tramontana'. No others can be seen from anywhere inside the piazza.

Taking the Signoria, therefore, to be the centre of a balanced composition, it can be seen that the same ninety-degree angle of vision, which Brunelleschi was described as using in the painting of the Baptistery, here takes in the whole of the south and east sides of the piazza. These include the Loggia dei Lanzi on the right, and on the left the important Palazzo della Mercanzia which was later decorated with works by Piero Pollaiuolo and by Botti-

celli.[17] The composition results in the same unbroken coulisses extending to the edges of the panel, though not this time running directly into depth, which were a feature of the previous work.

The issue is, unfortunately, complicated by Vasari who, this time, seems to contradict Manetti's text instead of corroborating it. This is implicit in the later author's longer list of buildings visible in the picture.

Vasari writes:

'. . . before long he began another (painting), drawing the palace, the piazza, and the Loggia de'Signori, with the Tetto dei Pisani and all the buildings about.'[18]

The difficulty arises out of the inclusion of the Tetto dei Pisani. This building stood on the west side of the piazza,[19], and at first sight its incorpora, tion in the painting seems to be quite reasonable. The buildings mentioned by Vasari fall, almost exactly, within an arc of ninety degrees, as in the earlier panel. Vasari's accuracy is, moreover, normally at its greatest when he is dealing with the work of Florentines in Florence. It is only when the perspec, tive structure is examined in detail that the reliability of Vasari's statement falls under suspicion.

Nothing that the later writer says can be taken to invalidate Manetti's clearly authoritative description of the panel. Not only is the latter closer to the events of which he writes, but he knew the works in question intimately. There is, on the other hand, no evidence that Vasari actually saw the panels at all. There is no record of them whatsoever after the probable references to them in the Medici inventory of 1494.[20] It must therefore be accepted that the whole of the Palazzo della Signoria was visible in Brunelleschi's panel. But the shape of the piazza is such that if it were, as M netti implies, the centre of the scene, it would be impossible, using Brunelleschi's focused perspective, to show the façades of the buildings on the west side of the square, amongst which stood the Tetto dei Pisani. This could only be achieved from Brunelleschi's position in the corner of the piazza if the vanishing point were moved a long way over to the right of the panel. Even then it would only be possible to show the building in such violent fore, shortening as to render it virtually unrecognizable. If this was, nonetheless, the construction that was used, a number of further difficulties arise.

Manetti's description makes it very unlikely that the panel's viewing dis, tance was markedly short in relation to its width. One of the reasons for dispensing with the peep,hole was that it would have been impossible to hold the mirror far enough away. The three or four to one relationship of the S. Giovanni panel may even have been retained. This would have entailed a relatively low visual centre in order to give the spectator the impression of viewing the scene from a normal head height.[21] The visual centre would, therefore, be somewhere in the bottom right,hand corner of the picture. The observer, supposed to look at the painting from a position opposite this

point, would then find that any possible illusion of reality was greatly weakened by his disturbing awareness of the bottom of the picture and of the closeness of the right-hand border. A central viewpoint, on the other hand, would allow him plenty of 'picture' at either side to strengthen the impression of reality. A lop-sided view would also have a mannerist quality which would be most unexpected in the early fifteenth century. This is not merely a compositional matter. Both Manetti and Vasari put the Palazzo della Signoria first, and concentration, by perspective means, on one of the less important structures would extend the mannerism to the treatment of the subject matter. In addition, Manetti gives size, and not uneven balance, as the reason for the impossibility of holding the picture in one hand and a mirror in the other. This unbalance, both visually and in terms of weight, would have been increased by the silhouette form of the top of the panel. No expanse of painted or reflected sky would have been there to counterpoise the towering mass of the Palazzo. Finally, if, in spite of all these objections, Brunelleschi had, for the sake of difficulty, chosen such an eccentric view-point in an attempt to increase the impact of his perspective through the shock effect of the unusual, it is extraordinary that there is no mention of the fact in either text.

It seems, therefore, that Vasari was mistaken in his reference to the Tetto dei Pisani, and that the original reconstruction, diagrammatically illustrated in Fig. 5 (p. 118), shows the contents of Brunelleschi's composition correctly.[22] This leads to certain conclusions about the historical meaning of Brunelleschi's achievement in the two paintings which he used for demonstrating his theories.

It is clear that he developed a complete, focused, system of perspective with mathematically regular diminution towards a fixed vanishing point.[23] This directly controlled the onlooker's position in relation to the pictured scene, both in distance and direction. It is the final crystallization of the increasingly close connection between the observer and the pictorial world which had been growing up throughout the previous century. The ever more confident attempts to relate pictorial space to everyday experience of the three-dimensional world—elastic experiments conditioned equally by physical, and psychological factors—are transformed into a logically precise mathematical system. All this is revolutionary in its novelty.

At the same time, in the very compositions with which Brunelleschi chose to demonstrate the new invention, he is careful to respect as far as possible the particular, simple, visual truths which underlie the achievements of Giottesque art. In the view of the Piazza del Duomo the whole problem of dealing with the forward surfaces of foreshortened, cubic buildings is, as far as possible, avoided. On either side orthogonal coulisses run inwards from the very edge of the painting.[24] In the panel of the Piazza della Signoria, the viewpoint is chosen so as to draw the eye diagonally across the

open space. Every building is obliquely set, and the jutting sharpness of the forms must have given dramatic emphasis to the new realism. Nevertheless, in its fundamental structure, the composition is exactly that of Taddeo Gaddi's fresco of 'The Presentation of the Virgin' in the Baroncelli Chapel (Pl. 27, *b*).

Brunelleschi must have been well aware of the one point of unavoidable conflict between his new mathematical system and the simple observation of reality which underlies the oblique disposition of Giotto's compositions. This conflict he succeeded in reducing to a minimum by the careful selection and manipulation of his viewpoint. The same acute sense of the achievement of the past is revealed in all the forms of Brunelleschi's forward-striding architecture. His perspective manifestos, giving artistic form to a new geo-metrical construction, can be seen both as a revolution and as a moment of transition.

LEON BATTISTA ALBERTI

It is in Alberti's Della Pittura, which he wrote in 1435, that a theory of perspective first attains formal being outside the individual work of art.[25] Theoretical dissertation replaces practical demonstration. The way is open, in art also, for that separation of theory and practice; that particular kind of selfconsciousness which, in the wider view, showed itself most significantly in the growing realization of the historical remoteness of antiquity,[26] and which underlies modern scientific achievement.

Alberti starts his treatise by explaining the simple geometric terms which he will have to use. He then begins immediately to describe the pyramid of visual rays which joins the objects that are seen to the beholder's eye.[27] There follows an explanation of the relationship between apparent quantities and the visual angle formed within the eye. In a single sentence Alberti sets forth the fundamental principle of Euclidean optics, and establishes the optical foundation of the pictorial diminution to a point, on which the new perspective system is constructed.[28] The definition of the picture plane as an intersection of the visual pyramid[29] is followed by a demonstration of the fact that all the pictured quantities are proportional to those found in the actual objects which are being reproduced. This also establishes the further fundamental point that there is no distortion of the shape of objects lying parallel to the picture plane. Artificial perspective is therefore, in its treatment of the individual object, essentially a development of the foreshortened frontal system which had reached its highest level of perfection in the Sienese school of the early, and the Paduan and Veronese circles of the late fourteenth century. It is fundamentally opposed in structure to that vision of reality espoused by Giotto and by Ambrogio Lorenzetti.

The Development of the Theory of Artificial Perspective

The new role of the spectator in relation to the picture, which played such an important part in the discussion of Brunelleschi's two panels, is underlined throughout Alberti's treatise, and reflects the growing humanism of the period. This humanist approach is carried into the pictorial world itself when Alberti points out that all the appearances of things are purely relative, and that it is the human figure which alone provides the measure of whatever else the artist cares to represent.[30]

Man's central position as observer of a pictorial world of which he himself is the measure, together with the new reality to which that world aspires, is shown immediately Alberti describes his actual method of perspective composition, beginning with a suitably large square which he says, 'I consider to be an open window through which I view that which will be painted there.'[31]

The idea of the imitation of reality as the painter's starting point, which is reiterated in various forms throughout the treatise, reappears in a discussion of the rules of history painting in which he stresses the absurdity of painting large men cooped in tiny houses.[32] He had previously also poured scorn on the old method of foreshortening a squared pavement by successively reducing the distances between transversals by a third.[33] The new rule of diminution in direct proportion to the intervening distance is implied in the whole preliminary discourse on proportional triangles, and is implicit also in the construction that Alberti uses to establish the squared and foreshortened pavement which is the basis of the pictorial space created by artificial perspective.[34]

It is only as a check on accuracy and not as a method of construction that Alberti mentions that 'one single straight line will contain the diagonal of many more quadrangles described in the picture'.[35] Although the distance point construction seems to have been known and occasionally used in fourteenth-century Italy, it is not essential for Brunelleschi to have used it in painting either of his panels. Certainly there is no evidence in Alberti's writings that he was aware of an alternative and mechanically simpler means of attaining his objective.[36] The fifteenth century Italian theorists' continued disinterest in the method seems at first a little curious. It becomes less strange when it is remembered that Alberti's own construction, with its perpendicular intersection of the visual pyramid, diagrammatically illustrates the whole conception of the threefold relationship between the object, the pictorial plane, and the spectator's eye, each time that it is used. The distance point construction—based on the convergence of the diagonals of a square with the horizon line at points of which the distance from the central focus equals that of the observer from the picture plane—this simple construction by-passes the whole conception of the visual pyramid and its pictorial intersection, which finds no clear and diagrammatic reflection in it.

Alberti, in the second book of his Della Pittura, goes on to explain how any object, whether angular or circular, can be accurately reproduced on the

foreshortened pavement. Its plan is either traced upon the receding plane by direct observation, or else by the transference onto the latter of co-ordinates obtained upon an unforeshortened square which has been similarly sub-divided. The height of its various parts will then be governed by multiples, or fractions, of the vertical distance between the horizon line and the part of the foreshortened plane on which they stand.[37] This distance, if the horizon is at head height, will be equal to the stature of a man.

Even the bare summary of a few aspects of Alberti's new construction reveals the autonomy achieved by the idea of space. During the thirteenth and fourteenth centuries it was possible to see space gradually extending outwards from the nucleus of the individual solid object, and moving, stage by stage, towards emancipation from its tyranny. Now the pictorial process

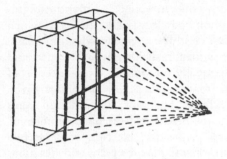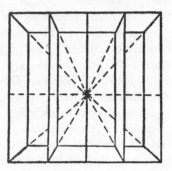

FIGURE 6

is complete. Space is created first, and then the solid objects of the pictured world are arranged within it in accordance with the rules which it dictates. Space now contains the objects by which formerly it was created. The change in pictorial method is a close reflection of the crystallization of ideas which were slowly taking shape in the preceding century, and which were earlier discussed.

The conception of the picture as the plane cross-section of the visual cone, or pyramid, which has its base in the object and its apex in the eye, is simi-larly the last stage in the slow transformation of the picture plane from the opaque, decorative, surface which was its medieval form.

The artificial perspective (Fig. 6), which Albert codified and himself conceived in part, and which dominated Italian art throughout the fifteenth century, has four principal characteristics. The first two of these are shared by all those centralized, but unfocused, fourteenth-century vanishing axis sys-tems which make use of the foreshortened frontal setting for individual objects. Towards the second two, the leading artists, both of Florence and Siena, had made steady progress by empirical means. The four characteris-tics are that: (*a*) There is no distortion of straight lines. (*b*) There is no distor-

123

tion, or foreshortening, of objects or distances parallel to the picture plane, which is therefore given a particular emphasis. (*c*) Orthogonals converge to a single vanishing point dependent on the fixed position of the observer's eye. (*d*) The size of objects diminishes in an exact proportion to their distance from this observer, so that all quantities are measurable. The result is an approximation to an infinite, mathematically homogeneous space, and the creation of a new, and powerful means of giving unity to the pictorial design.

These characteristics are precisely those which stood revealed in the con/ struction which Brunelleschi demonstrated in his paintings of the Florentine piazze. Yet although Alberti places Brunelleschi in the list of six great artists to whom he dedicates his treatise, and although his preface is addressed to him as an architect, there is no reference to him in the text itself. There is therefore nothing to connect his name with the creation of the new perspec/ tive which Alberti strongly implies is his own invention.[38] Since the origins of the new idea must have been common knowledge in the circles in which he and Brunelleschi moved, there must clearly be a sense in which his claim is true. He could not otherwise have written in such terms in Florence, and in Brunelleschi's lifetime. There are equally no grounds for a rejection of Manetti's factual account which was also written in the lifetime of many who had known both Brunelleschi and Alberti. The most likely solution seems to be that Brunelleschi was, in fact, the inventor of the basic geometrical constructions which underly the new perspective. He composed his two pictures by the laborious process of first drawing out the plans and elevations of the entire contents, and then combining them upon the panel. Such a procedure arises naturally out of the architect's preoccupation with the plans and elevations of buildings, and also closely follows the pattern established by Vitrivius' few surviving comments on the antique system. This method was afterwards abbreviated by Alberti's improved construction which con/ sisted in building a three/dimensional system or co/ordinates in foreshortening that enabled the artist to determine the relative magnitudes of all the objects which he wished to represent.

If this hypothesis is approximately correct, it also explains the curious diatribe against unspecified boastful and envious self/advertisers, which sud/ denly interrupts Manetti's story of the invention, or at least the rediscovery, of perspective. Such passages of invective are a commonplace in all such partisan, renaissance biographical sketches. What is unusual is its placing. There is no parallel for it elsewhere in the biography, although particular quarrels and acts attributed to jealousy are recorded as they occur, especially during the long story of the building of the great cathedral dome. There is nowhere else the sudden interruption of a train of thought, a lengthy, general/ ized tirade that splits in half the telling of a single, homogeneous story. But if this outburst finds its genesis in the subject of perspective in which it is embedded; if it is, in fact, directed against Alberti for his assumption of the

whole credit for the new discovery by his method of announcing the inven/ tion merely of an improvement in the mechanics of construction, then no further explanation is required.

This interpretation of the evidence does not in any way detract from the realization that whatever Brunelleschi had achieved in practice, it was Alberti, and Alberti alone, who gave expression to the ideas which under/ laid and surrounded the bare mathematical skeleton. It was he who related the construction to a complete theory of the status and objectives of pictorial art which was invested with antique authority. It was he who, by reducing the mathematical labour to a minimum, brought the new ideas within the realm of practicality for the ordinary artist. In doing this Alberti gives the method a schematic quality and a rigidity which were not present in Brunel/ leschi's compositions, for all their trickery of silhouettes and peepholes.

Alberti shows no sign of any awareness of the limitations of his method. It confers upon the artist a hitherto undreamt/of power to intensify and unify the spatial composition, and to harmonize it with the flat pictorial surface which can itself be controlled in a new way. There is no acknowledgement, however, of the points at which these achievements are made possible only by the acceptance of a geometrical convention which runs counter to the artist's visual experience of the details of the world about him. The theoretical perfection of the system, as a system, takes no cognizance of the aesthetic sensibility, and fundamental honesty of eye, which seem to be revealed in Brunelleschi's careful manipulation of his compositions; in his attempt to minimize the conflict between the rigidity of geometrical method and the soft variety of living experience, avoiding, as far as possible, the foreshortened frontal flanking elements which, under the influence of the new perspective, become a standard feature of renaissance compositions. The contrast between the mathematical and the empirical must not, however, be taken too far. It is not a question of the replacement of a method which is all fidelity to experience by another which is all convention. It is a substitution of one aspect of truth, and one convention, for a different convention and another truth. The softly bowed, centralized oblique composition evolved by Maso actually draws in the apparent dual recession of the individual object, but completely ignores the known and observed rectilinear setting of the series. The new system ignores the first appearance by construction, but acknow/ ledges the known fact, and with it a different appearance. The straight lines of common architectural usage not only can be seen, but are indeed all that is seen by the average modern man.[40] Moreover, when all the conditions postulated by the system are observed, as is hardly ever the case in practice, artificial perspective achieves a scientific accuracy and truth to nature which is quite outside the scope of any other system. Under such conditions, the diminution outwards from the visual centre of all visible frontal surfaces is taken care of by the natural foreshortenings of the representational surface.

The Development of the Theory of Artificial Perspective

The power generated by Alberti's systematic clarity can be demonstrated by the abrupt change which overtakes the choice of viewpoint in representations of the Piazza della Signoria. In the fourteenth-century fresco of 'The Expulsion of the Duke of Athens', and in an early fifteenth-century relief, the Palazzo Vecchio is obliquely set.[41] But this diagonal view of the piazza virtually disappears between the time of Brunelleschi's own design and Stella's etching in the early seventeenth century.[42] In the many well-known views which have survived from the intervening period, the observer is always either situated on the north side of the piazza, looking straight towards the Loggia dei Lanzi, or standing in the middle of the west side and looking straight towards the main façade of the Palazzo. The faces of the buildings are thus made to conform as closely as possible to the axes of an Albertian foreshortened square.[43] No better illustration could be given of the impact of a system of construction upon composition.

The innate pictorial qualities of artificial perspective were not the only sources of its popularity and prestige. Already in the Della Pittura, it is used as a lever with which to ease the humble craft of painting into the lordly circle of the liberal arts. With this ascent the formerly humble, but now scientific, painter was to move into the sphere of the princely patrons and attendant men of letters.[44] Social and economic pressures were combined with the aesthetic and the practical. It was Alberti's contribution to the history of spatial realism in painting that, at one blow, made an essential technical improvement and disseminated the new idea in palatable form, whilst harnessing it to the driving force of the whole current of contemporary ideas and aspirations.

LORENZO GHIBERTI

The final document which must take its place beside the work of Brunelleschi and Alberti in the story of the birth of artificial perspective is once more a written text. This is the *Third Commentary*, which Ghiberti wrote in the last years of his life and left unfinished at his death.[45] This *Commentary* does not concern itself with problems of perspective proper, but with what has been called natural perspective or optics. What is more, it does not contain, as far as can be seen, a single item of original material. The text is nothing but a patchwork of quotations from antique and medieval treatises, of which the most important are those of Vitruvius, Alhazen, Peckham, and Bacon. It is in this very fact that the significance of Ghiberti's work resides. Written after Brunelleschi's painted manifestos, and after Alberti's Della Pittura and his own essays in the new perspective for the Porta del Paradiso, it throws some much-needed light upon the relationship between the medieval optics and the new perspective science.

The Development of the Theory of Artificial Perspective

The opening part of the *Commentary* is chiefly concerned with the structure of the eye, and with the theory of vision, which are set forth in a series of excerpts derived from Alhazen, Bacon, and Peckham. Ghiberti was thoroughly up-to-date in his choice of authorities, since the medieval writers were the only available source of knowledge. It was not until later in the century, when artists turned to the serious study of anatomy, giving much-needed impetus to the practice of dissection, that direct observation began to supplement medieval and antique authority. The immediate interest does not, however, lie in these, and in similar passages dealing with proportion, or with reflection and refraction, but in those which treat of the means whereby the size and distance of visible objects are known to the beholder.[46]

In a long series of extracts from Alhazen and Peckham, five main propositions are put forward. These are that: (*a*) Visible things are not comprehended by means of the visual sense alone. (*b*) It is only possible to judge the distance of an object by means of an intervening, continuous, series of regular bodies. (*c*) The visual angle alone is not sufficient for the judgement of size. (*d*) Knowledge of the size of an object depends upon a comparison of the base of the visual pyramid with the angle at its apex, and with the intervening distance. (*e*) Distance is most commonly measured by the surface of the ground and the size of the human body.

The scope of the first proposition is to show, through a complicated argument, that vision is not purely a mechanical function of the eye; that it is meaningless without the operation of the intellect.[47] The understanding of any object in relation to its surroundings is found to depend upon the comprehension of five things. These are its lighting, its colour, its remoteness, its parts, and finally, the magnitude of the intervening distance.[48] As a result the nature of the thing seen is not understood 'except through discrimination, or recognition, or proof . . .'.[49] This conception of seeing, and of the function of the intellect, is extremely close to that underlying Alberti's 'Della Pittura'. It is the particular virtue of the new perspective that it contains within itself the true principles of nature. The processes of measurement and comparison, which alone give meaning to what is seen, attain a mathematical precision beyond the reach of the fallible human eye and mind. If some recent theories of visual perception seek to supersede this coach and driver view of the relationship of eye and intellect, it is only because the true complexity of the eye and its reflexes are just beginning to be understood. The fact that many of the judgements which Alhazen and Ghiberti, and their successors to the present day, believed, and still believe to take place in the controlling intellect, may actually be automatic responses to stimuli within the eye itself, does not detract from the importance of such ideas for the genesis of the new perspective.[50] Nor does it render them less valuable as a corrective to the crudely mechanical approach which is all too often to be found amongst writers on the processes of sight and their relation to artistic matters.

The Development of the Theory of Artificial Perspective

The coincidence between the form taken by the new artificial perspective and the analysis of visual experience given by the medieval authorities on optics is carried even further in the second proposition. Here the authority is once more Alhazen, who proves his point by two experiments.[51] In the first he shows how difficult it is to judge the height of clouds above a level plain. Error is almost certain. Yet, if there are mountains which reach into and above these same layers of cloud, the estimation of their height becomes quite easy. Even so, since it is a matter of calculation, it is later shown that only moderate distances can be measured accurately by the eye. Beyond them the visual angle becomes too small, and the spatial divisions are indistinguishable from each other. The second experiment is similar in nature. This time the observer looks through a peep-hole at the tops of two walls, which lie across the line of vision with their bases out of sight. It is then found to be utterly impossible to tell how far apart the two walls are.[52] It is only by comparison with some known distance that the unknown can be measured. The empirical nature of the judgement of depth is therefore established, and with it the necessity for a continuous, intervening series of regular objects.

'Non igitur comprehenditur quantitas remotionis rei visae a sensu visus, nisi remotio respexerit corpora ordinata continuata.'[53] This is matched in Alberti's artificial perspective by the fact that the first operation is the establishment of a regularly subdivided and diminished, rectangular pave-ment to provide the necessary measuring rod.

The next two propositions are derived from Peckham, who compresses into two short 'conclusiones' ideas that Alhazen elaborates in a series of lengthy sections.[54] First Peckham demonstrates that there is no direct con-nection between the angle at the apex of a triangle and the length of the triangle's base line. The visual angle alone is therefore insufficient as a means of judging size. Then he shows that all apparent sizes depend on a comparison of the visual angle and the base line of the visual pyramid, and that it is only by a further comparison of the latter with the distance intervening between object and observer that its true dimensions can be judged. A hand held in front of the eye will, he observes, blot out a large wall. It is only through a knowledge of their relative distances that their sizes can be compared.

Finally, it is once more in the words of Alhazen that the fifth important conclusion is set forth.[55]

'Bodies, therefore, which are orderly and continuous in relation to the distances of visible objects, are in the majority of cases parts of the ground, and familiar visible things, which are always understood by the visual faculty and more often they are the surfaces of the ground. . . . The most importan. of these, the size of which is certified by the visual faculty, is that which is at the feet: since the magnitude of that part, which is at the feet, is understoor by the visual sense and by the distinguishing faculty, and the visual sense certifies it by the measurement of the body of man.'

This passage is striking in two respects. The first is its similarity to that in which Alberti insists, with added classical allusions, but more restricted purpose, that man is the measuring rod of nature.[56] The second is that it confirms that the ground plane provides the most satisfactory and familiar, ordered, and continuous series of objects which can be used to measure distance. It therefore comes even closer than the second proposition to the formulation of the idea of the foreshortened, rectangular pavement which, in artificial perspective, creates, and measures out, the space that contains all the objects of the pictorial world. The very size of the subdivisions, based upon the stature of a well-built man, stresses the point already made by Alhazen.

These passages, which reveal the medieval view of the visual perception both of size and distance, do not explain the emergence of artificial perspective. They do show, however, a clearly defined conception of visual reality that was potentially fertile ground in a period of rapidly growing interest in the representation of space. It only needed the application of these ideas to representational problems for them to provide the complete basis for a system of perspective. The structure of Alberti's artificial perspective reveals at every stage ideas which are the exact reflection of those found in the medieval texts. It seems most likely that just such an application of optical theory to representational problems lies behind the invention of the new system. Such a process also explains the continued interest in the same texts not only on the part of Ghiberti himself, but also on that of Piero della Francesca and Leonardo da Vinci. The explanation of the necessity for artificial perspective given by Piero in the introduction to the third book of the De Perspectiva Pingendi provides, perhaps, the clearest evidence of the close connection of medieval optical and renaissance perspective thought.[57] He says:

'. . . since one part of any quantity is always closer to the eye than another, and the nearer part always appears under a greater angle in relation to the fixed limits, and because it is not possible for the intellect by itself to judge their measurements, that is to say how great the nearer and how great the more distant, therefore I say that perspective is necessary, which discerns all the quantities proportionally like a true science, showing the diminution of any quantity by means of lines.'

In this single sentence just those ideas which Ghiberti found in the writings of Alhazen and Peckham are adduced as the justification for artificial perspective. Throughout the medieval texts it is axiomatic that 'seeing' involves 'knowing', and that the knowledge of distance is one of the elements of this understanding of what is seen. The same conception of sight underlies Alberti's insistence that there must be some rule whereby this knowledge of the painted object can be passed on to the beholder before it can 'appear like the real'. It is the knowledge of the actual size which gives meaning to the appearance in the eye. It is with the actual size that the scientific painter must concern himself.

The Development of the Theory of Artificial Perspective

This close connection between medieval and renaissance ideas reveals Ghiberti's intention in writing the *Third Commentary*, which was to deal with natural perspective or optics. He wished to summarize for his contemporaries the conception of visual reality which was the basis and justification of the new system. This had not been done by Alberti, whose treatise, as he himself repeatedly says, is essentially practical rather than theoretical in approach. Whatever doubts may be entertained about the success of Ghiberti's undertaking, mangled as it is in subsequent transcription, the enterprise as such was certainly worthwhile. Ghiberti had himself used Alberti's artificial perspective with great success. It had made an essential contribution to the crowning achievement of his life's work as a sculptor. In the light of his experience, he rightly considered that the new pictorial science did not outmode the medieval writings. On the contrary, it gave them a new immediacy for artists and theorists alike.[58] Ghiberti's very lack of originality, his faithfulness to ancient texts invested with a sudden, new significance, furthers an understanding of the meaning and historical position of the new perspective system.

NOTES

1. The authorship is not certain, but is usually attributed to Antonio Manetti. All quotations are taken from Antonio Manetti, *Vita di Filippo di Ser Brunellesco*, ed. Elena Toesca, Roma, 1927, in which the attributional arguments are referred to briefly on pp. xi ff.
The succeeding passage occurs in op. cit., pp. 9 ff. The nearly literal translation is the present writer's, and is used because in E. G. Holt, *Literary Sources of Art History*, Princeton, 1947, which might otherwise have been quoted, there are, in certain passages, assumptions based upon the knowledge of what follows.

2. Manetti, op. cit., pp. 10 ff.

3. The Florentine braccio equalled a distance of ·5836 metres at the time of the adoption of the metric system. In the fifteenth century it seems to have been slightly longer, but varied a good deal, often according to the thing being measured. The analyses which follow would only be affected if Manetti had in mind a distance substantially shorter than seems to be the case.

4. The width of the present door at floor level is slightly less, and above the base moulding slightly more than the figure given.

5. With the actual figures given, the angle of vision would be about ninetyfour degrees, but as none of the historical information is exact only the general import of the description can be assessed.

6. The orthogonal mouldings on the forward pillar to the right of the entrance are distinguished in the drawing from their continuations in the mouldings framing the reliefs. The recession of the former is slightly steeper. This break in continuity implies that the forward pillars are rectangular, and not splayed, whilst the walls beyond them run together slightly. In such small details it is, of course, possible that the apparent distinction is only a personal trick of draughtsmanship.

7. See K. Rathe, *Der Figurale Schmuck der alten Domfassade in Florenz*, Wien, 1910, Fig. 1. This also includes a large reproduction of the drawing in the Opera del Duomo.

8. If Talenti's entrance was 3·5 metres deep, the angle of splay would have to be 25 degrees in order to widen the forward opening sufficiently to change the angle of vision by 30 degrees.

The Development of the Theory of Artificial Perspective

A greater depth would decrease, and a lesser increase the amount of splay needed, assuming that the width of the door itself was about 6 braccia.

9. Taking Manetti's measurement from the actual door, the entrance would, assuming that it was rectangular, only have to be about three braccia, or 1·75 metres deep in order to restrict the view in this way. Judging from the surviving representations it is most unlikely that its depth was less than three-quarters of the width of the doorway or about 4½ braccia. In that case the angle of vision would have narrowed to about 43° and parts of the Baptistry itself would already have disappeared. The reconstruction based on measurement from the door itself, given in R. Krautheimer, *Lorenzo Ghiberti*, Princeton, 1956, pp. 234 ff., therefore seems unlikely to be correct.

10. The diagram was drawn by combining a scale drawing supplied by the Ufficio Technico Erariale di Firenze with the reconstruction of the piazza as it was in 1427 given by G. Carocci in *Studi Storici sul Centro di Firenze*, Firenze, 1889, p. 17.

11. G. Vasari, *Le Vite*, ed. Milanesi, Firenze, 1878, vol. ii, p. 332.

12. Manetti, op. cit., pp. 11 ff.

13. In fact Brunelleschi evidently manipulated the viewing distance which, being doubled by the use of a mirror, comes to between 1½ and 2 braccia, or three to four times the width of the panel, giving a visual angle of between 19 and 14 degrees. The reasons for this action are clear. It is impossible to embrace anything like a ninety-degree angle through a hole of the kind described, and the reduced angle actually used is satisfactorily close to the angle of clear vision. It is significant that this manipulation would have greatly accentuated the impact of the forward corners of the piazza had they been included.

14. Manetti, op. cit., pp. 12 ff.

15. W. Limburger, *Die Gebäude von Florenz*, Leipzig, 1910, gives the original position of all the buildings mentioned. S. Romolo, p. 149, Calimala Francese, p. 198.

16. On entering a rectangle at one of its corners, a diagonal direction of attention is pressed upon the spectator, even where there is no such strong architectural attraction.

17. Limburger, op. cit., p. 112.

18. Vasari, op. cit., vol. ii, p. 332.

19. Limburger, op. cit., p. 139.

20. E. Muntz, *Les Collections des Medici au XVᵉ Siècle*, Paris, 1888, p. 62.

21. The height of a man being very small compared with that of the buildings shown, a high viewpoint would have the effect of lifting the onlooker off the ground.

22. Here the boundaries of the visual field are not controlled by an assumption of the 90-degree visual angle with which it coincides, but by the fact that any widening of this angle would introduce buildings the façades of which, because of their orientation, could not be shown by means of artificial perspective or of any similar system.

23. No detailed reconstruction of the technical procedure used in drawing these pictures has been attempted, since there is no way of deciding between the various possibilities. It should, however, be noted that the oblique setting could have been accurately achieved without recourse to the distance point construction. Nevertheless, in view of the evidence discussed by Klein, op. cit., pp. 211–30, considered in note 36 below, the possibility that the latter system was used cannot be disregarded. An illuminating discussion of Brunelleschi's possible technical procedures occurs in A. Parronchi, *Studi su la dolce prospettiva*, Milano, 1964, pp. 226–95, but it remains most unlikely that none of the ground in front of the Baptistry was shown, whilst the unbalanced design of the second panel is both improbable in the early fifteenth century and only generated by an unwarranted and radical diagrammatic reorientation of the west side of the Piazza.

24. Even so, this would probably allow some at least of the upper parts of the frontal surfaces of various buildings to appear as a result of their uneven heights. This would, however, have far less effect upon the composition than the potentially completely visible frontal surfaces of the buildings in the foreground at the nearer corners of the piazza.

25. All references are to the critical edition of the Italian text, Leon Battista Alberti, *Della Pittura*, ed. L. Mallè, Firenze, 1950. For critical notes on this edition, see C. Grayson, *Studi su Leon Battista Alberti*, Rinascimento, iv, 1953, pp. 45–62.

26. See E. Panofsky, *Renaissance and Renascences in Western Art*, Copenhagen, 1960, pp. 42 ff.

27. Alberti, op. cit., fols. 120ᵛ–1ʳ, ed. Mallè, pp. 55–8, and fols. 121 ff., ed. Mallè, pp. 58 ff.

28. Alberti, op. cit., fol. 121ᵛ, ed. Mallè, p. 59, para. 3.

29. Alberti, op. cit., fol. 123ʳ, ed. Mallè, p. 65.

30. Alberti, op. cit., fol. 124ʳ, ed. Mallè, pp. 68–70.

31. Alberti, op. cit., fol. 124ᵛ, ed. Mallè, p. 70.

32. Alberti, op. cit., fol. 130ʳ, ed. Mallè, p. 91.

33. Alberti, op. cit., fol. 124ᵛ, ed. Mallè, p. 71.

34. Alberti, op. cit., fols. 124ᵛ–5ʳ, ed. Mallè, pp. 70–3.
The base line of the perspective window is divided evenly, each division being a third of the height of an average man. Then the point of sight is fixed at a height usually corresponding to that of the figures to be inserted later, so that the spectator will seem to stand on the same plane as they do. The point of sight is defined as that point 'il quale occupi quello luogo dove il razzo centrico ferisce'. The central point in the construction is therefore understood as being distinct from the eye, or viewpoint, and despite the many subsequent diagrams in which an eye is inserted at this spot, is actually a 'vanishing point'. The latter is next joined by straight lines to the divisions of the base. Then, possibly on another sheet of paper, the divided base line is repeated, and a second point placed at the same height above it as the first. This point may be placed at any distance from either end of the base line providing that it be greater than that which is to intervene between the eye of the beholder and the picture plane. This point is, in its turn, joined up to the divisions of the accompanying base line. Then, when the spectator's distance has been decided, a perpendicular is dropped at the same distance from the constructional point, and this represents the intersection of the visual pyramid by the picture surface. The points at which the perpendicular is cut by the lines joining the point of sight to the base line indicate the precise distances separating the transversals of the foreshortened pavement which the artist wishes to create. Finally these proportions are transferred to the original perspective window. The result is a perspective square itself divided into smaller squares. These sub-divisions diminish in such a way that any multiplication of the supposed distance from the spectator of any given square is accompanied by a corresponding division of its dimensions. This does not, it must be noted, produce an A is to B, as B is to C, as C is to D relationship between successive transversals as is stated in E. Panofsky, *The Codex Huygens and Leonardo da Vinci's Art Theory*, London, 1940, pp. 96–7, but instead results in a direct proportional relationship between distance and apparent linear size.

35. Alberti, op. cit., fol. 125ᵛ, ed. Mallè, p. 73.

36. The distance point construction, which was popular in the north, is based on the fact that the diagonals of all squares, or, in other words, all lines on any plane which run into the pictorial space at an angle of 45 degrees, meet at a point the distance of which from the vanishing point is equal to that between the picture plane and the eye. (Illus. Panofsky, *Codex Huygens*, p. 96, the accompanying observations on diminution, referred to in note 34 above, being equally false when applied to this method.) R. Klein, 'Pomponius Gauricus on Perspective', *Art Bulletin*, xliii, 1961, pp. 211–30, has shown the extent to which, on the evidence, the distance point construction must have been used by Italian artists in the fourteenth and early fifteenth centuries for the construction of objects seen in an extreme oblique setting and for the drawing of chequerboard patterns. As is clear from the paintings of the period, the unification of the pictorial space as a whole does not necessarily follow from the use of the system for particular constructional purposes of this kind. The article contains an interesting discussion of Ucello's 'anti-Albertian' exploitation of the system, and of the latter's theoretical vicissitudes during the fifteenth and sixteenth centuries in Italy and in the North.

The Development of the Theory of Artificial Perspective

37. Alberti does not actually use the term 'horizon line', but speaks of the 'central line'. Alberti, op. cit. fol. 128v, ed. Mallè, pp. 86–7.

38. Alberti, op. cit., fol. 124v, ed. Mallè, pp. 70, 72 in particular.

39. The method is well described and illustrated in Panofsky, *Codex Huygens*, pp. 93–4.

40. Panofsky, 'Die Perspektive als "symbolische Form",' loc. cit. notes 10, 11, pp. 295–6, speaks of the effect of straight line perspective on visual habits. The built-in curves of Greek architecture, and their late rediscovery, are discussed in W. H. Goodyear, *Greek Refinements*, London, 1912.

41. Illus. A. Lensi, *Palazzo Vecchio*, Milano, 1929, p. 33, p. 30.

42. A number of modern photographs show the piazza from the same standpoint as that taken by Brunelleschi, but such things are apt to be aesthetically misleading. One of the closest, although from a high viewpoint, is in Lensi, op. cit., p. 45.

The nearest artistic approach is probably the Jacques Stella etching of the 'Fiesta degli Omaggi', illus. Lensi, op. cit., p. 279, which, however, takes in a wider range of buildings than was possible for the earlier perspective method.

43. Ghirlandaio's fresco is partially reproduced, and the Vasari and Stradano versions completely shown together with the Savanarola panel, in Lensi, op. cit., pp. 31, 223, 277 and 94. Similar views occur in the background of a portrait attributed to Piero di Cosimo (London, National Gallery No. 895) and in numerous engravings.

R. Wittkower, 'Brunelleschi and "Proportion in Perspective",' *Journal of the Warburg and Courtauld Institutes,* vol. 16, 1953, pp. 275–91, uses later texts and monuments in order to explain the genesis of Brunelleschi's invention. It is, however, by no means curious that of the small, closely knit circle which included Masaccio and Donatello, it should have been Brunelleschi, the architect and sculptor, who invented the new method, any more than it is curious that Donatello, the sculptor, investigated and exploited its application more thoroughly than any contemporary painter. The separation of the arts was not a feature of the early Renaissance.

There is no textual support for the belief that perspective was invented to justify architectural proportion, and plenty of evidence that it was invented in order to give proportion to painting, and to make the representation look like the thing represented when undergoing the optical distortions which affect object and picture alike.

As is observed in the article (loc. cit., p. 281), Alberti not only asserts that perspective views should not be used by architects in the process of design, but nowhere mentions perspective as giving additional validity to the metrical architecture which is his own chief claim to fame, a strange omission if this was indeed a major motivating force in its invention. It is, moreover, important to remember that Brunelleschi's invention of perspective appears to antedate the emergence of the new proportional architecture, and it may well be this fact that led Alberti to refer to painting as the 'maestra' of architecture.

The written evidence also shows that, as with most discoveries, the full mathematical, philosophical, and aesthetic implications were only gradually realized, some of them not until the seventeenth century. Similarly, the artistic remains show that it only gradually came to affect ways of seeing. It is significant, and not unexpected, that works such as S. Satiro should only occur at the end of the fifteenth century. Brunelleschi's own panels show that, for him, his new invention had not yet fully obscured or superseded the Giottesque way of seeing and composing.

The written evidence, whether mathematical or more directly aesthetic, and the surviving paintings, sculptures and buildings, all seem to demonstrate that the ideas characterized in such a masterly way and attributed to Brunelleschi in fact belong to the periods in which the records of them emerge; that they are conditioned by the existence of the new perspective, and cannot be transposed in time in order to explain its invention.

44. For Leonardo's views on the Paragone, which greatly interested him, see I. A. Richter, *Paragone*, London, 1949.

The Development of the Theory of Artificial Perspective

45. J. von Schlosser, *Ghiberti's Denkwürdigkeiten*, Berlin, 1912, is the definitive modern edition. A very useful concordance and discussion of Ghiberti's relation to his sources is given in G. ten Doesschate, *De Derde Commentaar van Lorenzo Ghiberti in Verband met de Mildeleeuwsche Optiek*, Utrecht, 1940.

46. Ghiberti, fols. 32v, 37r. Schlosser, op. cit., pp. 126–43.

47. Alhazen, *Opticae Thesaurus*, ed. Risnerus, Basle, 1572, bk. ii, sect. 22. Ghiberti, fol. 32v. Schlosser, op. cit., p. 127.

48. 'Remoteness' in this context simply means lack of contact, without any quantitative significance.

49. Alhazen, op. cit., bk. ii, sect. 23. Ghiberti, fol. 33r. Schlosser, op. cit., p. 128.

50. Interesting hypotheses concerning the processes of vision are advanced in J. Gibson, *The Perception of the Visual World*, Cambridge, Mass., 1950. See also R. L. Gregory, *Eye and Brain*, London, 1966.

51. Alhazen, op. cit., bk. ii, sect. 25. Ghiberti, fol. 33v. Schlosser, op. cit., p. 131. Similar experiments are still described in modern textbooks of which a particularly interesting example is W. H. Ittelson, *The Ames Demonstrations in Perception*, Princeton, 1952.

52. There may be some confusion between monocular and binocular vision in this passage, but this is immaterial as the scope of the experiment is only to show the inadequacy of the visual angle for judging distance.

53. Alhazen, op. cit., bk. ii, sect. 25.

54. John Peckham, *Jo. Archiepiscopi Cantuariensis Perspectiva Communis*, ed. Gauricus, 1504, Conclusiones 73, 74. Alhazen, op. cit., bk. ii, sects. 36, 37, 38. Ghiberti, fol. 34v. Schlosser, op. cit., p. 134.

55. Alhazen, op. cit., bk. ii, sect. 39. Ghiberti, fol. 35r. Schlosser, op. cit., p. 136.

56. Alberti, op. cit., fol. 124r, ed. Mallè, pp. 68–70.

57. Piero della Francesca, *De Prospectiva Pingendi*, ed. N. Fasola, Firenze, 1942, p. 129.

58. The fact that Ghiberti's treatise nowhere overlaps that of Alberti seems, in itself, to show that Ghiberti wrote late in life with full knowledge of Alberti's ideas. It seems likely that Ghiberti's selection from his antique and medieval sources was intended to be a complementary work, filling in the optical and philosophical background, and setting the whole within the historical framework of contemporary artistic developments.

CHAPTER IX

Masaccio

Ten years before Alberti's book was written, the ideas which Brunelleschi first translated into paint were given monumental form in fresco by Masaccio. Yet, as the spectator stands in the Brancacci Chapel and looks out on the pictorial world beyond the window of the wall, there may come the sudden feeling that although this world has grown a mightier race of men, who walk in their majestic certainty upon a freer, wider, and a firmer earth, his own relation to it has not changed as much as might have been expected. This realization calls to mind the slow, century-long preparatory process by which the whole meaning of the picture surface was seen to be transformed. Once again the past gives scale and meaning to the present.

In the Brancacci Chapel there is a classical form and classical economy in the painted architectural framing of the scenes. A single narrow architrave runs in an unbroken line from wall to wall, dividing the pictorial field into two equal parts. Corinthian pillars fill the corners, completing the closed framework of the frescoes, and at the same time satisfying the minimum demands of structural logic. There is nothing in between this architectural frame and the pictorial world which it encloses. Equally, nothing intervenes between the architecture and the onlooker, now firmly placed in the middle of the chapel, his position determined with new emphasis by the central focus of the unified vanishing points in all the compositions on the side walls. This stationing is further reinforced in the Shadow Healing and Almsgiving scenes on the end wall by the recession of the orthogonals towards the centre of the altar which divides them.[1] These two external vanishing points, without actually coinciding, give sufficient emphasis to the spectator's central placing as he stands, enclosed by the framework of the architecture, and looks out into the depths beyond. The wall has melted, and reality and picture are one world to the imaginative eye.

The similarity in the framing of the works of Maso and Masaccio, and of the latter's successors throughout the fifteenth century, is no coincidence, and it completes the picture of the growth of the ideas first put down on paper by Alberti. The theoretical basis lies in the medieval texts. The gradual approximation to the vanishing point during the fourteenth century, and the altering relationship between onlooker and picture, show the practical, empiric, roots of the new theory in the more immediate past. In the light of this his-

torical continuity,˙it is possible to emphasize the revolutionary aspects of the fifteenth-century achievement without danger of distortion.

Of Masaccio's own beginnings little enough is known. It seems probable that Brunelleschi's famous panels had a considerable, direct influence upon his earliest productions. The reconstruction of the view of the Piazza della Signoria adds to the significance of a passage in which Vasari, having emphasized the artist's close relationships with Donatello and Brunelleschi, says, in addition, that:

'He diligently studied methods of work and perspective, in which he displayed wonderful ingenuity, as is shown in a scene of small figures now in the house of Ridolfo Ghirlandaio, in which besides Christ releasing the man possessed there are some very fine buildings so drawn in perspective that the interior and the exterior are shown at the same time, as he took for the point of view, not the front, but the corner for its greater difficulty.'[2]

The probable accuracy of Vasari's description is supported by the exis-tence of the panel in the Johnson Collection (Pl. 30, *a*) which, if it is not actually the picture that is mentioned, must be very closely associated with it.[3] The added difficulty of the viewpoint is naturally present only in Vasari's eye, conditioned as he was by the then century-old dominance of the fore-shortened frontal patterns fostered by Alberti's pictorial method. The obliquely set representation of the Florentine Duomo in the Johnson panel is not an accurate bifocal structure. Only the main architectural lines receding to the left run to a single point, and there is a similar uncertainty in the perspective of the arches. The picture does, however, prove that in the circle of Masaccio, as well as amongst artists such as Lorenzo Monaco, the interest in the patterns of the previous century survived, although, as was suggested earlier, the immediate impetus in the former case was probably provided by Brunelleschi.

This is confirmed by the predella of the Pisa altarpiece which is Masaccio's one remaining documented work. Here the strongly oblique setting of the right-hand panel with the story of St. Nicholas, of which the execution by Masaccio has been doubted,[4] is balanced by the softer, but quite definite recession in the opposite sense that is apparent in 'The Crucifixion of St. Peter'. In this scene the forward surface of the left-hand pyramid is in reces-sion, and its base lies in a slightly deeper plane than that of its counterpart upon the right. There is therefore a soft slipping backwards into space upon both wings of the predella, in conformity with the Florentine empirical tradition that had also influenced Brunelleschi's compositions.

The development of Masaccio's figure style, which is evident in the various panels of the altarpiece, is reflected in perspective by the accurate vanishing-point construction of the monumental throne. The same interest in spatial problems is also revealed by the foreshortened halo of the Christ Child, and in the bold attempt to foreshorten both the cross and the figure of Christ Crucified in the panel which surmounted the whole altarpiece.

Masaccio

In the frescoes in the Brancacci Chapel the fundamental idea of the new perspective is expressed by the architectural framing. In the scenes themselves the compositional patterns indicate something of the potentialities of the system, and are, in their turn, influenced by it in a way that is characteristic of its effect on pictorial decoration throughout the fifteenth century.

[In all the scenes containing architecture, the horizon line, marked by the vanishing point, is at the same height as the general level of the heads of the participants.]In this way the onlooker is placed on the same level as the figures, precisely as Alberti later recommended. In each scene the frontal surfaces of the houses all lie undistorted in the plane, expressing the underlying ideas of artificial perspective which were crystallized in the rectangularity of Alberti's foreshortened pavement. The single vanishing point reveals itself not only as a symptom of the new spatial unity, knitting together all the contents of the scene—landscape, houses, figures, every detail—but also as a powerful compositional weapon.

In 'The Shadow Healing' and 'The Almsgiving' it is used, as has been noted, to express the relation of all the frescoes to the observer at the centre of the chapel. The simplicity and unity of the composition needs no further emphasis in either case, and the external vanishing point is used to great advantage in 'The Shadow Healing' to increase the sense of movement. In the companion scene the figure design is stressed in Giottesque fashion by the verticals of the architectural setting. A very different problem is posed, how-ever, by the three large frescoes on the side walls. Each is made up either of a complex of several episodes within a single story, or else of a single episode in time involving several centres of attention.

One of these three scenes, namely 'The Healing of the Lame Man, and the Resurrection of Tabitha', is distinguished by the structural peculiarity that the vanishing point expresses nothing but the unity of the space in which the separate incidents take place. It enhances neither narrative. Even the attempt to strengthen the connection across the central void by associating it with a pair of youths, who walk diagonally from the background past one episode in the direction of the other, is largely foiled. They themselves are so engrossed in conversation that they seem to be oblivious of the miracles of resurrection on the one side and of healing on the other. Only the mechanical qualities of the spatial unity are recognized.[5] This essentially non-dramatic use of artificial perspective does nothing to detract from the exploitation of its depth-creating qualities. The eye is swept straight into the pictorial space, and the abrupt change of architectural and figure scale gives instantaneous expression to the distance travelled. The very drama of the change of scale itself reveals, however, that the journey has no close connection with the action concen-trated in the foreground. Here is the joy of space creation largely for itself—exuberant exploitation of a new-found power.

'The Tribute Money' on the opposite wall betrays a striking difference in

emphasis. Nothing is for itself alone, and everything for the story told in terms of monumental human figures. The threefold action weaves the composition. The receding lines of the perspective hold the eye within the circling stillness of the central galaxy. Christ, the source of action and the centre of the composition, is the focus of the spatial unity. Trees recede into the distance, and the mountains loom and fade into a landscape at once closer and more spacious than any in the art of the preceding centuries. The forms of nature give expression to the monumental calm of the majestic figures. Space surrounds them like the heavy-folded cloak of the apostle on the right. It has its own reality, its own existence. Yet its meaning lies within the figures it contains. So cloak and body, individual and group; so man and architecture, house and landscape, space itself; each, gaining independence and reality, gains new power which may be harnessed in the service of the story.

The architecture in 'The Tribute Money', owing its new independence of the figures to its increased structural certainty, takes on fresh importance, both in terms of spatial definition and of compositional control, through its single focus in the head of Christ. At the same time, both in this scene and in that of 'The Raising of the King's Son', it shows its clear subordination to the action by its scale. Masaccio exercises similar control of its extension into depth. The simple, shallow, firmly limited space in the scene of 'The Raising of the King's Son' is the monumental counterpart of the carefully controlled complexity of the architecture in the small tondo of the Birth Plate in Berlin.[6]

The role of the architecture on the walls of the Brancacci Chapel is not confined to its effect upon the composition of a single fresco. It also plays a new part in relation to the spatial content and essential function of the chapel as a whole.[7] The house on the right of 'The Tribute Money', framing a separate incident in the action, is beside the altar. In 'The Healing of the King's Son', immediately below, a similar architectural division again enframes a separate action. The enthroned figure of St. Peter praying, with the kneeling circle at his feet, in fact underlines Masaccio's compositional creation of a sort of choir, or alcove for the altar.[8] Only in 'The Healing of the Lame Man, and the Resurrection of Tabitha' does the pattern falter. But in this case the design, and to a great extent the execution, are attributed by many to Masolino rather than to Masaccio. It is solely through the power of the new perspective, carefully controlled at every stage, that Masaccio is able, at one stroke, to use the architectural features of his compositions as individual frames for the separate elements of a complex action, and as a means for the articulation of the space in which the observer stands, so that its ritual significance and functional divisions gain new emphasis, whilst actually reinforcing the pictorial unity of each composition as a whole.

In what is probably the latest of Masaccio's works in Florence, the fresco of 'The Trinity' (Pl. 30, *b*) in Sta. Maria Novella, architecture and perspec-

tive play not merely an important, but almost a dominant role in the design.]
(The casual quality of the Brancacci architecture, despite its intricate composi,
tional function, the seemingly effortless relation of the figures to the space
surrounding them, give way to something more ambitious. The grandeur
of the massive barrel vault, and of the Ionic and Corinthian columns and
pilasters, is a new departure. The architectural majesty of the design is only
equalled by the calm ability of the figures to retain their rightful mastery. The
interaction of the two creates dramatic tension.]

The foreshortening of the architecture, in accordance with the principles
of artificial perspective, is accurate both in the diminution of the coffering and
in the single vanishing point which lies slightly below the plane on which
the donors kneel.[9] The space in which the figures stand is rectangular, and the
precise depth at which they are placed cannot be determined. The sarco,
phagus,like platform upon which the figure of God the Father stands is not
to be placed against the back wall, or supported upon consoles that project
from it. Its upper surface is about four,fifths of the height of the furthest
columns from the ground. This, in terms of the foreground columns, is on a
level with the chest of the figure of Christ upon the cross. Such a position
would, apart from anything else, leave insufficient head,room to contain the
figure of God the Father. The considerable masking of the inner columns
must therefore be attributed to the low viewpoint in conjunction with the
placing of the sarcophagus well forwards in the vaulted space, the ends of
its supports being hidden by the standing figures. How far forwards it is
impossible to tell exactly. It is equally impossible to say precisely how far
back the figures of the Virgin and St. John, and indeed the cross itself, are
placed. From the way in which the front line of the floor cuts off the feet of
the two standing figures, and the fact that St. John turns sideways, and not
backwards, to look at Christ upon the cross, the whole group seems to be at
least within the first half of the chapel space, and probably in the first third.
There is no reason, on grounds of perspective, for thinking that the relation
of the figure of God the Father to the cross he holds is, in any way, either
impossible or improbable. The fact that these two figures of the Trinity are
approximately the same height would seem to show that they are indeed as
closely related as they appear to be, and there is nothing in the fresco to
contradict this supposition.

The general accuracy of construction does not mean that Masaccio was
prepared to follow rules beyond the limits of their usefulness. This is shown
by the varied handling of the foreshortening of the figures. Those of the
Virgin and St. John are seen from the low viewpoint of the architecture,
greatly adding to the realism of the composition. The undersides of both
arms of the cross are likewise visible. But the experiment of 'The Crucifixion'
in the Pisa Altarpiece is not repeated as a whole. Here there is no foreshorten,
ing of the figure of Christ or of that of God the Father. The previous example

of the altarpiece proves that this is no error, but a definite intention. The reasons for it are not far to seek. The general foreshortening, consistent with the placing of the fresco, gives a strong impression of reality to the spectator looking upwards at the scene. The unforeshortened setting of the principal figures, on the other hand, has the effect of raising him to their own level, bringing them closer, and, in this particular case, increasing their emotional and apparitional impact. At the same time a foreshortening that would do nothing to enhance the intrinsic value of the central figures is avoided. Here, where a low viewpoint is combined with a relatively high positioning of the figures in question, the distortion involved would have resulted in a bold theatricality which might detract from, rather than intensify, the spiritual quality of the scene. The shifting of the viewpoint is a device often used, in various forms, throughout the fifteenth century. The added power to control the onlooker's attention gained through the use of several points of view within a single composition was of more importance to the artist than the mathematical implications of his action.

In Masaccio's fresco this controlled manipulation of the new perspective plays an essential role in making it possible for the Eternal, at the apex of the great sloping triangle of figures, to dominate the monumental, architectural space created with the aid of that same science. As soon as this is realized, the analytic mind is able suddenly to comprehend the full artistic value of a thing which the inarticulate eye accepted from the first. It is precisely because the entire central group is not irrevocably anchored to a single, sharply indicated point in space that it can take its place either within the spatial pyramid of figures running into that great cavity which Vasari so admired, or as part of a triangle piling up the surface of the wall. The sloping arms of this plane-stressing triangle continue through the capitals of column and pilaster, forming a St. Andrew's cross, which ties the massive verticals together and builds up a surface pattern of a strength and severity that is equal to the task of balancing the thrust of mathematically determined space.

This structural pattern seems to echo the work of Brunelleschi both as an architect, and as the creator of perspective. How much it may also reflect the vision of the sculptor Donatello, whose influence is so evident in the figures, will, perhaps, appear in the discussion of that artist's revolution of the art of the pictorial relief.

NOTES

1. See J. Mesnil, *Masaccio et les Débuts de la Renaissance,* La Haye, 1927, p. 71, in which the role of perspective is one of the chief topics discussed. See also J. Mesnil, 'Die Kunstlehre der Frührenaissance im Werke Masaccios, *Vorträge der Bibl. Warburg,* 5, 1925–6, pp. 122–46, and R. Oertel, 'Die Frühwerke des Masaccio', *Marburger Jahrbuch fur Kunstwissenschaft,* 7, 1933, pp. 191–289.

Masaccio

2. Vasari, ed. Milanesi, op. cit., vol. ii, p. 290.

3. For discussion, see Mesnil, lib. cit., pp. 45 ff., and H. Lindberg, *To the Problem of Masolino and Masaccio*, vol. i. B. Berenson, *Catalogue of a collection of Paintings*, vol. i, Philadelphia, 1913, p. 14, suggests the authorship of Andrea di Giusto.

4. The design, which is all that concerns the present analysis, must, however, have been supervised by Masaccio.

5. It is impossible to enter into the innumerable arguments concerning the authorship of this fresco. Mesnil, lib. cit. and Lindberg, op. cit., give good bibliographies.

6. Mesnil, lib. cit., pp. 92 ff., and Lindberg, op. cit., pp. 186 ff., the latter rightly putting great emphasis on the monumental figure on the reverse.

7. The following analysis of the relation of the frescoes to the architecture was given to me by J. Wilde.

8. The design of Filippino Lippi's fresco on the right wall does not follow this pattern, despite its division into two scenes.

9. See G. J. Kern, 'Das Dreifaltigkeitsfresko von Sta. Maria Novella', *Jahr. der K. Preuss, Kunstsamm.* xxxiv, 1913, pp. 36–58, who gives an essentially correct ground plan which has not, however, wholly dispersed the aura of uncertainty left by various erroneous attempts at reconstruction. The rediscovered lower section, which was unknown to Kern, is illustrated in U. Schlegel, 'Observations on Masaccio's Trinity Fresco in Santa Maria Novella', *The Art Bulletin*, vol. xlv, 1963, pp. 19–33.

CHAPTER X

Masolino

Masolino's attitude to pictorial space and to the new perspective is epitomized by the two faces of the altarpiece of 'The Madonna of the Snow' which he designed, and largely painted, for the Basilica of Sta. Maria Maggiore.[1]

The character of the painting on the back of the altarpiece is set by the central panel of 'The Assumption' (Pl. 31, a). The gradual diminution of the angels, accompanied by a lightening of the colour as the eye moves up the panel, appears to be dictated by a desire to fill the lower surface of the picture satisfactorily without making the mandorla seem top/heavy, rather than by any wish to create a deep recession of the figures. The inward movement of the lower figures is balanced by the slight projection of the foreshortened body of the Christ at the mandorla's apex. Despite this gentle inwards and out/wards movement that encloses the heavier figure of the Virgin, like the first, slight curling of a leaf, the design is, as a whole, a brilliant surface decoration. Perspective is too harsh a word to use of the soft nuances of space which enhance the wing/beating liveliness of the decorative pattern.

The same restricted interest in pictorial depth is to be seen in the two pairs of saints which flank the central panel. In each case the outer figure faces inwards in pure profile, his companion being shown full/face. The soft, and only slightly plastic forms do nothing to increase the gentle spatial quality of this heraldic disposition.

The contrast on the opposite face, which from Vasari's description must have been the front, is remarkable. Perspective is the dominant factor in the central panel of 'The Foundation of Sta. Maria Maggiore' (Pl. 31, b). The foreshortening of the transepts, marked out by the falling snow and sweeping the eye straight into the distance, can only be described as dramatic in inten/tion and effect. The spatial cavity is accentuated by the figures ranged in depth round the miraculous plan, by the steep orthogonals of the buildings that continue the inward movement, and finally by the small, mosaic/hard clouds which run, at times in unbroken lines, out over the distant hills. The change in figure scale between the Pope, plying his mattock in the foreground, and the immediately juxtaposed, diminutive figures of the distant crowd is striking in itself. Already carefully explained by the gradu/ated ranks behind and opposite the Pope, it is accentuated further by the

figure standing at the end of the far transept. His bright yellow tights stand out in sudden contrast to the midnight ultramarine of his scalloped jerkin, and are the brightest note in a colour scheme of pinks and softened reds and greyish browns. Colouristically, therefore, it does nothing to increase the depth. What does happen is that it attracts the eye, and holds it at the furthest point of the dramatically receding ground-plan, whilst the anatomic clarity of the brilliant hose stresses the change of scale. Finally, the contrast between space and plane is made explicit by the visionary figures of Christ and of the Virgin in the top part of the panel. Their relative size, the absolutely circular glory which surrounds them, and the horizontal bar of cloud that closes in the spatial box below, all emphasize the flatness of the panel which is so forcefully attacked in its lower half.

Upon the wings, the pairs of saints no longer stand in profile or full-face. Threequarter views are introduced, and the attempted sharp foreshortening of their arms betrays an interest in space which was not present on the opposite face.[2]

The spatial pattern of the altarpiece as a whole, therefore, reveals both a delight in the traditional qualities of surface decoration and an equally intense enthusiasm for the spatial possibilities of the new, focused system of perspective. These two aspects of pictorial design are, as far as lies within the artist's power, contrasted, and not blended. Each characterizes one face of the altarpiece, and where the two extremes are brought together in the principal panel, they are still divided by a carefully accented compositional break. Even a subsequent rearrangement of the reconstruction of the altarpiece is unlikely to affect this contrast, since the now separated sets of paintings, ascribed to its two faces, were actually sawn apart, originally being painted back to back on single panels. Furthermore, precisely this dichotomy of style recurs, in one form or another, throughout Masolino's major works in fresco.

In S. Clemente, Masolino's interest in perspective is well represented by the complex, steeply foreshortened architecture of 'The Annunciation' placed above the entrance arch of the chapel which he decorated. The design is in sharp contrast to the works of Donatello and Masaccio which it calls to mind, for its perspective is aimed only at the setting of a scene, at the capture of the sudden excitement of architecture seen from an unusual angle, making an unexpected pattern. This excitement is not shared and given human meaning by the figures. The architectural forms themselves do not betray it. It is for itself alone, a sudden vision of new beauty, framing a well-remembered scene with a spatial decoration born of new, and fascinating knowledge.

The fresco of 'The Dispute of St. Catherine' (Pl. 32, *a*) within the body of the chapel is perhaps even more typical of Masolino's outlook. Here everything is done to stress the box-like structure of the council chamber thrusting inwards through the surface of the wall. The panelling of the room looks like a diagram of the new perspective grid which happened to be left in place after

the inclusion of the figures, and then congealed into the form of architecture. Nothing obscures the spatial skeleton. As far as possible, the structural joints, where wall and wall, or walls and ceiling meet, are clearly visible. The figures compensate for any unavoidable blurring of the volumetric clarity by being likewise set in rigid rows that reinforce the inwards plunge.

It is the visual effect, however, not the mathematics of the system, which excites the artist. This is shown by the unregulated intervals in the panelling of the side walls, which conflict with the accurate construction of the ceiling network. On the other hand, the artist shows a definite interest in what might be called the abstract pattern of perspective. The distance point to which the diagonals of the ceiling run is made to coincide with the vanishing point of the next-door composition of 'The Liberation of St. Catherine' (Pl. 32, *b*), and a similar relationship exists between the frescoes of 'The Death of St. Ambrose' and of 'The Flood'.[3]

The enthusiasm for perspective space reveals itself again in the main cornice which runs round the asymmetric architecture of 'The Liberation of St. Catherine' (Pl. 32, *b*). The orthogonals and transversals of this spatial zig-zag are sharply differentiated from each other, and its backwards and forwards movement is further emphasized by its distinctive jet-black colouring. Here, the figures hardly penetrate the principal architectural inlet, and a similar dichotomy is dramatized in the 'St. Catherine Converting the Daughter of the Queen', in which calm figures, placid even in the course of a beheading, are confined to a narrow foreground strip, whilst the architecture plunges back into the depths with all the self-sufficient drama of extreme foreshorten-ing. The latter is a most remarkable pictorial invention, particularly when the date of its creation in the early 1430's is considered. Only in the final quarter of the fifteenth century can it be matched again in Italy. Yet it expresses no essential figure movement, and its dramatic thrust conflicts with the less abrupt recession in the fresco on its left. In conjunction with the wide over-lapping of these two scenes' external vanishing points, this means that despite the many purely decorative elements in the designs, the possible function of the bold recession in creating a visual centre for the whole lunette is anything but furthered. Such compositions stress the ever-present contrast between Masolino's disinterest in the plasticity of his gentle, decorative figures, and his pleasure in sharp-angled geometric space, the thrust of which is subdued neither by his clear, decorative colour, nor by the often weak construction of his buildings.

The extent to which the succession of simple, but irregular, architectural spaces cuts into the left wall of the chapel is underlined by the presence of a sole exception in the landscape of 'The Decapitation of St. Catherine'. The absence of the clearly defined orthogonal thrusting straight into the distance, and also of the geometric measurement of depth, means that the landscape composition is softer in its spatial effect. It is more dependent upon atmos-

pheric qualities which do not break the surface tension of the wall. On the opposite side of the chapel, where, paradoxically, every scene is architec, turally defined, the conflict between space and plane does not obtrude on the observer in this way, since there is no such sudden contrast with an area in which pictorial space and surface decoration are achieved by the same, and not by different elements in the design.

The greatest triumph in the evocation of pictorial space in S. Clemente is the much-damaged fresco of 'The Crucifixion' (Pl. 33, *a*) which covers the whole altar wall. Freed of the limitations which accompany the clarity and exactitude of architectural perspective, Masolino's spatial sense presses him to achieve a revolution in the art of landscape. Nothing on this panoramic scale had been attempted in the ninety years which separate it from Ambrogio Lorenzetti's memorable adventure.

The scene takes place on a high hill, with many of the figures only partly visible upon the downward slope beyond the foreground plateau. All the figures are confined, however, to a relatively narrow forward strip, with the great vista rolling out beyond them to the far horizon. It is a significant pointer to Masolino's attitude that, in spite of this, he does not use the hilltop composition to bring the figures close to the spectator, showing them from a normal viewpoint with the landscape distances unrolling in the background far below. That is the solution typical of figure painters from the time of Simone Martini's 'Guidoriccio da Fogliano' (Pl. 20, *b*) to Castagno's predella scene of 'The Crucifixion' and the Pollaiuolo 'Martyrdom of St. Sebastian'. Here, the panoramic bird's-eye view takes in the foreground as well as the distance, and banishes the monumental figure.

Within the figure composition several things are clear. The first is that the artist has done everything within his power to give a spacious feeling to the foreground, and not merely to the distant view. The figures obey the demands of space, and work to make it real. Those standing break into small, isolated groups. The riders each move in their own direction with a maximum con, fusion which has but a single steady purpose. This is to provide the greatest possible range of different foreshortenings and directions of movement, and thus to emphasize the entire composition's spatial content. Dramatic gesture is the means by which the artist then attempts to hold the purposefully dis, parate elements of his design together. Even so, the eloquent attitudes draw attention not to a single centre, but to three. Each of the crucifixes is the focus of a separate action and a separate interest without being, in any sense, the centre of a formally coherent group. All this is directly contrary to Masaccio's principles of composition even when applied to several actions going on at different times within a single scene. There is no way of connecting the isolated relief groups in the foreground, or the deliberately contrasted and disorganized individualism of the figures in the middle ground of 'The Crucifixion' (Pl. 33, *a*) with the tight, concentrated groups, and calm, figure,

subordinated clarity of Masaccio's compositions. The fresco bears the stamp of Masolino's personal qualities and attendant weaknesses from the nearest figure group to the furthest castled hill.[4]

The artist's unquenchable enthusiasm for pictorial space reveals itself again in the baptistery at Castiglione d'Olona. It is even present in the frescoes on the vaulting of the Collegiata itself, although there it is greatly restricted by the awkward shape of the pictorial fields.

In the whole first half of the fifteenth century there is nothing that can match the exuberance of 'The Feast of Herod' (Pl. 33, *b*), its arched columns stepping gracefully into the distance, and the blind arches racing with them like the palings of a fence seen from the window of a train. Such a clear, uninterrupted sweep of architecture from the foreground inwards to such depth had never been attempted till this time. Such a naive and delicate delight in the depth-creating possibilities of linear perspective and extreme foreshortening is not found again until the days of Jacopo Bellini. By then the springtime softness of the architectural forms of the first years of the Florentine renaissance has been lost.

Once again, the decorative artist is excited by the pictorial possibilities and not the scientific meaning of perspective. The ceiling in the 'Dispute of St. Catherine' (Pl. 32, *a*) shows that he could apply the rules in their entirety, if ever he felt so inclined, which was not often. Here only the unified vanishing point is carefully observed. There is no attempt to give the proper interval between the columns, and so to forge the scientific link between pictorial space and the real world of the beholder.[5] Similarly, the joy in three-dimensional composition far outruns any demands made by the action. The graceful silhouettes move in the very foreground, and the space runs on behind them for sheer pleasure.

This same quality is visible, though to a lesser extent, in the magnificent cloister in the fresco of 'The Namegiving'. Here the single action of the story allows the vaulted tunnel to be more easily related to the demands of the figures. The aged Zachary is indeed felicitously framed by the far archway. Something of grandeur takes the place of gaiety in the now-ruined architecture. Nonetheless the love of making holes in walls with the new weapon of perspective; the desire to show what it could do, to the amazement of the populace, and to the artist's own delight, seems not to be entirely absent.

The feeling for clear colour, decorative figures, and bold spatial play are seen from these analyses to run throughout the work of Masolino. His lack of interest in those fundamental qualities of the human form, which were the province of the great companion who so often shuts him from the sun of critical acclaim, does not diminish his own qualities or his real originality.

Masolino

NOTES

1. The reconstruction accepted in this study is that given by K. Clark, *The Burlington Magazine*, vol. xciii, November 1951, pp. 339–47. The alternative suggestions by J. Pope-Hennessy, *The Burlington Magazine*, vol. xciv, January, 1952, pp. 31 ff. appear to be unsatisfactory for several reasons: (*a*) The perspective structure is fully consistent with the previously suggested central position of the panel, and gives no indication that a position above eye level was intended. (*b*) The downwards glance of the lower left-hand angel in 'The Assumption' is naturally explained by the fact that the figure is playing a portable organ and also looking at it, whilst the angel on the other side is similarly concerned with problems of fingering. (*c*) The scene of 'The Foundation of Sta. Maria Maggiore' tells more than one episode of the story. The snow is actually shown as falling whilst the pope marks out the foundations. The two principal scenes are therefore combined and 'The Miracle of the Snow' cannot also have been a flanking scene. (*d*) In the original proportions, which are not preserved in the reproduction of the reconstruction, St. Jerome looks at the effects of the miraculous intervention, and the Baptist does in fact point at the Virgin and Child, the adult Christ being a traditional method of representation peculiar to Sta. Maria Maggiore (see M. Davies, *The Earlier Italian Schools*, London, 1951, p. 274, note 16). This entry contains copious references to the literature on the altarpiece. The discrepancy in Vasari's text is, therefore, more apparent than real.

Finally, the reconstruction accepted shows exactly what Vasari reports (Vasari, ed. Milanesi, vol. ii, pp. 293–4) and what he would have been able to see from the front. It is also supported by the technical evidence.

2. The very anatomical uncertainties resulting from these boldnesses, the boneless right arm of St. John, St. Jerome's armless hand holding the model church, all appear to show that these saints were designed by Masolino, even if the execution may be Masaccio's. The solution of the problem of attribution given by K. Clark, loc. cit., leads to the difficulty that these uncertainties must be put, at the earliest, very close to the Pisa altarpiece, in which the figures are notable for their structural clarity. The evidence for Masaccio's intervention in the central panel is, moreover, not at all easy to see.

3. R. Oertel, 'Die Frühwerke des Masaccio', loc. cit., p. 213 and Fig. 8, points this out in a study dealing very fully with Masolino's use of perspective.

4. R. Longhi, 'Fatti di Masolino e di Masaccio', *La Critica D'Arte*, vol. iv–v, 1939–40, pp. 145–80, repeats on pp. 162 ff. the attribution of certain figures to Masaccio. But this could, at most, extend to matters of execution.

5. Longhi, op. cit., p. 170, notes the variations in interval in the columns in 'The Feast of Herod' (Pl 33, *b*).

CHAPTER XI

Donatello and Ghiberti

THE EARLY WORKS OF DONATELLO

Donatello's attitude towards perspective is thrown into sharp relief by the contrast which exists between his methods and the characteristic practices of Masolino. In the course of a long lifetime he consistently elaborates the principles emergent in Masaccio's work. In so doing, he shows clearly that artificial perspective enables the artist to do three things.[1] First of all, it allows him to recreate reality in a way that is convincing to the eye as well as to the mind. The relation of solid objects to each other, and to the space which separates and surrounds them, attains fresh clarity. It is possible to 'portray' space convincingly, not merely to suggest it. Secondly, it enables the artist to give a new kind of unity to his design. He can organize its interrelated parts more clearly, and also control the spectator's interest and attention more firmly within the boundaries of this new-found unity. Finally it enables him, if he uses his new tool with care, to achieve a complete harmony, or, for that matter, a deliberate and dramatic disharmony, between his unified, and consciously organized re-creation of reality and the plane surface upon which he works. The latter aim, which differs from the largely unintentional conflicts triggered by Masolino's uninhibited enthusiasm, does not, however, enter into the consciousness of Italian artists until the sixteenth century. It is with harmony and balance, and, in later years, dramatic balance, that Donatello himself is concerned.

Donatello's earliest reliefs are especially interesting, as they reveal his artistic aims at a time when his grasp of the mechanics of the new perspective was incomplete. It is clear that the new discovery did not revolutionize his art by turning it aside into new channels, but by enabling him to develop it in a way which was itself a revolution.

In the relief of 'St. George and the Dragon' (Pl. 34, a) from Orsanmichele, the story in all its simplicity is the essential thing. The architecture is completely conditioned, in scale and disposition, by the needs of the figures, and diminishes towards a point placed in the body of St. George himself. At one stroke a sufficient space is created for the action and the central figure emphasized. At the same time the fairly high viewpoint tilts the ground allowing it to merge into the low hill which, by a similar alchemy, blends

with the verticals of the trees that crown it. Indeed, the ground plane would be almost completely unexplained but for the foreshortening of St. George's horse and of the base lines of the rocks on the left and of the building on the right. The figure of the rescued princess, which marks the main right angle formed by the base line of the wall and the end of the building, ensures, however, that the intrusion of geometric space shall not be overpowering. The squared pavement is, moreover, carefully segregated to one corner, where it is influential yet unobtrusive.[2] The graceful, blind-arcaded building is not a rectangular block uncouthly pushing into space. Its end curls round, and is softly carried on by the tree-trunks. Its smooth curve at once provides a niche for the princess and a soft harmonization of the side wall and the surface plane, a transition crudely reflected in the rock behind the dragon, where the narrow strip beyond the cave-mouth is similarly modified by being slightly gouged.

The relationship between the spatial content and the relief plane, whether wholly successful or not, is something which has nevertheless been worked for with a kind of simple subtlety. At the same time there are some things, such as the rather uncertain relationship between the horse's neck and body, and between the atmospheric background and the relatively high relief of the figures, or the partially oblique and partially foreshortened frontal setting of the building, which betray the tentative quality so often present in an early work. Similarly there are elements of technical rather than aesthetic uncer-tainty in the later bronze relief of 'The Dance of Salome' (Pl. 34, *b*) on the Siena font.

This relief is once more seen from a close,[3] fairly high viewpoint, and although the diminution of the squared floor more or less conforms to the laws of artificial perspective, the orthogonals as a whole do not vanish to a single point. Moreover, as a result of increased definition, the problem of the relationship between the figures and the floor, inherent in the high viewpoint, is posed with new intensity. But these are the less important facts about Donatello's use of perspective.

Space is taking on a new meaning. The banqueting hall is almost twice as high as the tallest figures. It is a prelude to the 'Trinity' (Pl. 30, *b*), which was the climax of Masaccio's work, and a further step in Donatello's own development. Space is suggested not only by the very proportions of the hall, but also by its extension to either side of the field of view. The children start away on one side; on the other only the back and one leg of a young man are visible as he rushes from the hall, the arch above him being severed in mid-air. Within the scene space is expressed by the explosion of figures round the severed head, by the tense hiatus at the centre, and by the deep inlet closed by the figure of Salome.

This new interest in space and movement is accompanied by a new deci-sion in the expression of the surface. The frontality of the succeeding architec-

Donatello and Ghiberti

tural planes weaves a network that maintains the surface tension whilst these very forms create the impression of the airy halls beyond the foreground scene. Only on the floor is a single orthogonal allowed to run unbroken, and that is countered by the heavy horizontal of the tablecloth. Indeed the repeated horizontals and the echoed curves of the arches are so powerful in their effect that the figures which amplify the story and define those secondary spaces, enlarged as they are for narrative reasons, serve less to increase than to decrease the effect of depth. The deliberate nature of this insistence on the plane is emphasized by a device which Giotto had already used at Padua, and which becomes almost a hallmark of the dual intention underlying Donatello's conception of the function of perspective. The high viewpoint not only gives the floor a substantial slope, adjusting it to the planar pattern of the whole, but also coincides with the main dividing cornice. As a result this cornice, which in fact turns through an angle of ninety degrees just to the right of Herod's head, and so defines the side wall of the room, takes on a form which is practically a straight line. In this way a main spatial feature is turned into a major surface accent.

The relief surface is further emphasized and unified by the overall incised patterning. What is more, the incision, although never heavy, varies little from the nearer to the more distant surfaces, so that a further interlock is formed in even this small detail.

As a seemingly conscious balance to this deliberate stressing of the flat surface, Donatello everywhere insists on the solidity and volume of the architectural features.

In the little building on the right of the St. George relief (Pl. 34, *a*), the squared floor showed its spatial content, and the single small window emphasized the solidity of the wall. Now this second feature, like so many others, takes on a new richness and variety. Triangular cavities break through the surface of the wall behind the figures. Cavities pit both the pillars that surmount it and the walls beyond them and at either side. In the shadows on the extreme right a door cuts through the second wall, and, in the hall beyond, steps, hollowed out beneath to emphasize their volume, climb to another door, while heavy lintelled pillars close an airy box about them. In the foreground on the left, buttressing and machicolation carry on the spatial game. Finally from the surfaces of the foremost row of pillars a line of beams, or possibly extruded masonry, juts out in sharp foreshortening. It is characteristic of Donatello that they are not set within the mathematical rigidity of one straight line. Yet in the dimly lit baptistery their smooth relief catches the candlelight, and forms a startlingly accented architectural drama which makes its contribution to the tension of the story. While flatness is the first reality in a pictorial art, all architecture deals in volume.

The narrative intensity remains, however, the most striking feature of the relief. It is the end to which all detail is directed. The moment of greatest

dramatic tension has been chosen, and the gestures and grouping of the figures give human expression to it. But this tenseness is accentuated by more abstract formal means as well. The central hiatus across which the taut play of emotional stress and conflict stretches is equally the focal area into which the orthogonals all concentrate. The whole weight of the perspective bears down upon the compositional break. In opposition to this disruptive stress, however, the triple arch bridges the gap, maintaining the essential unity. At the same time the straight perspective line of the cornice is like a bar linking the heads together.

The experimental elements in the two foregoing works are clear enough, and there are also features which might well be considered archaisms. The sloping floor has been a target, since the days of Alberti and Vasari, for those historians whose admiration for renaissance forms leads them to an evolu-tionary conception of aesthetic values. Representational innovation may move hand in hand with heightened aesthetic quality, but the two are not synony-mous. It is significant that Donatello was not prepared to desert such 'archaisms' until he had found a solution, or solutions, which enabled him to incorporate a new degree of realism without disrupting the decorative surface. In both the early reliefs he is at obvious pains to minimize this very danger.

The means by which Donatello reaches a first complete solution of this problem are, however, rather different from those so far discussed. Linear perspective is a way of constructing space by essentially architectural means, and the results tend to be clear and limited, visually speaking. Another way is through aerial perspective. This second method has the particular charac-teristic that there is far less of a tendency to break through the representational plane. Taken to its ultimate conclusion, and completely divorced from linear perspective and strong chiaroscuro, the result of this atmospheric approach is an absolutely monotone flat surface. Such a consummation is very nearly achieved by certain types of Chinese art, and, nearer home, by Turner in some late works. At any stage, however, the atmosphere tends to produce an unlimited, but also indefinite sense of space. It is largely towards this solution of the spatial problem that Donatello turns in his marble relief of 'The Ascension, and Donation of the Keys' (Pl. 35, *a*).

The stiacciato cutting and the slightly undulating surface, even in the apparently flat parts of the sky, bring out to the very full the atmospheric possibilities of the near white monotone of the marble. The result is an atmospheric envelopment of forms that is scarcely paralleled in the actual painting of the Renaissance. But the atmospheric vision of the Brancacci Chapel, here transmuted into marble, is not the only debt which the relief owes to the place for which it was possibly intended. The linear perspective has been handled with the same new understanding as the cutting of the figures.

Donatello and Ghiberti

The low viewpoint, which is the main feature of the perspective, enables Donatello to solve a number of problems. First of all it removes any difficulty about the relation of the figures to the ground plane. Amongst the apostles, only those in the foreground on the right have their feet in full view, and these stand absolutely firmly on the solid earth. Then again the ground plane itself is invisible, so that there is no difficulty about its harmonization with the background, or with the relief plane as a whole, whilst the sharply falling curve of the heads in the semi-circle of apostles gives a dramatic sense of depth. Finally, it enables Donatello to give visual expression to the emotional content of the scene. Indeed the impression of looking up is so strong that it almost gives the feeling that the ground falls away down a hillside, and that the apostles themselves are standing on a slope. But this is not so. All the standing figures are foreshortened in a way which is entirely consistent with a central viewpoint slightly beneath the lower edge of the relief. The suddenly diminishing group of three trees running into and behind the distant hills does nothing to contradict this fact, and there is even absolute confirmation of it in the minute buildings in the hill-town on the extreme left.[4]

The figure of Christ himself, hovering in the ambient air, is not, however, foreshortened from below. The avoidance of such a slightly distasteful realism has the dual advantage of distinguishing and emphasizing the main figure as a whole, as well as of allowing its more, and not its less essential parts to be thrown into higher relief. But despite this vital movement of the viewpoint, which paradoxically enhances the unity of the scene, the spectator remains fully conscious that he is a witness of the supernatural—that he is looking up.

The use of perspective to give direct emotional expression to the narrative becomes even clearer in the roundel of 'The Assumption of St. John' (Pl. 35, c) in the Sagrestia Vecchia of S. Lorenzo. Here the pavement plunges down completely out of sight. The three pillars of the forward parapet converge, and the buildings overhead lean in towards each other in strong vertical foreshortening. On the right, the horizontals of the arcaded houses and their line of windows plunge precipitously down. One is reminded of fantastic photographs of skyscrapers. These upwards accelerating lines, running together, sweeping the eye with them, give movement also to the doll-like figure of St. John, and the zig-zag architrave cutting erratically across the scene is like a springboard for the body leaping into space.

Yet all this rush of movement has a firm basis. The lower parapet, anchored by a pillar at each end and at the centre, steadies the circle and establishes the surface with its uncompromising horizontal. A strong vertical shoots up, uninterrupted, from the central pillar to the building jutting out from the background against the figure of St. John. The space-enclosing zig-zag of the upper line of the colonnade itself forms a dynamic compositional balance to the stark horizontal below, and, by completing its division into

three zones, ensures the final stabilization of the roundel.[5] Each detail makes it clear that Donatello comes uniquely close to exploiting perspective for the direct impact of dramatic foreshortening only because the vertical direction of the movement in this one relief allows him to avoid a consequent disruption of the representational surface.

In 'The Resurrection of Drusiana' (Pl. 35, *b*) the perspective is more normal, but perhaps no less exciting. The focal point is this time in the centre of the cornice underneath the triple arch which closes in the main hall. Once again the principal three-dimensional accent makes its appearance as a practically straight line. But now this main space-enclosing cornice is also made an actual visual equivalent of the balustrades which cut across the scene in two dimensions, and which are, not merely in appearance, but also in reality, entirely parallel to the surface. Even more surprisingly Donatello has made no distinction in colour between the great arch supporting the end of the barrel-vault and the vault itself. The result, especially from a distance, is to give the vault and the line of the cornice which supports it a far greater value as flat pattern than they would otherwise possess. It is noticeable that here the figures effectively mask the two rear corners of the room and all the joints between floor and wall except for one short unaccented stretch on the extreme right which is, however, sufficient, with the other visual indications, to make a convincing three-dimensional interpretation possible. Enough, but no more.

There is little need to dwell on the wealth of movement and intercommunicating gesture that weaves a network through the airy hall, upon the skill with which the repeated horizontals again steady the roundel, while the central dark band frames the main action, or on the brilliant invention by which the steps leading up out of the foreground allow the cubic content of that space to be suggested rather than obtruded. Equally clear is the way in which the focal point of the perspective, without actually coinciding either with the central figure, or with the geometric centre of the roundel, harmonizes with both, leading the eye freely but certainly towards the heart of the action centring on the distinctively coloured figure of Drusiana.

Donatello is now using linear perspective throughout its full formal range. He has created a great space, fully inhabited by the figures. Here is the renaissance heir of that great Gothic hall into which Giusto de' Menabuoi poured the seething crowds of his fresco of 'St. Philip Exorcising a Devil' (Pl. 29, *a*). The comparison stresses the subtlety with which the sculptor has been able to control the observer's attention within the increased unity of a composition in which the decorative values have not been sacrificed, but enhanced; for space runs hand-in-hand with the assertion of the surface.

The roundels in the Sagrestia Vecchia cannot, however, be considered merely as individual, self-sufficient units. They are more than that. They are part of a great narrative and decorative unity which rises through the building from the bronze and marble in the lowest to the stucco in the highest register.

Here too perspective plays its part, for in three of the four scenes from the life of St. John the verticals in fact converge.[6] The convergence is not scientific, in that it does not centre on a single point. It is certainly artistic, however, since it leads the eye towards the area of the centre of the dome, uniting the roundels with the dark, converging ribs above them, just as the slight concavity of surface weds them to the pendentives into which they are set, and their con-tent ties them to the room below.

It is with another series of reliefs, this time united in the complex scheme of a great altar, that the representational high-point in Donatello's long career is reached.

The Paduan Altar

The documentary evidence for the order of execution of the four scenes from the life of St. Anthony on the Paduan altar tells us only that 'The Miracle of the Miser' (Pl. 37, *a*) was begun after the other three had already been cast in the rough, and payments for one or other of the set are recorded between May 1447 and January 1449. There does seem, however, as will appear in the course of discussion, to be internal evidence for completing the sequence.

In 'The Miracle of the Speaking Babe' (Pl. 36, *a*) the perspective emphasis on the centre harmonizes with the subject matter and with the concentration of the figures. In general structure there are reminiscences of the marble 'Ascension, and Donation of the Keys' (Pl. 35, *a*). The similar, low view-point likewise concentrates attention on the all-important forward plane, whilst the downward pressure of the perspective lines, principally visible in the ceiling, and the lack of emphasis on foreshortening of the figures prevents the generation of the emotionally powerful vertical movements which are so striking in the marble low relief and in the terra-cotta 'Assumption of St. John' (Pl. 35, *c*).

The low perspective focus is, nevertheless, still effective in creating a firm, but largely invisible platform for the figures. An uncompromising spatial box is avoided, while the ceiling provides a quite sufficient feeling of enclo-sure. The constructional mechanics take place in the background, as it were, without encumbering the action. Similarly the deepest undercutting, with its resulting spatial shadows, is relegated to the wings, the only complete indication of the depth involved being given by the rapidly diminishing figures on the extreme left.

This careful weighing of the exact stress to be laid on the creation of space extends to the detail. The youth standing against the left screen wall softens this otherwise rigid spatial accent with his body, allowing the eye to flow past it on a bridge of figures. His upflung arm distracts attention from the main spatial accent of the corner of the room. This is no mere chance, for on the opposite side, where figures again bridge the forward-jutting wall, some

drapery is negligently hung across the wall-joint, its wrinkled folds effectively blurring the transition without in any way affecting the spatial clarity as a whole. At the outer wings, where the angles between the orthogonals and the transverse horizontals is less sharp, no softening is considered necessary. The general architectural pattern continues the careful counterpoise of depth and surface. Doors, windows, and blind arches stress the solidity of every wall, yet the intensive patterning of every surface weaves a decorative web that has the opposite purpose and effect. The even, overall gilding of 'The Dance of Salome' (Pl. 34, *b*), reminiscent of Ghiberti, is discarded, although in decorative intent the departure from the old system is less radical than that in any of the other reliefs. Nevertheless the difference is vast. Here the gilding is strongly applied in flat, rectangular, broken areas, and thick, clearly defined strips. Its hard, disruptive pattern makes little distinction between plane and receding surfaces, and swamps the delicate incisions of the brickwork in flat light. Beyond a distance of four or five feet the smaller pattern largely disappears, and the bold, jazz-pattern of the gilding takes command of the architecture, breaking up the whole of the space-creating area with its surface glitter. It is significant that gold is only used in this particular way in the one relief which is relatively deeply cut.[7]

In 'The Presentation of the Host to the Mule' (Pl. 36, *b*) gilding is used for a completely different purpose. In the previous scene there is, if only by contrast, a sense of atmosphere enveloping the dark, ungilded frieze of figures, even where, as in the centre, there is relatively little undercutting. But now gold is used directly to obtain an atmospheric luminism which has no parallel in renaissance bronze-work, while its part in the narrative composition and surface design is hardly less important.

The perspective once more focuses upon the centre of the lower border, and the viewing distance is extremely short. The total effect is to give the great barrel vaults, magnificent in their spatial quality, a considerable extension on the surface. The greater length of the bold ribbing, which is consequently allowed to run unbroken, means that the space created by the ceiling area no longer seems to be rather limited in comparison with the room-space indicated by the figure recession. Finally, a series of trellises in the background indicate a bold development of the idea used with such success in 'The Dance of Salome' (Pl. 34, *b*). A space, perhaps as deep as the relief is wide, is once again suggested, and the surface still remains intact.

The main action takes place in a relative hiatus at the centre. Consequently there are no countermovements amongst the more heavily concentrated figures in the wings, which all direct attention to the focus emphasized by the perspective. This concentration is further supported by the distribution of the gilding.

The three vaults are not evenly accented. On the left there is no gilding on the ribs, and only the lightest touches on the decorated soffits of the arches.

The same softly accented leaf-moulding is repeated on the right, but here the body of the vault itself glows with subdued light, while the trellising behind all three is touched with soft reflected gleams of gilding. The central vault, however, is lit by a distinctive lozenge pattern, repeated front and rear in emphasis of the surface stressing function of the close, low viewpoint. The surface and the central action are further stressed by the gilded fluting of the main pilasters, whilst the spandrels receive an even application of gold which emphasizes the forward planes and balances the figure frieze below.

Under the central vault, with its gold-glowing ribs, the altar itself leaps into brilliant light. The dossal is covered by the only extensive flat areas of heavy gilding. The frontal is picked out in broad, strongly accented golden circles. Here again there is a graduated stress, however, since in the few circles behind the saint's legs the gold is far less heavily applied than in those immediately below the Sacred Host in his outstretched hands. This sensitive play of carefully modulated gilding, so surely co-ordinated with the perspec-tive structure, creates a monumental scene of unforgettable subtlety and rich-ness. The dark figures, picked out by natural highlights, move in a vast interior glowing with old gold. The blaze of light from the altar sets the main vault on golden fire, and is reflected softly in those on either side, dying away in fitful gleams on the trellis-work and in the vaults that stretch into the shadowy depths beyond.

This airy space beneath the vaults is nevertheless attained with the greatest structural economy. As in 'The Miracle of the Speaking Babe' (Pl. 36, *a*) the scale of the architectural detail, such as the openings in between the vaults, barely allows the figures to squeeze through, whilst here too the figures soften the main spatial accents. Donatello's basic principles of construction are, however, clearest in the altar itself.

The low viewpoint means that none of the receding surfaces are visible at all, and the strong gold emphasizes the flat frontal planes. Yet its spatial structure is clearly indicated. The strongly foreshortened mule kneels on the invisible step. St. Anthony places one foot on it, whilst the other defines the space in front of it. At each succeeding stage the figures provide a careful definition of the otherwise invisible spatial content, although the explanation is sometimes rather to the investigating mind than to the instantly perceptive eye. This appeal to the intellect is, however, a feature which recurs increas-ingly often from this time onwards.

Another new element is also developed fully for the first time in the figures of this scene. This is the repetition, with only the slightest variation, of poses and movements, sometimes in the same, and sometimes in different planes. The result is the building up of the decorative pattern within the figure area as well as in the relief as a whole. This evolution of an idea seen in embryo in the five apostles on the left of 'The Ascension and Donation' (Pl. 35, *a*) now becomes increasingly significant in Donatello's work.

Donatello and Ghiberti

'The Healing of the Wrathful Son' (Pl. 36, c) is constructed on a basic plan which develops that of 'The Resurrection of Drusiana' (Pl. 35, b), although in cutting and detail there are many elements which intensify ideas embodied in the Salome relief (Pl. 34, b). The focal point is central again, but no longer in the lower border, being situated just below the parapet on which the figures stand at the back of the arena. By once more co-ordinating this with an extremely short viewing distance and utilizing the full width of the broad, low format, Donatello gives the lines running into depth the greatest possible surface extension, and also makes the angles between the orthogonals and transversals as wide and gentle as possible, so that the latter are sufficiently, but not too sharply differentiated from each other. In the extreme case the line below the second row of bricks in the back-wall under the figure parapet can be continued from wing to wing of the relief with only minor interruptions. In doing this it turns through five right angles without appreciably departing from the straight, and many of the other horizontal lines all but repeat the performance.

The intentional nature of this near ambiguity between lines in depth and lines on the surface is made clear by other features of the design. The gilded handrail of the steps leading up to the building on the left is almost parallel to the gold accented diagonal of the lower border of the portico cantilevered out above them, and also to the similar handrail of the tiers of seats beyond. From any distance these equally highly relieved diagonals stand out strongly and take on an equivalent value in the design, leading the eye down towards the central figures. But three of these diagonals are in a plane parallel to the relief surface, and one is at right angles to them, running into depth. There is a similar equation of the handrails on the opposite side of the scene with the accented diagonal into depth where the upper storey of the building juts forward, an equation emphasized by gilding and relatively high relief, as well as by pattern. In this way diagonals in depth and on the surface unite to form a cradle for the central drama, a surface pattern to which the counter-point is provided by the wide, inverted V of the building in the background.

The calculated equivalence of receding and planar surfaces is accentuated by the even intensity of the incised pattern of the brickwork, which is stronger now than in the earlier 'Dance of Salome' (Pl. 34, b). But as in that relief, the care for the surface is not unbalanced, or the space, which is so magnificent a feature of the scene, would shrivel into flat nothingness. Moreover, arches and inlets are again cut into every frontal surface, and the volume and solidity of the architecture are carefully emphasized.

In this scene also, gold, and silver as well, are major factors in the final spatial pattern, and play a role quite different from that in either of the other reliefs. The way in which gold, which is usually employed for its purely decorative properties, is used by Donatello in ways which are often dia-metrically opposed to each other, in order that it may contribute a vital

157

element to the final balance of the whole, is one of the most revealing features of his art. In this scene his purpose is the direct opposite of that in 'The Miracle of the Speaking Babe' (Pl. 36, *a*). The evocation of space and atmo-sphere is, if anything, more intense than in 'The Presentation of the Host' (Pl. 36, *b*), and the organization which underlies this achievement is in many ways more strictly defined.

In this scene of the miracle of healing, all the main surfaces which lie parallel to the relief plane are heavily gilded, the maximum intensity being reached in the frontal surfaces of the building on the left, and of the seating tiers beyond it. Next in brilliance come the sides of the steps on the right, the triangular buttressings of the overhang, and the forward facing inner surfaces of the window inlets above. The frontal surface of the tier beyond is also strongly gilded, and the back of the arena yet more strongly still, except for the left half of the building behind it, which is scarcely tinged with colour. In contrast the receding surfaces are touched only by the softest gleams of colour, so pale as to shine almost silver at times, which glows through from beneath the dark brown patina of the bronze. On the right, at the point of the most dramatic thrust into depth, this 'silvery' quality is intensified. The two lower flights of steps are covered by actual plates of silver let into their upper faces. The figures themselves, on the other hand, have only their natural high-lighting, with possibly an occasional trace of soft gold. The final impression is of a vast, sunlit, outdoor space, the sun and clouds themselves thrown for-ward by their relief and colouring, and the buildings seeming to glow at the same time with an inner radiance of their own.

There is no need to stress again the way in which the main figure group prevents an overpowering delineation of space, except to notice, in passing, that at almost every important spatial joint a figure diverts attention from the otherwise too harsh intrusion of solid geometry into art. The repetition of figure poses in succeeding planes intensifies as well. There is also, however, one quite new element in the spatial and decorative structure of the scene.

The building on the right is not in fact an exact counterpart of that on the left. It is obliquely set, none of its surfaces lying parallel to the plane. It introduces what might be called a hidden asymmetry, since it is not some-thing which immediately strikes the eye. It is one of the elements of illusion-ism that symmetrical designs, which can be instantaneously perceived as a whole without need of second thoughts, have, other things being equal, a more powerful effect on the eye, since they do not invite questioning by the rational mind. Asymmetry is, on the whole, more prone to do this. But a hidden asymmetry, a half-felt difference on the fringes of consciousness, is still more likely to destroy the spontaneous and complete acceptance of illusion. The mind questions, and the spell is broken.

This effect is augmented by the fact that the only visible part of the whole ground plane is associated with the oblique setting of the building. As a

result all the lines of its squaring are diagonals which carry on the cradling effect and centre stress already mentioned in other features. The apparent tilting of the ground is so increased that there is, on inspection only, it is true, a real conflict between this sloping surface and the figures in the foreground. These do not actually stand on it at all, but on the lower border of the relief which the prostrate youth grips with his left hand.

'The Miracle of the Miser's Heart' (Pl. 37, *a*) continues this exploration of the problem of incorporating unified space into the still paramount flat pictorial design. Here the composition is centred on a relatively narrow alley running abruptly into limited space. The sharper thrusts that result from such a compositional scheme are offset by the open, skeletal structure of the three main buildings in the foreground, which consequently do not solely funnel attention into the central alley. Similarly all the orthogonals are interrupted by arches, changes of level, or vertical breaks.

The central viewpoint at head-level and the placing of the bier strengthen the surface emphasis of the figures, whose spatial disposition, and relief variation with its natural high-lighting, harmonize with, and repeat the architectural disposition almost completely. Not only are the ground and its junction with the walls almost totally masked, but special attention is paid to the spatially speaking most important of the buildings, that on the left, which juts furthest into the foreground and is on the longer side of the central alley. By blocking the foremost fluted and gilded pillar with a dark figure in strong relief, and leaving the next pillar completely bare until much lower down, the front pillar is pushed back to a considerable extent, and the rear pillar allowed to come forward, without in any way affecting the spatial clarity of the building as a whole.

The plastic quality of the closing back-wall, and the rich complexity of the space created by the architecture in front of it, are immediately apparent. There is no longer any need for spatial cavities. Space, and plastic form, run riot in the very structure of the scene. But this spatial play becomes so complex that in detail it can be appreciated only by the intellect rather than the eye, a tendency visible in embryo in the right background of the Salome relief and here greatly developed.

The rich airiness of the spatial invention, and the sure complexity of the figure cutting and composition, are equalled by the richness of the gold and silver work. Now no balance needs to be restored. Each element is balanced in itself, and so it is with the gilding and silvering. It gleams in rich profusion throughout the whole relief. There is gold in the flutings of pillars, lighting the windows, and outlining and enriching detail everywhere. Silver is found in greater quantities than ever before: in the coffering of the temple on the right, and of the arch of the central doorway, and in innumerable delicate dotted patterns and small rosettes. The colouring is nowhere heavy, and makes no distinction between frontal and receding surfaces. It is present, one

might say, solely for its rich, decorative effect. Yet even as it enlivens the surface, it adds light and atmosphere to the space that circulates these airy halls.

The documents prove conclusively that this relief was executed after the other three, but from the gradual increase in the complexity of the gilding in the four reliefs, and from the progressive use of silver in the last two, together with the fact that 'The Miracle of the Miser's Heart' (Pl. 37, *a*) bears on it the signatures of three gold and silver smiths, one might alone be inclined to conclude that the present order was the order of conception, although in time there can be little separation.[8] The analysis of the perspective principles employed, inseparable as they are from the conception of the gilding, seems to point in the same direction, and this is also true of the relief, in which the modelling of the figures blends increasingly with that of the architectural forms. The modelling of 'The Miracle of the Speaking Babe' (Pl. 36, *a*) recalls the two and a half inch depth of 'The Dance of Salome' (Pl. 34, *b*). The merging is increased in 'The Presentation of the Host' (Pl. 36, *b*), and in 'The Miracle of the Wrathful Son' (Pl. 36, *c*) there seems, for the first time, to be a complete unity of texture between the figures and the architec/ tural relief. But in this scene the figures in the central group are, as a result, so flatly, and so delicately differentiated from each other that, seen from a distance of more than a very few feet, they blur into an indistinct mass. Only with 'The Miracle of the Miser's Heart' (Pl. 37, *a*) is there a variation in the relief depth which at one end of the scale approaches that of 'The Miracle of the Speaking Babe' (Pl. 36, *a*), and at the other is as low as, and yet more clear than that in 'The Miracle of the Wrathful Son' (Pl. 36, *c*), and which all the time maintains the figures in complete harmony with the architectural setting.

This evolution in the handling of relief presents so close a parallel with that apparent in Ghiberti's art that it seems worthwhile to pursue the comparison for a moment before discussing the late works of Donatello.

GHIBERTI

Certain aspects of the development of Ghiberti's style are implicit in the interest which he took in optics during the latter part of his life, and which inspired the writing of his unfinished *Third Commentary*. The main trend from the late Gothic first doors to the renaissance vision of the second is clear enough. The former, with all their echoes of antique sculpture, are composed of small, figure/dominated fields and fourteenth/century agglomerations of landscape-particles that stand out against the flat surface of the door. The movement from this conception to the pictorial experiments of his second doors requires no emphasis.

Within this general trend, the two reliefs of the Siena font, which were finished by 1427, represent an important moment of transition. In 'The Baptism of Christ' (Pl. 38, *a*), the sense of atmosphere, which is so note' worthy a feature of the Paradise doors, seems to be well developed. The landscape dissolves quickly into empty space, as in the centre of the panel of 'The Story of Adam and Eve' which begins the sequence on the doors. All the figures, including those in the foreground, are also in unusually low relief. In 'The Imprisonment of St. John' (Pl. 38, *b*), designed although not exe' cuted by Ghiberti, the soft atmospheric space gives way to rectilinear archi' tectural perspective. The building runs more deeply into space than any of those in Ghiberti's early doors, and the attempt to relate the whole figure scene to an architectural setting is more thoroughgoing than before. The structural firmness of the building is increased, and whilst the throne still stands obliquely, the orthogonals of the squared ceiling meet accurately in a single point, although the transversals are irregularly spaced. This architec' tural perspective is accompanied by figures in extremely high relief. At times they are almost in the round, and nowhere do they blend to any extent into the background space. The figure compositions in the two reliefs in fact exactly demonstrate the contrasting qualities of atmospheric and of linear perspective.

At this stage the two conceptions are kept rigidly apart. The atmospheric landscape has no high relief, and low relief is almost wholly absent from the architectural scene. This dichotomy, and its dissolution by great artists, is a recurrent phenomenon. Its progress has been followed in Donatello's sculp' ture from the alternating style of the earlier works to the final mastery of both high and low relief within the single composition of 'The Miracle of the Miser's Heart' (Pl. 37, *a*). A similar process can be followed in Titian's oils and in Rembrandt's paintings and drawings. In Ghiberti's case, the Ark of St. Zenobius reveals his personal solution of the problem.

The composition on the main face of the ark (Pl. 39, *a*) has to be dated after 1432, when Ghiberti won the contract. As even then no subjects had been selected, it seems most likely that the work was done between 1439 and 1442, when the whole ark was finished. Its decoration therefore indicates the direction in which Ghiberti's ideas were moving at a most important time.

The figures in the main scene run down in even graduation from high to low relief. In this they give expression to the sense of space which their assembly in two long processional groups, forming a human road into the distance, is intended to evoke. Architectural perspective is pushed far into the background. It makes no attempt at overall enclosure, and merges comfor' tably, in low relief, into the distant landscape. Even the sharply foreshortened buildings which carry on the steep recession of the foreground figures do not break appreciably into the atmospheric surface of the relief. In its new role the architectural content of the scene is no longer confined to a single building.

Donatello and Ghiberti

A whole town is visible, as well as several individual structures. The pattern of the gradual development of a pictorial relief style capable of uniting the two poles of atmospheric and linear perspective represented in the separate scenes of the Siena font is now complete, and the three architectural compositions of the Paradise Doors fit naturally into it. [9]

In 'The Story of Esau and Jacob' (Pl. 39, *b*) a single building fills the background with calm grace. It is Ghiberti's delicate answer to the drama of the gleaming halls of Donatello's 'Dance of Salome' (Pl. 34, *b*). Here the perspective pavement, now meticulously accurate in its construction, provides a scientific figure platform, and the eye is free to float uninterrupted through the graceful halls towards that golden point in space to which all lines recede. There is no violence in the movement, since it is only in the area of the vanishing point itself that the figures do not intervene. Even here, greyhounds, a fallen bow, and moving figures close on either side, slow down the flight into the distance. In the house itself orthogonals are few and short. As in Donatello's 'Dance of Salome' (Pl. 34, *b*) architectural space is formed by the succession of plane surfaces and the repetition of the arches.

In this clear continuum the figures are diminished in a series of staccato movements. Each episode tends to congeal into a small closed group. The technical mastery, which allows the foreground figures to be almost in the round, has the further effect of isolating them to some extent. The figure in the middle distance, running across the central space, barely succeeds in bridging the wide gap that separates the foreground high relief from the low cutting of the background figures, nearing *stiacciato* in the reclining woman on the left. The tendencies which show most strongly in the lonely Esau striding out into the desert, or the distant isolation of the episode taking place upon the roof, are present everywhere in this relief, despite the unifying force of the perspective. [10]

Whilst Ghiberti retains the single building, now transformed beyond all recognition, which accompanied so many episodes upon the earlier doors, and which is still seen at Siena (Pl. 38, *b*), he has completely given up any attempt to enclose the composition as a whole. [11] The onlooker sees into it and even through it, but remains outside it. The problem faced and solved by Donatello for the second time in the roundel of 'The Resurrection of Drusiana' (Pl. 35, *b*) is avoided by Ghiberti in his late pictorial style. The major problem in the harmonization of space and plane never arises. Ghiberti, who shows himself throughout the Paradise Doors to be intensely conscious of the surface values, achieves his ends by compositional means without needing to exploit the ambivalent potentialities of artificial perspective. Orthogonals and transversals are distinguished with the greatest clarity. There are no near ambiguities.

It is important to remember that the solutions of the problems of perspective space evolved by Giotto and by Donatello seldom recur outside their own

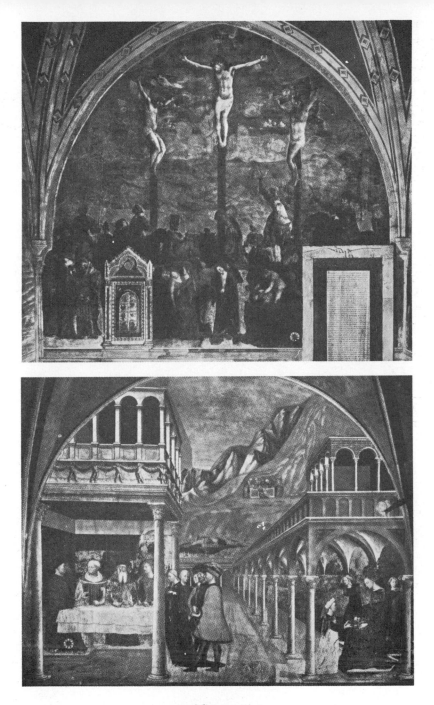

33. MASOLINO

a. The Crucifixion

S. Clemente, Rome

b. The Feast of Herod

Castiglione d'Olona

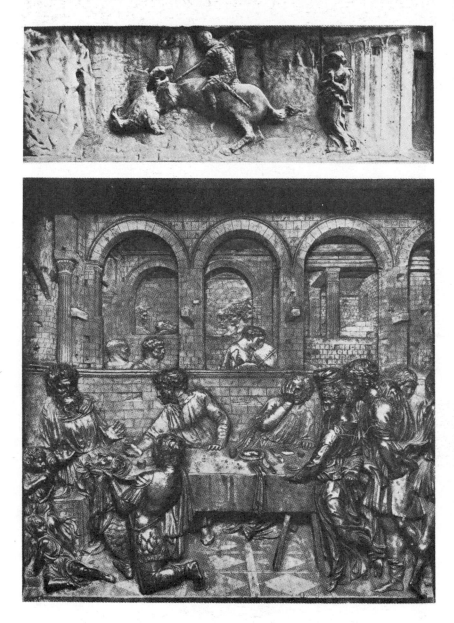

34. DONATELLO
a. St. George and the Dragon
Or San Michele, Florence
b. The Dance of Salome
Baptistry, Siena

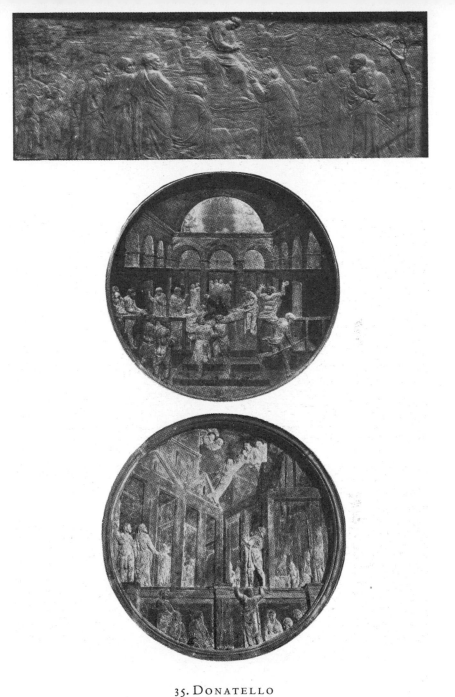

35. DONATELLO

a. The Ascension and Donation of the Keys
Victoria and Albert Museum, London

b. The Resurrection of Drusiana

c. The Assumption of St. John
S. Lorenzo, Florence

36. DONATELLO
a. The Miracle of the Speaking Babe
b. The Presentation of the Host to the Mule
c. The Healing of the Wrathful Son
St. Antonio, Padua

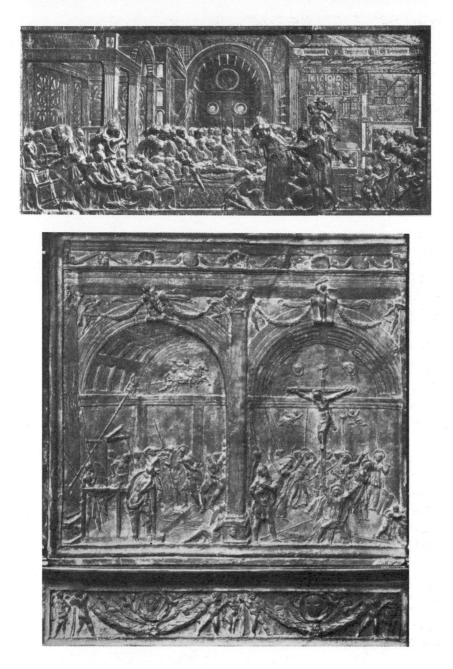

37. DONATELLO
a. The Miracle of the Miser's Heart
St. Antonio, Padua
b. The Scourging and Crucifixion
Victoria and Albert Museum, London

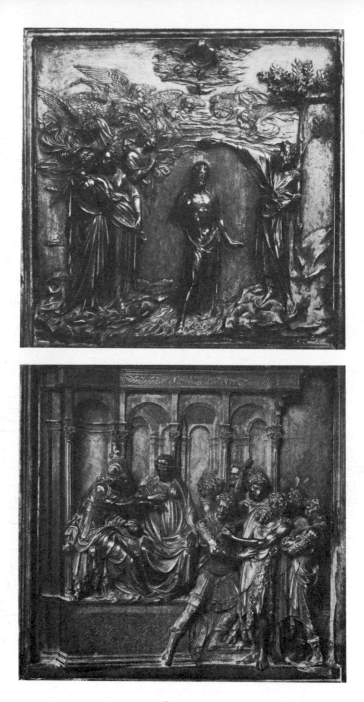

38. GHIBERTI
a. The Baptism of Christ
b. The Imprisonment of St. John
Baptistery, Siena

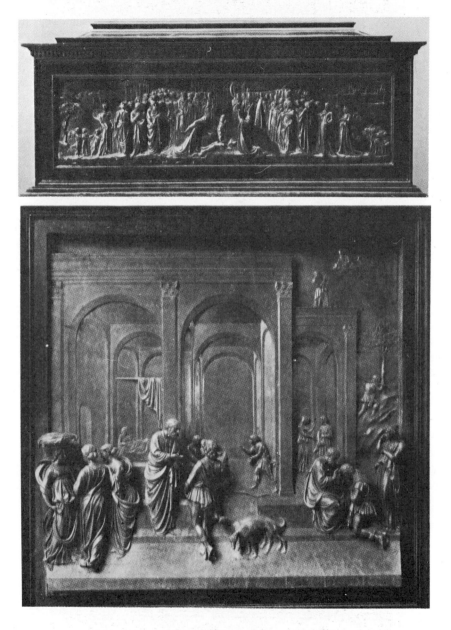

39. GHIBERTI

a. The Ark of St. Zenobius, The Raising of a Child
Duomo, Florence

b. Jacob and Esau
Baptistery, Florence

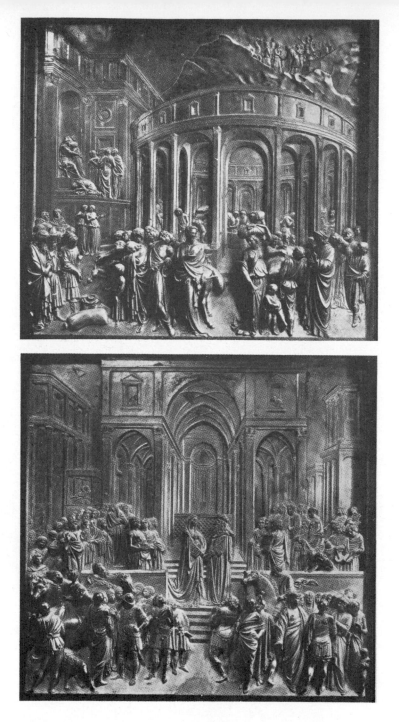

40. GHIBERTI

a. Joseph and his Brethren

b. The Meeting of Solomon and the Queen of Sheba

Baptistery, Florence

41. DONATELLO
a. The Martyrdom of St. Lawrence
b. The Maries at the Tomb
S. Lorenzo, Florence

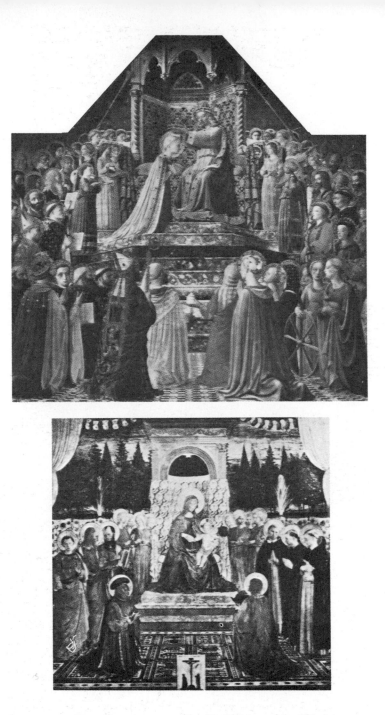

42 *a*. FRA ANGELICO. The Coronation of the Virgin
Louvre, Paris
b. FRA ANGELICO. Virgin and Child Enthroned with Saints
S. Marco, Florence

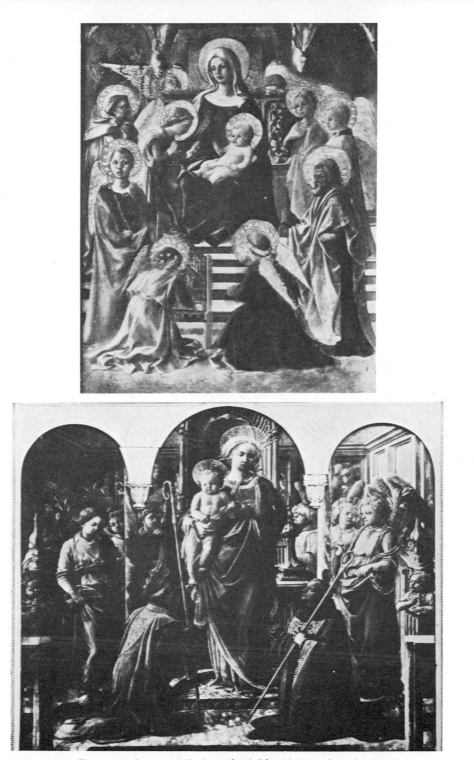

43. FILIPPO LIPPI. Virgin and Child with Angels and Saints

(a) S. Andrea, Empoli (b) Louvre, Paris

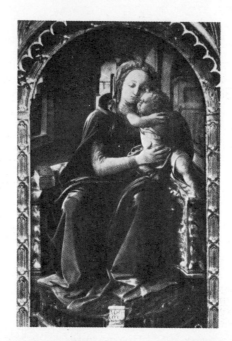

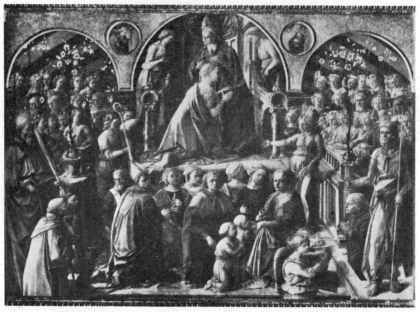

44. FILIPPO LIPPI
a. The Virgin and Child
Tarquinia
b. The Coronation of the Virgin
Uffizi, Florence

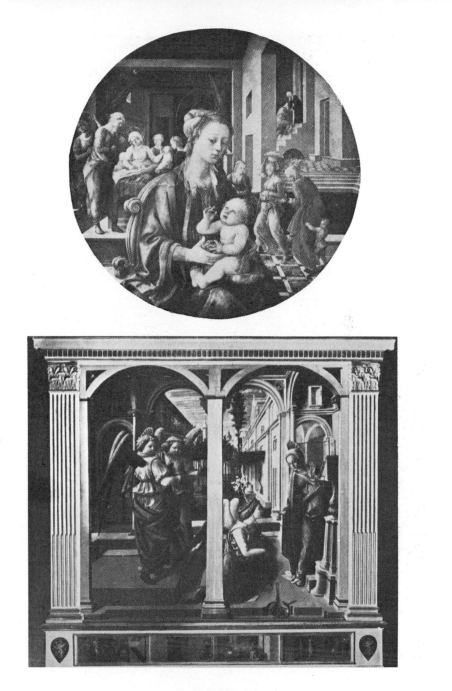

45. FILIPPO LIPPI
a. The Virgin and Child
Pal. Pitti, Florence
b. The Annunciation
S. Lorenzo, Florence

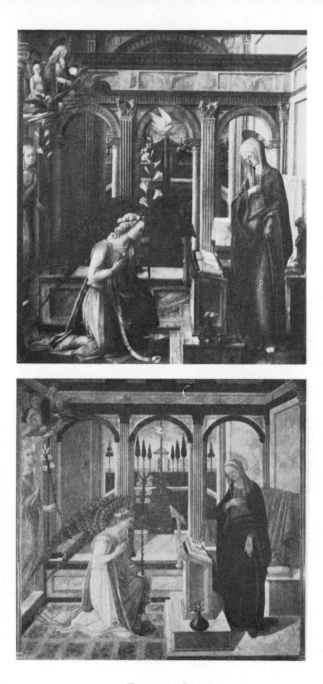

46. FILIPPO LIPPI

a. The Annunciation

Ältere Pinakothek, Munich

b. The Annunciation

Accademia, Florence

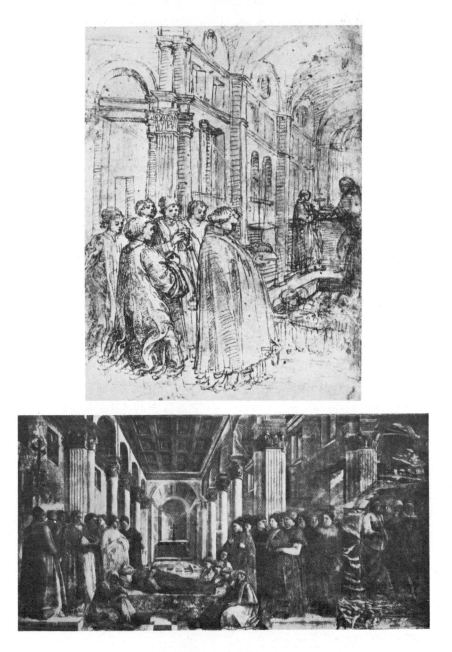

47. FILIPPO LIPPI
a. The Funeral of St. Stephen
Museum of Art, Cleveland
b. The Funeral of St. Stephen
Duomo, Prato

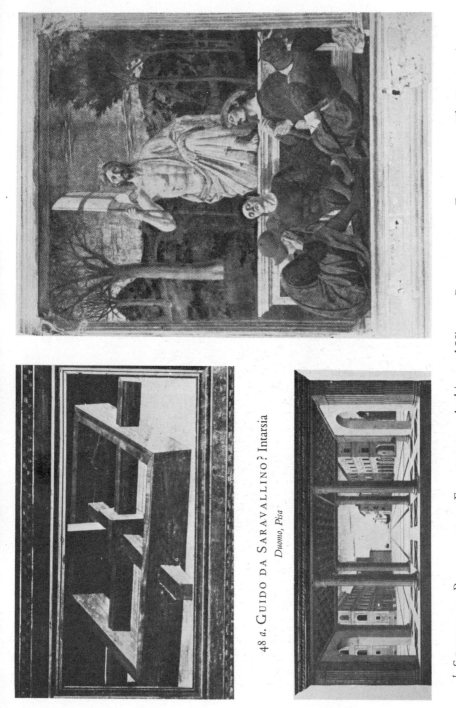

48 a. GUIDO DA SARAVALLINO? Intarsia
Duomo, Pisa

b. SCHOOL OF PIERO DELLA FRANCESCA. Architectural View. c. PIERO DELLA FRANCESCA. The Resurrection
State Museum, Berlin — *Borgo San Sepolcro*

49. CASTAGNO. The Last Supper

St. Apollonia, Florence

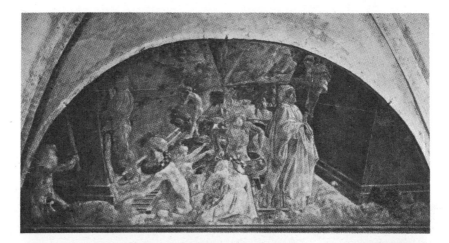

50. UCCELLO
a. The Flood
S. Maria Novella, Florence
b. The Attempt to Destroy the Host
Pal. Ducale, Urbino

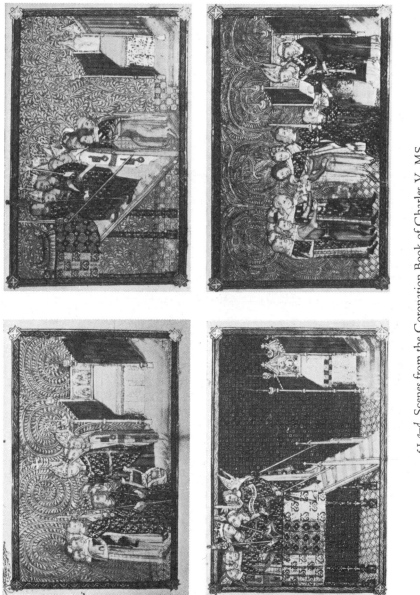

51 *a–d*. Scenes from the Coronation Book of Charles V. MS.
Cotton. Tib. B. VIII. Fols. 59, 63, 64, 65

British Museum, London

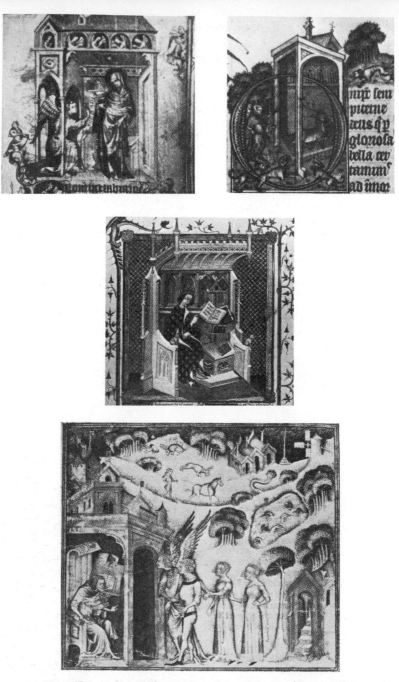

52 *a*. JEAN PUCELLE. The Annunciation. Hours of Jeanne d'Evreux
Metropolitan Museum, New York
b. Initial " O " Missal of St. Denis. MS. 18. 3. 91. Fol. 261
Victoria and Albert Museum, London
c. Charles V. Polycratic of John of Salisbury. MS. Fr. 24287. Fol. 2
d. Love Presenting Three of his Children. Poems of Guillaume de Machaut
MS. Fr. 1584. Fol. D. *Bibl. Nat., Paris*

53 *a*. DE LIMBOURG
January (Detail). Très
Riches Heures

53 *b*. DE LIMBOURG
June (Detail). Trés
Riches Heures
Musée Condé, Chantilly

54 *a*. Isabel of Bavaria and Christine de Pisan. MS. Harley 4431. Fol. 3
British Museum, London
b. FOUQUET. The Annunciation of the Death of the Virgin
Musée Condé, Chantilly

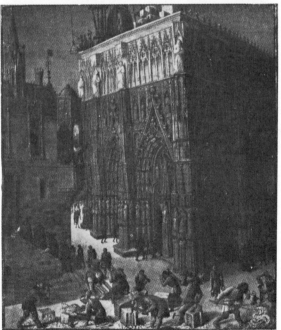

55. FOUQUET
a. The Arrival of the Emperor at St. Denis. MS. Fr. 6465. Fol. 444
b. The Building of the Temple at Jerusalem. MS. Fr. 247. Fol. 163
Bibl. Nat., Paris

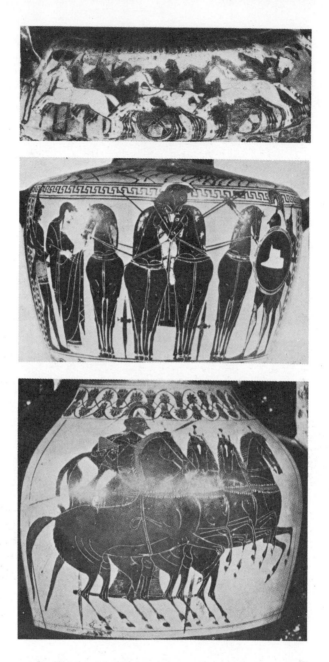

56 *a*. Galloping Chariots (Detail). The Amphiaraos Krater
State Museum, Berlin
b. Frontal Chariot. Attic Black Figure Hydria. B. 343
c. Chariot in Pseudo-Foreshortening. Attic Black Figure Amphora. B. 258
British Museum, London

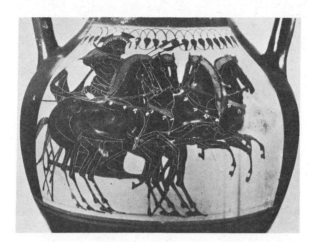

57 *a*. Foreshortened Frontal Chariot. Attic Black Figure Amphora. 1391
Museum antiker Kleinkunst, Munich
b. Chariot of the Trojans
Treasury of Siphnos, Delphi

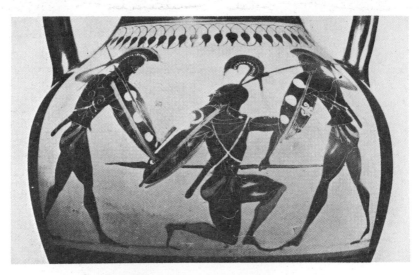

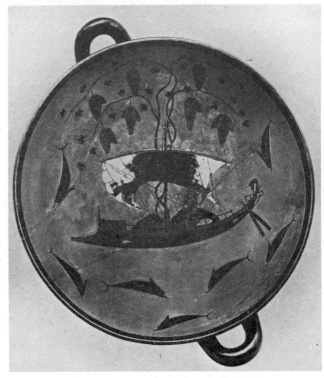

58 *a*. Warring Hoplites. Attic Black Figure Amphora. 1391
Museum antiker Kleinkunst, Munich
b. Exekias. The Voyage of Dionysos. Attic Black Figure Cup
State Museum, Berlin

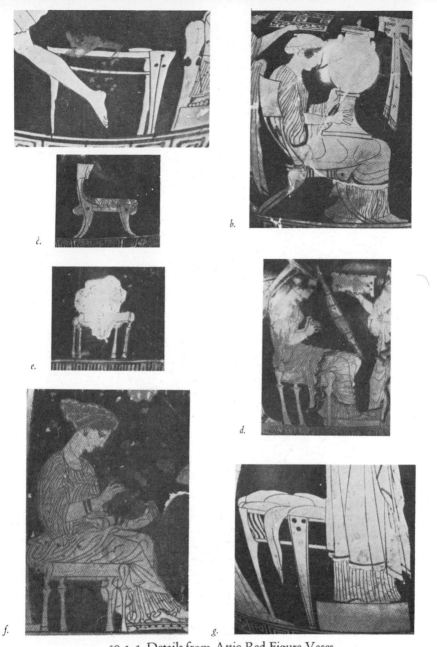

59 *a–g*. Details from Attic Red Figure Vases

a. NR. NIKON PAINTER. Amphora. E 302 *British Museum, London*

b. AMYMONE PAINTER. Nuptial Lebes. S 1671 *Louvre, Paris*

c. HERMONAX. Hydria. A 3098 *Brussels*

d. WASHING PAINTER. Nuptial Lebes. Richter 145
Metropolitan Museum, New York

e. NR. MEIDIAS. Squat Lekythos. C.A. 254 *Louvre, Paris*

f. ERETRIA PAINTER. Onos. 1629 *National Museum, Athens*

g. EUPOLIS PAINTER. Stamnos. E 452 *British Museum, London*

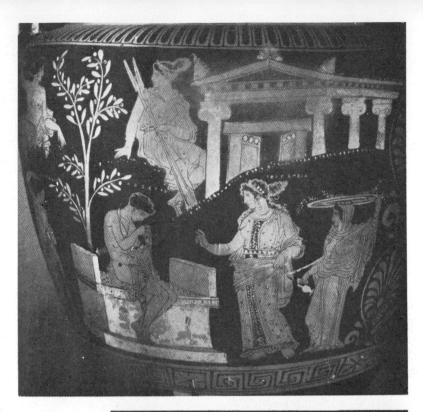

60 *a*. Orestes
and Iphigeneia
in Tauris.
Apulian
Krater
National Museum,
Naples

b. Phoenix and
Achilles.
Colossal
Amphora
Museum of Fine
Arts, Boston

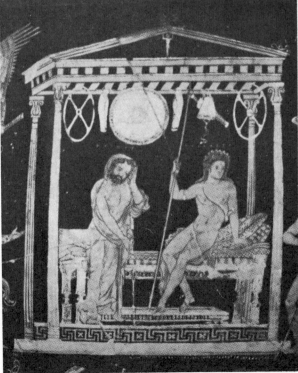

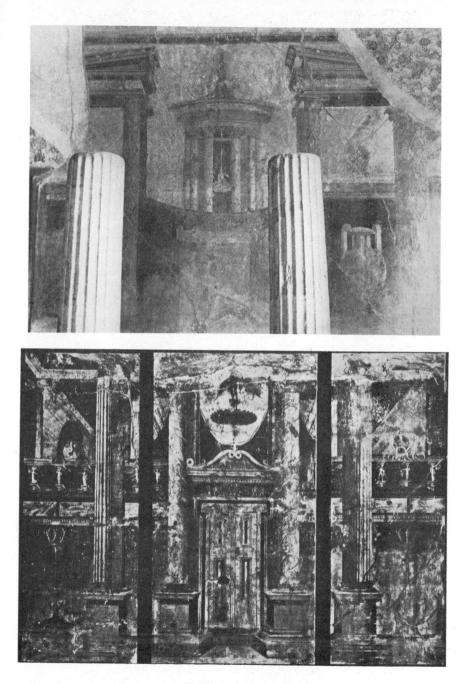

61 *a*. Wall of Corinthian Oecus
House of the Labyrinth, Pompeii
b. Wall from the Villa of Publius Fannius Sinistor
National Museum, Naples

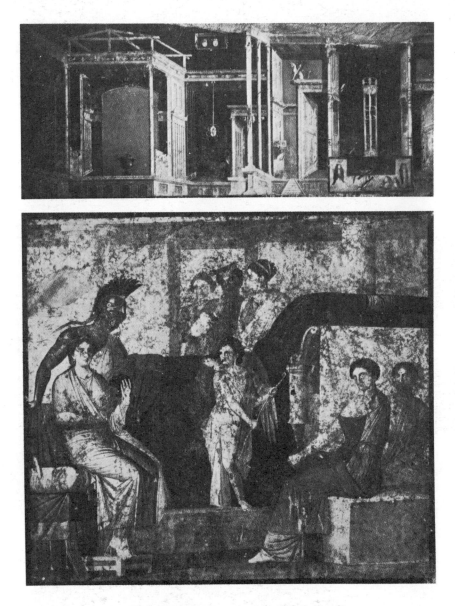

62 *a*. Detail of Frieze *b*. Ares and Aphrodite

Tablinum, House of Marcus Lucretius Fronto, Pompeii

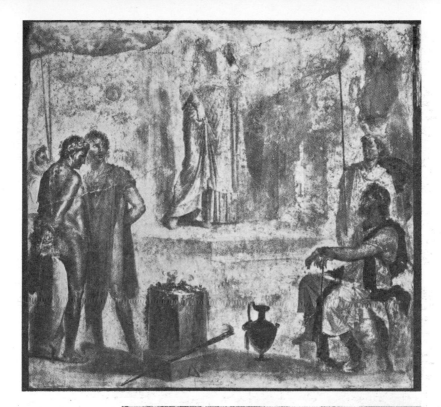

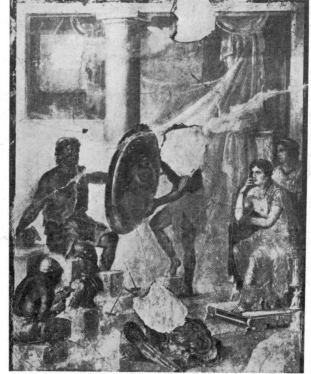

63 *a*. Orestes and
Pilades before
Thoas and
Iphigeneia

b. Thetis and
Hephaestus
*National Museum,
Naples*

64 *a–d*. Details from four scenes of Admetus and Alcestis

National Museum, Naples

e. Wall of Atrium

House of the Ara Massima, Pompeii

work during the renaissance period. When they do, it rarely seems to be as part of a co-ordinated compositional scheme. Examples of the straight line which encloses space, such as that to be seen in Ghiberti's relief of 'The Story of Joseph and his Brethren' (Pl. 40, *a*), soon to be mentioned, do occur, but seem to be largely incidental. A similar example is, perhaps, the line of capitals in Masolino's fresco of 'The Feast of Herod' (Pl. 33, *b*), where the space-enclosing straight line is easily missed in the company of so many spatially emphatic architectural elements. In such cases it is impossible to establish the intention in drawing the line in question. Unless they are carefully and consciously avoided, they are bound to occur incidentally now and then in complex architectural designs. It is only when such things are compositionally stressed, and given a place of honour, where their influence is strong, that they become potentially significant indications of the artist's aims.

Many of the qualities of 'The Story of Esau and Jacob' (Pl. 39, *b*) are also apparent in the succeeding panel of 'The Story of Joseph and his Brethren' (Pl. 40, *a*). The buildings are again presented from the outside, and have receded further from the foreground. There is a sharper emphasis on architectural recession. The orthogonals plunge more steeply, and only in the platform underneath the throne is there a near equivalence of surface and receding planes. In compensation there is no unbroken tunnel to the vanish-ing point. The squaring of the pavement is also less obvious in the more crowded scene in which the isolation of single figures is avoided and the diminution is less jerky. Nevertheless there is still something of a break be-tween the virtuoso high relief in the foreground and the busy crowd of people encircled by the building well towards the rear.

'The Meeting of Solomon and the Queen of Sheba' (Pl. 40, *b*) marks a further step towards the resolution of these problems. A high viewpoint spreads the figures over the whole surface. Flights of steps maintain the com-positional logic, avoiding any consequent necessity for an almost vertical ground-plane. Despite the courtyard wall, the figures now flow evenly into the background and are nowhere isolated. The continuous graduation in their size is accompanied by a similar smooth transition in relief. The per-spective pavement has now vanished, and the foreground space is defined exclusively by horizontal accents in full harmony with the plane, and by the disposition of the figures. The buildings stand still further back, hardly enclosing any figures, let alone the onlooker himself. There is the same clear separation of frontal and receding surfaces, the same extension in the plane, and now, not one, but many buildings. Here, in conjunction with the landscapes of 'The Story of Joshua' and 'The Story of David and Goliath', is the last intermediate stage of the painstaking compositional development that separates Ghiberti's early doors from the pictorial composition of the Ark of St. Zenobius.[12] (Pl. 39, *a*.)

This process of development, which fits the compositions of the Paradise Doors into the wider pattern of Ghiberti's life, shows that despite the many episodes within a single scene made necessary by the programme, his relief style undergoes changes which are fundamentally the same as those apparent amongst Donatello's Paduan reliefs. Perspective is essentially a unifying force, both spatially and compositionally, as handled by these two contemporaries. Its increasing use is accompanied by a steady effort to achieve a similar unity in their relief style without sacrificing that full range of modelling the two poles of which had, in their earlier works, to be confined to separate compositions. This similarity of aim is accompanied by a wide disparity of means. Donatello runs full tilt into the problems of creating architectural space in harmony with the plane. Ghiberti, influenced though his whole conception is by the new science, pushes it, once mastered, more and more into the background, overlaying it with softer forms. He never seizes upon the dramatic possibilities of his story in the same way as Donatello. Consequently he never attempts to bring the formal qualities of perspective to bear upon the emotional content of his subject, as Donatello does at every stage of his career. Ghiberti's use of linear perspective is consonant with his decorative gilding, and with the flowing draperies of the figures that enact his stories.

In Donatello's work the atmospheric mastery achieved at Padua is not the prelude to a soft late manner. On the contrary, the dramatic harshness of the figure style of his last years is accompanied not only by a reduction of pictorial space, but also by the statement of his conception of the function of perspective in the barest and most forceful, at times almost abstract, terms, thereby giving a maximum intensity to the contrast with Ghiberti's methods.

THE LATE WORKS OF DONATELLO

The transition from those works of Donatello which have so far been considered is effected by the modello in the Victoria and Albert Museum, of which the Scourging and the Crucifixion scenes remain (Pl. 37, *b*). Whilst there is much that still connects it with the Paduan reliefs, the figures have begun to take on the emotional intensity characteristic of the final years in Florence.[13]

The unity of the representational and the decorative spheres is perhaps most strikingly indicated by the way in which the swags held by the putti in the frieze below the main body of the relief form the decorative counterpart of the barrel vaults in the scenes above. The putti themselves link decoratively with those which stand on the scrolls marking the keystones of the arches, and which effectively flatten the deep architrave running across the top. This flattening effect is increased by the shortness of the viewing distance, and by

the placing of the viewpoint so that it once more straightens out the main space-defining cornice.

Amongst the expressive figures in the crucifixion scene the five-fold repetition of the gesture of the upflung arms does not create monotony, and in the other scene a new tendency appears which is symptomatic of the changing emphasis in Donatello's art. The figure of Christ at the column moves against the flow of the perspective, and his pose is repeated, but in reverse, by the elongated figure leaning on the foreground rail. The horseman in the lunette rides with the centring orthogonals, and the putto on the key-stone above runs out against them to the left. The element of contrast is on the point of being used in order to achieve, not balance, but dramatic tension.

Conflict, instead of balance, appears fully developed for the first time in the Bargello bronze relief of 'The Crucifixion'. The enormously elongated figures, especially in the background, the strong perspective of the trees, denied by the gold high-lighting of their trunks, and the strange, incomplete, gold-etched structure underneath them, all build up the tension. The scene piles vertically over the surface. The excited figures blaze with strong gold, the broken pattern of which greatly increases the confusion. Its overall glitter is the first thing that is seen, and the last to leave its impress on the mind. Silver is here used in profusion too. Thin lines of it decorate the accoutre-ments; broad bands of it accent the side-poles of the ladder; and plates of it everywhere highlight the rough ground, and flow in pools amongst the clouds through which the angels break in spatially inexplicable turmoil. Space is used, not for itself, but to heighten tension, and the term decorative hardly fits the jarring, flat pattern of the gold and silver.

Throughout Donatello's late work, in the round as well as in relief, the naturalistic elements seen at Padua are increasingly replaced by emotional expressionism. In the last works of all, the two pulpits in S. Lorenzo, perspective space is reduced to its barest terms, a mere indication often, yet with an essential part to play in building up the emotional impact.

In the scenes of 'The Pentecost', and 'Christ in Limbo', with 'The Resurrection', and 'The Ascension', the firm purpose of the vestigial indica-tions of space is at its clearest. In 'The Pentecost' the orthogonals of the little ardiculae centre attention on the descending Paraclete, and the viewpoint is equally high in the remaining three scenes. It has already been observed that, in contrast to this, a low viewpoint throws into relief the figures in the extreme foreground planes. Here there is a rising theme from left to right, the hierati-cally enlarged figure of Christ appearing from behind the crowded souls and saints. The rising lines of the perspective in these scenes, placed as they are above the spectator's head, draw attention to the backward planes, and tilt them forward into prominence, even as the figure of the ascending Christ itself surges forwards and upwards in ever higher relief.

The opposite effect is obtained in 'The Entombment' on the north pulpit. The sad scene is emphasized by the heavy, horizontal cleavage in the rock, face, weighing down upon the figures, and the falling lines of the low view, point draw the figure of the dead Christ down behind the wall of the sarco, phagus.

Most interesting of all, from the point of view of space creation on the surface in its latest phase, is 'The Martyrdom of St. Lawrence' (Pl. 41, *a*). A great ceiling, receding with unbroken side orthogonals into extreme depth, presses down upon the scene, stressing the prostration of the saint, already marked by the horizontal of the pole which forces him onto the flaming grid. The strange invention of the roof and upper part of the relief is not mere fantasy. The alternating pillars and columns, which appear above it, stand on those supporting its inner edge at the back of the deep hall. Yet they come into sight immediately above its forward edge, and are intimately associated with the decorative frieze that runs above the narrative scenes, stressing the decorative surface of the pulpit as a whole. Masking these upper columns reveals immediately the way in which, without them, the box,like space would punch a deep hole into the surface of the pulpit. The aged master has reduced the interplay of space and plane to its starkest, most simple terms.

The strange brilliance of Donatello's invention also extends to the design of 'The Maries at the Tomb' (Pl. 41, *b*). Alone of all the reliefs planned by him, its focal point lies right outside the area of the action, and is in the ball,frieze overhead. The subject of the scene is really the Risen Christ, and the perspective indicates the true direction of attention. The blank roof laid bare by it only emphasizes the emptiness of the scene below. The chaotic distribution of the figures dramatizes the moment of desolation and con, fusion.

The deep relief, with the complete undercutting of the pillars, gives a depth of shadow only attainable by such means, the broken quality and destruction of the surface reinforcing the compositional chaos. There is even a shattered arch, this time more firmly stressed than its counterpart in the relief of 'Christ Before Caiaphas and Pilate', and suddenly cut short in its leap into space over the spectator's head. Even in this relief, Donatello has a message for the intellect which the deep cutting, obeying the emotional demands of the scene, prevents him from giving more directly to the eye. The trunks of the decora, tive trees, which appear above the scene, and, like the columns in 'The Martyrdom of St. Lawrence' (Pl. 41, *a*), associate with the decorative sur, faces above, can be seen on close inspection to run down behind the tomb. Logical explanation for the mind again replaces the instant indication to the eye that artistic space and the flat surface are one and the same—a unity not to be dissolved but to be preserved and strengthened by every traditional, remembered skill, and by every new device made possible by the growing artistic science of perspective.

Donatello and Ghiberti

Historically there is nothing surprising about the development which has just been outlined, and the consistency with which Donatello, a sculptor, tackled the new pictorial problems is at once an indication of the impact of the new ideas, and of the genius of the artist. Wishing to take full advantage of the powers inherent in the new perspective, and faced with the necessity of con-trolling its disruptive tendencies, he turns with a new urgency, and a new persistence, to exactly those solutions which were first formulated by Giotto over a century before. The problem arose as soon as the suggestion of con-vincing space and solid objects enabled the artist to break through the flat surface. The invention of artificial perspective, with its vastly increased power to do precisely this, made the problem infinitely more acute. In Donatello's work the complexity and variety of the methods used, the innumerable com-binations working towards the same goal of harmony between space and plane and elaborated through the course of a long lifetime, seem to show that, in his case as well, the conflict between the two was realized. It was not merely an unseen hurdle surmounted by infallible good taste. To him perspective was no spatial game with a value of its own. It was, for him, only the means to more important, and essentially artistic ends.

The new artificial perspective was a tool finely fashioned to perform the three tasks for which the greatest masters used it from the moment of its inception: the creation of pictorial space; the organization of the composition; and the maintenance of a perfect harmony between this new reality and the surface upon which it has its being. It was on these fundamental aspects of the new invention that Donatello concentrated all the power of his genius.

NOTES

1. This chapter contains the greater part of a more detailed study, 'Developments in Renaissance Perspective—II', *Journal of the Warburg and Courtauld Institutes*, vol. xiv, 1951, pp. 42–69, which was suggested to me by J. Pope-Hennessy.

2. H. W. Janson, *The Sculpture of Donatello*, Princeton, 1957, p. 30, correctly notes that the orthogonals of this squared floor in the building on the right do not converge accurately to the vanishing point indicated by the side wall. The intervals between the transversals are also inexact.

3. The viewing distance in the 'St. George and the Dragon' is half the width of the relief or less from its surface. In the Salome relief the distance is almost one and a half times the width. The significance of these proportions is considered below on pp. 194 ff.

4. Detailed arguments are given in White, op. cit., p. 48.

5. The relief as a whole has suffered greatly from the disintegration of the colours, particularly the blue which picks out the arches, windows, and inner walls, and this has considerably de-creased its clarity of structure.

6. The use of vertical convergence is almost unknown in Italian art, and is noticeably absent from the work of artists such as Mantegna except in illusionist decorative schemes as opposed to framed pictures or reliefs. The overall excitement achieved in the Assumption relief, in which the phenomenon is exploited for dramatic effect, contrasts not only with the calm of the 'St. John

on Patmos', but also with Giotto's simple use of converging rays to give movement to the figure of the rising saint in the Peruzzi Chapel fresco. The vertical convergence seems, however, to be much less exact than is implied in Parronchi, op. cit., Pl. 99.

7. The effect is greatly reduced in reproduction, as the dazzling effect of the real gold is no longer present, and the architectural areas appear to be much calmer.

8. In terms of gilding, not only does the Salome relief provide a forerunner for the sequence that has been followed, but the Bargello 'Crucifixion', with its mass of inlaid silver, continues it naturally into the later Florentine period. Various problems connected with the sequence of conception, the inscriptions, and so forth, are considered in White, op. cit., p. 63, note 1.

9. The problems raised by the changeover from early plans for a door with twenty-four panels to the revolutionary ten-panelled scheme are complicated by the loss of the documents. These are only partially recorded in copies (H. Brockhaus, *Forschungen über Florentiner Kunstwerke,* Leipzig, 1902, p. 39. Vasari, *Le Vite,* ed. K. Frey, Parte I, Band i, Munich, 1911, p. 359). Of the two crucial passages, that of April 1436 says that 'ten histories and twenty-four pieces of frieze . . . are cast and the polishing is being begun'. The second, of July 1439, says that by early 1438 the stories of Cain and Abel, and Esau and Jacob were finished, that of Moses almost finished, and the story of Joseph halfway to completion, whilst in the panel of Solomon and the Queen of Sheba, the houses, the lower part, and the figures on the right were also completed. Finally, the original twenty-four panelled framework was used for the executed doors.

L. Planiscig, *Lorenzo Ghiberti,* Firenze, 1949, pp. 52 ff., argues that the document of 1436 refers to ten small scenes from the twenty-four panel plan. The changeover therefore occurred between 1436 and 1439 when reference is made to the completion or partial completion of five panels which definitely belong to the existing door.

This solution raises several difficulties. Firstly, neither Ghiberti, nor any other early writer, mentions such a dramatic change involving the scrapping of at least ten scenes and presumably of the worked-up designs for many others, altogether the fruit of several years' work. It is known from Ghiberti's own experience that casting was a risky enterprise in the early fifteenth century, and once successfully concluded such difficult labour would not be lightly discarded (see Vasari, op. cit., ed. Milanesi, vol. ii, p. 228, for Ghiberti's troubles when casting the earlier doors). Whether such a change were against the artist's will, which is unlikely, since he was already approaching the new style in the mid-twenties, or were achieved only at his own insistence after years of work on the original scheme, it would be a noteworthy incident, and ideal material for the typical artistic anecdote.

Secondly, this solution would make 'The Baptism of Christ' (Pl. 38, *a*) in Siena an isolated phenomenon followed, as well as preceded, by work in an earlier style.

Thirdly, it is most unusual to refer, as does the later document, to works as being completed, without further qualification, when they were only modelled in wax or terracotta. Such an interpretation would increase the stylistic anomaly by giving the latest possible date to a return to ideas that flow naturally from the work at Siena. The equally awkward alternative, that the reference is to works already cast, would involve Ghiberti's having committed new ideas to bronze at a rate that is quite contrary to all that is known of his working habits. Of the five reliefs not mentioned in 1439, four were still incomplete in June 1443, and the work only seems to have been finished in 1447.

Finally, this solution makes the stylistic development within the existing series itself rather hard to understand at certain points.

The documents themselves, however, by no means demand the dramatic interpretation. That of 1439 can very well be taken to concern the work of chiselling and polishing. If this is done all textual and stylistic difficulties are avoided, and the ten reliefs cast by 1436 need not belong to a different set which was suddenly discarded. The change of plan, unmentioned by early sources, could then have taken place quietly at a reasonably early stage when much less trouble and expense

would have been involved. The twenty-four panel frame, which survived the changeover, may even have been the only element completed at the time.

10. In this it recalls 'The Story of Cain and Abel', also mentioned as complete in 1439. See note 9.

The numerous deviations from Brunelleschian accuracy of construction in the architectural scenes are noted in Krautheimer, op. cit., pp. 248 ff. The attempt to give them an alternative theoretical justification contained in Parronchi, op. cit., pp. 313 ff., does not seem altogether convincing. In particular, there seems to be nothing either in the actual reliefs of 'Jacob and Esau' and of 'Joseph and his Brethren' or in the theoretical arguments to justify the lines in Pls. 118 and 119 which join the base lines in each scene to the vanishing point of its neighbour.

11. The need to combine the architectural scenes with the remaining designs may have influenced the matter. There are, however, no exceptions elsewhere to what appears to be the rule.

12. The greater unity of subject contributes to, but does not completely explain, the changes which take place in this design.

13. For recent objections to the attribution of this relief to Donatello, see op. cit., pp. 244 ff., and J. Pope-Hennessy, *Catalogue of Italian Sculpture in the Victoria and Albert Museum*, 1964, vol. I, pp. 86 ff., and Janson, op. cit., pp. 244 ff. The latter also, on pp. 242 ff., rejects the Bargello Crucifixion.

CHAPTER XII

Filippo Lippi

Pictorial space is so characteristic a feature of fifteenth-century painting, and its forms so varied, that it would require a treatment as exhaustive as exhausting to ensnare and label each new compositional element, each new progress, each success and failure. But since this age was also increasingly one which looked above all things for harmony in nature and in art, it may prove revealing to examine further some of the most characteristic visual methods of creating space harmoniously upon the surface. Donatello's exploitation of the threefold value of each individual formal feature is only a single method. His concentration upon linear perspective must be partly due to the limited colour range available to a sculptor. Even so it is hard to over-estimate the importance of his use of gold. In the following pages it will be feasible to do no more than enter upon the fringes of the vast question of the role of colour in fifteenth-century painting.[1] This will at least, however, partially redress a balance which has, up till now, been tilted so as to include little beyond the subject of perspective line. Since, moreover, in analysing Filippo Lippi's paintings, his compositional exuberance makes it necessary to touch on nearly all the points that are most relevant to the problems of pictorial space, it is through such an analysis that the various topics will be broached.

An interesting starting point is provided by the small, Masacciesque panel of 'The Virgin and Child with Angels and Saints' (Pl. 43, *a*). Datable in the early 1430's, it is closely connected with the small group of works which precede the formation of Filippo Lippi's personal style towards the end of the decade.[2] Its simple pattern is the prelude to the compositional complexities of works such as the Barbidori Altarpiece from Sto. Spirito (Pl. 43, *b*). The clear space enclosed within the perfect circle of the figures is paced out by the climbing horizontals of the steps that lead up to the platform of the throne. The position of the figures is simply, and quite logically explained, whilst the spatial circle is tilted so that they also climb upwards over the surface, making the pattern fill the entire rectangle with colour. An earlier, and less complete compromise between the renaissance desire for spatial clarity and the Gothic, surface-filling figure pattern is to be seen in Fra Angelico's Frankfurt 'Madonna and Angels', and the theme is fully orchestrated in his great 'Coronation of the Virgin' (Pl. 42, *a*) in the Louvre.[3]

In this altarpiece, the patterned floor and the alignment of the inwards turning figures tell of the new distance to be travelled before reaching the now monumental flight of steps that leads to the high throne. The low viewpoint gives a stronger space, clearer support for the new weight of figures. On the other hand the colour underlines the interest in the over-all surface pattern with which the climbing composition fills the panel. Circling downwards on the left the colour runs from lilac to a pale pink, almost shell, and then on the right runs upwards from vermilion, through soft pinks, and back to lilac. But whilst this circling range of pinks harmonizes with the spatial content, without in any way expressing it in naturalistic terms, cooling, and softening as it recedes and climbs, it is everywhere associated with a bright, pale blue. Unlike the pink, this endlessly repeated blue is quite unvaried from the figures in the very foreground to the distant sky. It has no spatial function other than to unify the colour pattern with the flat pictorial surface. The separate roles of the two dominant elements in the colour are as clearly distinguished as the dual intention of the architectural construction.

In Fra Angelico's work this composition undergoes its final metamorphosis in 'The Virgin and Child Enthroned with Saints' in S. Marco (Pl. 42, *b*), which he painted between 1438 and 1440.[4] Here, in the figure design the original compromise has been resolved, and space is dominant, whilst the surface filling is achieved by purely decorative elements such as curtains and garlands. Nevertheless the circle still retains its power to carry the eye smoothly round rectangular space, turning the contrast between orthogonals and transversals into a continuous movement that flows evenly in space and on the plane alike. The design forms, in fact, an interesting contrast with Filippo Lippi's almost contemporary Barbidori Altarpiece.[5] In themselves the compositions are quite similar, for both contain the circle in a square design, with kneeling figures in the foreground. The fact that they were each preceded by a similar compromise adds further interest to the comparison.

In the Barbidori Altarpiece the figures are brought up close to the spectator, and the viewpoint is lowered so that the main semi-circle of the angels' heads falls slightly as it runs into the background. Despite the hieratic change of scale between Virgin, Saints, and Angels, the viewpoint remains consistent for the entire figure composition. The interior itself is a simple rectangle, with the front plane clearly marked by the railings that run in from left and right. All the principal figures are placed in an even circle round the Virgin at the centre. Yet the result is not the clear space of the Fra Angelico composition or the early Empoli Madonna. It is instead a space filled up to overflowing, full of complex detail. The pattern of the different levels of the floor, the knobs, the bosses and deep flutings on the central throne and canopy; the broken shapes of the two ends of the low enclosing wall that separates the semi-circle of angels from the small onlookers beyond; all these add to the sense of crowding. In small reproduction the effect is one of clutter, almost of

confusion, as so many objects catch the eye, distracting it from the over-all design. A slight feeling of uncertainty is greatly increased by the columns on either side of the Madonna. They do not exactly coincide with the pendant bosses of the frame, so that there is no actual ambiguity in their position, no conflict between their bases, behind the forward figures, and their capitals which would then be in the foremost plane of all. Structurally it is clear that they belong to the pictorial space, and are cut by the Gothic frame as casually as the horizontal of the cornice at the back and sides. But columns and frame so nearly meet, and the former so nearly carry out the arch-supporting func-tion of the clustered columns that formerly divided up the Gothic triptych frame of which the separate compartments have here flowed together, that it is impossible to dissociate them. By so much, the certainty, the element of illusion weakens, and the crowded space contracts and flattens. Indeed, the final effect of the design is noticeably different from that made by almost any of its details. The Madonna and Child framed by the shell-niche of the throne, or the kneeling saints, for example, have a solidity, a quality of illu-sion, that is absent from the composition as a whole, in which the three-dimensional compulsion has been neutralized.

Within this scheme the colour plays a vital role. It injects a clarity that is lost in reproduction. The glittering, disruptive highlights are replaced by colours that develop and repeat each other, bringing unity to the whole com-position. It is a unity not of figures only, separated from their architectural surroundings, but one which embraces both. Not only the variegated marb-ling of the floor, but also the general greys that run from a near white down to deep and sombre darknesses and tinge with pink and violet; the light grey-blue of the ceiling that echoes out beyond the open window, and catches in the Virgin's cloak; all these provide an intimate connection between figures and surroundings. This unifying process carried out in terms of colour seems, as can be seen in the single instance of the blue, to be quite independent of the spatial placing of the objects it defines and brings together.

This is true in one sense, but not in another. The play of colour in the figures shows that there is a delicate balance between space and colour. The latter is not brightest in the foreground, toning down towards the back. Its function is not primarily realistic. The angel looking from behind the column on the left is bright vermilion over gold, which blends into the yellowish vermilion that appears above the Virgin's breast. It then sinks to dull ver-milion, this time flecked with gold, in the angel's wings on the far right, and sweeps across and forward to the left-hand kneeling saint in whom vermilion cools to cherry, drops to a dominant, deep crimson. Next it crosses back, and sinks to a dull bluish red, running grey-purple, in the right-hand angel's cloak; returns to the grey-purple wine of the hem of the Virgin's under-garment, to be echoed softly in the pink-tinged grey of the shell-niche above her head; and finally fades forward into the dull grey violet of the left-hand

angel's cloak. At this point the entire colour cycle that began in bright vermilion starts again, this time developing in grey. The colour does in fact move to and fro across the spatial circle of the figures, each nearest echo pulling back and forth across the space, with intense, bright colour often in small background patches, and muted tones filling broad foreground areas. Where there are actual repetitions these too frequently run counter to the spatial play, weaving a pattern on the surface, tying the space-separated strands together.

In the slightly earlier Tarquinia 'Madonna' (Pl. 44, *a*), dated 1437, the crispness of the folds, and the dramatic presentation of the plastic detail are even more noticeable. The dark chasm in the draperies between the Virgin's knees, and the Christ child's outflung leg, are as expressive as the dramatic closeness of the throne and the steep inrush of perspective lines. Nonetheless it is quite difficult to realize how far back this narrow space extends. The abrupt cutting of bed and window, and the half-closed door, prevent a clear perception of the distance to be travelled before the wall beyond the sunny courtyard in the background is attained. Again the crowded forms are tied together by the colour. The pink and grey tones of the flesh are echoed every-where, and the colour of the wall seen through the doorway at the back repeats the pink found in the highlight of the Virgin's sleeve. But if the crowding of the forms within the narrow confines of the frame, and the play of colour link this panel with the Barbidori Altarpiece, the high viewpoint and the steep perspective lead towards 'The Coronation of the Virgin' (Pl. 44, *b*), painted between 1441 and 1447, but belonging in conception to the earlier date.[6]

In Fra Angelico's 'Coronation of the Virgin' (Pl. 42, *a*), as in Filippo Lippi's own small panel at Empoli (Pl. 43, *a*), the architecture was used to extend the figure pattern over the whole surface. Now, in Lippi's Coronation, the throne once more stands on a raised platform, whilst the foreground wall, which was a feature of the Barbidori Altarpiece (Pl. 43, *b*), is used to carry the spatial design forwards and downwards as far as, and, by implication, even beyond the lower border. It also helps to spread the figure pattern from the top down to the very bottom of the panel. In this respect, however, it is the extreme height of the viewpoint, situated well above the Virgin's head, that is by far the most important factor. Taken in conjunction with the architectural design, the latter also has a number of other significant effects upon the composition.

The raising of the vanishing point gives the long orthogonals of the floor, left unencumbered by the artist, great extension on the surface, as well as a great power to create depth. Moreover, since there are absolutely no opposed orthogonals descending from above, except for the minute lengths in the central niche, there is no formation of a spatial tunnel. The eye is not forced inwards willy-nilly, and the surface pattern element in the space-creating lines

is heavily accented. Earlier this same surface-skating quality that accompanies a high viewpoint was observed in Cimabue's compositions (Pl. 1, *a*). It was then contrasted with the inwards thrust obtained by the addition of down-sloping roof orthogonals in all the buildings by the Isaac Master (Pl. 5, *b*). A similar comparison is valid here. It is even noticeable that the light and dark blue background stripes, which contract the depths of sky into an opaque, patterned surface reminiscent of Ottonian miniatures; these stripes slope in the same sense as the rising floor orthogonals and reinforce the pattern they create.

The high viewpoint also puts particular emphasis upon the hanging arches of the now vestigial triptych. All the perspective draws the eye into the area they enclose. The odd, transitional shape is underlined, not minimized. In detail the result almost exactly repeats that obtained in the Barbidori Altarpiece (Pl. 43, *b*), for the pendant forms are brought into close contact with the marble shells marking the forward ends of the arms of the throne. In this way an architectural form set deep in the pictorial space is inextricably associated with parts of the frame. The latter become two planar promontories jutting into the world of picture to question the existence of the whole extensive space inhabited by the foreground figures. Yet whilst the framing questions the entire, elaborately constructed space, it also accentuates the spatial tunnel of the throne itself, considered as a self-sufficient detail. Within the central area, which it isolates, the short orthogonals wield an influence that they do not have within the context of the composition as a whole. This intensifies the perspective stress upon the focus of the action. The 'archaic' survival, visible in the shaping of the frame, plays in this later altarpiece a more, and not a less important role than in its forerunner from Sto. Spirito.[7]

Another most unusual feature of the composition is that Filippo Lippi nowhere shirks the structural implications as regards the figures. Throughout the design they are shown foreshortened in complete accordance with the rules of unified perspective. The only limit is the artist's own ability. Even when, as in the figure of the donor on the right, the near birds'-eye view is startling in its consequences, there is no withdrawal. The partial applications to figures of the foreshortenings implied by a low viewpoint have already been seen in the works of Masaccio and Donatello. Nevertheless, Filippo Lippi's faithful elaboration, throughout a complex, crowded scene, of all the consequences of such a high viewpoint is so rare as to be nearly, if not quite, unique in what survives of fifteenth-century Italian art.

As a result of the architectural setting of the scene, and of the kneeling pose of the foreground figures in the partly isolated central group, there is a wide range in the degree of foreshortening that the figures undergo. The onlooker looks down so steeply on the kneeling saints, for example, that when he focuses on them, and not upon the composition as a whole, his eye runs down towards the floor, and tends to stop against the base-wall of the throne. Some

effort is required before it can re-focus and move on towards the scene above. All the inter-connected points that have been raised contribute, each in their own way, to the repetition on a wider scale of a phenomenon already visible in the Tarquinia panel (Pl. 44, *a*) and the Barbidori Altarpiece (Pl. 43, *b*). This time it is not the parts of figures as in the first case, or whole figures as in the second, but groups of figures, that give a much stronger impression of space than the picture as a whole. The isolation of the throne, or of the kneeling central group, shows this most clearly. This cumulative effect of all the formal factors that have been discussed is very obvious in reproduction, and the great increase in the size of the constituent elements of the conflict draws attention to it. The coagulation into groups may even to a great extent obscure the skill with which the compositional connecting links are handled, since it is only through the colour that the unity is re-established. On this occasion the reintegration is not brought about by colours placed in balanced opposition to the spatial thrust. Instead, they are used to strengthen and to emphasize the unifying force of the perspective space enclosing the massed groups of figures.

Strong colour is reserved, amongst the figures, for the central group of kneeling saints. Here are forceful reds; dark grey-blue beneath a honey cloak; deep green running to yellow; damasked green and gold. Above them, and beyond, the Virgin pales to a soft blue-grey, or greyish blue linked with pale cherry, and blends with the deep grey-blue and pale grey-rose of the Eternal. In the figures on the wings the colour drains away in paler greys, touches of quiet grey-blue, pale green, and rose and yellow, with the strongest accents in the subdued, grey-rose, shot material of the standing figures on the extreme left and right. Finally, strong areas of light are to be found in the two half-length figures placed in the most forward plane of all.

The distribution and graduation of the colour in the figures therefore emphasize the perspective concentration on the centre by expressing, in their own terms, the movement into depth towards the focus of the action. They also draw attention to the care with which space is developed on the wings, where large-scale foreground figures blend into the crowds beyond, and even the white, decorative pattern of the lilies has its spatial message told in terms of careful diminution. Indeed, so nicely calculated is the range of colour and of diminution in the figures that, in front of the original, the sense of unified, deep-running space is actually stronger if the main orthogonals of the floor are hidden from the eye. Nothing could reveal more clearly the complexity of the compositional balances by means of which the artist has built up this most ambitious scene.

It is only in 'The Annunciation' in S. Lorenzo (Pl. 45, *b*), however, that Filippo Lippi reaches what appears to be an absolutely harmonious solution to the problem of composing deep, pictorial space.[8] His interest in the maintenance of harmony with the plane is unabated. Here the frame is

almost square. No hanging arches point back to a Gothic past. But, as has been seen, the function of these archaizing elements was as important to the artist as several of the old-fashioned elements in Donatello's earlier reliefs had been to him. The frame is modernized, and yet the feature has not been discarded. Painted pillars and painted arches now play, in fully pictorial terms, the role that was formerly shared between internal and external elements. The vanishing point, upon which all the deep pictorial space is centred, only lies a matter of two inches to the right of the bright central pillar in the foremost plane of all. The eye is called back to the surface at the very point of greatest penetration.

It is only with the advent of the powerful, and potentially disruptive space-creating ability of artificial perspective that such a compositional pattern takes on its full significance. Where no space, or little, is intended, such a central arch is merely part of a coherent surface design. It has no balancing function because there is no balance to restore. It is noticeable that the interposition of a foreground column actually between the Virgin on the one hand and the angel on the other only becomes common with the advent of the new ideas of space.

Filippo Lippi now makes full use of the organizing power of artificial perspective in order to control the complex cubic patterns of the floor and parapets in the foreground of his picture. The plane-stressing qualities of the undistorted forward planes, which are an integral feature of the method, are exploited in the same way for artistic ends. Immediately at the bottom border a step rises parallel to the surface, and each short orthogonal is balanced by another firm transversal. The solidity of the forms and the reality of the space are asserted whilst the thrust of the sharply foreshortened receding elements is slowed. Similarly all the action of the figures takes place in the foreground, moving the attention back and forth across the surface.

The concentration of the figures in the foreground, and the increased plane-stress of the central pillar and the arches which connect it to those closing either side of the design, are balanced by the creation of a space far deeper than anything attempted elsewhere in Filippo Lippi's early work. The movement of the action and attention of the figures runs from left to right, and it is at the point of concentration in the figure of the Virgin that the strongest spatial thrust originates. The base line of the architecture, broken only momentarily by the Virgin's cloak and leg, runs from the extreme foreground in the bottom right-hand corner almost to the vanishing point itself. The line continues for the last few centimetres in the fence-like rose hedge which runs along the bases of the poles supporting the vine pergola. Its effect is strengthened by the repeated spatial emphases in the whole range of buildings on the right. These surfaces are not only the steepest and the most continuous receding forms in the picture, but are further emphasized by brilliant light which concentrates on them its maximum intensity. These snowy, high-

lit forms, which on the opposite side are balanced by the dark, unbroken cornice of a roof, unfailingly attract the eye and sweep it into the bright, sunlit, garden space of the Renaissance.

Space is insistent in its clarity throughout the S. Lorenzo panel, reaching out to either side and upwards overhead, as well as straight into the rapidly receding distances. In contrast there is the already observed juxtaposition of the foreground pillar and the vanishing point. Indeed the very brightness of the forms which so compel the eye to follow them into the distance ties it to the bright bar that slashes down the surface. Most remarkable of all, immedi/ately above the vanishing point, a tall, domed building rises on the far horizon. A pale ghost in reproduction, it is in reality a brilliant vermilion colour that is echoed only in the deeper hues of the cloak worn by the fore/most angel on the left. Similarly the deep, dull, green of this same angel's wings repeats the deep greens of the distant vegetation, so that there is a strong tension between this foreground figure and the furthest distances. The close connection becomes more significant still when it is realized that this figure, with its direct outward glance to the spectator, is the latter's closest point of contact, and of entry into the pictorial world. There are many other colour links of an immediate interest in the present context. As the grey wings of the further angel on the left run down in colour to the dark grey of the building which recedes beyond them, so the wings of the announcing angel link directly with the bright receding surfaces on the other side, his cloak connecting that of the angel just behind him to the warm pinks of the flooring. The annunciate Virgin, with her harmony of pale, light greys and pale grey/blues and changing grey/to/violet, connects the figure world with all the light and dark greys of the architectural surroundings, and finally with the sky itself.

Even from such a partial description it is clear that the whole picture can be seen, and was intended to be seen, as a harmonious surface, with the colours linking every part, sometimes by gradual development and delicate transformation, sometimes with the aid of direct repetition. It retains in a new form many of those values that are of paramount importance in the medieval picture. On the other hand, these elements of line and colour circling on the surface, circle also into deep pictorial space.

There is no one way in which to read a composition. The observer's interest rightly floats here and there, sometimes haphazardly, and at others with a purpose; sometimes obeying rules and sometimes, if it is aware of them at all, deliberately breaking them. Nevertheless the artist may incorpor/ate, besides a number of focal points for the attention, certain sequences, which form a special pattern that has some objective meaning even if the onlooker is quite uninterested in following its signposts. In this picture such a sequence is particularly clear, and since it reveals something of the niceties of the new perspective, it is perhaps worthwhile to follow it.

Filippo Lippi

The point of entry into the pictorial world is marked with unusual clarity by the angel on the left who glances back at the spectator. He is himself in the act of walking away into pictorial space. The abrupt torsion of his body immediately epitomizes the whole complex balancing of move and counter-move on which the composition is built up. Even as he walks he points to the annunciation taking place upon the right, and his companion, facing three-quarters out towards the onlooker, raises his hands in wonder and looks intently at the kneeling Gabriel. With the accompanying movement of the Dove above his head, he ensures that the observer's eye moves to the right across the surface and not onwards into depth. The wings and trailing cloak carry the eye on past the central bar, and the figure of the angel Gabriel in pure profile takes it to the centre of attention in the graceful person of the Virgin. At this point the compelling thrust of the bright, continuous, ortho-gonals begins. The eye speeds into the distance that is measured out by all the rapidly diminishing verticals of the buildings and of the pergola. Then at the point of furthest distance the insistent surface undertow sets in. The central pillar in the foreground makes its influence felt. But the bright accent of intense vermilion, and the deep, echoing greens pull the eye back, not to the inanimate stone pillar, but leftwards up along the dark orthogonals to the point of entry—to the figure of the angel in which both reds and greens find their response. Thus the subject matter and the figure action, the perspective structure and the colour, now obeying natural laws, now purely carrying out the artist's compositional demands, are all made to play their part. By these concerted means a controlled circulation in a clear pictorial space is made to balance the decorative circulation on the surface. Now, for the first time in Lippi's major works the realism of the whole has equal force with the reality of the parts.

The building of pictorial unity by means of move and counter-move, a system of dynamic balance, is quite different from the combination of ambiva-lent individual features which was Donatello's method. The artistic purpose is the same, however, and it is perhaps amusing to see how, in 'The Annun-ciation' (Pl. 45, b), the diagonal of the lily on the surface runs on through the swift recession of the distant hedge to the vanishing point of the perspective. This small detail serves to underline the fact that nowhere else in all the mass of architectural forms is there the slightest possibility of equating an orthogonal with a transversal. In Filippo Lippi's art, lines lying on the surface and lines leading into depth are everywhere distinguished with the greatest clarity.

The analysis of these few pictures also shows that even during the fifteenth century, the period of the most enthusiastic exploitation of geometric space, colour was continuously being used to retain, or to restore the unity of the pictorial surface.[9] In medieval frescoes the same colours were used impartially for the figures and for the linear or architectural borders, creating a great, unified design in colour. In Giotto's quieter range of hues, with its greater

element of realism, the same soft pinks and greens and blues still recur in figures and in architecture alike, as well as in the decorative patterns of the marble frames with their acanthus scrolls and cosmati inlays. This is particu‑ larly noticeable in the Arena Chapel. The colour, therefore, like the disposi‑ tion of the figures, takes on a novel compositional role precisely because it now counterbalances the tendency of the new spatial realism to burst through the surface of the wall.

In the late fourteenth century, and in the fifteenth, when the new concep‑ tions of pictorial space were crystallized and greatly strengthened, this over‑all colour pattern largely ceases to extend over the painted architectural framework of the frescoes. But within the picture efforts were continually made to balance the new realism by applying traditional methods of distributing colour to the new conditions. The kinship which exists in this respect between Maso di Banco and Piero della Francesca has quite recently been pointed out.[10] In Piero's fresco of 'The Reception of the Queen of Sheba' the close colouristic unity of figures and surroundings at which he aims is symbolized by the way in which the man in red, placed with his back to a great, fluted column, is echoed in the red dress and the white, fluted cape of the lady‑in‑waiting who stands just behind the kneeling queen. In 'The Testing of the Cross' a similar evocation of the static, and enduring monumentality of the human figure has significance in terms of space as well as colour. Here the left‑hand pillar of the temple in the background carries downwards in the smooth, white column of a cloak sleeve, and the space between them, carefully described by the steep change of scale, is quietly annihilated. In this temple, as in the columns which divide the scene of 'The Reception of the Queen of Sheba', Piero also uses his command of artificial perspective for a similar purpose. Through careful placing in relation to the vanishing point, the architecture is, in either case, seen in the most extreme foreshortening that is feasible. The orthogonals are thereby so reduced in length that it is very hard to realize the depth which is involved. In 'The Reception of the Queen of Sheba' space is emphasized by other features of the architecture. But the temple in 'The Testing of the Cross' is placed behind the figures. Piero therefore has no interest in the accurate definition of the space it occupies. The temple must at least be square, and yet it needs considerable imagination to equate the wide façade with the abbreviated cornice to the left.

It has already been seen that all the compositional, colouristic, and perspec‑ tive devices so far discussed in the works of Giotto, Donatello, and Filippo Lippi, are significant precisely because they accompany an ever‑increasing emphasis on realistic space. It has been fashionable, at various times, to over‑ stress the element of illusion. Conversely, it is most important not to under‑ estimate it in a period as influenced as the present by non‑representational art, and by the enjoyment of pure flat pattern. At the same time, these adventurous attempts to use the new perspective to the full without losing control of the

pictorial surface, must be related to a general pattern of development in which their historical significance far outruns their number.

Filippo Lippi's 'Virgin with SS. Cosmas and Damian, St. Francis, and St. Anthony of Padua' provides an example of the most popular fifteenth-century method of controlling the new spatial realism. This is to retain, or to return to, the shallow stage-space which was characteristic of so much of the output of earlier centuries. Space is not controlled by ambivalence, or by thrust and counter-thrust, but by the simpler, less ambitious, means of limitation. In this altarpiece there is spatial emphasis in the plastic treatment of the back-wall and in the way the frame cuts off the platform underneath the forward-thrusting throne. Yet the essential pattern is that of a space only a few feet deep, decisively truncated by a solid wall that lies completely parallel to the surface. Fra Angelico, the master craftsman of clear space in the first half of the fifteenth century, presents many examples of this basic composition reduced to its simplest terms,[11] and the scheme recurs, endlessly varied, in a surprisingly high proportion of renaissance paintings, both on panel and in fresco.

It is only on the miniature scale, and in the wide, low format of predella panels that Filippo Lippi is himself content with the creation of firmly closed interior spaces of a simple plan and unadorned severity reminiscent of Fra Angelico. It is, moreover, interesting that these plain interiors, following the precedent which Masolino in all probability established in the altar piece of 'The Madonna of the Snow',[12] have normally quite a high viewpoint, and are cut off by the upper border just above the figures' heads. They are thus related to the main body of the altarpiece, of which they form the base, by the very means which keeps their undecorated, simple clarity from creating an intrusive spatial box.

It is against this background that the complicated virtuosity of Filippo's Munich 'Annunciation' (Pl. 46, *a*) must be set. This picture, like the Palazzo Venezia 'Annunciation', carries on the complex spatial game of the S. Lorenzo altarpiece (Pl. 45, *b*). Here, however, the short moment of balance for the composition as a whole is past. The figure-crowding of the earlier works is replaced by crowded architectural forms and decorative detail. The figures, in themselves grown less robust, can hardly hold their own against the teeming life of their surroundings.

Once again the action takes place in a single forward plane, and now the movement is entirely side to side, and not enlivened by the variations seen within the S. Lorenzo composition. Once again orthogonals are short and strongly emphasized, and frequently repeated verticals and horizontals dominate the crowded scene. There is still the clearest possible distinction between diagonals running into depth and lines lying parallel to the surface. In even the most insignificant detail, there is no hint of ambivalence or approaching ambiguity.

Filippo Lippi

The crowding and complexity of the architectural features are alone suffi-
cient to maintain considerable surface tension, and numerous compositional
devices give additional assistance. The lower orthogonals of the side walls are
completely masked, so that the deeply cut pilasters and applied half-columns
appearing between the arches of the forward screen associate themselves quite
strongly with those situated in the same relation to each other on the screen
itself. Overhead, the great arch opening out into the garden is so drastically
cut both by the upper border and by the heavy horizontal of the screen, and
the orthogonals of the side walls, which are the only things that push the arch
backwards into space, are so instantaneously truncated, that it almost seems
to stand on top of the screen instead of behind it. This impression is most
strongly reinforced by the repetition of its colour in that of the smaller arches
of the screen, the pattern of which it also repeats exactly. This similarity of
form and colour, accompanied by greater size and only partial visibility,
inevitably tends to pull it forward, as though the relative positions in space
were, if anything, reversed. Meanwhile the pole-like trunk of the tall tree
that fills what little space is left beneath the curve of the far arch becomes
involved in even greater complications. First of all it coincides exactly with
the vanishing point. It also fills in the opening of the distant gateway, which,
by its steep recession, still suggests, but can no longer actually reveal, fresh
vistas opening out beyond. The form of the tree-trunk, moreover, already
associates it with the smooth, applied columns of the forward arch, and this
association is greatly strengthened by the flying Dove which simultaneously
masks the upper part of the trunk and overlaps the arch itself. The Dove by
seemingly covering both forms in a similar fashion effectively contracts the
space that actually separates them. Underneath the Dove, white lilies, echoing
its colour in a still more forward plane, again link tree and column, and still
further compress the intervening space.

The extent to which this spatial play, however over-involved, damps down
the full effect of the deep, centrally focused space, may readily be seen by
comparing it with an actual replica now in the Accademia in Florence
(Pl. 46, b). In this copy the whole structure of the Munich picture is carefully
reproduced, whilst the particular balance between space and plane, seen in
the prototype, is totally transformed.

The reorganization is achieved by two quite simple operations. First there
is a change in the proportions of the composition, and secondly misunder-
standing of, or a disinterest in, the various devices which Filippo Lippi had
specifically designed to tie the spatially separated planes together.

In the copy all the detail has been streamlined. The pilasters and applied
columns of the screen are now much slimmer in relation to the width of the
arches. Everywhere the mouldings shrink and cornices lose weight. The
pictured space no longer seems to be filled with cubic shapes, their plasticity
emphasized by the strong play of light and shade on deeply chiselled forms.

The architecture, losing weight, extends more deeply into space. Instead of being abruptly stopped by the heavy base of the transverse screen, the eye runs inwards for some distance over the perspective patterning of the floor. Another, wider expanse of light-coloured flooring follows before the limits of the building are finally reached. The enclosing parapet of the inner garden now seems thin and far away. The pine trees are now ranged like telephone poles, and carry the laws of regular, orthogonal diminution on beyond the limits of the architecture. The bole of the central tree still masks the opening of the distant gate, and still absorbs the vanishing point, but its knitting-needle thinness now no longer links it with the columns of the screen. The flying Dove no longer ties it to the forward arch, nor does the lily join in linking it with the flanking column. Finally, the space above the screen is so abbreviated as to lose all vestige of conviction. It becomes unimportant that the far arch, which incidentally does not begin to coincide with the columns that supposedly support it, seems to sit upon the screen itself. Only a reference to the Munich picture clarifies a situation so confused as to have lost all spatial meaning.

The result of all these sometimes seemingly trivial alterations is that, when compared with the prototype, the copy creates a strong sense of the disruption of the surface by perspective space. An enthusiastic minor artist[13] saw the spatial power of Lippi's composition, and either failed to see, or happily ignored the careful way in which it was controlled. It is the very enthusiasm for artificial perspective on the part of minor artists that so often leads to a combination of extreme imbalance between space and plane and disinterest in organic form. It is even noticeable that when, in the fifties, Filippo Lippi's own interest in the linear qualities of the human form increasingly replaces any preoccupation with its structure, his interest in the complex balancing of perspective space dies gradually away.

The tondo of 'The Madonna and Child' in the Pitti Palace (Pl. 45, *a*), probably completed in 1452, represents one of Filippo Lippi's latest, and perhaps his most extreme attempts to make strong geometric space live in complete harmony with the flat surface upon which it has its sole existence. Here colour once more plays an important part, and there is again the usual absolutely clear distinction between the numerous orthogonals and transversals that build up the spatial pattern.

In this bold experiment in sharp foreshortening the extreme rapidity of the change of scale is equalled by the steep recession of the architectural surfaces. This does not, however, anywhere result in an undue abbreviation that contracts or flattens the pictorial space. There is no foreshadowing here of Piero della Francesca's experiments at Arezzo. Instead, as in the Munich panel, the objective shortness of the receding elements, and their frequent interruption by emphatic verticals and horizontals, are the means which Lippi uses to prevent a too swift plunge into pictorial space. The architecture is,

however, far less cluttered than before, and the simplicity of profile contrasts strongly with the forms in the Annunciations of the middle and late 'forties. It marks a rediscovery and development of the fundamental clarity of the S. Lorenzo altarpiece (Pl. 45, *b*) and allows the figures to reassert their primacy.

A classic example of Filippo Lippi's method of slowing down the move, ment of the eye into the steeply plunging spaces which he loves is visible in the coffered ceiling. Not only does a heavy horizontal cut across it with its brilliantly contrasted whiteness, but not one of the orthogonals of the further section forms a direct continuation from the forward part. The two sections of the coffering are offset. No spatial tram,line tempts the eye to leap the buffers and rush onwards without pause. Here, moreover, both the vanishing point of the perspective and the geometric centre of the roundel, which are not coincident, draw the eye insistently towards the head of the figure of the Virgin who is seated in the extreme foreground. It is her sideways glance towards the onlooker that links him with the inhabitants of the pictorial world.

The balancing of strongly defined space is one of the main functions of the colour in the tondo. In contrast to the Uffizi 'Coronation of the Virgin' (Pl. 44, *b*) its effect is to provide immediate connection between widely separated planes. This is not done by the mere variation of colour themes from one figure to another, but by the creation of firm colour couples formed of identical hues of similar intensity set at different depths in the pictorial space. The grey,greenish blue of the Virgin's mantle is repeated in the distant figure on the extreme left.[14] The near white, and brownish grey of her head, dress reappear in the figure to the right, striding towards the centre with a basket on her head. The cherry red of the Virgin's dress, and of the cushion of the infant Christ are not, however, repeated quite exactly, but are con, nected with the yellowish vermilion of the bed and of the curtains even further back. These are themselves a little darker in tone than the dress of the woman nearest to the foreground. The latter is repeated exactly in the old man climbing up the steps in the very furthest background on the right. The salmon pink of the marble floor, which leads to these same steps, reappears in the girl behind the reclining mother's outstretched arm. The exact con, nection of the striking colour of the robe of the old man in the distance with a figure, which is, apart from that of the Virgin herself, one of the furthest forward in pictorial space, is matched by the equally striking repetition of the brownish mulberry worn by the small figure reaching down to greet him as he climbs. This is precisely echoed in the figure in the middle distance, visible just to the left of the Virgin's neck. It is this colour which is also used for the dark area of floor upon the right. This part of the design is, in itself, particularly interesting, although its effect is not so noticeable in re, production. In the original it is difficult not to see this dark, and quite unpatterned area as a sombre, vertical wall, despite the angle of the steps upon

the right and the diminution of the distant objects, both of which define it as a section of floor. Its importance in interrupting an otherwise over-powerful and continuous recession from the foreground to the extreme background is quite clear. The wall-like effect is largely due to the very fact that it is wholly devoid of all perspective pattern. Only in the right-hand corner is there a minimal indication of recession, and the dark mass cutting in between two areas of light is completely even in the intensity of colour. No graduation gives expression to the distance involved.

The new clarity and decision of the architectural space as a whole, and its total occupation by the sharply diminishing figures, are balanced by exactly that new firmness in the handling of the colour which is needed to maintain the equilibrium of the composition. The subtleties of colour graduations calling quietly across space would no longer be strong enough. There is, instead, clear repetition of firmly distinguished colour. The artist who, in earlier years, had shown himself to be well aware of the potentialities of tonal graduation, here consistently reverses all the laws of atmospheric perspective. The brightest colour couples are the ones which link the middle ground with the far distance, whilst soft greys, and cooler, quieter reds, and gentle blues are used to bridge the gap between the foreground and the middle distance. Within these couples any atmospheric change is quite ignored. In general, and in detail, colour has become a compositional counterweight to the growing pressure of perspective space.

The Pitti tondo is the last in Filippo Lippi's series of experiments in carefully balanced perspective composition. As in Donatello's work, the numerous variations on a single theme, each change of emphasis being accompanied by corresponding shifts and compensations in every other element of the design, all seem to show the firm aesthetic purpose underlying all that bears upon this aspect of his art. These same twenty years of constant experiment, which fall between the early 'thirties and the early 'fifties, are marked, in the figure style, by a steady movement away from the Masacciesque ideals that dominated Lippi's youth. Now, in the 'fifties and 'sixties, with the general move in Florence towards a gay, linear style of decorative art, a change in Lippi's own conception of pictorial design is crystallized. The former balance is fragmented, and its main components now achieve a separate existence. In panel painting interest in perspective space progressively dies out. In fresco a new tendency to cast the shackles of restraint is manifest.

The series of Adoration scenes in Berlin and Florence are typical examples of the change of emphasis on panel. The floating apparitions in a sky closed in by rocks and forest trees now play a central role in the design. Figures materialize, uncertain in position, and uncertain even in relation to heavenly or to earthly reality.[15] Flowers and figures bloom in crowded delicacy of line and colour. The high-climbing wall of forest carries the eye erratically upwards with the thrusting pines. The logical clarity of space gives way to a

new decorative fantasy, or, as in the Berlin panel, to a dark suggestion of the undefined.

The Prato fresco of 'The Funeral of St. Stephen' (Pl. 47, *b*), signed and dated 1460, brings out the contrasting element in Filippo Lippi's later style. The composition is essentially a variant of that established by Domenico Veneziano in the 'forties in his 'St. Zenobius and the Fallen Youth' from the predella of the St. Lucy altarpiece.[16] The tendency to create deep space beyond a figure composition moving across the foreground plane was very clear in Masolino's work. The St. Zenobius predella panel marks a deliber-ate development of this idea. The relationship between the foreground screen of figures stretched in a dramatic line across the panel and the deep perspec-tive of the street has none of the fortuitous quality which often seemed to characterize the similar Masolino designs. The recession of the houses leads the eye towards the point of highest tension in the distraught figure of the mother.[17] The dramatic balancing of space and figure composition is as clear in its own way as in the quiet companion scene of 'The Annunciation', or, indeed, in the main panel itself.

It is essentially this type of composition that Perugino endlessly repeated for his own very different purposes in the last quarter of the century. A screen of figures, rigidly held in the plane, and sometimes spreading like a brilliant stained-glass pattern over the whole surface of the picture, establishes a decorative network. Then, beyond the screen, deep architectural, or landscape space spreads out towards a vast horizon. Space and plane are independently developed, and their functions clearly separated.

In Filippo Lippi's 'Funeral of St. Stephen' (Pl. 47, *b*) the objective seems to be neither Domenico Veneziano's dramatic, nor yet Perugino's peaceful balance. The strong reds, whites and blacks, mixed with pale greens, which make up the bold pattern of the marble floor, carry the eye firmly inwards in spite of the heavy horizontal interruption of the bier. The plunging line of strongly lighted columns, and the coffered ceiling, with steep, heavily stressed orthogonals, and with the inward-leading longer sides of its rectangu-lar pattern replacing the more usual emphasis on width, increase the feeling of great depth. Orthogonals are everywhere sharply distinguished from transversals, and it is now the latter that are limited in number and extent. All the principal spatial joints between the back-wall and the four receding planes are, in addition, clearly visible. Finally, the figures themselves are not used unequivocally to stress the surface and slow down the movement into space. They are ranged in depth on each side of the central opening, and the regular line of heads with which the seated figures replace the invisible orthogonal of the bases of the columns is particularly obvious. The emphasis is no longer upon balance. The row of figures and the horizontal of the saint's body prevent the sense of space from running out of hand, but still make no pretence at holding it in equilibrium. Yet, in the dream realism of

the rocks that flow into the church like phantoms from some long-cooled eruption, are echoed ideas that are typical of the contemporary panels.

The gradual development of Lippi's new ideas of spatial emphasis is illus-trated by a preparatory drawing for the left half of the design (Pl. 47, *a*). [18] Here a halfway house between the old ideas of balance and the new idea of space triumphant can be seen. Complex Gothic vaulting gives a transverse stress instead of the orthogonal thrust of the coffering in the final fresco. The far more varied architectural detail of the side walls interests and holds the eye. No column-enclosed nave forms a narrow, plunging, spatial alley in the centre. Because of the greater exploitation of the width available, the ortho-gonals in the drawing fall more gently, lacking the same steep urgency. The structure of the floor still shows a remnant of the balanced play of the orthogonals and transversals in the S. Lorenzo and Munich annunciations (Pls. 45, *b* and 46, *a*), whilst the large size of the figures in the background effectively softens the sense of depth created by the architecture. On the other hand this spreading of the figure interest throughout the pictured space, recalling the Pitti tondo (Pl. 45, *a*), attracts the eye into the very depths the full effect of which is limited by the scale of these same figures. The bier is likewise set back further in relation to the principal groups of figures, only that on the left being visible in the drawing. This small cluster of individuals in itself betrays an interest in spatial grouping that is much less evident in the fresco's more numerous, and more regimented ranks, which, paradoxically, encourage the eye to slide off into the deeper, architectural space. The liveli-ness of grouping, like the variety of architectural detail, encourages the eye to linger. This drawing is, in fact, the key to the whole process of Filippo Lippi's movement from the all-pervading, balanced play of space, which was characteristic of his earlier panel paintings, to a monumental fresco style in which detail loses individuality and importance, and becomes subservient to the singleness of spatial purpose evident in the composition as a whole.

The analysis of this single fresco is sufficient illustration of the caesura which divides the later panels and frescoes. A similar dualism can be seen in other aspects of Filippo Lippi's late style, such as the contrasting emphases on stolid portrait realism and upon a decorative linear play that overruns the figure structure. It foreshadows the divergent lines on which so much of Florentine art develops in the last third of the fifteenth century, and out of which emerges Leonardo's towering figure.

The lack of Donatello's lifelong steadiness of purpose does not detract from the importance of the compositional experiments of Filippo Lippi's middle years. It is only in the light of such persistent efforts to exploit the possibilities of linear perspective, and to establish correspondingly effective methods of control, that the expanding universe of the renaissance picture can be fully understood. The experiments in graduated and in coupled colour are the complement of the exciting growth of interest in atmospheric

perspective and in tonal painting. Filippo Lippi's almost logical persistence makes it possible to come closer to an understanding of many of the seeming contradictions and sudden changes of direction, the conservatism, and the sudden outbursts of enthusiasm in a multitude of less articulate, and more elusive spirits. In at least this fundamental aspect of renaissance composition Filippo Lippi both reveals his greatness and illuminates the essential process of attrition whereby new ideas are crystallized in art.

NOTES

1. T. Hetzer, *Tizian*, Frankfurt am Main, 1935, gives a brilliant account, with the widest possible implications, of Titian's use of colour. Northern developments are considered to some extent in W. Schöne, *Uber das Licht in Der Malerei*, Berlin, 1954, with an excellent bibliography also covering colour problems.

2. The later literature returns to the attribution to Lippi. See R. Oertel, *Fra Filippo Lippi*, Wien, 1942, p. 63.

3. J. Pope-Hennessy, *Fra Angelico*, London, 1952, pp. 10 and 173, attributes to Angelico only the Gothic canopy, the steps leading up to the throne, and the minor figures of the choirs of angels and saints at either side of it. The subsequent planning and execution of the remainder of the main panel, as well as of the predella, are given to Domenico Veneziano. This suggests a curious working sequence and leads to several difficulties.

The overall design, with the inwards-turned figures, appears already in the early Frankfurt panel, and the fact that the altarpiece was planned from the first to have an unusually low view-point is shown by the empirically foreshortened steps and by the recession of canopy and floor to a single vanishing point. In general and in detail it seems most likely that Fra Angelico remained in control of the work that he designed, but did not wholly execute himself.

4. J. Pope-Hennessy, lib. cit., p. 174.

5. For dating see Oertel, op. cit., p. 64.

6. B. Berenson, 'Fra Angelico, Fra Filippo e la Cronologia', *Boll. D'Arte*, xxvi, 1932–3, pp. 1–2, 49–66, shows that Lippi often fixed the design of his works very quickly, and then did not complete them for years.

7. Where only part of the frame is visible, as in many reproductions, it could be seen as hanging in the middle of a pictorial space which extends further forwards. But in front of the picture itself this is not possible.

8. For dating see Oertel, op. cit., p. 64.

9. Hetzer, op. cit.. pp. 25 ff., tends to underestimate the attempts to use colour as a unifying force during the fifteenth century.

10. K. Clark, *Piero della Francesca*, London, 1951, p. 30.

11. The finest of these is the fresco 'The Madonna and Child with Eight Saints' in San Marco.

12. See J. Pope-Hennessy, *The Burlington Magazine*, vol. lxxxii, 1933, pp. 30–1, in which the now lost predella panel of 'The Marriage of the Virgin' is connected with this altarpiece.

13. B. Berenson, *Italian Pictures of the Renaissance*, Oxford, 1932, p. 343, attributes the panel to the Master of the Castello Nativity.

14. Allowing for a slight change in value, owing to the deterioration of the pigment, the repetition seems to be almost exact.

15. The monastic figure on the lower left of the Uffizi 'Adoration' is the extreme example of this tendency.

16. For dating see M. Salmi, *Paolo Uccello, Andrea Castagno, Domenico Veneziano*, Roma, 1938, p. 127. This altarpiece presents throughout a remarkable example of space creation and surface control. In the main panel the arched upper area is so cut as to appear to lie on the surface, whilst its supports prove it to be deep in space, and the niche-shaped back of the Virgin's throne is actually part of a wall lying many feet beyond it. In the predella panels the coupling of bright colours in the foreground and in the deepest spatial recesses augments the perspectival control of clearly-defined space.

Recent analyses by M. Meiss, 'Once again Piero della Francesca's Montefeltro Altarpiece', *Art Bulletin*, Vol. XLVIII, 1966, pp. 203-6, and J. Shearman in a forthcoming honorary volume, further emphasize Piero's concern for the harmonization of space and plane discussed on p. 179 above. In his Montefeltro Altarpiece, Piero, like Domenico, uses careful cutting of the architectural contents by the frame in order to compress the deep space which is represented.

17. The recession to a single vanishing point does not embrace the orthogonals of all the houses.

18. The drawing, now in Cleveland, was first identified by J. Byam-Shaw. See also A. E. Popham and Philip Pouncey, *Italian Drawings in the British Museum*, London, 1950, p. 90. In *The Bulletin of the Cleveland Museum of Art*, 1948, p. 15 ff., it is considered as by Ghirlandaio.

CHAPTER XIII

Illusionism and Perspective

Illusionism is an ugly word in modern critical usage. Yet, to the early writers the illusionist effects that artificial perspective put within the artist's reach were amongst the most praiseworthy, as well as the most revolutionary of its attributes. It is, indeed, the revolutionary aspect of the new realism that accounts for much of the emphasis laid upon it. It has already been seen that this imitative realism is only a single element in early renaissance painting and relief sculpture, and one that varies in importance not only from artist to artist, but from object to object. Instead, therefore, of attempting a generalization that would cover, however uneasily, the whole practice of perspective in fifteenth-century Italy, it seems wiser to try to summarize those principles of illusion on the one hand and of organization on the other, together with certain general principles of perspective practice, that bear directly on renaissance problems. This may at least provide a useful starting point when trying to assess the relationship between contemporary theory and a particular, practical example of the application of perspective, or when attempting to draw closer to the artistic purposes behind the individual work of art.

The main compositional means by which solid objects and three-dimensional space may be counterfeited are well illustrated by one of the still-life intarsias in the choir of Pisa Cathedral (Pl. 48, *a*), and by an architectural perspective associated with the school of Piero della Francesca, and now in Berlin (Pl. 48, *b*). It is important to remember, however, that many of the points which will be made in reference to artificial perspective may be wholly, or partly, applicable to the various empirical systems that preceded it, and that later survived side by side with it.

Clarity is the most noticeable feature of the two works mentioned—clear forms and clear space. In the intarsia there is no ambiguity between one clearly distinguished plane and another. The object is composed of simple forms, and is symmetrical, so that the eye is not confused, and can apprehend the whole in an instant. In the architectural view the main space is large and simple, and its inherent symmetry is emphasized because the spectator is seen as standing in the centre of the colonnade, whilst all the buildings are set upon the axes established by the squared pavement. The numerous, and regular indications of the change of scale give clear expression to the distance travelled into space. The vanishing point is not, however, coincident with

189

Illusionism and Perspective

any solid object. So, at the last moment, the imaginative eye is freed of measurement, and travels into the infinity beyond the far horizon. At the same time, there is no confusion between the many orthogonals, or lines running directly into depth, and the lines lying parallel to the surface. All the surface planes are rectangular in general and in detail. All diagonals lead into depth.

Strong lighting, or strong colour, consistently applied, are another means of emphasizing depth and solidity. In both examples the sharply contrasted lighting distinguishes the various planes and their spatial relationships even more clearly than the linear pattern with its insistence on sharp angles. In the same way, strong light on a rounded form stresses its solidity by the smooth transition from an intense highlight to a deep shadow. Only if the forms become complicated, and the lighting arbitrary, is the effect destroyed, and replaced by a dazzling surface vibration. Both strong light and sharp fore/shortening may also be used, however, for their attendant dramatic qualities.[1] The intarsia, besides creating an illusion of solidity, demonstrates that violent contrasts of light and shade have an inherently dramatic property as well.

The results obtainable by these means are rendered still more striking if the orthogonals are not only clearly differentiated from any lines running parallel to the surface, but are as far as possible uninterrupted, so that the eye may shoot unhindered into the imaginary space. If, in addition, the composi/tion is such that a spatial box is formed, the impression of depth may become almost irresistible, and the eye may, in some cases, be unable to dispel the illusion, whatever the promptings of the brain. No matter in what direction it travels over the surface, it is forced back towards the centre lying deep in pictorial space. Such a box is largely created by the architectural view (Pl. 48, *b*), and is a major contribution to its spatial forcefulness.

These are the main internal compositional features which, during the many earlier analyses, were found to bear most closely on the creation of seemingly three/dimensional space upon a flat surface.

The simplest method of avoiding such an illusion is, of course, by steering clear of the whole business of perspective, whether linear or atmospheric, and particularly the former. Artificial perspective finds its clearest means of ex/pression in architectural and cubic forms, the straight lines, sharp corners, and hard, cutting edges of which can most easily tear the delicate fabric of a picture. The corresponding difficulty of the task of controlling such powerful forces of visual realism is attested by the whole history of the evolution of linear perspective.

The easiest way to control such space, other than by abolition or limitation, is to exploit the undistorted frontal surfaces which are a characteristic of the renaissance system. Wherever such forms may occur within a composition, at that point the eye is made to move in the directions established by the picture plane. The apparent movement through the surface into depths that

seem to lie beyond it, is, if only for a moment, halted. This slowing of the spatial movement is increased by breaking up the orthogonal lines and planes into short, discontinuous lengths, and may be further assisted by burying these forms behind figures or objects that emphasize the surface. An actual counter-balancing of spatial thrust can be achieved by placing the vanishing point within the confines of an object situated in the foreground. Then the orthogonals, however deeply placed in the pictorial space which they define, also lead the eye back towards the surface of the composition. A gentler method of achieving similar results is the avoidance of sharp contrasts be-tween orthogonal lines and planes, and the compositional equation of these forms by such devices as the space-enclosing straight line, or the repetition of diagonals, now running into space, now lying parallel to the surface.

The exploitation of the properties of perspective in the interests of har-monizing space and plane can be augmented by a number of more purely compositional devices. One of these is the creation of a vibrating pattern that spreads over the whole surface as a result of filling the design with an extreme complexity of solid forms. Another is the impartial application of strong decorative patterns to every feature of the composition, thereby building up an even, decorative texture. On the other hand, a quiet lack of contrast between one part and the next, ignoring spatial connotations, may be substi-tuted for the positive emphasis of the decorative surface by vibrating patterns of light and shade with their accompanying emotional effects.

Colour is another factor which can be used in many ways to balance the too-positive qualities of a perspective composition. The tendency of cold colours to recede and warmer colours to advance may be exploited by moving the one forward and the other back, so closing up the space between one part of the design and another. A similar closing of the spatial gap can be achieved by the reversal of the atmospheric graduation, placing stronger, brighter colour further back than softer, grey, foreground hues. Lastly, compositional elements which, in spatial terms, are widely separated, may be linked by colour similarities or graduations, or more firmly still by actual repetitions of a single hue.

The most subtle means of all for harmonizing space and plane, however, is the use of systems of proportion; the building up of the whole composition, for example, on a single modulus, which, since it is measured on the surface, ignores all distinctions between space and plane. In this way a harmony in the relationship of parts and whole may be created which is independent of foreshortenings or of spatial setting.

In addition to these various compositional elements, which contribute either to the creation of realistic space or to its harmonization with the surface, there are a number of other important factors which can, by their incorpora-tion or their absence, contribute towards, or militate against, the production of a complete '*trompe l'oeil*.' These external factors are particularly important in

relation to the permanence and completeness of the illusion. The first of them is the harmonization of the object, whether it be easel picture, relief sculpture, or frescoed wall, with the architectural surroundings. The reality of the scene is then increased by a coincidence of the painted fall of light with that from the real, external light source, even if this coincidence is not accompanied by the representation of cast shadows. The easy initial acceptance of the illusion, and the subsequent conviction which it carries, are largely influenced by the familiarity of the thing in itself and in its placing. Books and cupboards painted in a library may cause less conflict in the viewer's mind than, say, the sudden apparition of a coach and four. The startling anomaly—the object seen from an unusual angle, or abnormal range, carries great emotional impact, but also draws attention to the trickery, and may therefore in the long run prove the less successful. For similar reasons, quiet permanence of effect, as well as initial conviction, are more easily obtained in cases where the representation is in full conformity with the possibilities of actual vision. This entails, for instance, oblique disposition in the case of solid objects, such as that shown in the intarsia (Pl. 48, *a*), in which not a single plane lies absolutely parallel to the surface.

Apart from these internal and external compositional devices, there is the further possibility of direct imitation of the real thing in texture and colour. More important in the present context are, however, certain of the more purely technical aspects of the handling of perspective which affect the final visual result.

One of the most significant characteristics of artificial perspective is that it assumes an observer with his eye in one particular position at a fixed distance and direction from the scene before him. In theory everything is dependent upon this fixed viewpoint, for upon it hangs the whole construction, and at it the illusion of reality will be at its most intense. This was clearly shown in the discussion of the theoretical beginnings of the new construction. Accord-ing to Manetti, Brunelleschi's first perspective picture was constructed with a fixed peephole, and a similar importance was attributed to the fixed relation-ship between picture and spectator by Alberti and Piero della Francesca alike. Actual peepholes, and their desirability and disadvantages, are later discussed exhaustively by Leonardo, and the matter is thrashed out again and again by subsequent theorists. Yet in Donatello's work, six out of the seven reliefs completed before the Paduan journey, and mentioned in an earlier chapter, are never, under normal circumstances, seen from the point for which their perspective was constructed. The St. George relief (Pl. 34, *a*) is over six feet from the ground, and not constructed to be seen from below, whilst the 'Dance of Salome' (Pl. 34, *b*) is less than two feet from the top step leading to the font, and well below eye level even when seen from the baptistery floor itself. Of the four S. Lorenzo roundels, only one is to be viewed from below, and certainly in one, and probably in at least two, the

spectator's distance is supposed to be about six feet from the surface of a relief which is nearly forty feet above his head.[2] Only 'The Ascension, and Dona' tion of the Keys' (Pl. 35, *a*) remains, and here the question cannot be decided, since its original position is unknown.

It is possible to put forward facts such as Donatello's inexperience, or the novelty of artificial perspective at the time, to explain the apparent contradic' tion in some cases. But similar contradictions recur in a very high proportion indeed of the whole of renaissance painting, including the works of the great perspectivists. Masaccio observed the rules quite strictly for the low, main viewpoint of the architecture of 'The Trinity' (Pl. 30, *b*), yet in the Brancacci Chapel the viewpoint even of 'The Raising of the King's Son' in the lowest zone of all is still placed far above the observer's head. This is not to be explained by postulating an evolution from lesser to greater strictness in the observance of the rules. The viewpoint of the lowest of Filippo Lippi's Prato frescoes is again too high, and of course in these, as in nearly all the decorative schemes involving vertical tiers of frescoes, the disparity grows progressively more enormous as the eye moves up the wall. In this respect the advent of a focused perspective system makes no material alteration to a decorative pattern well established in Giotto's day, and itself unchanged from the times when spatial realism was of no concern to artist or onlooker.[3] Even such exceptions as Mantegna's Eremitani cycle were not consistent in their conformity to the rules. It was only on the left wall that the spectator's view' point was catered for in the low setting of the vanishing point, and then solely in the bottom pair of frescoes. It is, however, interesting to notice that whereas the early fourteenth'century artist always chose the topmost scenes, those furthest from the onlooker, as the most suitable for a heightening of the element of illusion in the frame, Mantegna, working with the focused artificial perspective took the opportunity of going furthest in the lower scenes. A far more radical degree of realism was thus achieved in characteristically closer contact with the onlooker.

The general position does not alter greatly if, instead of cycles ranged in vertical tiers, those ranged in a single rank, or even isolated, individual scenes are scrutinized. Raphael's Stanza della Segnatura with 'The School of Athens' and 'The Disputa', Piero's 'Resurrection', and Leonardo's 'Last Supper' are perhaps the most famous of a varied host of masterpieces in which the viewpoint is set in a physically unattainable position, either as regards distance or direction, or very often both. The factors bearing on this problem are consequently of some importance.

First, there is the question of direction: the viewpoint high or low, or central, to one side or the other, and the relation of this point to the observer's actual position. Here one major consideration is the normal point of view from which both artist and onlooker see the contents of his pictures, whether they be chairs or people, the inside of a room, or the outside of a house. Any

departure from such normality will entail juggling with studio props in unusual positions, and other similar difficulties, if the artist wishes to draw from life, and special powers of accurate imagination if he does not. A high degree of compositional skill will also be needed to control the many startling incidental effects which accompany such experiments. Far more important, however, is the fact that difficulty for the artist entails trouble for the public. A special imaginative effort is required, and even when it is made the per/spective effect may continue to distract attention, rather than to focus it unobtrusively. Perspective accuracy as regards a particular site is only one factor amongst many, and important aesthetic considerations frequently make it either unnecessary or positively undesirable.

An unusual viewpoint, say Donatello's 'Dance of Salome' seen from high overhead, may, besides straining the spectator's imagination, greatly detract from the solemnity and dramatic intensity, as well as from the clarity, of a narrative scene. The general avoidance of such distortions, and the lack of any necessity for them in most cases, underline the fact that the strongest hold of perspective is normally over the mind, and the imaginative and associative faculties, rather than over the eye in a deceptive or illusionistic sense. The observer usually has little difficulty in associating himself with the desired viewpoint even if, as in many frescoes, it is set far above his head.

Finally there are practical difficulties inherent in the nature of artificial perspective itself. Whatever trouble the artist takes, the people who look at his work will invariably want to move, if only to examine detail, thereby defeating his best efforts. Then again, as Leonardo insisted, only one person can be at the desired point at one time. Moreover, if the artist goes to any extremes to satisfy this individual, the greater will be the unwanted distortions seen from anywhere else. Artificial perspective can, in any case, take no account of the effects of normal, binocular vision, and only by the provision of a peephole, or through the observer conscientiously closing one eye, can the system's fundamental assumptions be given practical reality. Once the method had been demonstrated, such elaborate games were, from the begin/ning, seen to lie outside the realms of art and of the interests of the artists.[4]

Similar practical considerations influence the choice of the distance of the viewpoint from the representational plane. While the normal comfortable range for viewing a picture is certainly not less than twice its width, in a very high proportion of cases a one to one, or one to one/and/a/half relationship exists. These are the usual proportions for Masaccio, Donatello, and Ghiberti, whilst Masolino and Filippo Lippi frequently use less. In Donatello's case there are also several examples of much shorter distances. The explanation for this may well be in part the psychological effect of the artist's own distance from his work whilst creating it. Another factor is the difficulty, where a very long viewing distance is required, in finding room to make an accurate construction. For a viewpoint six times the width of his picture away from it,

the artist has actually to control his construction by a point at least as far away as that from the edge of the sheet of paper on which he is preparing the design. But this does not explain the persistence of the same proportions long after the discovery of abbreviated systems during the seventeenth century allowed the whole construction to be made within the limits of the composition.

Once again, however, important aesthetic considerations also affect the problem. A fairly close viewpoint has a number of advantages. It means that the orthogonals or lines running into depth are given the greatest possible

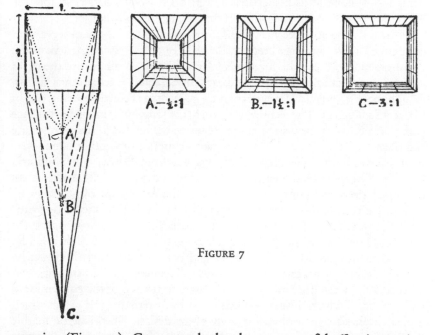

FIGURE 7

extension (Fig. 7, *a*). Consequently they have a powerful effect in creating depth, but at the same time have their maximum value as surface pattern. As a result they also give maximum clarity to the receding surfaces, whether they be ceilings, walls, or more especially floors or ground planes. Any patterns can be seen clearly, and the disposition of any figures or objects placed on them is given a similar clarity. Of course, if the distance is too extremely short, the resulting change of scale becomes overpowering, as can be seen in the diagram, while the steep slope of the ground plane may make an uneasy platform for the figures. Beyond a distance of about three to one in proportion to the width, on the other hand, the receding surfaces become very abbreviated (Fig. 7, *c*). The impression of depth becomes more impelling on the eye, but also far more limited. There is, therefore, in actual fact, a special virtue in the proportions of one, or one-and-a-half to one which are in practice those most commonly used (Fig. 7, *b*).

Illusionism and Perspective

The near viewpoint has the further advantage that it gives the spectator a sense of immediacy, of being close to the event, and of inclusion in the pictured scene. Moreover, when he is standing beyond the set distance there is a distinct tendency for him to be 'sucked in' towards it. This both encourages the inspection of detail and means that when it is being inspected the impression of the reality of the whole, half-seen beyond the boundaries of clear vision, increases rather than decreases. On the other hand, when the spectator is still looking at the picture as a decorative unity, the perspective, while losing none of its associative power, does become flatter, so that the impression of reality remains without the '*trompe l'oeil*' illusion of it.

So far only the absolute necessity for the coincidence of the observer and the painted viewpoint has been challenged. But the very singleness of the vanishing point, the most fundamental conception of all in the theory of artificial perspective, was by no means inviolable to renaissance artists, though more frequently observed than the preceding theoretical demands. In Masaccio's fresco of 'The Trinity' (Pl. 30, *b*) the foreshortening in accordance with the lowness of the principal viewpoint was extended to the architecture and the supporting figures. The two main figures, on the other hand, were swung forward into the plane, and seen not from below, but absolutely frontally. This puts special emphasis on them, and removes the danger of an unwanted stress on unimportant details, or the distraction of attention by theatrical effects. It also raises the spectator to the level of the pictured apparition. This particular effect is used in Piero della Francesca's masterpiece, the fresco of 'The Resurrection' (Pl. 48, *c*). Here, the framing, which is hardly ever shown in reproductions, is an integral part of the design. Fortunately, although its outer parts are later restorations, all its inner sections are original.[5] They still show the pricking, visible throughout the rest of the composition, with the aid of which the cartoon was transferred on to the wall, a fact which further emphasizes the indivisible unity of the design. This majestic marble framing is painted as if it were seen from below, but in itself has a double function. The bases of the columns converge to a point about a foot below the lower border. The devout are once more looking up towards an extension of reality. The capitals, meanwhile, converge into the body of the Rising Christ, and help, if help is needed, to increase the concentration of attention. The sarcophagus is in pure elevation, the pricked outline showing that the foot of Christ rests absolutely level on its rim. Similarly there is no foreshortening in the body or the head of the figure of Christ. Within the picture the whole question of the viewpoint is laid aside as unimportant by the very artist who, for the first time, produced a thorough-going exposition of the constructional problems involved in the rigid application of the laws of artificial perspective. In 'The Trinity' (Pl. 30, *b*) Masaccio carefully avoided pinning the figures to exact positions in space. Here, Piero likewise leaves eye and imagination free. The soldiers form a circle set in space, and a

pyramid centring in the head of Christ. They create a triangle upon the surface, or are part of a diagonal cross in space that runs into the distance with the trees that echo in their silvery greys the flesh tones of Christ's trunk. The dual spatial values of Masaccio's composition take on new variety and rich‑ness, a new timeless movement, an absolute calm that is reflected in the still completeness of the circling colour harmonies.

The use of several viewpoints in a single composition was also seen in Donatello's work. The advantages of such a practice—sometimes even the necessity for it, are shown most obviously in Uccello's Hawkwood, and Castagno's Tolentino monuments in Florence. A fairly high degree of realism was desirable in frescoes which were substitutes for more expensive marble monuments, and this element of illusion is supplied by the steep fore‑shortening of the architectural bases. On the other hand a worm's eye panorama of a horse's belly and a general's feet can be at best a dubious tribute to his memory. The realism of the low‑set viewpoint is therefore restricted to the architecture. In Uccello's fresco there is no foreshortening of horse or rider, while in Castagno's later version of the same design there is extremely little when compared with the rapid downslope of the architec‑tural orthogonals.

These few examples, and the host of others that could be added to them, show that the needs of the pictorial organization often overrode the demands of absolute realism, even insofar as these could be met by the faithful applica‑tion of the rules of artificial perspective. Indeed, the multiple viewpoint greatly increases the organizational range and effectiveness of perspective. The principal of controlling attention by means of a vanishing point becomes more important than the maintenance of theoretical unity and of a strict relationship between the onlooker and the pictorial world.

The single viewpoint of the artificial perspective system is in itself a power‑ful weapon of pictorial organization. It may coincide with the focal point of the action, as in Masaccio's 'Tribute Money', or harmonize with it, as in Donatello's 'Resurrection of Drusiana' (Pl. 35, *b*). It may even be in conflict with it, fighting for the onlooker's attention in a tug‑of‑war that communi‑cates its tension to him, as in many mannerist designs. It may be used, as in Filippo Lippi's Pitti tondo (Pl. 45, *a*), to stress the principal link between the observer and the pictorial action, the direct outward glance welding two worlds together. It may finally be used to emphasize some area of the com‑position which would otherwise be insufficiently forceful to play the part required of it within the pattern of the whole. The subtlety and range of this differential emphasis on various parts of the composition can be greatly increased by the use of more than one perspective focus. Separate vanishing points, and different foreshortenings, can be used to highlight figures, archi‑tecture, special areas or secondary actions, individual personages, and single objects, with a controlled gradation of emphasis that enhances the effect of

Illusionism and Perspective

the whole. The demands of realism can be exactly balanced with those of the subject matter and of the decorative design.

Besides increasing the strength of the artist's grip upon the observer's attention, the features which give artificial perspective its new realistic force, by their very nature, contribute towards compositional unity in certain of its aspects. The subordination of all objects to a single set of rules is far more than a mere device for closer imitation of the natural world. The measured relationship between each element of the pictorial world is a potent factor in increasing the unity of the composition, as well as its realism. Perspective diminution brings space into harmony with the unity of lighting and of atmospheric graduation of colour which was of increasing interest to the artist. As a tool for the construction of new subtleties of pictorial organization the new perspective is as much a revolution, and a consummation of the longfelt desires maturing in the upheavals of the thirteenth and fourteenth centuries, as it is in its other role as a means of heightening the illusion of reality.

The mention of the element of measurability that was introduced into pictorial art by artificial perspective again draws attention to the careful distinction which must be made between the implications of the theory of perspective and its significance as it appears in individual works of art. At first sight Andrea Castagno's 'Last Supper' in the Cenacolo di Sant'Apollonia (Pl. 49) might appear to be a perfect illustration of the mathematically defined relationship between onlooker and picture, and between one object and another within the painted scene itself. The appearance is deceptive. It is quite impossible in fact to tell how deep the picture is supposed to be, or how far away from it the onlooker should stand. In the sharply foreshortened, and almost indistinguishable pattern of the floor in front of the table there are ten lozenges in depth and ten in breadth. Does this signify a square? If so, the distance separating this square from the back wall of the room must be twice that which separates it from either side wall, if the room as a whole is to be considered as being based upon a foreshortened square. Such a supposition seems to be supported by the apparent repetition of the six square marble panels of the backwall upon either sidewall; two panels on the right wall being taken up by windows. But this is contradicted by the interlacing of the decorative frieze immediately above, in which just over seventeen loops in depth match thirtythree and twothirds loops upon the backwall. This implies that the room is not a square, but only half as deep as it is wide, if indeed there is any exact relationship at all. Meanwhile the seemingly simple blackandwhite chessboard of the ceiling numbers sixteen rectangles in depth and only fourteen in width. The resulting doubt as to the squareness of any and all of the apparent squares shown in foreshortening carries with it the impossibility of saying with certainty just how far away the onlooker must stand in order to fulfil the theoretical demands of the construction. The

meticulous incising of the whole design, and its geometric clarity, make it impossible merely to assume an inability to count upon Castagno's part. Similarly, pure disinterest in the matter seems, on general grounds, to be less probable than a positive determination to avoid the stiffness and sterility of a too-obvious mathematical logic. A similar intention is revealed in Piero della Francesca's painting even where a modulus similar to that which under-lies Alberti's architecture governs the proportions of the whole design.[6]

In Castagno's fresco, the impression of measurability nevertheless remains. Moreover, the lack of certainty about the theoretically correct viewing dis-tance gives an accompanying freedom to the onlooker to stand just where he feels like standing; a freedom which is usually assumed in any case. It would indeed be a lengthy business to count the pictures by the great renaissance painters in which it is not actually possible to measure out the distances that it is within the power of perspective to define. The impression of orderliness and unity, and of connection with the onlooker, was of far greater importance than the counting out in inches of a mathematical diagram. This, like every other element of perspective, was a feature which the fifteenth-century artists felt themselves quite free to accept or to ignore as far as the individual com-position was concerned.

The final aspect of this question of the relation between artistic practice and perspective theory at a time when, for social, as well as for purely artistic reasons, the new science was at the height of its reputation, is the matter of the accuracy with which artists carried out those parts of the construction which they did incorporate in their pictures. The answer to this question throws a certain light upon the problem of illusionism with which the whole discussion opened. It has already been seen that the unified vanishing point is often ignored for particular reasons. But this is not a matter of inaccuracy. On the whole it is true to say that the unified vanishing point, when it is used, is observed with a fairly high degree of accuracy. The interval between the transversals is often much less certain, particularly when the construction is at all finicky, or difficult to apply in any way. What is particularly interesting, however, is the demonstrable fact that a satisfactory degree of illusion can be obtained despite a high degree of inaccuracy in construction.

The convincing structure of many of Giotto's buildings has been noted, together with the successful element of illusionism in many thirteenth- and fourteenth-century fresco frames. It is therefore interesting to see that Piero della Francesca in his Borgo San Sepolcro 'Resurrection' (Pl. 48, *c*) does not bother to make the orthogonals of the bases of the columns run together under the centre of the composition. Even more striking is the fact that Castagno, in his decorative scheme for the Villa Carducci, no-where takes the perspective structure beyond the stage of development reached in the late thirteenth and early fourteenth centuries. The orthogonals of the putto frieze and of the main coffering above the figures all recede in

parallel towards a vanishing axis at the centre. The dentils of the cornice take no note of this arrangement, and are mechanically repeated as if looked at from the right. Similarly, whilst the framing and pilasters of the figure niches recede towards the central door, the capitals of the latter are seen from straight ahead.

In Mantegna's Camera degli Sposi, it is only in the illusionism of the circular well that seems to pierce the vaulting that there is any evidence in the framing of the use of artificial perspective. In this room, where the realism extends to the hanging of a painted curtain on the real, projecting moulding of a door, or to suggesting landscapes barely seen through gaps in the hang﹍ ings that cover the two walls that are devoid of figure decoration, there is no attempt at accuracy in the recession of the pillars which articulate the decora﹍ tive scheme. Even the accurate construction of the steps in the principal scene only serves to emphasize the conflict with the generally centralized design. As in the Castagno scheme the dentils of the painted moulding are all seen from one side in mechanical repetition. Yet this is no vast decorative scheme, but one small room in which there is no possibility of questioning the master's ability to control the details of execution. On the other hand the successful realism of this painted architecture cannot be denied.[7] Meticulous accuracy was simply unnecessary. The time spent in carrying perspective logic into every detail would achieve no comparable increase in the impression of reality.

It is precisely because such a high degree of realism in architectural border﹍ ing can be obtained by relatively primitive means that these schemes by master perspectivists of the mid﹍fifteenth century reveal in detail no advance upon the achievements of a hundred years before. It is in the conception of the schemes as a whole, and in the handling of the scenes, that the impact of the new ideas is felt. In this, the history of the growth of spatial realism up to its renaissance climax is radically different from the history of the similar development in late antiquity. In Pompeii, secular decoration—the adorn﹍ ment of the walls of living﹍rooms, and in earlier times the production of the architectural scenery for plays, was the principal occupation of the painter. Consequently it is in the architectural framework instead of in the small scenes from mythology that the main development of perspective must be traced. In the period leading up to the renaissance all the emphasis was on the exposition of religious history on the walls of churches. The didactic purpose stressed the telling of the story. It is in the history scene that the development takes place, while the technical side of the construction of the relatively unim﹍ portant framework changes little.

These discussions of various aspects of the way in which artificial perspec﹍ tive was actually used in fifteenth﹍century Italy lead to a number of conclu﹍ sions. The first is that the threefold function revealed in Donatello's work is generally valid. The re﹍creation of reality, the organization of the composition and the harmonization of the new reality with the flat pictorial surface are

indeed the main divisions of the formal potentialities of the new perspective. Secondly, whilst extremely few examples of complete illusionism can be found, some of the elements making for illusion can be seen in varying pro- portions throughout nearly all renaissance art. The analyses also show that, even in the pseudo-scientific realm of perspective, it is only through the works of art themselves, as opposed to the writings of theorists, historians, and com- mentators of whatever generation, that the full meaning of any artistic method can be grasped. The importance of the new geometric construction is as incalculable as the pictures which refuse to serve as illustrative diagrams are numerous.

NOTES

1. For the effects of sharp figure foreshortening see K. Rathe, *Die Ausdrucksfunction Extrem Verkurzter Figuren*, London, 1938.

2. The diameter of the roundels is about 6½ ft. As was remarked in chap. XI, note 3, the viewing distance in the St. George and the Salome reliefs is very short in relation to the practical possibilities.

3. The very placing of scenes one above the other was attacked at times by renaissance writers, but even when the practice became less common the change was not necessarily accompanied by a more rigid application of perspective rules.

4. The realization that the spectator will, in practice, move about does, of course, provide a fundamental motive for painting in lateral foreshortenings and not leaving them to be taken care of by the visual distortions undergone by the picture surface as a whole.

5. The fresco was at one time moved bodily from its original position, and the original outer parts of the painted marble framing have largely been lost.

6. See K. Clark, op. cit., p. 20. More complex analyses are given in R. Wittkower and B. A. R. Carter, 'The Perspective of Piero della Francesca's "Flagellation",' *Journal of the Warburg and Courtauld Institutes*, vol. 16, 1953, pp. 292–302.

7. The degree of illusionism in Mantegna's painting is discussed by H. G. Beyen, *Andrea Mantegna*, S'Gravenhage, 1931, who notes the structural freedom of the Camera degli Sposi framing. The author defends Mantegna against the charge of being an 'illusionist', and the rela- tionship between space and the plane surface is discussed, whilst pictorial space and artificial perspective are wholeheartedly defended.

CHAPTER XIV

Paolo Uccello, Leonardo da Vinci, and the Development of Synthetic Perspective

The triumphal progress of artificial perspective in fifteenth-century Italian art is of such absorbing interest, and the conquest is seemingly so complete, that attention is often completely distracted from the quiet continuation of that stream of development which is so fundamental to the fourteenth century. The current of ideas which unites Cavallini and Giotto, Maso and Ambrogio Lorenzetti; the slowly developing conception of pictorial truth to nature which Brunelleschi wished to respect in his perspective panels; all this does not die. It is no longer the main stream. None the less, it still flows on beside the swift current of the new ideas, and again becomes a torrent itself from the seventeenth century onwards. It is therefore essential, both for the study of renaissance art itself and for the understanding of subsequent history, that this continuing development be given its due emphasis.

The surviving power of the old ideas is to be seen in the continued popularity of the oblique setting of architecture with artists, such as Lorenzo Monaco, who cover the turn of the century. The setting was seen in Masaccio's early work; Ghiberti's first doors are dominated by it. In Fra Angelico's painting the peak is reached in the predella panels of the Linaiuoli Madonna of 1433, and the setting continues to be important throughout his life. It is, however, in the work of Paolo Uccello that the most interesting developments take place.

PAOLO UCCELLO

'Oh what a sweet thing this perspective is,' cries out the aged artist, working through the night.[1] Ever since Vasari fixed Uccello's character with an easy flow of similar anecdotes and reputed sayings, his name has been almost a synonym for the new science. In spite of this, the nature of Uccello's interest in perspective still remains surprisingly obscure; an obtrusively precise question to which many vaguely unsatisfactory answers have been given.

Uccello was born in 1397, and his earliest known works were painted in the 'thirties. There is consequently no question of his being one of the inven-

tors of artificial perspective, as was implied by Vasari who believed that he died in 1432 at the age of eighty-three. It is clear from his few remaining works that his interest in the new method was as much directed towards the exploration of the geometry of individual objects as towards the exploitation of the unified space by which they were enfolded. His excitement at the revelation of the close relationship of human and animal forms to the geo-metric purity of cylinder and sphere shines through the medieval pageantry of 'The Route of San Romano' or the quiet power of the Hawkwood monument. The famous drawings of 'mazzocchi' support Vasari's statement that he drew 'circles armed with spikes represented in perspective from differ-ent points of view, spheres with seventy-two facets like diamonds, and on each facet shavings twisted round sticks'.[2] These experiments foreshadow Piero della Francesca's De Prospectiva Pingendi and his projected treatise on the regular solids. Piero's work not only provides a comprehensive survey of the constructions to be used in solving innumerable perspective problems, but also applies exact perspective methods to the reproduction of the subtle imprecisions of the human form.[3]

The complexity of the task of discovering Uccello's own approach to artificial perspective is admirably illustrated by the simple-seeming predella of 'The Profanation of the Host'. This work, which he seems to have painted towards the end of his life, consists of six scenes of which the most interest-ing is possibly that of 'The Attempt to Destroy the Host' (Pl. 50, *b*).[4]

The composition of this scene, as it now is, appears to be, not the first, but probably at least the third design considered by the artist. This is shown by a complex series of still partially visible incisions.[5]

The original design appears to have been an almost exact repetition of the centralized interior of the adjoining scene of 'The Redemption of the Cloak'.[6] After a hasty adumbration of the new plan,[7] a finished design was carefully worked out on proportional principles, only to be modified again in a final version.[8] The finished composition, like that of 'The Redemption of the Cloak', contains a fully elaborated system of proportion reminiscent of that in Piero della Francesca's small panel of 'The Flagellation'.

The opening of the room itself is square, its width being equal to the total height of the panel. The width of the remainder of the scene, measured along the horizontal centre line, is half the side of this main square. The width of the visible section of the back wall, and that of the right side wall, are both equal to the vertical distance covered by the floor, and just exceed that taken up by the ceiling. This same unit marks the distance between the front of the left wall and the right-hand edge of the communicating door, and between the ceiling and the horizontal band of the chimney, whilst it just exceeds the interval between the band and the floor. The chimney itself also divides the back wall in a two to one ratio, repeating in reverse direction the ratio between the room square and the scene as a whole.

Apart from this system of proportion, a very complete series of linear coincidences creates a network which is essentially an architectural variant of the web which governs the relationships between the figures in the Arena Chapel.[9] The rear, inner corner of the room lies on the diagonal which runs from the forward, lower right-hand corner, through the distance point, exactly to the forward, upper left-hand corner. This line is emphasized in the construction by the clear, incised diagonal on the floor. Similarly, the other diagonal on the surface, which joins the lower left- and upper right-hand corners of the forward opening of the room, passes exactly through the corner which is the meeting point of the ceiling and the back and left walls. This line too is marked by the remnants of an incision visible between the head of the man and that of the elder child. A similar incision points to the existence of a straight line running from the forward left-hand lower corner of the room through the point at which the panel's indented, horizontal centre line runs into the chimney piece, and on to the further of the upper corners of the door on the right.

This little composition therefore seems to be an almost unique case in which incisions, sometimes fragmentary, and sometimes more complete, actually mark out compositional correspondences, as opposed to indicating merely the structural guiding lines of the architecture.[10]

The problem of Uccello's approach to perspective design is matched by the problem of his attitude towards perspective realism. In this connection the fresco of 'The Flood' (Pl. 50, *a*), which is one of Uccello's most majestic compositions, is of particular importance. It is a singular fact that in this scene, which has been shown to be connected with Alberti's descriptions of ideal pictures,[11] the Albertian perspective is not used. The two great wooden structures vanish to two separate points. The focus of the ark upon the right lies well inside the boundaries of the long, foreshortened, wooden wall upon the left. The ladder, and most of the other objects, recede towards the vanishing point belonging to the left-hand ark and lying in the distant, light-coloured line of hills. The ladder is particularly interesting, since it does not merely recede into the background. Its rungs converge as well, running towards a vanishing point that lies out to the left, beyond the confines of the scene, and on a level just above that of the waterline of the ark. But this lateral convergence is not confined to the small detail of the ladder's rungs. It is an obvious feature of both arks themselves. The horizontal timbers at the waterline run visibly up and outwards; those above them, out and down. The latter feature is less noticeable at first, because the timbers are cut off much sooner by the curve of the lunette, and there is no straight, level base-line for comparison. In either case the convergence, which is not accurately carried out towards unified focal points, is into a general area that lies a good deal higher than the vanishing point of the rungs of the ladder, which lies nearer to the centre of the scene. The resulting pattern closely resembles that shown

diagrammatically in Fig. 2, *c* (p. 29), and discussed in relation to the works of Maso di Banco and Ambrogio Lorenzetti. This fresco, which Uccello painted long after he had mastered the principles of artificial perspective, is no mere exercise in the Albertian method. Instead, it incorporates certain features of the system, notably the use of vanishing points, in a composition which carefully acknowledges the phenomena that accompany the turning of the head and eyes of artist and of onlooker alike. Uccello is returning to the visual truth which Giotto recognized, and is trying to develop it compositionally. It must, moreover, be remembered that these experiments, still visible in the present ghost-like ruin, must have leapt to the acutely critical eye of the Florentine connoisseur when the fresco was first unveiled in all its freshness.

In the fresco of 'The Nativity, and the Annunciation to the Shepherds' Uccello tries a different solution to the problem of uniting artificial perspective with those observations of the detailed appearances of reality that are made by the ranging eye of the observer. Here a single series of transversals runs from one side of the composition to the other, whilst the orthogonals of the pavement recede, not to a central vanishing point, but outwards from the centre towards two separate focuses on the wings. It is as if the adjacent halves of two entire Albertian constructions lying side by side had been incorporated in a single composition.[12]

In addition to the complexity of the ground plan, it is noticeable that the cross-bars of the stable roof, the vanishing point of which lies on the right, slope down towards the left. The continuous horizontals of the floor have been combined with an obliquely set, if not an actually bifocal building. The stable is in fact no typical artificial perspective construction. Finally, the whole design is drawn together by the figures of the Virgin and Child. The central placing of the main subject interest counterbalances the centrifugal flight of all the structural receding lines, and also masks the point at which the orthogonals of the two systems would otherwise meet in irreconcilable conflict.

The effect of this ingenious complexity is to express the continuous shifting of the 'vanishing points' that occurs as the eyes are turned to look at nature. There is the central focus of the figure of the Virgin. Then, if attention is diverted to the left or right, the eye flows with the converging orthogonals to a new focus. Where one looks, there is the centre of the visual world. The mathematical logic of measurement, characteristic of the new artificial perspective construction, is combined with a vision which essentially develops that of the wedge-shaped buildings of 'The Legend of St. Francis' at Assisi, past which the eye slides out to left and right into the distance. Here, however, the new sense of space expressed in the perspective revolution of the fifteenth century has dissolved the solid central core.

Ideas similar to those expressed in the fresco of 'The Nativity, and An

nunciation to the Shepherds' are set forth with immeasurably greater subtlety in the late panel painting of 'The Hunt' which is so close in figure style to the predella at Urbino. The mathematical division of the composition, present in the latter, as well as in the fresco which has just been discussed, is here presented with new softness.[13] The unity of the scene is magisterially expressed by the myriad figures spiralling in unending chase towards the distant centre of a moonlit galaxy. The mathematical expression of this unity in the orthogonals of the fallen tree-trunks seems hardly to be necessary. Once again new centres form as the attention shifts. In each of the two main outer compartments formed by the nearer trees, the placing of the more distant trunks is carefully calculated so that, instead of leading the eye across to the centre of the panel, they form a new focus of their own within the confines of the smaller unit. This tendency is accentuated by the opening out of the foreground figures to allow the eye to be attracted towards these secondary centres by small, distant forms. In the compartment on the left the effect is nothing less than startling in its intensity. Similarly on the extreme wings of the design the relation of the foreground trees to those beyond encourages the eye to venture outwards. In this composition, where no architecture inter-venes with its rectangular bulk, the harmony between perspective unity and the natural roaming of the eye becomes complete.

Seen in this light, Ucello's passion for perspective becomes a much more interesting and understandable thing. He was not merely elaborating ever more complex applications of the theory of artificial perspective, like some old and fuddled schoolmaster muttering theorems to himself long after the class has run away. He was inquiring into the nature and validity of the new method, and weighing it against his experience of the natural world. Brunel-leschi himself apparently felt the contradiction of the evidence of his eyes which seemed to be entailed in his new system. Uccello was trying to eradicate this flaw, this apparent element of convention and, as many must at first have seen it, of untruth. Vasari, in his supreme self-confidence, had no longer any inkling of the existence of such problems. But to thoughtful men schooled in the vision of the fourteenth century, proud of the acuteness of their eye and of their faithfulness to it, acceptance of the new idea must often have come gradually, and sometimes with misgivings. Uccello's over-preoccupa-tion with perspective, and his minutely calculated constructions become compatible with his real artistic stature when it is seen that he was fighting with a genuine and fundamental problem. In certain compositions he was busily increasing his knowledge of the powers of artificial perspective; in others he was shaking its foundations.

These conclusions are strongly supported by Vasari's description of a lost decorative scheme in Sta. Maria Maggiore.[14] This contained, amongst other things, some columns which ran-upwards into the curved area of the vault, but which were so designed that they appeared to be straight throughout their

length, and therefore to break through, or to abolish, the actual curve of the vault. Such an illusion is beyond the reach of Alberti's abbreviated version of the laborious *costruzione legittima*, and must have been based on the Euclidean proposition 'that things appearing within a like angle appear to be of similar size'.[15] Only in the curved world of Euclidean optics, with its dependence upon the visual angle instead of on proportional triangles, can the solution to such problems be found. This adds interest to Vasari's statement that Manetti and Uccello were friends, and often used to argue about Euclidean matters.[16] In the early fifteenth century, Florentine mathematical circles and the small group of artistic pioneers were closely linked, and there must undoubtedly have been much argument about the relationship of Euclid's propositions to the practice of artificial perspective. Uccello was the very man to translate such theorizings into art.

LEONARDO DA VINCI

Leonardo's contributions to the theory of artificial perspective itself are relatively small. His principal interests seem on the one hand to have been the philosophical implications of the system as a reflection of the universal harmony, with marked emphasis upon its consequent usefulness in helping the painter up the social ladder, and on the other the investigation of its technical weaknesses. This probing led him to evolve the complete perspective theory towards which Uccello and his fourteenth-century forerunners had been making the first groping movements. This is his real, and outstanding contribution to the evolution of perspective theory, and it is only through a long series of misfortunes that his achievement has been obscured.

Benvenuto Cellini says in his *Discorsi* that, whilst he was in the service of Francis I, he bought a manuscript copy of a book by Leonardo.[17] This was a treatise on perspective:

'. . . il più bello che mai fusse trovato da altro uomo al mondo, perchè le regole della prospettiva mostrano solamente lo scortare della longitudine, e non quella della latitudine e altitudine. Il detto Lionardo aveva trovato le regole, e le dava ad intendere con tanta bella facilità et ordine, che ogni uomo che le vedeva ne era capacissimo.'[18]

These words imply that Leonardo's method entailed foreshortening not only into the picture plane, but horizontally and vertically across it, and this is only possible in a system based on curves instead of on the straight lines used in artificial perspective and its forerunners.[19] Such a system represents an attempt to translate the natural perspective of the Renaissance or the optics of antiquity, which were quite unconcerned with representational problems, into the field of art. It entails the transference of the subjective appearances of the real world, conditioned partly by physical, and partly by psychological

207

limitations, on to a plane surface. This is done by the projection on to it of proportions obtained on an intersection of the visual cone by a spherical surface concave to the eye (Fig. 8).[20]

The four main characteristics of such a perspective are: (*a*) All straight lines not passing through the point on the plane surface nearest to the eye are given a curvilinear distortion. (*b*) There is foreshortening and increasing distortion of objects in all directions from this point, vertically, horizontally, or longitudinally, with no tendency to stress the plane surface. (*c*) This point coincides with the main vanishing point, towards which all orthogonals converge in straight lines. (*d*) The size of objects is dependent on the visual angle and does

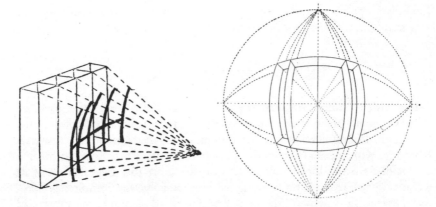

FIGURE 8

not diminish in direct proportion to the distance, the discrepancy being greatest for wide angles. The result is a spherical space which is homogeneous, but by no means simple, and which possesses some of the qualities of Einstein's finite infinity.

This 'perspectiva naturalis in usum artificum',[21] which will be referred to as synthetic perspective, was, as has been seen, the goal of many earlier Italian artists. None of them had, however, been prepared to take the final step of bending straight lines into the curves implied by their compositions as a whole, and so achieving a homogeneous system of construction similar in that respect to artificial perspective itself. Only in the curvilinear designs of Jean Fouquet is the essential element of a synthetic system consistently foreshadowed, although there is, as yet, no evidence that Leonardo was influenced by such empirical developments in the north. He seems to have evolved the general theory out of his preoccupation with a particular problem. The one definite point of contact with his predecessors seems, not unexpectedly, to have been through Paolo Uccello, who was still alive when Leonardo had reached his early twenties.

The evidence that Leonardo actually created a system of synthetic perspec-
tive would be fairly strong upon Cellini's word alone. That volatile character
and brilliant craftsman, who, in all his writings, is invariably accurate and
up-to-date on matters of technique, was thoroughly excited by his discovery
and intended to publish it in a separate book. Unfortunately Leonardo's
manuscript was stolen before he could do so. This was doubly a misfortune,
as the original notes for it have also disappeared.

Luckily Cellini's statement does not have to stand alone, since those notes
of Leonardo's which have survived reveal that by 1513–14 his mind was
indeed moving firmly in the direction indicated in the *Discorsi*. The notes

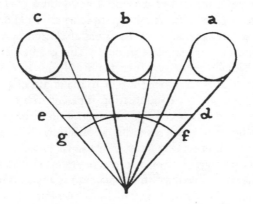

FIGURE 9

dating from the 1490's show that Leonardo was, at first, primarily interested
in examining the basis and methods of artificial perspective, amplifying cer-
tain points, and noting others at which it conflicts with natural perspective
or optics. These contradictions are chiefly visible where observations are made
from a very near viewpoint, and it is characteristic of Leonardo's critical
attitude that his interest in the existing perspective is to a great extent confined
to the borderline cases that magnify such conflicts. His conclusions at this
stage are orthodox reflections of contemporary practice.

The main source of passages bearing on the present problem during this
first period of activity is Manuscript A, dated 1492.

It is on the same folio page in which he develops the principles of propor-
tional diminution that Leonardo makes a first obscure note of a contradiction
inherent in the nature of artificial perspective:

'Why things seen from afar appear large to the eye, and the test made in the
intersection shows them to be small.'[22]

As soon as it is realized that the '*pariete*' to which he refers is, in two dimen-
sions, not a straight line but an arc of a circle centred in the eye, his meaning
becomes clear.[23] A complete illustration is given a few sheets later in a

diagram which is repeated several times elsewhere (Fig. 9).[24] In it he demon/
strates that only if the visual pyramids of three equal circles placed in a straight
line are cut by an arc (g, f) centred on the focal point, will they bear their
natural relation to each other and appear to diminish as the line is extended
in either direction. If the intersection is by a straight line (e, d) as it is in
artificial perspective, it will cut through the pyramids more and more
obliquely, and the circles will in representation grow larger instead of smaller
as they recede from the eye. Underneath his original diagram he simply
writes, 'Come l'ochio vide semplicemente le cose.'

It is on the back of the very sheet containing this diagram that Leonardo
notes and illustrates a method of making a figure on a twelve/braccia wall
appear to be twenty/four braccia high by applying the Euclidean optical law
that apparent sizes are dependent on the visual angle and by making use of a
section of coved ceiling or barrel vaulting.[25] This is an exact description of
the system that Uccello must have used for his illusion of columns running
up through a vault. It is an important clue to the origin of Leonardo's ideas
that his first illustration of a contradiction inherent in artificial perspective
should be so closely accompanied by a full exposition of the principles under/
lying Uccello's single recorded scientific application of the laws of natural
perspective to the task of solving a representational problem.

In four further passages[26] Leonardo elaborates on the causes and precise
nature of the distortion illustrated in his diagram of the columns, and comes
to three conclusions. The first is that a lifelike representation of an object very
close at hand will only be convincing if the spectator's eye is firmly fixed at a
spot exactly corresponding to the point of view from which it was painted.[27]
Consequently it can only be seen by one person at a time. This is a return to
Brunelleschi's original method. Secondly Leonardo says that if a number of
people are to see the picture at once, it must be painted from a viewpoint
which is distant from the object at least ten times its own width, since it is
impracticable to allow a different viewpoint for each spectator, and only at
such a distance will the contradictions otherwise inherent in artificial perspec/
tive become negligible.[28] Thirdly and finally, if a near viewpoint must be
used,[29] and no fixed peephole is provided, all identical objects parallel to the
picture plane should be given the same size. This compromise which is the
normal practice of renaissance painters has, however, the disadvantage that
while the painted objects will be realistically diminished by the action of the
eye, the lack of relief prevents a natural masking of the intervening spaces,
which consequently 'have no definite ratio'. The resulting work, despite the
avoidance of the more extreme distortions, ceases to conform completely to
the laws of either of the perspectives, natural or artificial, that Leonardo has
been at such pains to distinguish. It is certain that the disharmonious element
in such a compromise was far more disquieting to Leonardo, imbued with
the renaissance conception of the overriding significance of ideal harmony,

than it is to the modern mind. This aspect of the question probably accounts for his continued absorption in the matter some twenty years later.

It is unfortunate that for the crucial second stage of Leonardo's development there remain only four directly relevant passages in his notes, one of them containing definite evidence of a residual confusion in his thought. The consolation is that his intention is absolutely clear.

A note in Manuscript G,[30] which may be dated to the period 1510–16, reads:

'Simple perspective is that which is constructed by art (*fatta dall' arte*) on a surface equally distant from the eye in every part—complex perspective is that which is constructed on a surface in which none of the parts are equally distant from the eye.'

The definitions form a simple homogeneous comparison. The words *fatta dall' arte* in the first sentence show that Leonardo is here applying to representational problems conceptions that have hitherto been confined as a whole to natural perspective. There is no escape from the conclusion that, in his definition of simple perspective, Leonardo is visualizing a concave spherical surface, the three-dimensional counterpart of the arcs centred on the eye that have already appeared amongst his diagrams. No other surface can be 'equally distant from the eye in every part'. It is the first step towards the theory of synthetic perspective.

This conclusion is supported by two long, connected notes on either side of a folio in Manuscript E, which dates from 1513–14. The first reads:[31]

'The practice of perspective may be divided into . . . parts, of which the first treats of objects seen by the eye at any distance; and it shows all these objects just as the eye sees them diminished, without obliging a man to stand in one place rather than another so long as the wall does not produce a second foreshortening.

'But the second practice is a combination of perspective derived partly from art and partly from nature, and the work done by its rules is in every portion of it influenced by natural perspective and artificial perspective. By natural perspective I mean that the plane intersection on which this perspective is represented is a flat surface, and this intersection, although it is parallel both in length and height, is forced to diminish the remoter parts more than its nearer parts. And this is proved by the first of what has been said above, and its diminution is natural. But artificial perspective, that is that which is derived by art, does the contrary; for objects equal in size increase on the intersection where they are foreshortened in proportion as the eye is more natural and nearer to the intersection, and as the part of the intersection on which it is figured is further from the eye.'

Leonardo does not specify the number of branches into which perspective is divided, but has left a blank space. It is not, therefore, a matter of the automatic division into natural and artificial favoured by most modern writers on

renaissance theory; a point which is sufficiently emphasized by the remainder of the passage. The perspective of which Leonardo speaks first is based upon the 'simple perspective' of the previous definition, which, unlike artificial perspective, is valid for any distance between object and viewpoint. It is clear, however, that he is not referring to a final design upon a spherical surface. He is speaking, instead, of the projection onto a flat surface of the result obtained on a spherical intersection of the visual cone or pyramid. This is shown by the use of the term *il muro*, the wall, which only occurs in such contexts when Leonardo is referring to plane surfaces. It is also confirmed by the mention of 'a second foreshortening'. In artificial perspective, anomalies, such as the enlargement of quantities with the increase of lateral distance, are only corrected by the natural foreshortenings of the representational surface itself when the eye is at the fixed viewing position directly opposite the vanishing point and at the right distance away from it. In the system to which he is now referring, the diminution from the visual centre is not dependent upon the exact position of the spectator. It is drawn in, and is only falsified if the onlooker's position is so abnormal that the representational plane as a whole is substantially askew in relation to his line of sight.

The second paragraph clarifies the definition of what he now calls 'natural perspective'. The careful way in which he stresses that the latter system is a representation on a flat, rectangular surface, which, however, *è constretta a diminuire le parti remoti più che le sua parti prime*, makes it certain that what he is describing is the projection of the proportions obtained in simple perspective onto a plane surface. It is the statement of a process to which the diagram and explanatory text, which occur below the passage, give a ready clue (see Fig. 9, p. 209). In effect, the proportions obtained on the arc g, f, are to be projected on to d, e. It is precisely this process which results in the creation of synthetic perspective.

The 'second practice', to which Leonardo refers in the first, and also in the final sentence of the final paragraph, corresponds to the system of Brunelleschi and Alberti. He begins by stating that it is not a completely homogeneous method, being dependent upon two different principles, the one natural and the other artificial. He underlines his meaning by defining the latter element in the last sentence of the passage. The composite system is non-homogeneous because, as his often repeated diagram of the three circles demonstrates, the drawn, or artificial foreshortening enlarges things as they recede laterally from the eye. It then requires natural perspective to correct these contradictions by means of the actual foreshortenings which take place when the eye is in the one and only correct position.

In Leonardo's new system there is no longer any drawn contradiction of the natural laws of diminution. There is nothing which has to be corrected by the processes of sight. The whole perspective is actually drawn in full accordance with the natural law that what is further away looks smaller.

Uccello, Leonardo, and the Development of Synthetic Perspective

There is no perspectival reason for denying the onlooker the freedom which cannot be withheld from him in practice.

There has been a certain unavoidable multiplication of terms, since Leonardo, in speaking specifically of perspective, is almost invariably dealing with representational problems. Consequently his 'natural perspective' is not the natural perspective of Euclid. Pure optics is not in fact defined as a form of perspective, but serves as a determining source from which he draws as he finds it necessary. It is probable that in his first definition of 'simple perspec/ tive' Leonardo had in mind the whole process of what he calls 'natural perspective' in the second, since in a further passage in Manuscript E he uses the terms interchangeably. Similarly the 'complex perspective' of the first note is identical with the 'artificial perspective' of the second. The types of perspec/ tive finally apparent in Leonardo's surviving notes may, therefore, be summed up as optical, artificial, and simple, and these are the natural, artificial, and synthetic perspectives which have been referred to throughout this chapter.[32]

Any remaining doubts about the direction in which Leonardo's mind was moving are dispelled by the note on the other side of the folio in Manuscript E.[33] After a reference to the previous passage, and a recapitulation of the properties of 'natural' and 'artificial' perspective, it continues:

'It is well therefore to avoid such complex perspective and hold to simple perspective, which does not regard intersections as foreshortened but as much as possible in their proper form. And of this simple perspective in which the intersection cuts the pyramids by which the images are conveyed to the eye at an equal distance from the eye, we are given constant experience thanks to the curved form of the light of the eye on which the visual pyramids are intersected at an equal distance from the visual faculty.'

Once again he reiterates the desirability of avoiding a system in which it is only a particular set of visual distortions, or foreshortenings, of the representa/ tional surface itself that can correct the contradictions that have been incor/ porated in the drawing. He wishes perspective to have that self/contained perfection which was the ideal of the renaissance architects, who built for an eternal harmony of proportion. He, like them, could find no final satisfaction in the fleeting and theatrical compositional effects that are dependent on the momentary position of an individual observer.

Here is an almost complete reversal of the early tendency to remain within the bounds of Brunelleschian artificial perspective. *Egli e dunque da fuggire tal prospettiva* could not be put more plainly. The 'simple' perspective, which is to be preferred, is proved to be based on a spherical intersection of the visual pyramid. This explicit reference to the spherical intersection in the eye is a final link in another sense, for it is accompanied by the same simple plan that had done duty on three other occasions (Fig. 9, p. 209). A final passage,[34] mainly concerned with a further account of the distortions which may occur in rigidly applied artificial perspective, seems to show Leonardo extending

213

into a perspective based on Euclid the principle of proportional diminution which is only valid in the renaissance artificial perspective. The main reason for this seems to be that the particular distortions in the latter, with which he has chiefly been concerned, occur in planes parallel to the picture surface, and not in those at right angles to it. As a result he has not appreciated the implica-tions, as regards orthogonal recession, of the conclusions which he has reached. The wide philosophic import of the theory of proportional diminu-tion during the renaissance makes such a lack of co-ordination extremely understandable, especially when the whole subject has been approached in this particular way. It seems, therefore, that the ideas which appear to be well developed in outline by 1514 have not yet advanced completely from the par-ticular to the general and been incorporated in a self-sufficient unified system, although the evolution in this direction is undeniable.

When the evidence of the notes is combined with that of Cellini's reference to *lo scortare della longitudine . . . della latitudine e altitudine*, and seen in the light of the whole story of Italian renaissance art from its beginnings in the mid-thirteenth century, it is difficult to avoid the conclusion that Leonardo's researches into perspective theory were more revolutionary than is usually realized.

The troubled course of Leonardo's last years, culminating in his journey to France in 1516, the loss of the notes for the book which he probably wrote there, and the theft of the final draft before its publication in Italy, alone provide a sufficient explanation for the submergence of Leonardo's ideas. Apart from the material misfortunes of the manuscripts, the unpublished theories themselves, considered as a complete system, were not of the sort to have immediate influence upon practising artists.[35] They were foreign in many ways to accepted renaissance modes of thought, and it is a common occurrence for advances, both in theory and practice, to lie dormant for decades because they are beyond the scope of contemporaries. Vasari's own misunderstanding of Uccello's interest in perspective, and his ignorance of what lay behind Masaccio's oblique constructions, are themselves con-temporary indications of the way in which modes of thinking and of seeing can be entirely controlled by the suggestive power of a system as successful as was artificial perspective in renaissance Italy.[36]

Leonardo's theories do, however, appear to have left some traces. The Codex Huygens, attributed to a Milanese painter active about the year 1570, possibly Aurelio Luini, is a valuable case in point.[37] Besides some thirty-two or thirty-three pages, mainly on proportion, containing copies of original Leonardo drawings, the author's interpretation of movement as an infinitely variable and divisible process has also been shown to derive, though less directly, from the same source. It is therefore likely that the apparently revolu-tionary section in which the author rationalizes the treatment of the fore-shortening of the human figure, turning to the Euclidean conception that

apparent magnitudes depend solely upon the visual angle, also derives from him.

Leonardo's interest in optics was steadily maintained throughout his lifetime, and his occupation with its relationship to linear perspective, which is less apparent in his earlier notes, increases as his mind develops the problem. His method of showing the way in which light falls on an object, or on the human figure,[38] and his rationalization of cast shadows;[39] his method, probably derived from Uccello, of making a figure on a twelvebraccia wall appear to be twentyfour braccia high—all these reveal a process of thought very close to that in the mind of the Huygens author when he deals with the lines of sight striking a foreshortened body. The illustrative diagrams are practically interchangeable at times. If Leonardo in any way developed a system of synthetic perspective, it becomes almost a certainty that the rather pedestrian author of the Codex Huygens is throughout his work reflecting the ideas of his great predecessor. Moreover, figures such as those on folios 98 and 99 of the Codex reproduce exactly that dichotomy, distinguishing the proportional diminution of straightline geometry from the visual arcs determining apparent quantities, which underlies the advances made by Leonardo.[40]

With the creation of a theory of synthetic perspective that part of the historical drama of the Italian renaissance which is the subject of this study draws to a close. It has been seen as a continuing tension between the artist's desire to portray the world of space in which he lives and his feeling for the individuality, and essential flatness, of the surface upon which he works. Sometimes the one, sometimes the other, seemed to be the more important. Sometimes the destruction of the surface was attempted. Sometimes the demands of realism were ignored. Often, out of the shifting materials of imagination, experience, and tradition, balance was achieved; always a new balance, and a new beauty. Out of this living pattern not one, but two main systems were evolved, which found their full expression in the theories of artificial, and of synthetic perspective. The stream of development surged first in the one direction, then in the other; sometimes stagnated; sometimes separated; and, as often, flowed together once again.

The issues raised and the attitudes revealed seem fundamental to an understanding of Italian renaissance art. In forms altered by the historical and geographical circumstances, they also appear to have close parallels in other countries and at other times. The example which is nearest, both in time and space, is that of French art in the fourteenth and fifteenth centuries. There, in miniature, shorn of all extraneous detail, the story is retold with a Gallic clarity of contour that at once intensifies the meaning, and extends the scope, of the Italian narrative.

Uccello, Leonardo, and the Development of Synthetic Perspective

NOTES

1. Vasari, op. cit., ed. Milanesi, vol. ii, p. 217.

2. Vasari, op. cit., ed. Milanesi, vol. ii, p. 205.

3. The reason for not discussing Piero della Francesca's work on perspective theory at length in this study is that it appears to be rather concerned with codification than with discovery, except as regards those points mentioned in passing.

4. J. Pope-Hennessy, *Paolo Uccello*, London, 1950, pp. 153-4, summarizes the dating argument and the connections with the altarpiece of 'The Institution of the Eucharist'.

5. These incisions are, for the most part, invisible in reproduction, but in Alinari 37865 some can clearly be seen. It must be emphasized that the reconstructions given are very tentative. They are based upon observation with the naked eye, and might therefore be greatly modified by the results of X-ray examination.

6. The vanishing point lay at the juncture of the horizontal centre line and the chimney-piece. Five sets of lines, including the top and bottom of the left-hand wall, then in steeper recession, the double incision of the original door-lintel, and two lines, one of them double, in the existing ceiling area, all converge on this point. The faint, interrupted remains of a vertical incision, possibly marking the corner, runs down from the incised ceiling line just to the right of the door. Its continuation passes through the right shoulder of the larger child to meet the extension of the present base line of the back wall at precisely the point at which the latter cuts the incision of the base of the original side wall. This side wall would then have almost exactly balanced the existing right wall of the scene immediately to the left.

7. A series of double lines, almost in parallel recession, appear merely to record the intention to shift the visual centre over to the extreme right.

8. In the final scheme the vanishing point is set on the horizontal centre line where it joins the tip of the framing baluster. Diagonal controlling lines on the floor and on the outer wall run to the distance point contained within the scene, and dictate a viewing distance of a little less than threequarters of the width of the scene. Two vertical incisions running the whole height of the panel appear to mark an original forward limit of the right-hand wall somewhat to the left of its present position and about halfway across the chimney. A single vertical passing through the head of the second soldier from the left seems to indicate the extension of the outer wall into the landscape. The incision of the wall-base confirms this, connecting the double vertical on the left to the junction of the base line of the back wall with the vertical now isolated in the landscape. Two vertical incisions on the left wall, running into the left shoulder of the father, are probably part of this scheme. They mark the halfway point in the pictorial depth, and, together with the left border and the incisions of the originally wider right wall, help to divide the architectural area into three approximately equal parts.

9. W. Ueberwasser, *Von Mass und Macht der Alten Kunst*, Strassburg, 1933, pp. 97-113.

10. School intervention in this panel has not been discussed, but may account for the fact that in two of the remaining scenes original architectural features with straight cornices which, together with the lines of altars and altar steps, converge accurately to single vanishing points, have been covered by more ambitious, but none the less crudely drawn, shell-niches. The late date does not allow of structural uncertainty on Uccello's own part.

11. Pope-Hennessy, op. cit., p. 17.

12. In fact, the recently disclosed underdrawing (illus. Klein, op. cit., Fig. 5, and Parronchi, op. cit., Pl. 170a) shows that Uccello obtained his effect by drawing a squared pavement complete with its two distance points and central vanishing point and then suppressing the latter.

13. See Pope-Hennessy, op. cit., p. 26.

14. Vasari, ed. Milanesi, vol. ii, pp. 206-7.

15. Euclid, *Optics*, 4th Preliminary Proposition.

16. Vasari, ed. Milanesi, vol. ii, pp. 215–16.

17. Benvenuto Cellini, *Trattati dell'Oreficeria e della Scultura*, ed. C. Milanesi, Firenze, 1857, p. 225. The text is based on the *Marciana Codex*.

This section largely repeats arguments advanced in greater detail in J. White, 'Developments in Renaissance Perspective—I', *Journal of the Warburg and Courtauld Institutes*, vol. xii, 1949, pp. 58–79.

18. Cellini, op. cit., ed. Milanesi, p. 226. 'The most beautiful that was ever found by anyone in the world, for the rules of perspective show only the foreshortening of longitude, and not that of latitude and altitude. The aforesaid Leonardo had found the rules, and explained them with such wonderful ease and order, that any man who saw them was fully able to understand them.'

19. The possible significance of this passage was suggested by I. A. Richter in a review of Panofsky's publication of the *Codex Huygens* which was unknown to me when these observations on Leonardo's theories were published in 1949. See *Art Bull.*, xxiii, 1941, p. 337.

20. This diagram and the following summary of its essential characteristics correct those previously put forward in White, op. cit., p. 59, in which curves running to the central vanishing point were introduced. These would only occur through projection from a cylindrical intersection. As is indicated below on p. 227, this correction of the theoretical construction does not materially affect the analyses of the experiments made by artists working on an empirical basis.

21. Panofsky, *Codex Huygens*, p. 99.

22. MS. A, Fol. 8[a]: 'Perche le cose dallontano paiono a l'ochio grandi, e la ripruova fatta nella pariete le dimostra picole.'

23. The fact that Leonardo intended 'pariete' to cover a number of meanings is further witnessed by references on other occasions to a pariete 'piana' or 'rettilinia' (MS. E, fol. 16[b]; J. Richter, *Literary Works of Leonardo da Vinci*, second edition 1939, sect. 107). The word 'intersection' seems to cover the various uses to which 'pariete' is put, and avoids the necessity for a different translation in each new context. The precise word chosen is less important than the fact that it should not connote a surface of any particular shape.

24. MS. E, fol. 16[a] (Richter, op. cit., sect. 108): MS. E, fol. 16[b] (Richter, op. cit., sect. 107): C.A. Sheet I (Richter, op. cit., sect. 95, note). This problem of the representation of a row of columns is dealt with by Piero della Francesca, *De Prospectiva Pingendi*, ed. G. N. Favola, bk. ii, theorem 12, fig. 44.

25. MS. A, fol. 38[b]. Richter, op. cit., 526, and illustrations.

26. MS. A, fol. 38[a], 40[b], 41[a], 41[b]. Richter, op. cit., sect. 86, 543, 544, 545.

27. When the eye is in this position the foreshortening of the representational surface itself will correct the distortions which are visible from any other point.

28. In the note in MS. A, fol. 38[a] (Richter, op. cit., sect. 86), he gives this minimum distance as three times the width of the object, and this was the figure later accepted by theorists such as Lomazzo.

29. It is with the problem of the near viewpoint that Panofsky is primarily concerned in his analysis of these passages in 'Perspektive als "symbolische Form",' loc. cit., p. 294, note 8. Mesnil, *Revue Archéologique*, xvi, 1922, pp. 55–76, part II Section A, arrives at a very partial understanding of Leonardo's ideas.

30. MS. G, fol. 13[b]. Richter, op. cit., sect. 90.

31. MS. E, fol. 16[b]. Richter, op. cit., sect. 107.

32. The term artificial perspective used in this study has a long history and is, moreover, that used by Richter to translate Leonardo's 'prospettiva accidentale', exactly describing the system's primary quality—that it is a scientifically accurate man-made substitute for natural perspective. It seemed unprofitable to multiply terms when none of the possible substitutes such as centralized, geometric, and so forth distinguish it from other systems with common properties. As with the term synthetic, no derogatory, or laudatory, implications are involved.

33. MS. E, fol. 16[a]. Richter, op. cit., sect. 108.

Uccello, Leonardo, and the Development of Synthetic Perspective

34. MS. Br. M (Arundel 263), fol. 62ª. (Richter, op. cit., sect. 109). Folios 61 and 62 are interpolated, and of later date than those which surround them.

35. In Leonardo's own case there is a marked separation between his art and his scientific research. Many of his observations on colour, reflected light, and so forth, find no place in his paintings. It is quite probable that this dualism would also have extended to his perspective theories, since there are no indications of them in existing works. (The background of the Mona Lisa appears to show the curvature of the surface of the earth, and therefore concerns a literary, artistic, and scientific tradition which cannot be considered here.) As, however, there are no paintings from his last years, a final judgement is impossible.

36. Panofsky, 'Perspektive als "symbolische Form",' loc. cit., p. 296, note 11.

37. See Panofsky, *The Codex Huygens and Leonardo da Vinci's Art Theory*, London, 1940.

38. MS. BN, 2038, fol. 32ª. Richter, op. cit., sect. 574, and illustrations.

39. MS. BN, 2038, fol. 16ᵇ, 32ᵇ. Richter, op. cit., sect. 576, 203, etc. A lengthy passage in Cellini's Discorsi dealing with the techniques for mastering complex foreshortenings by means of cast shadows is confirmed by the illustration on folio 90ʳ of the *Codex Huygens* (ed. Panofsky, Pl. 51).

40. Ed. Panofsky (Pl. 56, 58).

CHAPTER XV

Fourteenth- and Fifteenth-century Manuscript Illumination in France

The splendours of French painting in the fourteenth century are bounded by the turning of a page. A decorative balance so firmly founded on the written word could not be easily or rapidly adjusted to ideas of spatial realism. The stages of development that in thirteenth-century Italy melted into one another with explosive force become in France a gentle disengagement from the arms of the initial and the tendrils of the decorative border.

Thirteenth-century Gothic illumination, with its patterned backgrounds, and flat, architectural or lettered frames, is both less three-dimensional in itself and less ready for translation into spatial terms than the Byzantine forms and antique reminiscences which played so great a role in Italy. The dominance of the flat frontal and complex frontal patterns is far more complete. The very rare exceptions are provided by the surface-stressing foreshortened frontal settings, and oblique constructions are almost non-existent.

The first movement in the new direction seems to take place at the end of the first quarter of the fourteenth century. This is the Parisian Jean Pucelle's adoption of the foreshortened frontal setting for consistent use. The new construction is predominant in the Bylling Bible of 1327, and is accompanied by occasional use of the oblique setting for such things as stools.[1] In the more or less contemporary *Hours of Jeanne d'Evreux*, it is equally important, sharing the honours, in this instance, with small open-sided structures that reveal their one-room, centralized interiors.[2] Despite the survival of purely frontal (Fig. 1, *a*, p. 27), and, more rarely, of complex frontal structures (Fig. 1, *b*), it is clear that the new ideas of space have gained their first firm footing on the manuscript page.

The impulse for this new departure is derived, as might be expected, from the initial impact upon French artistic consciousness of the new ideas that had held Italy in ferment for some fifty years.[3] Apart from the general evidence of Italian leavening in France, Pucelle's own work reveals at least one definite connection with the art of Duccio and the Sienese. This clear link, confirming an impression often less amenable to proof, is his adoption for 'The Annunciation' in the *Hours of Jeanne d'Evreux* (Pl. 52, *a*) of Duccio's composition for 'The Annunciation of the Death of the Virgin' in the

Maestà. The single substitution is the standing Virgin also used by Duccio for the first 'Annunciation'. The resulting design was so successful that it was not only repeated by Pucelle and his atelier, but actually survived essentially unchanged into the fifteenth century.[4]

The tie with Italy is underlined by the fact that such a boxed interior is otherwise extremely rare so early. Moreover, it alone amongst the textual illustrations is divorced from any patterned ground, and stands directly silhouetted on the parchment. This second feature stresses the Italian reminis, cences amongst the small, free,standing buildings that are used in calendar scenes and for the marginal illustrations at the bottom of the page.

Another reflection of Italian influence is the use of a normal viewpoint. This is not very noticeable at first in Pucelle manuscripts, since small objects like chairs or tables so often stand in isolation. These are naturally seen from above without in any way detracting from the normality of the down,sloping roof,lines in the majority of the buildings.

Despite this budding naturalism, Jean Pucelle, or possibly an intermediary, has transformed Duccio's true interior into a little open,sided house, and so reverted to the earlier pattern of the object set in space. There is, as yet, no feeling for an enclosed void divorced from all description of the outside of the box that shuts it in.

The tendency for naturalist innovators to begin by concentrating on the individual solid object that was noted in connection with the frescoes at Assisi and Padua, here recurs in far more drastic form.[5] The visible ground plane was a well,established feature of late thirteenth,century Italian frescoes. In Pucelle's early fourteenth,century miniatures, on the other hand, it some, times extends no further than the limits of a one,roomed house, and it is usually represented by the narrowest of strips, or even by a mere line.[6] Pictorial space is, therefore, in a real sense an attribute of the individual solid; both created by it and unable to extend beyond its borders. These solids are, moreover, held to the very minimum necessary for the setting of a scene or for the illustration of an action. The borrowing of Sienese patterns carries with it no awareness of the complex and continuous pictorial space so typical of Duccio himself, whilst the dominance of the surface is even further stressed by the ever,present text.

The isolation of the individual solid remains a characteristic of most of the miniatures painted by the Maître aux Boquetaux, who was active in the middle and third quarter of the century. Although the ground plane is by now established, and at times a quite extensive landscape is developed, there is, as yet, little effort to relate the viewpoints of the various structures occupying a single scene. The great, page,width illustration of 'Love Presenting Three of His Children' on Folio D of the *Poésies de Guillaume de Machaut*[7] (Pl. 52, *d*), which together with the similar scene on Folio E is probably his greatest achievement, reveals his capabilities and his limitations. In the mass of

smaller, less ambitious miniatures from his hand and workshop, he remains almost completely faithful to the simplified Sienese constructions taken over by Pucelle. The patterned background is also retained, stressing the decorative qualities of the centralized and foreshortened frontal structures which provide the major spatial accents. Throughout contemporary French illumination these constructions are completely dominant wherever the frontal and complex frontal systems do not still maintain their hold. Until the final quarter of the century the oblique construction remains, in comparison, unimportant, whether in quantity, in quality, or in function.

An insight into the creative processes that seem to be so typical of early experiments in spatial design, yet tend to stay for ever in the realm of mere assertion, is provided by *The Coronation Book of Charles V*.[8] In this manuscript of 1365, scene follows scene, each with its gaily patterned background, each with figures standing on a narrow plane of equal gaiety beside an altar in foreshortened frontal setting (Pl. 51, *a*). Folio 63 (Pl. 51, *b*), however, reveals the little group of personages in the act of climbing up some wooden steps into a draped, rectangular pulpit standing on four columns. The scene is then repeated on the following page (Pl. 51, *c*), with the difference that king, prelates, and attendant nobles have all reached their ceremonial places. The steps that bore their weight so sturdily in the previous illustration are no more in use. Immediately, they are swung back into the picture plane, flattening upon the surface as if no one ever did, or ever could, climb up them.

Seldom is the creation of pictorial space so graphically tied to the demands of action. No subtleties of analysis are needed to reveal the seemingly most important motive in the making of the early forms of space; a space which clings, expanding and contracting, to the figures, and to the simple solids that are indispensable to them in the playing of their parts.

The fact that an unusual effort or achievement may occasionally arouse a new, if momentary, ambition, even in a craftsman miniaturist, can perhaps be seen in the succeeding illustration (Pl. 51, *d*). Suddenly, caution is forgotten in the placing of the figures that are usually set so carefully to one side of the altar, or else overlap it slightly without spatial explanation. Now, not only do they stand partly in front of it, but space is cleared for them. The altar pivots back upon its outer corner, and becomes, for the first and final time, softly oblique in setting. The figures walk for a brief moment in the thin wedge of space which is left free before it is squeezed out again by the flat pressures of the page.

The actual invasion of French manuscripts by the oblique construction sets in slowly during the early 'seventies. An unusually bold example of the intermediate stage, which was seen in Italy in some of Cavallini's frescoes and mosaics, can be recognized in the dedication page of *The Polycratic of John of Salisbury*, given to Charles V in 1372 (Pl. 52, *c*).[9] Here the extreme oblique construction of the lower sections of a throne appears in combination with a

221

horizontal upper line that implies a foreshortened frontal setting. There seems to be an element almost of illusionism in the bold design of this great throne. The angular base which juts across the border, and the canopy which stands completely in front of it, appear to show a sense of purpose that distinguishes them from the earlier overlappings in which figures, or else minor details such as spires and pinnacles, were usually involved. There is, however, some uncertainty in the relationship between the upper and lower parts. It therefore seems impossible to tell whether the overlapping is dictated by a wish to have a more imposing throne than that allowed by the dimensions of the decorative field, or whether it reflects a truly spatial purpose. Such uncertainties seem to be the rule in the first stages of the introduction of the oblique setting into French illuminations. They reflect the great role played by the purely decorative considerations which, when coupled with the desire for greater realism, contribute to each innovation.

The penetration of the oblique setting into the established workshops is revealed by manuscripts such as the Bible of Charles V, illuminated in the circle of the Maître aux Boquetaux and completed in the year 1371.[10] Similarly, one of the earlier manuscripts in which the many fine examples of the new design outnumber the foreshortened frontal settings is the Missal of St. Denis, decorated by the Pucelle atelier, or by his followers.[11] The extreme oblique construction on Folio 261 (Pl. 52, *b*) is of particular interest, as it shows the strains and stresses to which long-accepted patterns were subjected by the intrusion of realistic space. The way in which the letter O is woven into the design, part before, and part behind the foremost pillar, creates visual excitement. The new existence in a world of space is underlined at the same time by the hounds that leap diagonally through the letter just as circus dogs leap through a hoop.

The motives of the painter are again uncertain. He may have been intrigued by the new possibilities of spatial interweave, or have actually exploited the plane-stressing qualities of the capital to control the thrusting force of his design. Perhaps, on the other hand, he merely did his best with what was, after all, a mandatory element in the composition. Of these three solutions, the latter seems, in the end, to prove the least promising. It is possibly significant that this particular little building, so securely set upon deep-running greensward, is at once the most firmly constructed, and spatially the most aggressive structure in the missal. Moreover, in the two additional miniatures in which the initials cut into the composition in a similar way, a simple planar pattern is created, forming no such complex interweave.[12] In all the other scenes the letters function as a mere surrounding border. This, combined with the least possible emphasis on any part of an initial which cannot be kept entirely clear of the representational field, is the most common solution of the problem for those artists who were pioneering fresh conceptions of pictorial space during the fourteenth century.

Fourteenth- and Fifteenth-century Manuscript Illumination in France

The special case of the historiated letter is important simply because it represents, in extreme form, the varying yet ever-present problem of adjustment characteristic of those periods of history in which a desire for greater spatial realism is first felt. The old, impartial intertwining of figures and initials raised no conflict, since the element of realism was hardly appreciable. It is only with the advent of the new realistic space that the old balance is upset, and new pictorial combinations must be generated even where the earlier forms are not entirely superseded.

It is the last quarter, and particularly the last decade of the fourteenth century, which sees both the rapid development of the interior and the extension of the influence of Italian ideas of pictorial space from the building and the individual object out into the landscape. It is now that the Northern manuscript illuminators start on their Italian travels, seeing for themselves the source of so much inspiration. Simultaneously, even in their native city, the stars of the Parisian masters begin to wane before the Franco-Flemish supernovae.

In this time of ferment an increasing number of manuscripts reveal the extreme oblique setting impartially intermingled with the foreshortened frontal and centralized constructions. In many of the most important examples, such as the Brussels 'Très Belles Heures',[13] extreme oblique and foreshortened frontal settings are to be found in almost equal numbers. In other cases there is a closer dependence upon earlier prototypes, at times amounting to actual repetition, and in these the oblique construction is much less common.[14] Nevertheless, a survey of the few surviving panel paintings,[15] or of the manuscripts illuminated by the leading artists at the turn of the century, reveals the increasing, and now widespread use of the extreme oblique construction as a new, and striking feature of pictorial design.

The high-water mark of this trend occurs in the output of the de Limbourg brothers during the first two decades of the fifteenth century. The extreme oblique setting becomes the dominant motif throughout their autograph work, appearing far more frequently than either foreshortened frontal or centralized constructions. It almost becomes as characteristic of their art as it was formerly of that of Giotto. Almost, but not quite—for that is inconceivable of these exuberant eclectics. The Limbourg brothers' predilection for the oblique setting does, however, take its peculiar significance from the fact that, as far as France is concerned, the miniatures which they painted far outstrip the work of their contemporary rivals in any field of natural observation that may be chosen for consideration.

This supremacy is clearly visible in their acknowledged masterpiece, the 'Très Riches Heures'.[16] The anatomy of the human figure; loving observation of the details of plant and animal life; the continuity of deep-running landscape; delicate architectural portraits of identifiable localities; there is no apparent end to an enumeration of the achievements of these artists in whose

223

Fourteenth- and Fifteenth-century Manuscript Illumination in France

work the part played by tradition is so often of the first importance. There is even a full-page interior (Pl. 53, *a*) which, with its truncated, barrel-vaulted ceiling, with the sharp cutting of the figures at each side, and with the abbreviated left wall balanced on the right by an indefinite extension of the room-space through the cutting of the banqueting table and the fireplace, is, in general structure, comparable to Donatello's great 'Dance of Salome' (Pl. 34, *b*). The vividness of this comparison and contrast is enhanced by yet another detail. Where Donatello, the Italian, carries his hall into depth through the repeated, arching planes of monumental architecture, the de Limbourg uses the softer, more pictorial, and typically northern medium of a hanging tapestry that sweeps the eye into a landscape of indefinite extent, the placing of the figures so blurring the transition that one scarcely knows where free space ends and woven space begins.

In such a manuscript the predominance of the extreme oblique construction amongst all the major foreground structures is of interest in itself. More striking still, however, is the fact that the softest conceivable oblique settings are used in most of the detailed architectural portraits in the backgrounds.[17] In the Calendar scene for June (Pl. 53, *b*), the construction takes a form in which the main face of the building is almost, and yet quite definitely not, set in the plane. It is a subtle application of a method similar to that habitually used by Giotto in his mature works. In other miniatures it is the extreme oblique construction itself that is transformed. The evenness of recession upon either side remains. But now the slope of all the architectural horizontals is reduced until the sharp, and jutting, angular effect is lost, with each line scarcely moving from the horizontal, yet no line maintaining it.[18] In the de Limbourg architecture it is patent that the very buildings which disclose the greatest evidence of direct observation are those which reveal the greatest subtlety of oblique construction.

During these same years the application of the setting to the problems posed by the interior is likewise extended and refined. The dedicatory miniature of a manuscript of 'The Poems of Christine de Pisan' (Pl. 54, *a*), dating from between 1408 and 1413, even reflects the transference to an indoor scene of those same visual principles and compositional devices which had been developed in Italy by Maso di Banco and Ambrogio Lorenzetti.[19] Here, the beds to left and right are each obliquely set. Although the straight back wall reveals quite clearly that the room is actually rectangular, the artist recognizes that as head and eye are turned in order to survey each individual object, each in turn recedes obliquely from the onlooker—as in nature, so in art.

In an interior this arrangement intensifies the problem of the alignment of the side walls which had always faced the artists working on the basis of tradition and experience when they turned to the observation of individual appearances. In the north, particularly, there is a persistent tendency for the

baselines either to be insufficiently inclined towards each other or to be inclined so much that they cut into the chequer-board pattern of the floor. It seems probable that one of the underlying reasons is that it is in observing just these lines that the artist turns his head furthest. As a result, the conflict between what he sees in each individual glance and the known structure of the room as a whole is at its most intense. The more firmly he makes up his mind to set his walls according to his detailed observation of their surfaces, as in the miniature of 'Isabel of Bavaria and Christine de Pisan' (Pl. 54, *a*), the greater are his troubles at the centre of the picture. This is often, like the side orthogonals, covered up in artistically effective embarrassment.[20] It remained for Jean Fouquet to face the issue, and draw in upon the floor the curves which are implied in the area that separates the beds shown in this miniature, and to do consistently in practice many of the things which Leonardo later advocated in his theory of synthetic perspective.[21]

The Roman journey which Fouquet undertook between 1445 and 1448 was undoubtedly amongst the most significant episodes in his whole life. The importance of it is increased by the lack of any agreement about his earlier activities.[22] There are therefore, throughout his certain works, constant, and often very strong reflections of early renaissance art. It seems clear, more-over, that he became acquainted with the new system of artificial perspective, although there are never more than fairly close approximations to it in his own productions. Even these are rare, and for the most part confined to the pages of 'The Book of Hours of Etienne Chevalier', which appears to have been his first commission after his return to France.[23] These approximations to the contemporary Italian theory are, however, less exciting than Fouquet's development of the empirical endeavours of his French, and therefore, indirectly, of his Italian predecessors.

A noticeable feature of these Hours is the clear way in which the artist underlines the foremost plane of the illumination. This is seen as coinciding with the surface of a page pierced by pictorial space. The conception, there-fore, of the pictured world as things seen through a window, which is com-mon both to Eyckian practice and Italian theory, appears also to be present here.[24] In half the miniatures the effect is simply gained by placing at the bottom of the scene an unforeshortened strip of lettering which lies implicitly at right angles to the ground or floor immediately above it (Pl. 54, *b*). The change of plane is made explicit in 'The Visitation', where the vertical forward surfaces of the foremost row of marble pavement slabs are clearly shown. In the remaining scenes all possible ambiguity is avoided by pre-senting the main action on a platform rising up behind a narrow forward space reserved for allegorical figures or for genre-like illustrations of the humble preparations for the next act in the drama. In over half of this second group of miniatures, however, it is not a straight line that divides these two spheres of reality, but a curving wall or rock-ledge. These scenes are also

those in which it is impossible to find major reflections of renaissance archi^
tectural or perspective forms.[25] In most of them the curved wall of the fore^
ground, signifying final entry into the pictorial world, is accompanied also
by a semi^circular grouping of the figure composition, or by circulation round
the forward^jutting corner of a sharply oblique architectural feature similar to
those which often occur even when the straightforward lettered strip provides
the lower border.

The most convincing evidence that these deviations from renaissance prac^
tice have significance beyond that of an inherited pattern preference is pro^
vided by the scene of 'The Annunciation of the Death of the Virgin'
(Pl. 54, *b*). Here, over the plain, lettered base^strip, part of a large, rectangu^
lar, half Italianate, half northern bedroom opens out. The back wall is set
parallel to the surface of the page. The right^hand side wall, which alone is
visible, is definitely straight. Despite this evidence of the normality and
rectilinearity of the room, it is found that as the eye swings over to the right,
away from the perspective centre, all the transverse lines of the matting on the
floor begin to curve away into depth as they approach the side wall. The
horizontal cross^beams of the forward part of the ceiling also start to splay,
and swing into recession on the right. Fouquet has painted in the curves that
were implicit in the dedication scene of 'The Poems of Christine de Pisan'
(Pl. 54, *a*). As the head turns, and the visual centre changes, so the room
sways in adjustment, making new foreshortenings apparent.[26]

It is remarkable that strikingly original developments of such a kind should
occur in that same manuscript in which the influence of Italian forms is at its
peak. It is, therefore, no surprise at all that as the memories of his journey fade
a little the development of Fouquet's personal vision is intensified. The nature
of this vision is abundantly confirmed in the extensive illustrations to 'Les
Grandes Chroniques de France', which date, in all probability, from the
early 'sixties.[27]

In the 'Arrival of the Emperor at St. Denis' (Pl. 55, *a*) the form of the
spatial structure is set by the curved network of the flagstones, which in this
case appears to record objective fact, since the imperial sedan, together with
its horses, cuts across it in a definite straight line. This does not account,
however, for the slight bending of the lines leading into depth. Such curving
of a chequer^board pattern is one of the recurring features of the work of
Fouquet, and in the majority of cases it is used where there can certainly be
no question of objective curves.[28]

In the miniature of 'The Banquet of the Emperor Charles IV', not only
are there gentle curvatures in the chequered pattern of the floor, but the
banqueting table, and also the steps leading up to it, which likewise stretch
across the whole width of the scene, are delicately curved, their ends receding
softly as the eye runs out to either side.[29] Similarly, in 'The Coronation of
Charlemagne', represented as taking place in the nave of old St. Peter's, the

familiar, curving network of the flagstones is seen again. There are altogether about ten cases in this, and in other manuscripts, which confirm the interpre, tation originally placed upon 'The Annunciation of the Death of the Virgin'. In each the interior is undoubtedly rectangular, although in two cases the impression of a bending side wall is obtained by rather muddled means.[30] In each there is also a more or less close approximation to the curving world of synthetic perspective.

In the theory of synthetic perspective itself, orthogonal recession was observed to retain its rectilinear quality, although in this it is unique, since every other kind of straight line running into depth acquires a curvilinear distortion (Fig. 8, p. 208). This straight line recession of orthogonals stems from the equal value that is given to diminution in the vertical and horizontal directions. In everyday experience, however, seeing with two eyes set side by side in a head that traverses more easily than it tilts, it is by no means inevi, table that an equal stress will be placed upon the two directions. Such equality is very often not attained in practice, and perspective theories have, in fact, been based on the assumption that there is a constant horizontal emphasis.[31] It is, in any case, quite certain that if one axis is given more importance than the other, the orthogonals will share in the curvatures of a curving world. It is therefore no surprise that artists who were, by trial and error, translating their experience of the world into curvilinear designs, should often give the orthogonals a curvature similar to that which is a property of every other kind of recession according to rigidly applied syn, thetic perspective theory. It is equally understandable that the curves in depth should sometimes bend in one sense, sometimes in another, and that the whole problem should prove to be unusually perplexing to them.

Apart from actual curvilinear distortions, the 'Grandes Chroniques' are dominated by the oblique setting. Sometimes it is the bold knife, edge of the extreme oblique construction that creates the pivot of the composition.[32] Often the pattern is refined and softened so as to be almost, but not quite mistakable for a centralized, or a foreshortened frontal setting. As occasionally with Giotto, and more frequently with Maso, the forward faces of such build, ings are divorced from the flat surface only by that irreduceable minimum which appears to have meant so much.[33] Time and again, in these same compositions, great processions curl across the foreground, sweeping up out of the distance, past the thronged spectators in the real world, and back into the picture space.[34] Compositionally, these cavalcades are an excellent solution of the problem of fitting long processions into narrow decorative fields. Visually, they conform to the fact, recognized in synthetic perspective, that, for the roadside onlooker, only the horses passing immediately in front of him appear in pure profile. All the others are seen in a threequarter hind or front view, depending on whether he turns to look at those which have gone by or at those which are to come. The very unity of compositional

demands and visual experience serves to set the whole gay cavalcade in motion.

The subtly curving streets of the late medieval towns of France, enlivening the backgrounds of so many scenes, are a further illustration of the union between visual experience and pictorial composition which was being forged by Fouquet at this time. The natural, compositional curve unobtrusively fulfils the eye's requirements. No conflicts are caused here by actual distortions. Yet a curving world resembling that which Leonardo was, for his own very different reasons, to organize in theory, still comes into being. In this world specifically Italian forms are blended more and more into the artist's personal vision. Occasionally, however, they remain as bold, contrasted patterns underlining the empirical, and non-dogmatic nature of Fouquet's art.[35]

These street scenes stir the recollection of such earlier masterpieces as the view of Mont. St. Michel in the 'Très Riches Heures'.[36] The imperial processions seem only to be a transformation of the green-decked lords and ladies riding through de Limbourg's maytime woods. Stylistic links, in some ways even stronger, lead back also to the Bedford atelier. Yet the half-conceptual, and half-decorative curvilinear horizons of the Bedford and Sobieski Hours[37] serve only to accentuate the new qualities infused by Fouquet into his own use of curves. On no occasion does he give a decorative curve to the horizon, even where a curved procession fills the foreground. Since it is only in the widest panoramas that the curved horizon would have any validity as an expression of psychological or visual experience, Fouquet has no use for it.[38]

The final confirmation of the basis in reality of the vanishing axis patterns, oblique settings, and recurrent curvatures in Fouquet's art occurs in the 'Antiquités Judaiques'.[39]

The vertical foreshortenings, later recognized in Leonardo's theory of synthetic perspective, which make the sides of a tall building run together when one stands in front of it, are quite well known. It is not so often noticed, on the other hand, that if one stands before a gap between two such structures, it is the two buildings that converge, leaning across the intervening space. This phenomenon was observed and substantially reproduced by Fouquet in the architectural mass which dominates 'The Building of the Temple at Jerusalem' (Pl. 55, b). Even allowing for the structural inclination of the walls and buttresses, the whole temple leans firmly over to the left. There is also a general tendency for the vertical displacement to increase as the eye moves away from the visual centre of the miniature in the figure of King Solomon. The lessening of distortion at the centre is not wholly due to the need for harmonization with the vertical of the building containing the king's balcony, for the outline of the farthest buttress still leans to the left, whereas in true elevation it would be inclined towards the right.

There can once again be no suggestion that a theoretical system has been applied, since the objective, ruled lines of the main horizontals show a lack of interest in such things that is emphasized by the use of an optically correct curve in the feet of the buttresses. It does appear, however, that the penetrating observation which, as in the rest of Fouquet's work, characterizes the genre scenes and the architectural detail, is reflected also in the general structure.

The underlying truth of this interpretation can, by chance, be proved in this particular case, as the whole scene is repeated in 'The Taking of Jerusalem by Nebuzar-Adan'.[40] Here the same buildings are seen from a distance, and the temple is indeed a structure in which the verticals appear as such within quite narrow limits, while the buttresses have their normal inward inclination. This is so in yet a third view of the building found in the same manuscript.[41] It is significant that these particular distortions of the vertical only appear with such strength on the one occasion on which Fouquet represents an extremely tall building seen from a near viewpoint.[42] Optical distortions are subtle in actual vision, and, as Leonardo later realized, it is just for the wide angles entailed in such cases that they are most noticeable. A reference to Fig. 8 (p. 208) shows that even in theory, distant, isolated buildings would be affected relatively little.[43] The diagram also shows the very increase in distortion as the eye moves sideways from the visual centre that was noticeable in the representation of 'The Building of the Temple' (Pl. 55, *b*).

The realization that the core of Fouquet's art lies in a remarkable approximation to the synthetic perspective later developed by Leonardo must not be allowed to obscure the realization that in fifteenth-century France the current of development towards artificial perspective flowed with equal strength if possibly less spectacular results. The fact arouses no controversy, and as the complementary development, whilst associated with intrinsically beautiful and interesting works of art, presents no fundamentally original spatial aspects, it seems to be unnecessary to elaborate the point.

The pattern of development that now emerges is essentially clear. It is also an astonishing reflection of the one revealed within the framework of Italian art.

The earliest stage, both in France and Italy, is marked by concentration on the individual object. In both countries the latter first attain solidity through the foreshortened frontal setting with its powerful surface-stressing qualities. In France the new construction, pioneered by Jean Pucelle, retains its dominance for fifty years, until, in the last quarter of the fourteenth century, the extreme oblique construction challenges its undisputed rule. By the end of the century the two constructions reach a state of parity similar to that in Cavallini's later works, or in the frescoes of 'The Legend of St. Francis' at Assisi. The development of the foreshortened frontal setting is still continued over a wide field of French and Franco-Flemish illumination, just as it was

continued at the hands of Duccio a century before. The oblique setting nevertheless attains, in the art of the three de Limbourg brothers, a dominance as striking in its way as that which it had previously enjoyed with Giotto and his closest followers, and this later triumph is accompanied by a similarly rapid toning down of its aggressive qualities.

In France, even more than in Italy, the patterns which had been estab' lished by the men who looked most keenly at the natural world were casually, if decoratively, intermingled and misunderstood by their less perceptive followers.[44]

At the point reached during the first quarter of the fifteenth century the speed of flow of the two currents of development, which are visible both in north and south, is radically altered. In Italy the emphasis is on the organiza' tion of the monumental fresco. There the elaboration of a theory of artificial perspective precedes the invention of a systematic synthetic perspective by almost a hundred years. The experiments of Maso di Banco and Ambrogio Lorenzetti die in the Black Death, and are only painfully, and partially carried forward by Uccello. In France, which was less concerned with monumental painting, and, in the early fifteenth century, still relatively un' touched by the intellectual fires of the Renaissance, frank empiricism rules. In this very different artistic climate an approximation to a synthetic system is brought into being with astonishing rapidity through the genius of Fouquet.

The fundamental similarities and fertile differences visible in these two patterns of development straightway raise a question as to how much the common forms and sequences merely reflect direct dependence and the altering availability of prototypes.

Jean Pucelle's adoption of the fully fledged foreshortened frontal setting appears to have been inspired by Italian sources. His concentration on the individual object is, however, less a reflection solely of the transmitted models, than of a tendency characteristic of the early stages in the development of spatial realism. Pucelle's structures lean towards a greater isolation than that visible either in Italian art or in the crowded and frankly non'spatial archi' tectural designs of his French predecessors.

It is therefore important to discover whether the long continued adherence to the foreshortened frontal construction on the part of Pucelle, the Maître aux Boquetaux, and their many followers, reflects a genuine choice, and a rejection of the oblique construction, or merely derives from the absence of oblique settings in the Italian works which came to their attention.

Unfortunately, no definite answer to this question appears to be obtainable at present, and it is possible that the adoption of the oblique setting in the final quarter of the century coincides with the first general dissemination in France of knowledge of a construction which was, by then, a commonplace through' out all levels of Italian art.

The part played by choice becomes clearer, and the possibility of a rela~ tively mechanical explanation correspondingly more remote, in the case of the stage in development represented by the dominance of the oblique construc~ tion in the work of the de Limbourgs. In the majority of Italian manuscripts no such predominance occurs. The de Limbourgs seem, however, to have had first~hand knowledge of both Sienese and Florentine monumental painting.[45] But even if one of the brothers did travel through Italy in person about the turn of the century, it would by then have been quite impossible for him to have returned with an impression of an artistic world in which the oblique setting predominated. To do so would have required both the establishment of a restricted canon of the work of Giotto and his closest followers and a subsequent concentration on it that would be alarming even in a modern specialist on the subject. Consequently, the fundamental con~ structional parallel between the otherwise very different arts of Giotto and of the de Limbourgs cannot be associated with the availability of only a single set of prototypes. It must, instead, be attributed to the fact that their new willingness to look at nature itself, as well as at the patterns laid down by their predecessors, led them, like Giotto and Cavallini before them, to put special emphasis upon the oblique construction.

The work of Fouquet also seems to present a case of parallel development, and not of direct dependence. His artistic evolution shows that renaissance artificial perspective was what impressed him in Italian painting, just as it was early renaissance, rather than Italian Gothic architecture that caught his eye. He may well have discussed the validity of the newly invented perspective system whilst he was in Italy. But even if he spoke to Uccello himself, every~ thing that is known of Italian fourteenth~ and fifteenth~century art points to the unlikelihood of his having found in Italy the theoretical or pictorial bases for his own compositions. This conclusion is confirmed by the association of his most personal pictorial inventions with specifically northern elements of observation and iconography. His art therefore seems to represent a genuine parallel to the experiments already begun in mid~fourteenth century Italy. It was a movement in the same direction, undertaken for the selfsame reasons.

The historical evidence seems, as a result, to point to a high degree of parallelism in the fundamental aspects of the evolution of perspective space in these two separate areas of Europe, despite their closely interwoven cultural heritage. The ransformations undergone by cubic forms beneath their icono~ graphic trappings and particularities of shape seem to reveal a number of constant features, and to reflect certain constant tensions. Nevertheless, where the cross~currents of influence are so strong; where the two countries have a common boundary in space, and where the individual phenomena are never separated by more than a single century; no complete confidence can be felt. Only by severing the web of direct action and reaction and examining a

similar development in something more approaching ideal isolation is it possible to go further. The analysis of the rebirth of pictorial space can only be controlled by a reference to its first birth in antiquity.

NOTES

1. Paris, Bibl. Nat. MS. Lat. 11935. For oblique settings see folios 293V, 326V, 461, 467, 633V. For a full bibliography and concise discussion of the present state of the studies in fourteenth- and early fifteenth-century illumination covered by this chapter, see E. Panofsky, *Early Nether-landish Painting*, Cambridge, Mass, 1953, and also Bunim, op. cit.

2. Ex coll. Maurice de Rothschild, Paris, now Metropolitan Museum, New York.

3. Rusuti and his son were in France in 1308, and the new Tuscan forms and the Roman style of Cavallini and his followers are reflected soon afterwards at Beziers. See M. Meiss, 'Fresques Italiennes Cavallinesques et Autres, à Beziers, *Gazette des Beaux Arts*, 6e Per. Tome xviii, 1937, 2e Sem., pp. 275–86.

4. D. M. Robb, 'The Iconography of the Annunciation in the Fourteenth and Fifteenth Centuries', *Art. Bull.* xviii, 1936, pp. 480–526, fully discusses the vicissitudes of the design. Concerning the perspective, see Panofsky, 'Die Perspektive als "symbolische Form",' loc. cit., p. 315, note 49, and Bunim, op. cit., pp. 153 ff.

5. See above, pp. 34 ff., and pp. 75 ff.

6. The *Belleville Breviary* throughout, and also the *Hours of Jeanne d'Evreux*, and the *Hours of Yolande of Flanders* (London, British Museum, Yates Thompson 27) contain excellent examples of ground lines.

7. Paris, Bibl. Nat. MS. Fr. 1584.

8. London, Brit. Mus. MS. Cotton, Tib. B. VIII. See E. S. Dewick, *The Coronation Book of Charles V of France*, London, 1899.

9. Paris, Bibl. Nat. MS. Fr. 24287. Compare with Pl. 12, *b* and *c*.

10. The Hague, Mus. Meermanno-Westreenianum, MS. 10 B 23, fol. 467, provides excellent examples of oblique settings. Illus. A. W. Byvanck, *Les Principaux Manuscrits à Peintures de la Bibliothèque Royale des Pays-Bas et du Musée Meermanno-Westreenianum à La Haye*, Paris, 1924, Pl. 50.

11. London, Victoria and Albert Museum, MS. 18.3.91. Discussed, A. de Laborde, *Les Manuscrits à Peintures de la Cité de Dieu de Saint Augustin*, Paris, 1909, p. 207 and p. 232, note 5.

12. Fols. 179V and 242. The compositional solution on Fol. 261 is almost identical with those adopted in the *Missal of Robert of Geneva*. (Paris, Bibl. Nat. MS. Lat. 848, particularly fols. 27V, 183, 194, 236, 278V.) The French borders and Italian illuminations in the latter stress the continuity of intercourse between France and Italy, quite apart from such major events as Simone Martini's sojourn in the early 'forties.

13. Brussels, Bibl. Roy MS. 11060. In Berry inventory of 1402 as partly illuminated by Jacquemart de Hesdin.

14. See *Les Grandes Heures du Duc de Berry*, Paris, Bibl. Nat. MS. Lat. 919, and *Les Petites Heures du Duc de Berry*, Paris, Bibl. Nat. MS. Lat. 18014.

15. See G. Ring, *A Century of French Painting, 1400–1500*, London, 1949.

16. Chantilly, Musée Condé. Panofsky, *Early Netherlandish Painting*, gives an excellent analysis of the importance of the Boucicault Master, placing less emphasis on the de Limbourgs because of their relative lack of influence on fifteenth-century Netherlandish painting.

17. P. Durrieu, *Les Très Riches Heures de Jean de France, Duc de Berry*, Paris, 1904, identifies the châteaux of Lusignon, Dourdon, Poitiers, D'Etampes, Saumur, and Vincennes, in the

Fourteenth- and Fifteenth-century Manuscript Illumination in France

calendar scenes for March, April, July, August, September, and December, together with many other recognizable buildings and localities.

18. The Château de Saumur in the September scene, fol. 10v, is one of the finest examples, and fol. 4v, April, provides another.

19. London, Brit. Mus. Harley MS. 4431. For dating, see H. Martin, *La Miniature Française du XIII au XV Siècle*, Paris, 1923, p. 76. This passage, and those on Fouquet which follow, are based on the article, 'Developments in Renaissance Perspective—I', loc. cit.

20. Panofsky, 'Die Perspektive als "symbolische Form",' loc. cit., p. 280, and note 47, Bunim, op. cit., p. 148, note 56, consider this problem, but from a slightly different angle. With Fouquet, uncertainty about the relation of the side walls to the foreshortened pattern of the floor is relatively rare. Masking of the vanishing point or axis nearly always occurs, even when he seems to use the systematic Italian method as in the floors of 'The Coronation of the Virgin', 'The Pentecost', and 'A Funeral' in the *Hours of Etienne Chevalier*, in which, however, 'The Visitation' provides a fine unencumbered approximation to a general vanishing point.

21. See above, pp. 207 ff.

22. See P. Wescher, *Jean Fouquet*, Basel, 1945, and K. G. Perls, *Jean Fouquet*, London, 1940, pp. 9–13, in which a rapid summary of the problem is given, together with a complete photographic survey of the generally accepted works.

23. Museé Conde, Chantilly. See Note 20 above.

24. O. Pächt, *The Master of Mary of Burgundy*, London, 1948, gives a fine analysis of the relation of the surface of the page to pictorial and to external reality.

The main reason for not considering the Flemish development fully in this study is that, as is so clearly shown by Panofsky (*Early Netherlandish Painting*) who has now so largely covered the field, it does not in any sense represent a 'fresh start' as regards spatial realism, its roots lying in the French and Franco-Flemish art of the fourteenth century. It represents a stage comparable in maturity to that of early fifteenth-century painting in Italy. There the ascendancy established by the new artificial perspective in its abbreviated Albertian form seems to account for the rapid and almost complete disappearance of the oblique setting. The emphasis on the squared pavement as the starting point in effect reduces all oblique forms to the status of interlopers cutting across the essential rectilinear network (see above, pp. 125 ff.). In the north the monumental polyptych emerges as the dominant form. This, when combined with realistic architectural and landscape settings, puts an even greater premium on organizational factors than is the case with the typical Italian mode of expression, the fresco cycle, since the relationship between the parts is so instantaneously and insistently apparent.

Another important factor may well be the contemporary development and exploitation of the true interior as the most popular element in the new art. It is in the interior that the distortions accompanying any synthetic system are most acute and the pressure to use an 'artificial' method at its strongest. This is particularly so when, as is habitually the case with Jan van Eyck, the rectilinear frame itself is being incorporated in the design as an actual window, often of imitation marble.

The complexity of design that is being achieved by the end of the first quarter of the fifteenth century provides a further impulse towards the use of approximations to the system that is organizationally most suited to the plane surface. All these factors would, of course, be reinforced by knowledge of the Albertian system when the latter reached the north. Only when the artificial perspective vein has been worked out, and reaction sets in, is it possible, either in north or south, to return to an extensive use of the oblique disposition for solids and to the diagonal setting of interiors.

The validity of these tentative conclusions is supported by the fact that it is only in France, where manuscript illumination remains of prime importance until well past the mid-century, as is not the case in Italy or in the Netherlands, and only in the manuscripts themselves that, as will be seen, a close approach to a full synthetic system is achieved during the fifteenth century. Only

on the small scale of the illuminated page is such daring possible, and only in such a format are the disadvantages of the method at a minimum.

Despite the rapid triumph of approximations to artificial perspective in Netherlandish painting, the changeover is not instantaneous, and the traces of the earlier ways of seeing and composing remain visible just as they do in early fifteenthcentury Italian art.

In the work of the Master of Flémalle, the oblique setting is used exclusively in 'The Betrothal' and in 'The Nativity' at Dijon. Similarly, the extreme oblique setting is used in the Friedsam 'Annunciation' which is often attributed to Hubert van Eyck.

In the work of Jan van Eyck, a consistent softened oblique setting is used for 'The Requiem' in the *Turin Hours*, if this be by him. The viewpoint is on the right, and whilst the upper parts of the right transept are almost horizontal, those of the left transept slope downwards firmly, and the bier shares in the oblique disposition of the whole. A similar downslope is present in the transept in the panel of 'The Virgin in a Church'. In many of his panels with their illusionistic window frames, sometimes, as in the Van der Paele altarpiece with the perspective of the floor continuing the carved recession of the lower ledge, a soft oblique setting is reserved for the architectural details, particularly the capitals of columns. This is noticeable in the Dresden 'Virgin Enthroned', 'The Annunciation' and in the 'Rolin Madonna'. Finally, as a subtle hint of the synthetic approximation nascent in 'The Requiem', there are delicate curvatures in the flooring of the Arnolfini 'Double Portrait', with its superb convex mirror.

H. Schwarz, 'The Mirror of the Artist and the Mirror of the Devout', *Studies in the History of Art Dedicated to William E. Suida*, London, 1959, pp. 90–100. Contains an important study of the use of convex mirrors in Northern Art. D. Gioseffi, 'Complementi di prospettiva, 2', *Critica d'Arte*, 5, 1958, pp. 103–4, in continuing a somewhat polemical article begun in *Critica d'Arte*, 4, 1957, pp. 468–88, also refers to the subject.

It seems likely that the use of convex mirrors, both in everyday life and as an aid to painting, influenced the appearance of optical curvatures in fifteenthcentury Northern art. The peculiar ability of such mirrors to reflect wide vistas on a minute scale must have made them particularly useful to the miniaturist. The precise extent of their use by painters in this period is, however, conjectural, and cannot be taken to explain the entire range of such phenomena. The interesting question which arises, assuming the connection with painted curvatures, is why these latter were not 'corrected' and straightened out on the flat page or panel, and it seems probable that the answer lies precisely in the reasons suggested in the succeeding pages below.

25. The finest examples with straight walls are 'Christ Before Pilate', 'St. Bernard of Clairvaux', 'The Nativity of St. John', 'St. Hilary' (Perls, op. cit., pp. 45, 56, 58, 66). The best with curved walls are 'The Betrayal', 'Via Crucis', 'Conversion of St. Paul', 'Crucifixion of St. Andrew', and 'St. Martin's Charity' (Perls, op. cit., pp. 44, 46, 60, 61, 70).

26. The analysis of optical refinements without the aid of external evidence requires ideally that they should be clearly distinguishable from: (*a*) Objective facts or peculiarities which the artist may be portraying faithfully. (*b*) Chance results of free handling. (*c*) Internal demands of composition, or artistic preferences for certain forms or patterns. (*d*) Modifications introduced to harmonize the contents of the picture surface with its borders. (*e*) External accidents such as warping of panels or distortion of parchments. Fortunately, with Fouquet, as earlier with Maso, there seems to be enough evidence to justify the attempt to distinguish the optically motivated phenomena.

27. Paris, Bibl. Nat. MS. Fr. 6465.

28. A more complete analysis of 'The Arrival' and of certain associated scenes occurs in J. White, 'Developments in Renaissance Perspective—I', loc. cit., p. 62.

29. Illustrated with perspective emphasized, White, 'Developments in Renaissance Perspective—I', loc. cit., Pl. 24 ᵇ.

30. 'The Coronation of Charlemagne' occurs in Paris, Bibl. Nat. MS. Fr. 6465, fol. 89ᵛ (Perls. op. cit., p. 93). Other examples occur on fols. 163, 247ᵛ, 323, 332, 459ᵛ (Perls. pp. 98, 103, 109, 112, 126). Fols. 301ᵛ, 442ᵛ (Perls. pp. 108, 118) show incipient curves in the side

walls. Further curved floors also in addition to those cited in the text occur in Munich, Staatsbibl. Cod. Gall. 369, fol. 122v (Perls, p. 144), and in the double scene of 'The Presentation of Etienne Chevalier' in the MS. bearing his name (Perls, p. 34 and Pl. II).

31. See G. Hauck, *Die Subjektive Perspektive*, Stuttgart, 1879, and Panofsky, 'Die Perspektive als "symbolische Form",' loc. cit., in an attempt to reconstruct the antique system.

32. See Paris, Bibl. Nat. MS. Fr. 6465, fols. 326, 445, 445v (Perls, op. cit., pp. 110, 121, 122).

33. See Paris, Bibl. Nat. MS. Fr. 6465, fols. 70, 119v, 163, 292 (Perls, op. cit., pp. 91, 95, 98, 107).

34. Especially fine amongst the many such cavalcades are Paris, Bibl. Nat. MS. Fr. 6465, fols. 444v, 445v, 446 (Perls, op. cit., pp. 120, 122, 123).

35. See Munich, Staatsbibl. Cod. Gal. 369, fol. 10 (Perls, p. 128). This miniature illustrates the fact that Fouquet, almost without exception, gives a curved recession to his streets when they are based on his observation of medieval towns. Particularly fine, amongst the numerous examples, are those of 'Ptolemy Soter Entering Jerusalem' (Paris, Bibl. Nat. MS. Fr. 247, fol. 248—Perls, p. 213) and of 'De Rochechouart Receiving a Letter' (Paris, Bibl. Nat. MS. Fr. 20071—Perls, p. 243) in which Fouquet is responsible for the conception of the background. In most cases the streets appear either to be curved in themselves, or to run over the brow of a hill, but whether in some instances they were actually straight, it is impossible to say. More important is the fact that in many cases the curved lines of contemporary scenes based on observation are contrasted with the rectilinear handling of imaginary buildings in renaissance style.

36. Fol. 195r, Durrieu, op. cit., Pl. LXIV.

37. British Museum MS. Add. 18850, and Windsor Royal Library.

38. This is especially noticeable where a curved procession fills the foreground, as in Paris, Bibl. Nat. MS. Fr. 6465, fol. 444v (Perls, p. 120).

39. Paris, Bibl. Nat. MS. Fr. 247.

40. Fol. 213v (Perls, p. 212).

41. Fol. 248 (Perls, p. 213).

42. There are many cases in Fouquet's work in which the verticals of buildings are drawn out of true, sometimes quite consistently. Usually the deviation is slight, and in no other case does it affect the impression made by the composition as a whole. A further example in which the distortion definitely seems to have an optical basis is 'The Arrival of the Emperor Charles IV at St. Denis' (these features are analysed in the article Dev. Ren. Persp.—I, loc. cit.), and this may be true in others, although it is difficult to prove the fact. It must be remembered that every alteration of the centre of vision is an alteration of the centre of distortion, and this may be a fruitful source of confusion, especially since psychological impressions are a determining factor. Moreover, whilst curves may seem appreciable in large objects, they cease to be so in small things or in details. A conflict may therefore be set up between the parts and the whole in any given case. See Hauck, op. cit., p. 33, etc.

43. They would normally be confined to the central area of the visual field where distortion is at a minimum.

44. The jumbled forms of Giotto's followers are paralleled not merely by the followers of the de Limbourgs, but even by minor members of their atelier. See Brit. Mus. Add. MS. 35311 and Harley 2897. In the former, vol. ii, fol. 26v presents a good example of a confused derivation from the *Très Riches Heures*, fol. 48v.

45. See the *Très Riches Heures*, 'Presentation of Christ', fol. 54v, derived from Taddeo Gaddi's fresco in Sta. Croce, and the 'Plan of Rome', fol. 141v, similar to Taddeo di Bartoli's fresco in the Palazzo Pubblico, Siena, for the most striking examples pointing towards such first-hand knowledge. O. Pächt, 'Early Italian Nature Studies and the Early Calendar Landscape', *Journal of the Warburg and Courtauld Institutes*, vol. 13, 1950, pp. 13–47, considers these matters on pp. 37 ff., stressing the importance of North Italian influences.

CHAPTER XVI

Spatial Design in Antiquity

VASE PAINTING IN GREECE AND ITALY

The painters of ancient Greece hold an unique position in the history of spatial realism. It was in their work that the absolute dominion of the flat, pictorial surface was, for the first time, seriously challenged.[1] This knowledge only serves to throw into relief the obstacles with which the lapse of time has fortified the approaches to their art.

All the panel paintings and frescoes by so many men of legendary greatness are destroyed. Apart from the magnificent survivals of Greek sculpture, which seldom have more than a very general bearing on specifically pictorial problems, only the painted vases remain to hint at what is lost. These represent, in their own right, a major artistic achievement, and their decoration is anything but a minor art in the usual sense. Their idiom is, to a very great extent, their own, and the designs are seldom merely scaled down adaptations and repetitions of well-known monumental compositions.[2] This means that arguments about Greek monumental composition based upon the evidence of the vase paintings are bound to be dangerous in the extreme. Even with the aid of sculpture and of literary descriptions, valid reconstructions of what has been lost appear to be impossible to achieve. Moreover, a falling-off in the number of vase-painters, and a decline in the quality of much of their work, become apparent just at that period which is singled out by the later Greek and Roman writers as having seen the revolutionary developments in representational technique that mark the onset of the golden age of ancient monumental painting. The information given by the vases thins and fades precisely at the point at which it is most needed.[3]

These difficulties are aggravated by the fact that the exact relative dating of individual vases remains impossible, despite the existence of a firm general chronology. Consequently, it is only possible to establish an historical outline which is entirely devoid of the detailed sequences that are so important during those short periods of rapid growth in which the most significant changes in composition and construction frequently take place.

Finally a fundamental difference between vase, and either wall or panel painting must be carefully evaluated. This is that the art consists, with few

exceptions, of designs conceived and executed upon curved and often upon spheroid surfaces.

It is only with these severe limitations in mind that the pattern of the development of pictorial space in ancient Greece can be to some extent unravelled.

A certain sense of space is imparted to the figure decoration of Greek vases at a very early date by the complex overlapping of form on form. The Proto-Corinthian Chigi Jug provides perhaps the best-known illustration of how much could be achieved by the simple superimposition of completely planar forms, and a similar prefiguration can be seen in the Corinthian Amphiaraos Krater (Pl. 56, *a*) in Berlin.[4] In the latter there is once again no figure diminution, and no decorative piling upwards over the pictorial surface. The hustling crowd races along the narrow picture band, once more upon a single ground line. On the extreme right a sense of crowded space and movement is gained by overlapping horse on horse twelve deep, by chariots glimpsed beneath their arching bellies, and by means of streaming reins and half-seen charioteers. All this is crystallized by the sudden juxtaposition of the wheels of two pairs of quadrigae. Here, as elsewhere in the scene, the depth created visually is small compared with that implied by the number of horses, chariots, and drivers. The two wheels of a chariot in profile coalesce into a single round. The four wheels of each pair of chariots produce the mock-foreshortening of a single galloping quadriga. The vitality of the design imparts a sense of space that overrides the logic of its factual limitations.

The promise of these seventh-, and early sixth-century decorations is fulfilled in the late sixth century by the painters of the Attic black-figure ware. At a moment when the invention of the red-figure technique was about to present a challenge that could not be answered by the older, simpler art, a sustained attempt was made to grapple with a single, complex problem of foreshortening. This problem is the very one posed by the four-horse chariot with its galloping steeds and eager warriors.[5]

From the earliest times two standard horse and chariot compositions had been handed down. The first, and the more common, was the purely profile view, whether with stationary, with walking, or with galloping horses (Pl. 56, *a*). The other is the frontal view, in which the horses are invariably shown as standing still (Pl. 56, *b*). These compositions represent the front and side elevations of a chariot and four, and are the counterpart of the pure frontal settings which are always used for the more simple solid objects.

In the profile disposition absolute unity is preserved. All the forms lie in a single plane. All the movement is in one direction. In the full-face setting, on the other hand, an element of complication is introduced by the general practice of showing all the horses' heads in profile. This corresponds to the profile legs and frontal torsos used for the human form in action, although here the forward-facing and the profile elements are exchanged. In horses, as

Spatial Design in Antiquity

in human beings, no attempt is made to give an anatomical explanation of this swift transition from a front-view to a side-view. The result is consequently not foreshortening in the accepted sense.

An extension of this process of combination produces, in the late black-figure ware, a quite new type of composition. A blending of the two original patterns is achieved in which the front view of a chariot is combined with charioteers and horses in pure profile (Pl. 56, c). These are sometimes set more or less directly in front of the actual body of the chariot, which may be almost entirely hidden. Often, as in the example illustrated, the main intermixture of forms is accompanied by an extension of the principle to the smaller elements of the design. In the original front-view quadriga pattern all the horses' heads were shown in side-view. Now, in the second horse from the right, the body is shown moving one way in pure profile, whilst the neck is twisted in the opposite direction, once again in profile, and the head itself is in a purely frontal setting.

By these means the artist can almost create an impression of diagonal movement in the design as a whole without introducing a single foreshortening. Just as the rapid succession of the photographic frames produces movement on the cinema screen, so here the rapid shuttling of the planar forms almost induces a diagonal compromise within the mind of the spectator. The result is what has often been called 'pseudo-foreshortening',[6] and if this type of composition were the only evidence at hand, it would be very difficult to say how much the impression of depth and diagonal movement is merely a contribution of the modern eye, or to what extent it represents a tentative indication of the artist's own intentions.

Fortunately the question of intention is clarified by the existence of a number of more far-reaching experiments. The simplest of these consists in giving an elliptical or almond shape to the wheels of the chariot, thereby introducing a single genuine pair of foreshortenings into the design. Since the axle itself remains parallel to the baseline, this constitutes the first stage in the evolution of a foreshortened frontal setting. In some cases there is also an attempt to foreshorten the body of the chariot itself, and this may be accompanied by partial foreshortenings in the foreparts of some of the horses.

The high-water mark in this development, the production of a true foreshortened frontal construction, is exemplified in the clear, incised line of a late sixth-century amphora in Munich (Pl. 57, a). The complicated grouping of the horses' heads is accompanied by a definite foreshortening of the foreparts of the central pair. The implied threequarter view is not extended to the collar of the harness, as it is in other cases, but the handling of the chariot itself dispels all doubts about the artist's aims. Here, the idea which lies behind the foreshortened wheels and the rather uncertain asymmetry of the incised markings of the body of the car is made explicit by the bold, diagonal recession of the shaft-pole to its junction with the axle-tree.

However many problems may remain unsolved, and however many forms may still cling obstinately to the plane, such achievements must undoubtedly be differentiated from the 'pseudo-foreshortenings' that are no more than the product of an alternation of full-face and profile details, none of which are in themselves foreshortened.

The conclusions prompted by a study of the late black-figure vases are confirmed, in contemporary monumental structure, by the east frieze of the Delphic Treasury of Siphnos, dating from the years immediately before 524 B.C. This frieze is particularly interesting because it is a composite work in which painting supplements the carving, and supplies essential, missing elements in an otherwise incomplete design. This is seen most clearly in the left-hand of the two quadrigae that form part of the symmetrically treated right-hand section of the frieze (Pl. 57, *b*).[7]

Here, the charioteer, with full-face body, and with head turned back in profile to the right, rides behind horses that reveal complexities of form which lie beyond the reach of the black-figure painter, but that are by no means set beyond the range of his ambition. The fore-quarters of each horse are carefully and subtly distinguished in their setting from those of every one of its companions. The pure profile of the foremost animal is distinct from the near-profile of that lying in the furthest plane. The foreparts of the central pair are likewise variations on a broad threequarter view, but this time avoiding any hint of pure frontality. In the Munich amphora (Pl. 57, *a*) the subtle difference between the outer horses has been lost, and both appear in profile. Yet, despite his failure to adapt the harnesses, the vase decorator has succeeded in distinguishing the foreparts of the two shaft-horses in a way that parallels in intent, if not in quality, the achievement of the sculptor. The latter's already clearly defined purpose is confirmed by traces of red pigment on the pair of horses nearest to the foreground. These reveal a differentiation and fore-shortening of the painted harness in close correspondence with the sculptural setting of each animal. Finally, the vase painter's bold grouping but uncertain draughtsmanship in the horses' heads is transformed in sculpture into a full range of confident foreshortenings that appear to be in vivid contrast to the plane-enslaved contortion of the charioteer.

The transition from the sculptor's to the painter's art is emphatically underlined by the fact that the leading leg of the deepest lying horse was actually painted and not carved. Beyond this point in space the painter is supreme. The entire chariot, picked out in red and yellow, is created by pictorial, not by sculptural means. The carefully drawn foreshortening of its pointed, almond wheels; the axle lying parallel to the ground; the shaft-pole tilting upwards and forwards to the left at forty-five degrees to the horizontal, all provide an exact repetition of the genuine foreshortened frontal setting which constitutes the most advanced construction used in the black-figure ware. The result, in vase or frieze, is the creation of a lively impression of a

chariot wheeling round with body in threequarter view and horses swinging wide.

The lack of any other relevant sculptures, or of comparable monumental paintings, combined with the complexities in the detailed chronology of the vases, not to mention the fact that the Siphnian chariots are painted and not sculpted, makes it impossible to decide at present whether painting or sculp/ ture took the lead in the introduction of foreshortening into the chariot designs.[8] All that can reasonably be said is that the apparent lack of any coherent sequence of development in the vases seems to point to a position of dependence in this respect which can only be explained by reference to lost monumental art.

Such observations can do nothing, however, to explain the highly selective attitude towards foreshortening which is characteristic both of the black/ figure artists and of the early sculptors. From the time of Exekias onwards the painters of the vases tackled the foreshortening of three things, namely sails, and shields, and chariots, with a boldness which is quite unequalled else/ where in their work. The diversity, and the particular nature of the objects singled out, appear to indicate that the reasons for their selection lie within themselves, and not in some unknown, external factors.

The sails that billow over Exekias' vine/bowered ship (Pl. 58, *b*), and over the more prosaic vessels of Nikosthenes and his contemporaries, hang beneath a curving yard which lies in one plane with the hull, instead of at right/angles to it. It is in the same non/functional relation to the ship itself as is the standard, full/face torso to the profile legs beneath it. The impression of foreshortening is created by the curves which flow from the attachment of the halyards to the stern half of the ship, and its vividness is accentuated by the brilliant device of the wind/scalloped new moon of canvas, seen from the other side, which the artist adds upon the left. The painter's aim is achieved by means of easily drawn, and decorative curvatures that do nothing to disturb the unbroken surface of the cup.

The nature of these curves appears to be the main connecting link between the sails and the foreshortened shields which form the second favoured group of objects (Pl. 58, *a*). Here, the curves required to change the side/view of a shield into a sharp three/quarter view are visible already in the convex forward contours. The very simplicity of the task of conversion may well have proved a major contribution to its popularity.

In the case of the quadriga it is clear that explanations such as these are not enough. The solution of this final problem may, accordingly, complete the elucidation of the questions to which only partial answers have so far been given.

The answer seems to be the simple one that has been proffered many times before; excitement at the rushing speed of the quadriga, and a wish to give to the portrayal of its movement the immediacy, the direct impact, which is

such a dominant feature of the static, full-face composition. The correctness of this explanation, for all that it may seem at first only a naive rationalization, is supported by the fact that the attempts to gain the effect of a threequarter view are scarcely ever accompanied by standing or by walking horses.

Once this primary motivation is brought into play, the self-same factors, which were operative in the previous cases, once more seem to control the form that the foreshortenings take. The wheels, the simplest elements of all, are the most easily dealt with, and come first. They are foreshortened in designs in which there is not one other true foreshortening to be seen.

The simple, geometric shape is not the only formal quality which affects this primacy. There are also the negative factors that their thin, and open contour and their small extent mean that they make no radical attack on the integrity of the pictorial surface. In this respect they are even less aggressive than the shields, in which it is very noticeable that the sharp threequarter view is spatially little different in effect from the pure profile. As a contrast, the impossibility of foreshortening a whole horse at one blow, owing to the complexity of anatomical distortion and internal modelling that is required for a threequarter view of even so small a fraction as its chest, accounts for the relative reluctance to attempt it. It is undoubtedly this same difficulty which holds back the foreshortening of the human figure in a similar way.

It is this combination of essential associational qualities and both positive and negative formal factors that alone seems able to account for the early rise of the three groups of bold foreshortenings which have been discussed.

The elementary foreshortenings of the simple cubic shapes of stools and tables present no great difficulties, and the first, preliminary steps appear to be, if anything, less complex than the oblique setting of a wheel. Yet it is not until the mid-fifth century that vase painters troubled to take the simplest step of all, and merely show four legs of a chair instead of only two, without the need for any further complication of the pattern. Firstly there was no emotional motivation. Tables neither move nor do they clash in fighting. On the other hand, any true foreshortenings of such cube-shapes comparable to those achieved in the quadriga, are, as has been seen in earlier chapters, far more powerful in their results than are the almond-shaped distortions of the chariot wheels. Consequently they do not appear until the final quarter of the fifth century.

The invention of the new techniques of the red-figure decoration allowed the action-conscious artists of antiquity to obey the emotional urge towards foreshortening of the human figure which undoubtedly worked strongly in them. The formidable difficulties inherent in the older method now give way to new, and vastly greater possibilities of internal modelling, and therefore of anatomical foreshortening. The accent falls immediately upon the human figure, and upon the exploration of new decorative patterns favoured by the colour change.

241

A red-figure composition executed by Euthymides in the final years of the sixth century seems to indicate that the leading artists were acutely conscious of the nature of the innovations they were making. The design, which shows three naked dancing figures, is remarkable for the quality of the anatomical drawing, and particularly for the astonishing mastery with which the artist handles the extremely difficult foreshortening of the central figure's sharply twisting back. There can be little doubt as to Euthymides' meaning when he added the self-satisfied inscription—'Euthymides son of Polios drew this as Euphronios never did.'[9]

The stages by which the foreshortenings of rectangular objects such as chairs and tables are evolved in red-figure painting are in general fairly clear, although at certain points the exact chronological sequence cannot be established. The first, isolated divergences from purely frontal settings, which had been the rule in black-figure compositions, seem to occur as early as the start of the second quarter of the fifth century.

Apart from very rare appearances of fully fledged complex frontal settings, apparently under the stimulus of the desire to describe everyday activities,[10] the first stage is normally to show one of the rear legs of a chair or table as well as its two forward supports (Pl. 59, *a*). In the case of chairs a figure may explain the invisiblity of the fourth leg, but no potentially receding surfaces are shown. An unrelenting frontality is maintained in every detail. This cautious beginning is sometimes accompanied by the depiction of the further support of the back rest of a chair (Pl. 59, *b*), and in the years preceding the mid-century the complex frontal setting is elaborated by bringing all four legs and the far upright of the back into view (Pl. 59, *c*). This pattern is further developed, soon after the mid-century, by revealing the rear-lying horizontal bar beneath the seat.

The next important development takes place between 430 and 420 B.C., when direct recession is introduced by showing the horizontal support at the back of a stool, as well as the far and near horizontals of the sides, both of which lie parallel to the base line (Pl. 59, *d*). With this change, a complete foreshortened frontal setting is suggested. Only the seated figure prevents the construction from appearing in its entirety, as it finally does at the end of the century on a vase in the style of Meidias (Pl. 59, *e*). In the meantime, direct, centralized recession had already been developed by the Eretria Painter (Pl. 59, *f*).

This line of development is accompanied by the relatively early introduction of tentative oblique settings. These have already made an appearance by the mid-fifth century. These constructions are, however, extraordinarily delicate in their recessions, the impression of an oblique setting in some cases even proving, upon close examination, to be without a factual basis.[11] In the clearer cases, the new setting is achieved by showing only one end of a table with its upper edges in the softest possible recession, the problem of the deep-

lying far end being avoided through the interposition of a masking figure (Pl. 59, *g*).

The early emergence of a tendency to use the oblique construction in red-figure ware is of especial interest, as it seems to introduce a significant variation into the sequence of development that was later to be established in Italian and French painting, and which was considered in some detail in preceding chapters. The meaning of this change of emphasis will be discussed when the pattern of evolution in the antique vases has been seen in its entirety. At this point it is enough to note that whilst an extremely soft oblique construction, often in a very hesitant form, appears quite early in red-figure painting, it is only intermittently used, and does not strengthen or develop. Only, as might be expected, in the special case of the fast-moving chariot does it finally achieve a certain popularity. The much firmer pattern of development pre-sented by the foreshortened frontal setting and the accompanying centralized recession is in marked contrast to such hesitance. These are the settings which survive the withering away of the art of the vase painter in Greece itself, and flower in the long succession of Italian vases stretching on through the fourth century.

A useful starting point for any study of the further expansion of ideas of space and three-dimensional solidity that is revealed by South Italian vases, is the well-known volute krater from Apulia, decorated with the story of 'Orestes and Iphigeneia in Tauris' (Pl. 60, *a*).

One of the many striking things about this vase is the solidity of the altar upon which Orestes sits. This new boldness in the handling of the fore-shortened frontal setting is a characteristic feature of the best Italian vases. Equally characteristic is the fact that an increased ability to give a convincing appearance of three-dimensionality to relatively complex forms is not accom-panied by the evolution of a vanishing point or even of a vanishing axis.[12] There is a tendency for the orthogonals to converge, but quite haphazardly, and they occasionally stay parallel to each other, or, in several cases, actually diverge to some extent. These divergences are not so strong, however, as to cause a serious disruption of the general pattern. In plain, rectangular boxes, simple stone blocks, marble bases, stelae, and the like, all the few, visible, receding lines quite frequently converge. But this is rather a reflection of the lack of complexity in the object which is represented, than a witness to the attainment of a higher degree of organization than is shown in the altar on the Orestes krater.

The altar, with its white front and its red, receding sides, which serve to emphasize its clarity of volume, draws attention to a further spatial innova-tion. Whereas in the Attic vases a low viewpoint is the unvarying rule, except occasionally in the curving backs of chairs, here the upwards flowing lines establish a high point of view. This signifies a change of attitude towards the base or ground-line, and foreshadows the consolidation of a visible, horizon-

tal ground plane, with its untold consequences for the subsequent history of the visual arts.

The ground plane had already been suggested at a very much earlier date in Assyrian, and in Minoan art, but had not congealed into a stable, horizontal platform, and no strong tradition was established to be handed down to subsequent civilizations. It had been the surface-climbing hill-scene that had achieved the greater popularity in the early history of the Middle East, although with hardly less impermanent results. This hill, or rock convention does not reappear in Attic art until the mid-fifth century, when it can be seen, upon the vases decorated by the Niobid painter, as a probable reflection of the fresco paintings of the two great innovators, Polygnotos and Mikon. It is this convention which is used once more in the Orestes scene (Pl. 60, *a*). Here it places in sharp focus the essential contrast that exists between its unformed, vertical hill-surfaces with their implied, but hidden figure platforms, and the level ground which is created by the bold recession of the left side of the altar. The element of conflict is quite clear, although this level space is still, as yet, almost unable to extend beyond the altar's marble boundaries even with the help of the two figures standing on its right.

The high viewpoint and the confident foreshortened frontal setting of the altar are still more revealing when they are considered in conjunction with the temple that appears above the latter on the right-hand side. This seems to be softly, but undoubtedly oblique in disposition, although the recession of the pedimented forward face is so slight that the first impression may quite easily be that of a foreshortened frontal building. In any case, there is a complete change of viewpoint when the temple is considered in relation to the altar. This is yet another illustration of the familiar observation that neither the Greek, nor the Italian vase painters ever felt that it was necessary to coordinate the viewpoints of a number of separate objects. This is true, however, only in the horizontal sense. The casual collection of things seen indiscriminately from left or right, or straight ahead, is not accompanied by an equally carefree attitude to things seen from above or from below. This again is illustrated by the painting of 'Orestes and Iphigeneia' (Pl. 60, *a*). Here there is no question of a single eye level, as there are neither vanishing points or vanishing axes to establish such a line. On the other hand there is no vertical conflict comparable to that occurring in the horizontal sense. The altar at the bottom of the picture is seen quite sharply from above, whilst the temple at the very top of the scene, with only its upper half in sight, reveals down-sloping lines as if it were viewed from a slightly lower level.

The vertical consistency in the late vases is probably a continuing reflection of the almost unvaried use of the low viewpoint in the earlier work.[13] The latter still remains the most popular form, despite the use of a high viewpoint on a number of the finest and most often illustrated vases. In any case the high viewpoint is confined to objects such as altars, chairs, and tables. Temples

are, for instance, never shown as if seen from above, and the bird's-eye view appears to be unknown in the vase decorations of antiquity.

The softly oblique setting of the temple on the Orestes krater (Pl. 60, *a*) has been taken, up to this point, to reflect the actual intention of the artist and this view is probably correct. Nevertheless, the down-slope of the temple front is very delicate indeed, and the possibility remains that it is not deliber-ate, and means nothing. If its setting is not accidental, it is practically unique as far as temples are concerned. These are otherwise almost invariably shown in frontal, or foreshortened frontal setting, the construction being independent of the placing of the building in the decorative field. In a very great majority of cases the Italian artists show their temples standing clear and unobstructed on their bases. They are usually large in scale, and dominate the general decorative pattern. Their sheer size and solidity, and their consequent impor-tance on these grounds alone, appear to have made it seem essential to the artists that the principal face should be in absolute harmony with the surface of the vase.

This question of the effect of shape and scale on spatial setting was earlier considered in relation to Italian fourteenth-century painting, and to Chinese, and Islamic art.[14] It is of equal, or of even greater importance in antiquity when painters were for the very first time adventuring boldly and directly into a still strictly limited space.

The influence of scale alone is, for example, often to be seen in grave reliefs. A footstool or a small box underneath a seated figure's chair is often shown in an extreme oblique position, whilst the chair itself lies fully in the plane, or has its main face only very slightly in recession. Similarly, in vase decoration, a completely frontal bier or bed may rest its legs upon small, cube-shaped blocks in very strong foreshortening.[15] The small scale of the latter, and their consequent inability to exert too powerful an effect upon the decora-tive whole, allow the artist to indulge in spatial boldnesses that would have seemed disruptive to him if applied to more important elements in the design.

In the late vase paintings, shape, and the position in relation to the ground line or to the decorative border, are as influential as the relative scale. This is demonstrated by such solid, cubic objects as the altar in the scene of 'Orestes and Iphigeneia' (Pl. 60, *a*), and by the rectangular bases of statues or of stelae, and even by the tops of the stelae themselves. All such things, when placed in close conjunction with a base line or a decorative border, are, with very rare exceptions, shown in a foreshortened frontal setting, unless they retain the wholly flat, frontal, or complex frontal structures. As in other ages, and in other cultural centres, the latter persist alongside the constructions which are spatially more advanced. Similar observations can be made of such less solid objects as long-sided couches, when placed on or near a base line. A contrast is provided by such things as stools, and chairs, which have no large, flat surfaces and no extended axis. These are much more likely to be seen

obliquely even when they stand upon a base line, though the setting is, in many cases, so extremely soft that it is hard to be quite sure that it is being used. The construction is in fact seen far more frequently in objects, be they boxes, chairs, or couches, which are not immediately influenced by the border of the decorative field. Even then long-sided objects are distinguished by the very soft recession of their principal faces, which remain closely con-nected with the surface. Chairs and stools, when similarly floating freely in the pictorial void, or when they are only partly anchored by an equally floating, dotted vestige of a broken ground line, are much more often shown in full three-quarter view. There is still, however, little connection with the jutting surfaces and sharply defined angles of the extreme oblique construc-tion that was seen so often in the period leading up to the Renaissance. There are only a handful of exceptions to the general observation that the more nearly the oblique construction approaches a symmetrical three-quarter view, the nearer it moves to the pseudo-foreshortenings of the three-quarter view so often implied by what is actually a complex frontal setting.

It is extremely significant that the relationship of the painted object to the spheroid surface of the vase should so closely parallel the relationship to the flat, pictorial surface which was previously observed in connection with later, widely separated cultures. It might easily have been imagined that the con-stantly receding surfaces of the painted vase would have encouraged the creation of elaborate, well-defined oblique constructions, whereas, in reality, the constant reluctance to disrupt the surface, allied to the fact that a spheroid surface produces natural optical foreshortenings of far greater intensity than a flat surface of equivalent size, seems to have largely removed any need for such adventures.

The discussion of the painting of 'Orestes and Iphigeneia' on the Naples krater, which has such a direct bearing on the general analysis of the treatment of individual objects scattered in a complex scene or decorative scheme, leaves out one of the most important aspects of the decoration of the South Italian vases. This is the problem of the space-enclosing temple and its contents, which extended to the full the antique painters' powers of organiza-tion and construction.

The variation in quality that is found within the complete range of South Italian painted vases is enormous, and the representations of shrines and temples run the whole length of the scale from top to bottom; from the most elementary form, the purely frontal setting, which is quite without receding elements, and is also usually the weakest in its execution, to various kinds of centralized recession, and finally to the foreshortened frontal constructions amongst which are numbered the majority of the most magnificent inventions.

In vases such as the colossal amphora of 'Orpheus in Hades' now at Naples,[16] and that of 'Phoenix and Achilles' (Pl. 60, *b*) in the Museum of Fine Arts at Boston, 'temples' are developed into well-constructed spatial

boxes in foreshortened frontal setting. More important still, the structure of the couches and the footstools they contain is well co-ordinated with that of the building as a whole. In the first the roof and the base, together with a couch and its platform, which recede upwards, are all seen in the same way from the left, so that the position of the spectator and his eye-level are both coherently suggested. In the second (Pl. 60, *b*), base and ceiling, the ornate couch and carved footstool, are again seen from the left with ceiling, roof, and couch-top sloping down, and the base platform seen as if from the eye-level of the onlooker. In this case, the only note of conflict is provided by the way in which the upper surface of the footstool is made visible, implying that the level of the eye is set between it and the superstructure of the couch. Even so, the visible, receding surface is effective spatially, providing a firm platform for Achilles' feet. The clarity with which the figures are disposed within the spatial cage is striking, and the artist has made an unusually successful effort to create a series of precise and understandable relationships. Phoenix stands convincingly upon the platform in between its forward edge and the long footstool, which, in turn, is placed before the couch on which Achilles sits. By no means all the difficulties are resolved, but it is none the less quite evident, from paintings such as these, that in the best work of the late vase decorators there is a genuine feeling for the co-ordination of furniture and figures within a coherent interior. This is a far cry from the disorderly chaos of conflicting viewpoints and uncertain structures which is often, but by no means always, characteristic of exterior space, and which not infrequently extends to the interior.

It is only fitting that the spatial story that began with the galloping war-chariots of the mid-sixth century black-figure ware should be concluded by the chariots of the Gods. The settings in the late fifth century, and throughout the fourth, are impartially foreshortened frontal or oblique. In the drawing of the detail there is now no shirking of the issue. All the parts of wheels and body are drawn with an equal clarity. There is also a new confidence, born of a century of experience and experiment, in the foreshortening of the heads and necks and foreparts of the horses, and in setting the hind legs in space. The vigorous movement of the old, black-figure chariots gains new, loose-limbed freedom. As in the late Attic ware, so in the more summary drawing of the Italian vases, the light structures of the galloping quadrigae once again enjoy a liberty denied to the sharp-angled, motionless, rectangular blocks of architecture, altar, chair, and table.[17]

The pattern of development revealed by this attempt at an analysis of the first emergence of the solid object from the decorative surface is not altogether unfamiliar. It has many elements in common with the opening stages of the patterns which were previously observed beneath the varied forms of the pictorial arts of Italy and France between the mid-thirteenth and the late fifteenth centuries. These similarities do not, however, hide the variations of

emphasis that reflect the widely different historical settings within which the constant problem was attacked.

The French and the Italian stories each began with a predominance of frontal, and of complex frontal settings. This was followed by a revival of the popularity of the foreshortened frontal setting, often with a bird's-eye view-point that enhanced its surface stressing qualities. This was in turn succeeded by the development of an extreme oblique construction which proved too aggressive and self-isolating, and was subsequently softened. It is interesting, therefore, to see that these patterns differ only at two points from that estab-lished by the antique vases and supported by the evidence of sculpture. The first is in the use of the bird's-eye view for the foreshortened frontal setting, and the second in the relatively early appearance of the extreme oblique con-struction which had subsequently to be modified.

In each case the variation stems from the fact that the antique discovery of space was a true first beginning. There were no strong spatial patterns, left behind by earlier artists, to be copied and reworked as soon as interest in realistic space revived. This was the first experiment, and the Greek painter felt his way with sensitive and cautious steps. No ground plane existed if he did not make one, and he was content to work for a long time without so doing. Only in late antiquity did the by then spatially powerful normal view-point gradually give way again to frontal settings and to bird's-eye viewpoints that allowed the eye to run on upwards unopposed over the whole pictorial surface. Throughout the following centuries the memory of the ground plane and the bird's-eye view was handed down in one form or another, and given substance in an intermittent series of revivals of the antique source material. Building on the basis of a visible, if vertically sloping ground strip, the adop-tion of the bird's-eye viewpoint made it possible for the spatially still cautious late medieval artist to emulate the solid structures of his predecessors without breaking too abruptly through his decorative surface. It also provided much the simplest way of blowing three dimensional realism into prototypes in which roof, wall, and ground were all shown laid out flat on the pictorial plane. For the antique artist there existed no such pressures to adopt high viewpoints from the first.

In a similar way, the absolutely planar art from which he started entailed a slow evolution of the idea of emancipation from the surface. The fore-shortened frontal setting had to be developed slowly, step by step. It could not be taken over quickly through the observation of the patterns left behind by earlier artists, as it was in the late medieval period. Consequently the oblique construction was evolved with a similar gentleness and caution, and appears quite early, since, particularly on the curving surface of a vase, it could be given the softest spatial quality that was desired. For Greek artists there was no inherited spatial pattern to revolt against with an extreme oblique exaggeration and the subsequent necessity for compromise. Even so, the

foreshortened frontal setting appears alone on the black-figure ware, and although the oblique construction appears early in the red-figure vases, it is the foreshortened frontal construction that advances the more rapidly, and expands the more boldly into the flat surface, foreshadowing in significantly varied form the fundamental patterns of development that lead to the spatial world of the Renaissance.

The fact that this development of space on the curved surface of the vase should be so closely similar in its essentials to the patterns which were later to evolve on the flat planes of panel, wall, or page, shows that the tension of the smooth, continuous surface of the clay was the prime reality for the early artist. Its curvature did not induce an attitude to pictorial space distinct from that aroused by the flat wall or panel, except in so far as it encouraged the primitive tendency to make use of disparate viewpoints for the individual objects that were represented.[18] This leads on to the conclusion that this surprisingly constant pattern was undoubtedly reflected also in Greek monu-mental painting.

The observation of these constancies may well make it easier to accept the existence of still further and more complex constants that reveal themselves in the still-living frescoes of Pompeii.

ANTIQUE PERSPECTIVE THEORY AND POMPEIAN PRACTICE

The simple spatial patterns which appear for the first time upon the deli-cate, curved surfaces of antique vases seem to echo no elaborate theoretical construction. In themselves they call for no inquiry as to the nature of perspec-tive systems which, if they existed, find no echo in surviving work. At a later, better documented period no elaborate theoretical background is de-manded by the work of Giotto or of Duccio. No such intellectual calm can be maintained, however, in Pompeii. Consequently it seems wise to broach the subject of Pompeian art by trying to assess the written evidence for the existence of an antique theoretical perspective. This textual evidence is so scanty that it seems to be more than usually essential to attempt an assessment of its value strictly on its own merits. The few relevant sentences are otherwise too apt to take their colouring from eyes dazzled, and perhaps confused, by the provincial glories of Pompeii.

The three main documents in the discussion are provided by a mathemati-cian, a philosophical poet, and an architect, namely Euclid, Lucretius, and Vitruvius. Of this triumvirate it is Vitruvius alone who speaks of a pictorial perspective, whilst the observations of the others are confined to the purely optical problems that arise in natural perspective. This very fact that neither Euclid nor Lucretius reveals any awareness of the problems of pictorial

representation must be kept most carefully in mind, for it is only after the event that it becomes all too easy to transfer ideas from one field to another.

Euclid, in his *Optics*, gives an admirable summary of the stage in the observation of optical phenomena which had been reached by about the year 300 B.C. The dependence of apparent magnitudes on the size of the visual angle is demonstrated, together with the corollary that the rate of apparent diminution is not proportional to the distance. He also notes that planes above the eye appear to slope down, and those below to slope up; that lines on the left incline to the right, and those on the right run left; and finally, that the arc of a circle at eye-level appears as a straight line.[19]

Setting the systematic, mathematical presentation on one side, these observations are comparable, in pictorial terms, to those repeated by Cennino Cennini after a lapse of seventeen hundred years. How little can be learnt of fourteenth-century Italian perspective from Cennini's pages has been seen already, although he at least, however ill-equipped in some ways for the task, was speaking specifically of the art of painting, in which Euclid, as a mathematician, naturally shows no interest whatsoever.[20] The relevant passages of the Optics accord well with what is known of the practice of vase decoration during the preceding century in Italy and, to some extent, before that in Greece itself, but contribute no new information. Apart from these facts, Euclid throws no light at all upon the problem of the existence or the non-existence of perspective theory in antiquity. It cannot be taken as a certainty, although it may be considered probable, that in the antique world the mathematician led the artist in perspective matters. The artificial perspective of the Renaissance was, on the contrary, originated by an architect and sculptor and developed by the painters. With reference to perspective theory, nothing, therefore, either in a positive or a negative sense, can be deduced with safety from the omission in The Optics of all mention of the intersection of parallel lines. Nor, in relation to artistic practice, do Euclid's writings disprove the existence of ideas beyond the scope of those same fragmentary relics, mostly of a superb minor art, which tend to show a marked deterioration in their quality the more closely his own lifetime is approached.

The first references to perspective in pictorial art do not occur until Vitruvius wrote his 'De Architectura', probably in the years between 25 and 23 B.C. The fact that the two short passages concerned are merely incidental to an architectural textbook, and are not part of a treatise on perspective, is at once unfortunate and important. Their brevity and isolation impose an obligation to assess each shade of meaning. They also render it essential to employ extremes of caution in conclusions reached on the basis of those things Vitruvius leaves unsaid about the theory and practice of perspective.

The first, the briefer, and the more ambiguous of Vitruvius' references to perspective occurs at the end of an enumeration of the different kinds of archi-

tectural draughtsmanship.[21] After mentioning ichnography and ortho-graphy, which deal with plans and elevations, he writes:

'Item scaenographia est frontis et laterum abscedentium adumbratio ad circinique centrum omnium linearum responsus.'

Translated literally and neutrally, that is to say without assigning any specialized significance to the word 'responsus', and so favouring one or other of the various theories that are based upon such attributions, the whole passage runs:

'In like manner, scenography is the sketching of the front and of the retreat-ing sides and the correspondence of all the lines to the point of the compasses.'

The second passage,[22] which is included in a survey of antique authorities on various subjects, reads, in a similar literal translation:

'For in the beginning in Athens, when Aeschylus was presenting a tragedy, Agatharcus set the stage, and left a commentary upon the matter. Instructed by this, Democritus and Anaxagoras wrote about the same thing, how it is necessary that, a fixed centre being established, the lines correspond by natural law to the sight of the eyes and the extension of the rays, so that from an uncertain object certain images may render the appearance of build-ings in the paintings of the stages, and things which are drawn upon vertical and plane surfaces may seem in one case to be receding, and in another to be projecting.'

The first question raised by the wording of these passages and their trans-lation is that of the meaning of the phrase 'circini centrum', 'the point of the compasses', which can, however, be shown, with little room for doubt, to signify the 'centre of a circle'.

A much more difficult problem is the significance of 'respondere' and 'responsus'. The whole meaning of Vitruvius' references to perspective is dependent on the type of 'correspondence' which was in his mind when using these two words.

The primary clue to Vitruvius' intentions lies, not unnaturally, in a study of his own use of words, regardless of any corroboration which may, or may not, be found amongst the ruins of Pompeii. The textual evidence is plentiful, as the word 'respondere' and its derivatives appear at least twenty-nine times in relevant contexts upon the pages of 'De Architectura', quite apart from the two cases which are being discussed. As a result a definite impression of Vitruvius' usage can be gained.

The one thing that stands out with absolute clarity in the comparative material is that, for Vitruvius, the 'correspondence' is, in almost every in-stance, an exact, not a vague relationship. In twenty-eight of the twenty-nine cases, it concerns such mathematically precise things as the relations between fractions and whole numbers, the equality of angles, or comparative weights and volumes. There is only a single example in which the meaning is not demonstrably exact in this way.[23]

The very great preponderance of mathematically definite 'correspondences' among Vitruvius' uses of the word 'respondere' makes it extremely likely that a similarly precise correspondence is intended when the same word is used in the two passages dealing with perspective. The probability is increased to near certainty by the fact that in two cases Vitruvius actually repeats the wording of the shorter passage on perspective in a wholly unambiguous context. These examples are such as to remove any doubts which might be engendered by the one relatively free use of the word.

The two culminating uses of 'respondere' occur in a discussion of the structure of relieving and supporting arches.[24] Vitruvius explains that the relieving arches in a wall must be arranged with joints and voussoirs all 'ad centrum respondentes'. Arches under buildings which are set on piers must similarly be constructed 'cuneorum divisionibus coagmentis ad centrum respondentibus', so that they may stand the necessary load. But it is a generally accepted principle and universal practice that the joints in the stonework of an arch should point directly to its centre, as in this way it achieves its maximum stability and strength.[25] It is therefore absolutely certain that Vitruvius is speaking of the accurate convergence of lines towards a single, central point.

This twice-repeated use of 'respondere', taken in conjunction with the other twenty-six cases out of twenty-seven in which 'correspondence' is certainly used in an exact sense, makes it very difficult to believe, on any rules of evidence, that in the precisely parallel case of the phrase 'ad circini centrum omnium linearum responsus' anything can be meant except the direct convergence of all lines towards a single point. Similarly, all the linguistic evidence points without equivocation to the fact that in the second passage on perspective, correspondence has an equally exact significance. Whatever the failures, or the disappointments, which may subsequently seem to face the inquirer when confronted by the surviving monuments, such frustrations can in no way justify an attempt to water down the meaning of Vitruvius' words in contradiction of the accumulated, unequivocal evidence of his use of language.

Bracketing the precise significances which have been established, the relevant parts of the two references to perspective must now read:

'. . . scenography is the sketching of the front and of the retreating sides and the correspondence (convergence) of all the lines to the point of the compasses (centre of a circle).'

and

'. . . it is necessary that, a fixed centre being established, the lines correspond (exactly) by natural law to the sight of the eyes and the extension of the rays . . .'

Once a precise translation has been established in this way, it is possible to continue the investigation of Vitruvius' meaning with considerable effect.

By the reiteration 'ad aciem oculorum radiorumque extentionem' in the second passage, Vitruvius emphasizes the point that the 'lines' to which he refers must correspond to the complete phenomenon of the visual cone. This had been defined by Euclid, without subsequent demur, as being 'a cone with its vertex in the eye and its base at the limits of the objects seen'.[26] Vitruvius mentions the possibility, however, that the origin of sight may lie either in the eye or in the thing it sees. Although he proposes no solution, the discussion is important here because the wording shows that he thinks of rays as being projected outwards from the apex of the visual cone. For Vitruvius the idea of a ray is connected with free space and not with the pictorial world.

'Hoc autem sive simulacrorum impulsu seu radiorum ex oculis effusionibus uti physicis placet, videmus, . . .'[27]

This outwards projection of the visual rays is implicit in the use of the phrase 'extension of the rays' in the passage on perspective which is being discussed. It follows from this that 'the sight of the eyes and the extension of the rays' are both referred to the observer in the world outside the picture. But since these words describe the entire structure of the visual cone, the lines which 'correspond exactly by natural law' can only be the drawn, or painted lines. These lines, moreover, since they 'correspond exactly', must reflect all the essential features of the selfsame visual cone. They must be both straight and all convergent on a single point.

If this distinction between 'rays' in real space and 'lines', which are by clear implication those 'drawn upon vertical and plane surfaces', is applied to the definition of scenography, it becomes clear that the whole of this first passage refers to the representational surface. This is further implied by the correspondence or convergence of the lines towards a centre, as opposed to an extension outwards from it. The definition of scenography, which is specifically stated to be a sketching, does not even stand alone. It follows the description of ichnography, and of orthography which is referred to as an image.[28]

The use of the termination ,graphy itself implies drawing, and there is therefore no linguistic support for the view that 'circini centrum', the centre of a circle, lies outside the pictorial reality and refers to a position in free space. This first passage is, in fact, a description of antique perspective method, whilst the second complements it with a reference to the latter's basis in the fundamental optical principles of the visual cone.

These purely textual analyses demonstrate the unsoundness of the recently much-favoured hypothesis that 'correspondence', as Vitruvius uses it, is a vague, and purposefully imprecise term, and therefore that the passages con-cerned mean next to nothing in perspective terms, beyond revealing that no fundamental change in outlook had occurred for some two hundred years.[29] The same analyses invalidate a second, equally important theory insofar as it concerns the writings of Vitruvius.

This hypothesis is that the antique world possessed a system which was based, like that of synthetic perspective, on a curved, though in this case cylindrical, and not upon a planar intersection of the visual cone.[30] Then, in order to efface the curvilinear distortions of straight lines involved in such a process, chords were substituted for them. This retention of the drawn straight lines, despite the curving intersection of the visual cone, means that a vanishing axis pattern (Fig. 3, p. 75) is produced, with the orthogonals no longer centring upon a single vanishing point.

If this is the perspective system that Vitruvius is supposed to be describing, those same difficulties, which arose in the preceding case, are just as prominent as ever. The correspondence that is mentioned in the definition of scenography must once more, in contradiction of all the evidence, be vague. It can imply no linear convergence to a point. The theory equally entails the supposition that 'circini centrum' is a reference to a centre in free space and not on the pictorial surface. Once again Vitruvius' use of language points towards the opposite conclusion. Moreover, in the second passage, dealing with the work of Agatharcus and his followers, Vitruvius' unvarying usage of the word 'respondere' comes into conflict yet again with the belief that he is speaking of a system of perspective in which the convergence of orthogonals towards a single centre plays no part. Finally, there is the important point that in the absence of any major qualifications, ichnographia and orthographia, the drawing of plans and elevations, only lead directly, as in the Renaissance, to an artificial perspective. It is this very process of combination that comprises the *costruzione legittima*, which was probably used by Brunelleschi for his demonstration panels, and which is the basis of Alberti's abbreviated method.

If then there is to be a return substantially to the old interpretation of Vitruvius, it only remains to scrutinize the two main objections to which it remains open. These are: firstly that there is no actual use of the term 'vanishing point', and secondly that the vanishing point in artificial perspective can in no way be considered as the centre of a circle.[31]

As far as any mention of a 'vanishing point' as such is concerned, it would be astonishing if such a thing occurred in an actual treatise, let alone a couple of sentences on perspective, written in the early years of the Augustan period. The nonappearance of a clear definition of the idea in antiquity is made thoroughly understandable by the history of artificial perspective in the Renaissance. Alberti's 'Della Pittura' is a fully fledged treatise on a vanishing point perspective about the nature of which there is no doubt at all. Yet this same work makes it clear that Alberti himself had no full understanding of the nature of the vanishing point, and the term itself does not occur. Nor does Alberti's text provide a satisfactory exposition of the relationship between the visual pyramid expanding from the eye and the pictorial pyramid that contracts towards what he calls the 'central point'.

It is clear from this renaissance analogy that whilst it would be exciting, and most unexpected, to find a reference to a vanishing point as such in antique literature, its absence can provide no basis whatsoever for erecting any theory about the nature of a possible antique perspective system. The coinci/ dence between Vitruvius' 'circini centrum' and Alberti's 'punto centrico' is, moreover, so close as to make the further investigation of the parallel seem to be an obvious step.

The genesis of Alberti's term, if it does not lie in Vitruvius' very words, is to be found in the series of definitions which provide a starting point for the renaissance author.

He begins by describing the nature of a surface, enumerating the different kinds, among them the circular. This leads to a discussion of the properties of a circle, and after defining the centre as the meeting point of equal radii, he continues:[32]

'That straight line which will cover the point and will cut the circle in two places is called diameter by mathematicians. We are used to call it central; and here let us be convinced by what the mathematicians say: that no line cuts the garland of the circle with equal angles but that straight one which covers the centre.'

A little further on Alberti draws away from the Euclidean optical concep/ tions in order to establish, with the aid of similar triangles, the proportionality of pictorial quantities, which he therefore relates, not to a visual cone, but to a visual pyramid. Having described the extreme and middle rays, which form the skin and body of the pyramid, he writes:[33]

'There is among the visual rays one called central. This, when it reaches the surface, makes on this side and this all round it angles which are right and equal; it is called central from resemblance to the aforesaid central line.'

Despite the transference to a visual pyramid, the central ray receives its name precisely because of the parallel between its own properties and those of the diameter of a circle.

Finally the connection of this central ray with what is now known as the vanishing point emerges during the construction of the foreshortened pavement essential to Alberti's system.[34]

'First where I have to paint. I draw a quadrangle of right angles . . . Then within this quadrangle, where it pleases me, I mark a point which occupies that place where the central ray strikes and for that I call it the central point.'

Alberti's vanishing point, which he refers to as the central point, is there/ fore explicitly stated to be the point at which the perpendicular from the apex of the visual pyramid strikes its rectangular base. The central point is fully described as the centre of a rectangle, although its very name is derived from the properties of a circle, and the visual pyramid needs only to be replaced by the visual cone for the point to become once more the centre of that circle.

If Alberti, an expert, and indeed an originator of artificial perspective, was

able to think along such lines, it is difficult to argue that because Vitruvius, who was not a specialist, also used such simple, and to modern minds, inaccurate phrases, he could not be writing of a centralized perspective system that employed a vanishing point.

Nothing could be more natural, or more logical, than to re-use the terminology of the visual cone in order to define the cone of diminution that is its counterpart upon the pictorial surface, instead of transferring in midstream to the concept of a visual pyramid.

Both Euclid's visual cone and Alberti's visual pyramid are, so to speak, generic terms. They are both defined as having their apex in the eye and their base in the limits of the objects seen. They would, therefore, actually be cones or pyramids only when the objects seen were respectively circular or rectangular. All Alberti's theorems about similar triangles are as valid for a cone as for a pyramid, and the latter is evidently only preferred because it conforms to the normally rectangular picture shape. Although the fact is usually overlaid by the ensuing spatial illusion, the receding lines of a well-developed renaissance architectural composition create a pattern which is exactly that of a series of radii meeting at the centre of a rectangle or circle. Conversely, rectangular, as indeed all other forms, are as at home in the visual cone as in the visual pyramid. As will be seen, Lucretius finds nothing odd in a reference to a rectangular colonnade receding into a cone. It is again entirely reasonable that Vitruvius, with the visual cone in mind, should refer to 'circini centrum' rather than to the centre of a rectangle, as there is no essential need to divorce the perspective geometry from the visual geometry in so far as the two overlap.

It is the well-known passage in Lucretius' 'De Rerum Natura', which was just referred to, that provides external support for the already firm conclusions derived from Vitruvius. This support is especially valuable as the poem probably reflects ideas that were current only twenty-five years before the approximate date of the writings of Vitruvius.

In the course of a dissertation on visual images, Lucretius speaks of the appearance of a colonnade in the following terms:[35]

'Indeed although a colonnade is in an unvarying line, and stands continuously supported by equal columns, yet when its whole length is seen from the topmost end, little by little it draws together the top parts of a narrow cone (angusti fastigia coni), joining the roofs to the floor and all the things on the right to those on the left, until it has led them together in the indistinct top of the cone (obscurum coni . . . acumen).'

Here 'fastigia', which primarily means the points of gables, has been given the indefinite, if unlovely, rendering of 'top parts'. Similarly 'coni acumen', appears as 'top of the cone'. Nevertheless, 'acumen' is also a forceful word denoting extremes of sharpness, such as are found in needles or the stings of insects, and cannot possibly be associated with the idea of a truncated cone, any more than 'fastigia' can be thought of in connection with flat roofs. Even

when allowance is made for the possible demands of metre and of poetic diction, the repetition of the idea rules out any possibility that an over⁄forceful word has given rise to false appearances. There would also be little sense in the introduction of 'obscurum' unless the actual point or apex of a cone were meant, for the slightly drawn⁄together end of a short colonnade is scarcely 'on the boundaries of vision'.

Lucretius is neither speaking of, nor interested in, the problems of represen⁄tation. His description of the purely optical phenomena does, however, go considerably beyond the cautious observations of Euclid. It is a complete description, not of the expanding visual cone, but of the apparent cone of contraction, or diminution, which is its counterpart. The ideas which Lucretius expresses a quarter of a century before the writing of 'De Architec⁄tura' are the optical equivalent of the perspective system which Vitruvius describes. The one is the translation into representational terms of the other.

Unfortunately, even where the simple, literal interpretation of Lucretius' meaning is accepted, the significance of that acceptance is not always realized. It is a genuine distortion of meaning to say that the passage in the 'De Rerum Natura', taken at its face value, shows no more than that the convergence of receding parallel lines was envisaged in antiquity as a pheno⁄menon of the appearance of single objects.[36] The colonnade described by Lucretius cannot be treated in this way, as if it were just a single, isolated, solid object. Seen from its centre, with floor, ceiling, and sides receding and running together, it is not the equivalent of an external view of a house or piece of furniture. It is the counterpart of the boxed interior of a room, and as such it is evidence, not of an early, but of a very late stage in perspective development. The slow, and painful processes that precede the establishment of perspective unity in the period leading up to the Renaissance have been seen in earlier chapters. Vanishing points are achieved for single planes and for solid objects long before the complexities of the interior are resolved, and its parts co⁄ordinated. There is therefore no basis for an attempt to combine acceptance of Lucretius' evident meaning with support for the vagueness theory about Vitruvius' writings. The two first⁄century writers stand to⁄gether, and do not merely echo the words of Euclid, but assert the existence of ideas which, in terms of painting, produced a true vanishing point per⁄spective able to unify whole designs, its essence summarized in the words 'ad circini centrum omnium linearum responsus'.

These investigations show that the written evidence, although small in quantity, is far more precise and consistent than might have been expected. It only remains to examine the artistic legacy of late antiquity in the hope that a similar, close analysis will give equally good results.

It has already been seen that there is no external evidence to confirm Vitruvius' attribution of a unified perspective to the Athenian Agatharcus working under Aeschylus in the early fifth century. Any clear reflection of

such a system is similarly lacking in the meagre pictorial remains of the suc⁄ceeding centuries. This means that there is at present no way of deciding the extent to which Vitruvius may have been merely attempting to give ancient lineage to a relatively new invention.[37] The passage in Lucretius seems, however, to show that its origins must go back at least to the first half of the first century B.C. It seems impossible to say more than that the system was evolved between the fifth and the first centuries B.C., and probably not earlier than the third or second century. Against this must be set the fact that it was not until 80 B.C. that the Oscan and Samnite city of Pompeii was finally colonized by Sulla. The earliest of its remaining fresco paintings of the Second style, in which a centralized perspective might be sought, appear to fall in date between Lucretius' death in the mid⁄century and the writing of Vitruvius' treatise in the twenties.[38]

The quality and complexity of the finest of these decorations of the Second style reveal, in company with a wealth of other evidence, that the fresco paint⁄ing of the colonial city was derived, fully developed, from the art of other more important centres. Consequently it seems to be natural, upon chrono⁄logical grounds alone, to look for first reflections of Vitruvius' system in the earlier, rather than the later decorations at Pompeii. In the event, not only is this expectation justified, but the earliest prove to be the sole reflections of Vitruvius' method, since Pompeian art moves swiftly into other channels. It is the realization that the earliest decorations of the Second style reflect the tail end of a lengthy evolution, and show the system, which Vitruvius describes, in the very moment of its final break⁄up, that makes it possible to appreciate the pattern of development which underlies the apparent confusion of Pompeian pictorial space.

In the earliest phases of the Second style the painted architecture is so simple that problems of perspective scarcely exist. Perspective only makes its entry in the later stages, when new depths are created in the wall, and pros⁄pects open up beyond it. At the present time this early flowering of the monumental architecture of the Second style is only fully visible in the remain⁄ing decoration of three houses: the Villa of the Mysteries at Pompeii; that of Publius Fannius Sinistor at Boscoreale; and a town house in Pompeii, the House of the Labyrinth. Of these three, it is the last named which, by virtue of the composition that is repeated on the side walls of the Corinthian oecus about which the house is balanced, is undoubtedly the most important in the present context.

The solidity, and the structural clarity of this sharply drawn and boldly lit design immediately strike the eye (Pl. 61, *a*). The firm foundation of this first impression is laid bare with the discovery that in the upper parts of the remaining section of the composition over forty receding lines in many widely separated planes, both vertical and horizontal, vanish to a single point low in the centre of the altar. A further half a dozen miss it only by an inch

or so.[39] This constancy of the recession to a single point, with only occasional aberrations, mostly in the small, repetitive detail where the ease of execution readily becomes the chief consideration, is repeated in the fragments on the opposite wall. It therefore represents a definite intention.

Despite the quantity of vanishing lines receding accurately to a point, it is quite clear that the composition is not fully unified. Although certain of the orthogonals in the bases actually recede towards the vanishing point, and others run quite close, the bases as a whole are not controlled by it. This inconsistency does not call attention to itself, as it is not near the strongly lighted centres of interest. The contradictions in the decorative vases and in the central altar itself are far more obvious. The former show a genuine internal inconsistency in drawing, since the mouths alone are seen from a high viewpoint that conflicts with the slightly lower setting of the vanishing point. The altar, on the other hand, presents a rather different problem. Here there is no question of confusion or inaccuracy. There is instead a radical change of viewpoint which is quite unparalleled elsewhere in the fresco. The sudden adoption of a slightly high viewpoint and of a foreshortened frontal or very softly oblique setting, right in the middle of the composition, seems to stem from a desire to reveal the solidity of this central feature, which would only show its flat, forward surface in an accurate construction. The altar neverthe-less remains the single radical departure from a visual unity which is other-wise maintained throughout the composition, and, for the most part, with that extreme accuracy of construction which is entailed in the adoption of a single vanishing point.

Similar constructional features are present in the decoration of the small room immediately to the left of the Corinthian oecus. Although the scheme is far too ruined to allow of any judgement as to its consistency as a whole, it is still possible to see that all thirteen lines in the only visible receding cornice are centred accurately on a single spot which is also the focus of a number of other isolated and more damaged lines.[40]

A less ruined example of the use of a vanishing point is to be found in the Villa of the Mysteries, on the back wall of Alcove A in Cubiculum 16.[41] In this case the whole area of the triple vaults, involving a large number of receding lines, is centred, with a few minor inconsistencies in execution, on a single, central point. Here, however, there can be no question whatsoever of the co-ordination of the bases in the scheme. Their recession does not even run approximately into the same area, and individual surfaces occasionally show an actual divergence. This complete dichotomy does not, however, diminish the importance of the fact that in the upper area of this wall a quite extensive architectural complex has been unified about a single point, and a number of other examples, some more elaborate, some less, are to be found in this and in other rooms in the Villa dei Misteri.

This confinement of focused recession to the upper parts of the architecture

is also visible in the decoration of the Villa of Publius Fannius Sinistor at Boscoreale.[42]. In the fresco from the West wall of the summer triclinium (Pl. 61, *b*), which is now preserved in the museum at Naples, practically all the downwards running orthogonals which can still be seen appear to have centred on a single spot. These lines, which number almost twenty, are all those associated with the colonnades that run back into space about a central court resembling those seen in the decoration of the Corinthian oecus in the House of the Labyrinth (Pl. 61, *a*) and constructed with similar accuracy. Finally, in the wall of the cubiculum which has been set up in the Metro-politan Museum at New York, the two sections which again resemble the designs in the House of the Labyrinth both reveal the adoption of a single vanishing point for the cornices of the receding colonnades on either wing, and also for some of the orthogonals lining the central gap in the principal broken architrave.

A part from such examples, a few cases can be found of the use of vanishing points for the component lines of single cornices, or even of whole buildings, such as the temple which appears in the middle of a fresco taken from the Villa of Julia Felix.[43] These rarities are, in any case, of far less interest than the co-ordination of the three complex elements of a single extensive archi-tectural design, as in the Villa of the Mysteries, or, as in the frescoes of the House of the Labyrinth, the unification of a number of completely separate architectural elements of the design.

This summary of the available evidence shows that there can be absolutely no talk of the development of increasingly accurate vanishing point perspec-tive in Pompeii. Beyond the three decorative schemes which have been singled out lies nothing more. In the later, orientalizing phase of the Second style the vanishing point idea still seems to wield a certain influence, although no examples at all comparable to those which have been analysed are to be found in the surviving works. Beyond this point there are not even traces of the pattern. In the Third and Fourth style paintings the development moves in a radically different direction. This will be examined later.

A second fact, which militates against the idea of a genuine development upon Pompeian soil, is that in each one of the houses that have been con-sidered vanishing points are only used in individual, even isolated composi-tions. No general trend in the organization of pictorial space is indicated, for there is no demarcation line between these frescoes and their neighbours even upon grounds of quality. In the cubiculum at Boscoreale the dividing lines between compositions that reveal a tendency to use a vanishing point, and others that do not, occur within the boundaries of a single wall. Simi-larly in the Villa of the Mysteries there is no deterioration in the quality of frescoes in which the convergence to a single point is not observed.

These considerations lead directly to the conclusion that the Pompeian frescoes which are being discussed reflect advances that were made elsewhere.

In addition these advances must have taken place at an earlier date. Even if the structure on the wall in the Villa of the Mysteries is adjudged the simplest of the examples quoted, it is none the less extremely complicated in itself, and cannot be a starting point, or even its reflection, any more than the compositions in the House of the Labyrinth (Pl. 61, *a*) can be seen as the culmination of little more than a decade of experiment.

The complexity of these frescoes does not merely indicate a different and earlier centre of original development. It also reveals something of the nature of the system that had been evolved. Its shortlived reflection in Pompeian art, and the little that appears to have been done to develop the idea, seem alike to indicate that the parent system must have been at least as elaborate as its progeny. If, as is likely, it was even more advanced in its development, and was already in decay amongst the artists who transplanted it to the provincial city—a moribund system, surviving only in connection with certain famous compositions—that would do a great deal to explain its intermittent use.[44] The frescoes in the House of the Labyrinth show that in that case it must originally have been no less than a completely unified vanishing point construction. Nothing else is left.

There are certain other factors which may influence the readiness to accept such a conclusion on the evidence of the surviving works. To establish the existence of a sequence of development valid for a whole school of painting, a quite large number of examples must be provided, and the existence of more than a few exceptions of equivalent quality leaves no alternative but to search for some more inclusive pattern. It is therefore important to realize that no such limitations are, on principle, involved in the establishment of the past existence of a system of perspective. Twenty to forty lines upon a wall do not converge upon a single point by chance. Just one example of a system's use is proof of its existence, if not of its popularity. No historian of the future, digging down to rediscover the Renaissance, could, by the assemblage of the evidence of innumerable frescoed architectural schemes, and of derivative and provincial paintings, occasionally fortified by works of quality similar to that of Piero della Francesca's 'Resurrection'; no such historian could disprove the existence of artificial perspective, providing one example of its use, or the relevant passage in Manetti's 'Life of Brunelleschi' still survived. The rules of evidence once clarified, however, it must be reiterated that the present state is not so parlous as that hypothetically described. Apart from any question of the literary evidence, each of the three remaining complexes of first quality, early Second style decoration at Pompeii has revealed clear traces of a vanishing point perspective.

Finally, though none of the examples found, including the finest and most complex of them, that in the House of the Labyrinth, is wholly unified, it is impossible to find equivalent complexities of recession to a vanishing point, involving more than one plane, in the far more fully documented period that

leads up to the invention of the artificial perspective of the Renaissance. Any parallel in Middle Eastern, or in Oriental art is equally noticeable for its absence.

There seem, indeed, to be no valid grounds for denying the probability, based on the surviving visual evidence, that an antique system of perspective, founded on the single vanishing point, existed at a slightly earlier date in at least one of the cultural centres that influenced Pompeii.

Vitruvius' definite assertion of the existence of just such a system must be set beside this probability. His meaning was established upon textual grounds alone. His words have an intrinsic worth, as the contemporary evidence of a knowledgeable, if conservative, practising architect, which could never under any circumstances be impugned by the pictorial remains. At the most they could merely be left without the support which the latter, in reality, supply.

When these two independently established lines of argument are brought together, probability comes near to certainty. The assertion of the texts finds its support precisely at the expected point in the first flowering of Pompeian art. All the evidence points to the existence, in antiquity, of a theoretically founded system of vanishing point perspective.

Precisely when the system was invented; where it principally flourished; whether it was ever used extensively in domestic fresco painting, or was reserved chiefly for the stage; if it included the principle of proportional diminution as well as that of recession towards a single point;[45] all these are questions which await the discovery of new evidence, or perhaps no more than a closer look at the available material. In the meantime there is reason to believe that when and if the answers to these questions are discovered, they will add to the knowledge of an antique 'artificial' perspective, not deny the very fact of its existence.

FRESCO PAINTING IN POMPEII

The establishment of the existence of an antique focused perspective is only the starting point as far as the development of Pompeian painting is concerned. The completion of the picture is both interesting in itself and valuable for two added reasons. In the first place it provides a compact source of irreplaceable comparative material. Further light is thrown upon the processes that have been followed in the renaissance art of Italy and France, and in that of the parent civilization of ancient Greece. Secondly it asserts the real values of those penetrating observations that appeared to lead to the conclusion that Vitruvius was speaking of a system of perspective based upon Euclidean visual arcs.[46] The practical recognition of such a mode of vision is of just as much importance in first-century Pompeii as it is in thirteenth- and in fourteenth-century Italy. Its vital role is unaffected by the fact that it does not provide the system about which Vitruvius wrote.

In Pompeii, as in almost any other artistic centre, and in almost any age, the question of quality is of paramount importance when considering the problems of perspective structure. In this case it is impossible to discern the essential pattern underneath the welter of increasingly provincial forms unless the relatively few remaining first-class works in each phase of development have first been carefully examined.

The relationship between the onlooker and the pictorial world implied in such masterpieces of figure-painting as 'The Initiation to the Rites of Diony-sus', in which the action leaps across the intervening real space of the room,[47] is established with meticulous care in many of the finest architectural com-positions.

Several of the most highly organized of such designs in the Second style have already been seen. The symmetrical treatment of the Corinthian oecus in the House of the Labyrinth with its extensive use of vanishing points sets the spectator in the centre of the room, and the real and the pictorial light sources are made to coincide completely. The reflected sunlight glows alike on the observer and upon the unified constructions of the painted architecture that surrounds him.

The main focus of Pompeian rooms is often distinguished from their mathematical centre. This is particularly true of long, narrow rooms lit from one end in the manner of Room 6 in the Villa of the Mysteries. Here the parallel recession of the painted architectural features runs towards a single centre situated two-thirds of the way towards the inner wall. No matter in what direction the spectator stationed at this point may turn, the spatial logic is maintained.

The spatial pattern of this room is, as it were, a summit from which weaker variants descend. Sometimes the logic is destroyed by introducing minor architectural features that have their own disparate centres of recession. Often, in rooms decorated in the later Second style, the parallel recession of the architecture runs unbroken round the four sides of the room towards a single centre in the middle of the back wall.[48] This means that the visual realism of the painted architecture of these walls is independent of any possible centre in the free-space of the room. Only by melting through the back wall can the observer reach the mythical point at which the visual and spatial logic is complete.

This tendency to carry a shallow spatial decoration mechanically round the walls of a room towards a decorative centre, paying no attention to the corners turned upon the way, becomes characteristic for those rooms in the later Second style in which each wall does not contain its own centre, or centres, of recession. It is as if a single sheet of wallpaper, covered by one undivided composition, had been rolled out on to the walls of a room. The light-fall on the architectural detail tends to follow the same centring process, flowing along the side walls to the middle of the back wall. This 'wall-

paper' approach to pictorial space may even, paradoxically enough, be accompanied by the boldest efforts to run certain of the unforeshortened elements of the pattern upon one wall into the pictorial space of that next door to it by means of illusionist foreshortenings upon the latter.[49] This mixture illustrates the partial understanding of spatial realism, or the limited interest in it, which underlies the whole tendency to break up the consistent spatial patterns that are sometimes to be found. This disinterest in fundamental realism can, at times, descend into a pure confusion even in the structure of the architectural detail.[50]

The general spatial pattern of the painted architecture in rooms decorated in the Second style is clearly subject to the same wide range of handling that was visible during the discussion of the more technical problem of approximation to a single vanishing point construction. This variation in organizational method seems to have no obvious connection with the date of execution. The only clear chronological sequence appears in the primary group, in which the spatial unity of the room finds its direct expression in the painted architecture. Within this category, those designs in which the visual focus and the geometrical centre of the room are not coincident tend to be the earlier. These are superseded by those compositions in which symmetry asserts itself upon each wall, so that the visual and the geometric centres of the room are identical. It is the latter pattern which becomes the rule in all the finest of the complex decorative schemes of the Third and Fourth Pompeian styles. In this later art the tendency for the individual decorative elements to form centres of their own remains, and is intensified by the increasing number and the relative smallness of these secondary structures. At times the result, particularly in low quality work, is the total break-up of the visual, though not necessarily of the decorative unity. This development is accompanied by a steady increase in the richness and freedom, though not necessarily the realism and depth, of the painted architecture.

The essential characteristic of the early Second style is its architectonic quality. The wall is the primary decorative unit, and its subdivisions are invariably created by essential elements of the architectural structure. The dominant consideration is the organization of the whole. It is consequently no surprise to find that the foreshortened frontal construction is not only used for the painted architecture itself, but also for any buildings or other isolated objects which are represented. The oblique construction only appears with the introduction of framed pictures into the general decorative scheme. But even in the mythological scenes which play an increasingly important part in Third-style frescoes, the foreshortened frontal setting maintains its predominance. This is not entirely the result of its more frequent use. A vital contributing factor is the amazing softness of the oblique constructions that are employed. These are often almost undistinguishable from the complex frontal and foreshortened frontal settings into which they merge. Even the frontal and

the foreshortened elements of the latter construction are frequently so deli-
cately differentiated that it too approximates to a complex frontal setting.
The extreme sensitivity of touch that accompanies the introduction of the
oblique construction recalls the similar caution visible in late fifth-century
vases. There is also a further link with the early history of perspective space in
the fact that the high viewpoint is practically unknown in scenes containing
large-scale figures near at hand.[51]

The emergence of the oblique setting in late Second- and in early Third-
style painting, coupled with the disappearance of the vanishing point raises
interesting possibilities. It is conceivable that the fading echoes of an antique
'artificial' construction were being superseded by the corresponding echoes of
some Euclidean or 'synthetic' system. An alternative is simply that there was
a reversion to empirical methods much like those which later produced such
similar results in fourteenth-century Italy and in fifteenth-century France.

As far as an actual 'synthetic' system is concerned, no evidence for it can
be found in Second- or Third-style decoration. In both of them the archi-
tectural framing elements and the contents of the mythological scenes alike
maintain the integrity of the straight line. No evidence of curvilinear distor-
tion can be found. On the other hand, as early as the Second-style decoration
of the summer triclinium at Boscoreale, those lines which do not actually
converge towards a single point tend to recede in pairs towards a vanishing
axis. The varied inclination of these lines distinguishes them from the
mechanical parallels that have been observed on numerous occasions. It is
this fluid recession to a vanishing axis, which can later be seen again and
again in Third- and Fourth-style architectural decoration, that gave rise to
the idea of the existence of a perspective system in which straight-line chords
(Fig. 3, *a*, p. 75) were substituted for the curves of what, on mathematical
grounds, can only have been a variant of a true synthetic construction.[52]

The textual support for the existence of any system of this kind has already
been removed by showing that Vitruvius' description cannot be a reference
to it. There is yet another serious objection to the likelihood that such a
method ever formed an actual system in the sense that artificial perspective is
a system. This objection is that although such a vanishing axis construction
may be relatively easy to abstract as the mathematical skeleton of a finished
work of art, it is impossible to reduce it to a simple and complete set of
instructions for the working artist. The sole alternatives are rules so simple
that they only partially cover the system, or so complicated that they require
the use of advanced mathematics for each separate application. It is therefore
inherently an empirical perspective.

A good example of over-simplification in the first sense is provided by the
popular device of parallel recession, in which the optical values are largely
sacrificed to a desire for organizational clarity. Between this extreme and the
reintroduction of the vanishing point at the other end of the scale, no general

rule can be laid down which can in any particular instance fix the exact places at which the receding lines shall cut the vanishing axis. The alternative, which is the use of higher mathematics by Pompeian artists, can be ruled out, both on general grounds and upon the evidence of the frescoes. It seems, therefore, that the vanishing axis in Pompeian art must be just as empirically based as its later counterparts in French and Italian painting.

The Pompeian artists' awareness of the visual effects of the recession of the visible world in all directions from the onlooker was not the less intense because it was reflected in no representational theory. Their observation of the precise appearances of objects as they came under the scrutiny of their roving eyes were as acute as those of their successors in the France and Italy of the Renaissance. Once again it is amongst the few remaining works of finest quality that the subtlety of their perceptions are apparent. The most remarkable of these rare examples is perhaps the Third-style decoration of the walls of the tablinum in the House of Marcus Lucretius Fronto.

The importance of the architectural friezes of this room (Pl. 62, *a*) in relation to the spherical field of vision and the artist's moving eye has been recognized for some time, and set forth with exemplary precision.[53] A comparison with the architecture of surviving theatres shows that the great width of the central feature of this twice-repeated miniature *scaenae frons* and the relatively narrow doorways in the flanking structures are an optical phenomenon reflecting the latter's greater distance from the observer at the centre. The splaying of the outer walls of these flanking structures equally expresses the effect of the observer's glance as it sweeps out to left and right.

This interpretation of the design is strikingly corroborated by the detailed form of the architectural receding lines.[54] Wherever these are complex features, the artist takes advantage of the fact to break the continuity of the straight line. The gently inclined, white lintels, that run inwards from the upper corners of either frieze, grow suddenly steeper when they are continued in the coffering of the ceilings of the two small flanking elements. Nearer to the centre of the composition, the cornices of the outside walls of these same buildings do not make a straight line with the tops of the pole-like columns that support the linking features. A similar steepening of orthogonals is also visible where the projecting architraves, which top the outer wings of the central accent, are broken downwards into the receding lines of wall and ceiling. There is nowhere any distortion of straight lines. Yet this consistent treatment of the recession of complex architectural elements produces, in a most exciting way, essentially the same effect as the continuous curves of an approximation to synthetic perspective. Despite the lack of theoretical backing by Vitruvius, it is evident that here, in practice, is the simulation of a single curve by means of two short chords.

Complete consistency in the design is lost by the unexpectedly satisfying combination of a low viewpoint for the foremost features of the podium and

a higher one for the deeper-lying floors which slope upwards in full view. The satisfying result may well be partly due to the fact that, whether by a sheer coincidence—an unconscious harmonization with the dominant idea —or actual intent, the broken lower orthogonals also substantially reproduce the forms which would be taken by the sweeping convex curves of a synthetic approximation in which horizontal scanning was the dominant feature. However this may be, it can be seen that in these little architectural friezes, with their lateral diminutions, splaying wings, and steepening recessions, superb craftsmanship is accompanied by a very sophisticated attack upon the problems of visual appearances and pictorial space. Unfortunately such high quality is rare in Third-style painting, so that the comparative material is scanty. Other examples of the bending of complex receding lines exist, however. And these betray a certain consistency in that, being invariably set above the level of the eye, their inclination almost always steepens as the centre is approached.[55]

The probability that several artists, each with their own spheres of activity, collaborated in this decorative scheme is not difficult to establish. The likelihood is greatly increased by the treatment of the pair of mythological scenes which form the centre-pieces of the two main walls. In both of these delicately coloured compositions the planar contraction of the space depicted is very marked, and at times gives rise to uncertain relationships between the rather stiff little figures that have been gathered with eclectic zeal from extremely varied sources.[56] The furnishings of the interior in the scene of 'Ares and Aphrodite' (Pl. 62, *b*) nevertheless discloses another aspect of the very approach to visual reality which is indicated by the more delicate construction of the miniature *scaenae frons* upon the wall above it. The large couch that fills the middle ground is actually oblique in setting, even though the down-slope of its receding surfaces is so gentle that they scarcely seem to leave the plane at all. The rectangular central block, on which Eros stands, reveals an almost equally soft oblique construction, with its long and short sides both inclined at the same gentle angle to the horizontal. This even recession is no longer used for the block-like seat upon the right, or for the drapery-covered chair upon the left. Instead, the oblique construction is used in such a way as to approach a foreshortened frontal rather than a complex frontal setting. The long forward face of the block upon the right is almost, but not quite, set in the plane, while the short inner face runs much more sharply into depth. This pattern is repeated in reverse upon the left side of the picture. Here are essentially the same design, and the same approach to visual reality that were later to be exploited by Maso and Ambrogio Lorenzetti, by Fouquet and by Paolo Uccello, and which, finally, was to gain a theoretical basis in Leonardo's system of synthetic perspective.

This type of pictorial organization becomes more and more important in the later Third-style frescoes. A striking coherence of design is to be found in

the finest works, whilst an ever bolder handling of the oblique construction contributes to an increasing compositional depth.

One of the best, and most typical of the surviving transitional, late Third-style scenes is that of 'Orestes and Pilades before Iphigeneia' (Pl. 63, *a*) from the House of the Citherist. The character of the spatial design is set by the slight, yet firm upslope of the evenly receding faces of the temple steps that dominate the centre of the composition. All the minor solids: the altar standing at the top of the steps on the right-hand side; the seat-blocks in the right foreground; the low stele on the extreme left, or the small altar in the central foreground, with its more sharply jutting forms; all of them are fully co-ordinated with the dominant oblique construction of the temple steps. It is only in the internal structure of the foot of the foreground altar, with its slightly over-aggressive solidity, that there is a certain confusion in the drawing. The more gentle outwards recession at each side of the composition is a feature which was already noticed in the 'Ares and Aphrodite'. The concern for the pictorial surface, another major characteristic of the mythological paintings of the Third style, revealed in the careful closing of the wings by foreground figures, and in the use of steps to create a level platform which, at the same time, is made to carry the figure composition upwards over the whole pictorial surface, is equally typical of such works.

In the late Third-style painting of 'Thetis in the Workshop of Hephaestus' (Pl. 63, *b*), formerly in the house IX.1.7, the composition from the House of M. Lucretius Fronto is essentially repeated, but without the same degree of spatial crowding and contraction. A similar screen of architecture closes in the background, and the visual focus of the scene, in the polished shield held slightly to the left of the geometric centre, is stressed by the simple, heavy column. The spacious foreground is measured out by the work-blocks and the piled-up armour, and by Thetis' throne and footstool on the right. Yet the busy confusion of the ground plan is less real than apparent. The majority of the stone blocks on the left are quite strictly in alignment with each other. All the faces nearer to the centre of the composition once again recede more steeply both in the blocks themselves and in the footstool on the right. The alignment of the forms upon the left is only buried to the casual glance by the oblique direction of its axes, just as it is buried also in the crowded towns and villages of San Francesco at Assisi (Pl. 6, *a*, *b*). Here is no confusion, but the curving composition which both organizes and expresses in artistic form the everyday experience of the turning head and roving eye.

Designs such as these prove that the popular assertion that the artists of antiquity never achieved the spatial co-ordination of isolated solid objects has no valid basis. It is refuted by surviving works of art, as well as by the literary remains.

There is nothing more exciting than the vivid picture of a lost yet living

culture that the frescoes of Pompeii still evoke. It is therefore all the more tantalizing that it should be so imperative for the historian to remember that only a tiny fraction of the surviving paintings can have even approached the vanished masterpieces of the great artistic centres of antiquity. The provincial status of the city must be borne in mind at every turn. It is occasionally possible, where there is a series of like compositions, to obtain an actual cross, section of the numerous graduations in the interest in structural and spatial clarity visible within the hierarchy of Pompeian art. The four copies of the scene of 'Admetus and Alcestis' (Pl. 64, *a–d*) in the museum at Naples make up one such sequence. A small, table, like seat, which appears in every version, starts out as a firmly constructed piece of furniture with the principal receding lines of its extreme oblique construction all converging clearly. Step by step it is transformed into a clumsy concoction of warped planes and tilting, uncertain members receding from each other in disorganized diver, gence. The more important elements of the composition show an equal range. There could be no clearer warning of the danger of asserting the limitations of antique pictorial art on the evidence of paintings which must represent, in many cases, only the lower rungs of such a hierarchy of coherence.

The increased use of the oblique construction, already noticeable in Third, style painting, is continued and intensified by the Fourth, style artists. The setting attains a marked predominance throughout the entire range of quality, and is almost invariably used in the finest work. There is a similar increase in the strength as well as in the popularity of the extreme oblique construction. Often, as in the famous composition of 'Achilles and Briseis',[57] a single oblique structure forms a background for the figures. Everywhere the Fourth, style mythological picture is highly independent of the constructional rules which govern the increasingly luxuriant framing architecture. This duality of approach can only be compared with that reflected in the fresco cycles of Giotto and his immediate followers. In all the surviving frescoes there appears to be only a single instance of a bold attempt to apply the rule that governed the small world within the picture to the architectural framework of the decorative scheme as a whole.

This unique pictorial adventure occurs in the Fourth, style decoration of the main wall of the atrium of the House of the Ara Massima (Pl. 64, *e*). The front door and entrance passage are not central in relation to this atrium, but are situated opposite the left, hand edge of the impluvium. The visitor's first impression of the fresco spread before him on the opposite wall is there, fore gained from a position which almost exactly corresponds to that of the shield which hangs between the columns of the painted porch to the left of the central landscape panel.

The first, and most obvious peculiarity of the construction is the strong curve of the painted moulding of the lower border. This curvature is very marked, even in the short undamaged section beneath the right, hand flight

of steps. It must have been extremely striking when the golden paint was new, and when it stretched unbroken from one wall of the atrium to the other. Less obvious, but still no figment, is a similar curve in the lower border of the central landscape panel. Higher yet, a further steeply hanging curve is implied by the strong up and outwards slope of the lintels of the doors to left and right. If attention is transferred from the horizontals to the verticals, it is difficult to talk with certainty of the left-hand porch, and of the nearby border of the central landscape panel. The latter is now tilted very slightly to the left, and this might well be due to the subsidence of the wall. No similar explana-tion holds good for the right-hand porch and doorway. These must still have leaned considerably to the left when every possible allowance has been made. It is equally impossible to ignore the violent splaying of the parapet upon the right of these same steps and doorway.

There seems to be no escape from the conclusion that the painter of this fresco made a bold, and strikingly successful attempt to curve the whole design away from an onlooker standing well to the left of the centre of his symmetrically balanced composition. Pausing at the entrance to the atrium, the visitor sees all the horizontals curve increasingly towards the right, whilst all the uprights start to tilt in vertical foreshortenings as his eye sweeps out and up. In spite of certain obvious shortcomings the fresco represents the culmina-tion of the tendencies already apparent in the optical splaying of the buildings in the stage-like friezes in the House of M. Lucretius Fronto.

Whether this unique design is more than a personal idiosyncrasy, or whether, like so much else upon the walls of the ruined city, it is but the last reflection of a great tradition, is impossible to say at present. Whatever may be the answer to this individual problem, the main lines of development in the short period of Pompeii's life-span under Roman rule are not in doubt.

The story that opens with the dying reflections of an antique 'artificial' perspective is continued in the Third- and Fourth-style painting with the increasing popularity of freer, empirical methods. These were based upon the shifting observation of reality through the artist's roving gaze. The vanishing axis pattern dominates the architectural framework of the wall, reflecting, not a mathematical application of Euclidean natural perspective to the realms of art, but a practical empiricism. This is equally expressed in the treatment of the inset, mythological and landscape panels. These reveal an ever more-frequent use of an increasingly accentuated oblique setting. In the finest work a new degree of spatial organization is achieved, and a great advance is made along the road that finally leads, after a lapse of nearly fifteen hundred years, to the creation of a theory of synthetic perspective. Beneath the apparent welter of conflicting forms there lies a clear prefiguration of the two great strands that weave the spatial pattern of renaissance art.

The fresh set of circumstances in which the fresco paintings of Pompeii were conceived and executed, gave birth to a highly derivative art, which

none the less possesses a distinctive character of its own. Once again, beneath the old forms, recreated under new conditions, it is possible to see the inter-action of unchanging tensions. The luxuriant profusion of the new growth does not hide the influence of those simple forces that were seen at work upon the surface of the Attic vase. It is no surprise that the development of pictorial space in the ruined city of Pompeii wears, already, a familiar air.

NOTES

1. The contents of this chapter are published in more detailed form, with full references, as a supplement to *The Journal of the Hellenic Society, 1956*, entitled 'Perspective in Ancient Drawing and Painting'.

2. See G. M. A. Richter, *Attic Red-Figured Vases*, New Haven, 1946, p. 5, etc.

3. Polygnotos and Mikon were active in the middle, and Apollodorus and Zeuxis in the last quarter of the fifth and beginning of the fourth centuries. Throughout this period the emphasis on the major arts was steadily increasing, and that on vase painting correspondingly decreasing. Only by the end of the period do extensive reflections of perspective innovations begin to appear on the vases, and by then the thinning out in quantity and quality is extreme. By the middle and second half of the fourth century, when artists such as Pausias, Nikias, and the legendary Apelles were carrying painting to new heights, the great tradition of vase painting is in its death throes, and can give no hint of the nature of the flourishing pictorial art which had supplanted it.

An admirable short summary of the place held by vase painting from its proto-geometric origins onwards is M. Robertson, 'The Place of Vase Painting in Greek Art', *Annual of the British School at Athens*, vol. 46, 1951, pp. 151 ff.

4. The compositions on these two vases are probable examples of derivation from paintings on a flat surface. See H. Payne, *Necrocorinthia*, Oxford, 1931, and M. Robertson, op. cit., p. 155.

5. W. Deonna, 'Le Quadrige', *Geneva*, ix, 1931, pp. 85–115, and G. Haffner, *Viergespanne in Vorderansicht*, Berlin, 1938, consider the foreshortened chariot in great detail. See also E. Pfuhl, *Malerei und Zeichnung der Griechen*, Munich, 1923, vol. i, pp. 313 ff.

6. See A. della Seta, *La Genesi dello Scorcio nell'Arte Greca*, Rome, 1907, pp. 100 ff.

7. Ch. Picard, P., de Laloste-Messelière, *Fouilles de l'Ecole Française D'Athènes, Fasc. II, Sculptures Grecques de Delphes*, 1928, pp. 98–116, discuss these works fully, describing the traces of colour which are shown in vol. iv, Pl. XXI–XXIII.

8. Della Seta, op. cit., argues strongly for the priority of sculpture, dealing with the Siphnian reliefs on p. 218, and ignoring the large strictly pictorial element duly observed in Pfuhl, op. cit., p. 313.

9. ἔγραψεν Εὐθυμίδης ὁ Πολίου ὡς οὐδέποτε Εὐφρόνιος. Richter, *Attic Red-Figured Vases*, p. 55, stresses that comparison with Euphronios' work shows that it can only be to the foreshortening that the inscription refers (illus., Fig. 44).

10. British Museum, Kylix, E. 86. Close to Euaichme Painter, showing a cobbler at work is a particularly good example.

11. Athens, National Museum, White Ground Lekythos, att. Achilles Painter, No. 12786, provides a good example of such an illusion (illus. *Corpus Vasorum Antiquorum*, Greece I, Athens I, III j.c. Pl. 2).

12. G. M. A. Richter, 'Perspective, Ancient, Mediaeval, and Renaissance', *Scritti in Onore di Bartolomeo Nogara*, Rome, 1937, pp. 381–8, Pl. L, 1, gives a diagram of the perspective structure.

13. This consistency is even maintained when chairs, tables, couches, and the like are spread

over the surfaces of colossal amphorae such as those of 'Darius' and of 'The Tomb of Patroclos' at Naples.

14. See above, pp. 68–9 ff.

15. See Italiote Bell Krater, Vatican, R. 2, illus. A. D. Trendall, *Frühitaliotische Vasen,* Leipzig, 1938, Pl. 7.

16. Naples, Museo Nazionale, Inv. 82113, Heydemann 3222.

17. See British Museum, Hydria, E. 224, Meidias, illus. Pfuhl, op. cit., Fig. 593; Arezzo, Amphora, No. 1460, Manner of Dinos Painter, illus. Pfuhl, op. cit., Fig. 583.

18. It did produce subtleties of design that can never be hinted at by line reproductions on a flat surface. These, except in an archaeological sense, are inevitably thoroughly misleading. See Robertson, op. cit., p. 151, note 1.

19. Euclid, *Optics,* "Όρος 4, Theorems 4, 8, 10, 11, 12, 22. See Richter, Perspective, Ancient, Mediaeval, and Renaissance, loc. cit., p. 384.

20. Cennino Cennini, op. cit., chapts. LXXXVII, LXXX VIII. This point was discussed above, p. 108.

21. Vitruvius, *De Architectura,* bk. i, ch. 2, s. 2. A useful edition with parallel translation is F. Granger, London, 1931.

22. Vitruvius, op. cit., bk. vii, preface, s. 2.

23. The relevant book, chapter and section references in Vitruvius are:

1. 1. 2. 3.	7. 3. 5. 6.	13. 5. 2. 1.	19. 6. 8. 5.	25. 9. Pref. 11.	
2. 1. 2. 4.	8. 3. 5. 8.	*14. 5. 6. 7.*	20. 7. 1. 3.	26. 10. Pref. 1.	
3. 2. 5. 3.	9. 3. 5. 12.	15. 5. 12. 2.	21. 7. 1. 5.	27. 10. 6. 1.	
4. 3. 1. 3.	10. 3. 5. 15.	16. 6. 8. 1.	22. 7. 3. 5.	28. 10.6.4.	
5. 3. 1. 4.	11. 4. 3. 4.	17. 6. 8. 3.	23. 8. 6. 14.	29. 10.11. 2.	
6. 3. 1. 9.	12. 4. 7. 5.	18. 6. 8. 4.	24. 9. Pref. 4.		

* This passage marks the possible exception.

In 10. 12. 2. 'correspondence' is not entailed. The word is used to mean 'in reply'.

24. Vitruvius, 6. 8. 3. and 6. 8. 4.

25. This is, of course, true only of the round arches of which Vitruvius speaks. Gothic arches, for instance, have more than one centre for the voussoirs.

26. Euclid, "Όρος 2.

27. Vitruvius, 6. 2. 3. 'Thus whether we see by the impact of images or by the effusion of rays from the eyes as the natural philosophers believe . . . the sight of the eyes renders false judgements.' The idea of effusion of rays is paralleled in Vitruvius, 9. 1. 9. by the mention of the rays of the sun, and there are numerous similar passages.

28. Vitruvius, 1. 2. 2.

29. Richter, 'Perspective, Ancient, Mediaeval, and Renaissance', loc. cit.

30. Panofsky, 'Die Perspektive als "symbolische Form",' loc. cit., pp. 265 ff.

31. Richter, 'Perspective, Ancient, Mediaeval, and Renaissance', loc. cit., pp. 383–4, advances both these arguments.

32. Alberti, *Della Pittura,* fol. 120ᵛ, ed. Mallè, p. 56.

33. Alberti, op. cit., fol. 121ᵛ, ed. Mallè, p. 59.

34. Alberti, op. cit., fol. 124ᵛ, ed. Mallè, pp. 70–1.

35. Titus Lucretius Carus, *De Rerum Natura,* ed. C. Bailey, bk. iv, lines 426–31.

36. Richter, 'Perspective, Ancient, Mediaeval, and Renaissance', loc. cit., pp. 384–5.

37. The desire to give ancient authority to modern achievements is common to historians from Antiquity to the Renaissance, and does not necessarily discredit their technical knowledge of the system or events which they wish to embellish.

38. H. G. Beyen, *Die Pompejanische Wanddekoration,* Band i, Haag, 1938, gives detailed surveys of the various dating problems involved. In his article, 'Die Antike Zentralperspektive', *Jahr. des Deutschen Archaeologischen Instituts,* liv, 1939, pp. 47–72, the same author discusses and illustrates

Spatial Design in Antiquity

all the examples of vanishing point constructions referred to on pp. 258–60 below, together with a number of further instances including that of the early first century B.C. Casa dei Grifi in Rome which confirms the existence of such ideas in Lucretius' lifetime.

39. Beyen, lib. cit., pp. 255 ff., emphasizes the significance of this painting and in Fig. 94 gives a perspective reconstruction. See also Beyen, 'Die Antike Zentralperspektive', loc. cit.

40. Room 42. See Beyen, lib. cit., pp. 258 ff.

41. Beyen, lib. cit., stresses the importance of the construction, giving a diagram in his article, loc. cit.

42. Beyen, lib. cit., in dealing with this room, surveys the problems of antique perspective. P. H. Lehmann, *Roman Wall Paintings from Boscoreale in the Metropolitan Museum of Art*, Cambridge, Mass., 1953, considers the whole subject very thoroughly, and from a substantially different point of view, discussing perspective on pp. 149 ff.

43. Naples, Nat. Mus. Generally described as from the Villa of Diomedes. See Beyen, lib. cit., pp. 268 ff.

44. Beyen, lib. cit., pp. 180 ff., implies such a solution.

45. Beyen, lib. cit., p. 160, believes that a fragment from Alcove 14, Villa of the Mysteries, shows convergence to one point in the diagonals of the coffering as well as in certain orthogonals, but this seems to be a little uncertain.

46. Panofsky, 'Die Perspektive als "symbolische Form', and above, p. 254.

47. This is considered at some length in White, *Perspective in Ancient Drawing and Painting*.

48. The great hall of the House of the Cryptoporticus is a fine example.

49. The best example is Cubiculum 8, Villa of the Mysteries. Illus. Beyen, op. cit., Fig. 13, and A. Maiuri, *La Villa dei Misteri*, Roma, 1931.

50. Room 46, on the right of the Corinthian Oecus, House of the Labyrinth, shows fine examples of incoherent relationships between the capitals of columns and the architraves that they support.

51. It is only used where a natural context exists, as in the distant landscapes that begin to appear in the later Second style.

52. Panofsky, op. cit., and above, pp. 207 ff., and 227.

53. A. M. G. Little, 'Perspective and Scene Painting', *Art Bull.* xix, 1937, pp. 487–95, in which he notes an example of vertical diminution towards the wings of a design, achieved by exploiting compositional breaks and without introducing curves. This produces the vanishing axis pattern shown in Fig. 3, *b* (p. 75), which like Figs. 6 and 8 (pp. 123, 208) derives from Little and Panofsky.

54. Little, op. cit., does not remark on these particular phenomena.

55. Strong splaying effects and steeply increased slope in complex orthogonals are particularly clear in the tablinum of the House of Apollo.

56. See L. Curtius, *Die Wandmalerei Pompejis*, Leipzig, 1929, pp. 250 ff., and 296 ff.

57. Naples, Museo Nazionale, from House of the Tragic Poet.

CHAPTER XVII

Present Problems

The exploration of pictorial space which started in antiquity is not a mere historical adventure in a vanished, scarcely-to-be-recreated past. The artists of today are still experimenting with the possibilities of artificial perspective, and still rediscovering those aspects of reality which led to the development of synthetic perspective. In some cases they are even using the latter as a whole, in its developed, curvilinear form.[1] Similarly, there is still much argument about the relative worth of the two systems, and about their relationship both to exterior reality and to the internal, physiological processes of vision. It seems, therefore, to be essential to clarify certain points, since any attempt to discern the historical facts is, in any case, taken to denote a stand on one side or the other in the continuing, day-to-day controversy.

Analysis of the historical developments that precede and follow the invention of artificial perspective underlines the elements of realism, of convention, and of compatibility with the plane surface, which are essential features of the system. It is clear that if all the conditions imposed by the strict geometry of construction are fulfilled, it achieves a completely scientific realism and accuracy of representation. In these respects it can scarcely be approached, and certainly never equalled, by any other system. The main artistic difficulty lies in the imposed conditions. To close one eye and hold the head still at a single predetermined point in space is not the normal way of looking at things.

The slower and more complicated growth of synthetic perspective reveals, in historical terms, the difficulty which exists at every stage in using it as a method of pictorial organization on a flat surface. In the early phases realism is achieved at the expense of co-ordination. Each solid object fights each other object, and all of them fight the representational surface. The avoidance, or the softening, of such conflicts can be achieved, as has been seen, without the sacrifice of the straight line. Yet a unity comparable to that attained in artificial perspective is only made possible through the introduction of the curve. The achievement of unity therefore brings new troubles in its train.

On the one hand, it seems to be established that extensive use of straight lines gives a cold effect to a work of art, and that a certain psychological discomfort is involved, whatever the distortions that such lines may undergo in the processes of vision.[2] The comparison of Greek temples with many

modern neo-Greek revivals illustrates this fact, as do the innumerable methods which have been evolved by modern architects for softening the excessive rectilinearity of steel and concrete buildings. Optical softening is not sufficient in itself. On the other hand, the curves which can be introduced within the confines of a picture are apt to be so greatly magnified as to have little to do with any kind of realism. Similarly, there can be no question of 'accuracy' in the curvatures of synthetic perspective, either in theory or in practice. They may conceivably be beautiful, but they can never claim to reproduce exactly what is seen, no matter what conditions may be postulated.

This does not mean that a synthetic system is necessarily an artistically inferior method of representing space. It has been noted that under normal conditions a picture is very seldom seen from the precise position for which the perspective was designed, even when the latter is ascertainable. Apart from this, the viewer looks at it with both his eyes at once. He also almost invariably moves his head as he scans its surface, and very often walks about as well. A theoretical accuracy under certain abnormal conditions, which are anything but ideal in practice, may, in consequence, often be as unimportant to the artist as it is essential to the scientist. A type of perspective which expresses the constantly roving quality of the painter's gaze, and the recession of the visible world in all directions, may well appear to be more satisfying in practice, quite apart from the aesthetic qualities of the curving lines which are involved. Moreover, as Leonardo says, the drawn relationships of such perspectives remain constant under all the normal circumstances of inspection.

The frequently experienced urge to give concrete expression to the recessions from side to side across the picture surface, and even upwards and downwards over it, may also derive much of its force from a desire to escape the limitations imposed by the picture as a framed and bounded object. In theory, the actual foreshortenings of the painted surface should take care of such recessions. In fact, a picture is usually seen at such a distance, and is framed in such a way, that the observer is primarily conscious of it as a not very large rectangular object which is set more or less at right angles to his line of sight. The verticals and horizontals of artificial perspective are inescapably seen as being parallel to the rectangular boundaries of the frame. Unless the recession from side to side is actually drawn in, and the parallelism between the frame and the drawn lines is intentionally broken, painted architecture gives no hint of that recession in all directions which would be experienced if the observer scanned such architecture in reality.

Synthetic perspective may equally well be described as a thorough-going attempt to express an experience of visual reality which is only to be gained by a process of introspection, of asking what it is that is really seen. It has been fully recognized in some of the most recent and most promising studies of visual perception that the visual field, which corresponds to the pattern of shapes and colours to which the realistic painter must reduce the normally

experienced world, is the creation of an analytic process requiring conscious effort.[3] The results obtained by such an effort differ, moreover, from those of everyday experience. The simplest illustration of this difference lies in the first lessons in perspective draughtsmanship. To the normal person a cube is a cube, and remains a cube, however it is moved about. Its faces are always at right-angles, and its edges always parallel. The unhesitating certainty of the observer only breaks down in unusual, carefully planned conditions. To the painter who is interested in pictorial realism, things are very different. The unchanging cube becomes a changing, constantly distorted pattern of con-verging planes and edges, each new transformation of which must be ob-served and faithfully reproduced. Herein lies another reason for the reappear-ance of the all-pervading foreshortenings that lead towards synthetic perspec-tive whenever artists are looking closely at nature and trying to analyse what it is that they are really seeing.

The already long list of artists who have used approximations to synthetic perspective lengthens continually with the passage of time. It reveals that although, for practical, as well as for aesthetic reasons, synthetic perspective has been relatively little used as a complete system, the ideas which led to its invention, and those which it subsequently inspired, have been a powerful factor in the history of European art throughout the last six centuries.[4] Their influence upon the final flowering of antique design was hardly less extensive. In much the same way, artificial perspective was, from its beginnings, as important when its rules were only partially applied, or else deliberately dislo-cated, as it was when it appeared as a complete, consistently executed system. The fact that so many sensitive artists of so many nationalities, at such widely separated periods of time, have tended to see artistic reality from a point of view that leads towards, or is dependent on one system or the other, seems to imply that any argument that denies the value of either may be more polemical than sound.

NOTES

1. For example, Ivon Hitchins, many of whose works seemed to me to reflect a fully developed synthetic type of perspective, told me that as far as he was aware he had never read anything on the subject, but that he had, during a period of prolonged and intense observation, become aware that objectively straight lines did in fact appear to him to be subtly curved, and that such observa-tions formed the basis of these compositions.

2. Borissavlevitch, *Les Théories de l'Architecture*, Paris, 1926, discusses various nineteenth-century theories with optical bases. W. H. Goodyear, *Greek Refinements*, London, 1912, shows that Greek architectural curves were used for their softening effect and were not optical corrections.

3. J. J. Gibson, *The Perception of the Visual World*, Cambridge, Mass., 1950.

4. During the seventeenth century in Holland, to take one of many possible examples, when artists such as Vermeer were making brilliant use of artificial perspective for the majority of their pictures, others were again experimenting with synthetic systems. The fact that the camera

obscura and the perspective box were both arousing great excitement makes it particularly interesting that, beside 'trompe l'oeil' architectural vistas exploiting the uncompromising rectilinearity of the one system, there are others, as austere, in which the drawn curves of the second method are employed. (See 'Perspective of a Hall', No. 281, *R.A. Winter Exhibition,* 1952–3, as Houckgeest? J. van Gelder, 'Dutch Pictures at the Royal Academy', *The Burlington Magazine,* vol. xcv, February 1953, p. 33.) The perspectivists apart, it is almost startling to see the extent to which Jan Steen, the great observer of the daily life of his fellow townsfolk, also repeats, again and again, the architectural patterns that were pioneered by Fouquet. Once more the oblique setting comes into its own as walls splay and straight lines curve under the artist's intense and roving gaze.

Index

Achilles Painter, 242 n. 11.
Aeschylus, 251, 257
Agatharcus, 251, 254, 257
Alberti, Leon Battista, 121–6, 137, 151, 192, 205, 212; as architect, 126 n. 43, 199; compositional influence, 125–6, 136, 204, 225 n. 24; Della Pittura, 113, 121–6, 127, 128, 129, 135, 254–6; and Vitruvius, 254–6. See also Perspective: Proportional Diminution; Vanishing Point; Viewing Distance; Visual Pyramid
Alhazen, 126–9
Altichiero, 108; Crucifixion, 109
Amymone Painter, 242
Anaxagoras, 251
Angelico, Fra, 104 n. 5, 180; Coronation, 170–1, 173; Frankfurt Madonna, 170; Linaiuoli Madonna, 202; Madonna, Child and Sts, 180 n. 11; S. Marco Altarpiece, 171
Apelles, 236 n. 3
Apollodorus, 236 n. 3
Aretino, Spinello, 104 n. 5
Arezzo (Dinos Ptr), 247 n. 17; (Piero), 179, 182
Assisi, S. Francesco:
Lower Church; Magdalen Chapel, 103, 107; St. Martin's Chapel, 83, 84; St. Nicholas's Chapel, 87; St. Stanislaus's Alcove, 88; Transepts, 103, 107 n. 10, 75 n. 8.
Upper Church, 23–47, 50, 67, 88; Choir and Transepts, 23–30, 33 n. 21, 35, 37 n. 28, 39, 40, 44, 47, 51–2, 59, 105, 174; Lower Walls of Nave, 20, 26 n. 5, 33–47, 51, 57, 59, 61, 65, 65 n. 8, 65 n. 9, 66 n. 10, 76, 76 n. 13, 78, 80, 80 n. 7, 82, 104, 105, 106, 205, 220, 229, 268; Upper Walls of Nave, 30–33, 51, 106, 174. See also Persp.: Centralized Setting; Foreshortened Frontal Setting; Illusionism; Interior, Development of; Oblique Setting, Extreme

Assyrian Art, 244
Athens, Nat. Mus. (Achilles Ptr, lekythos 12786), 142 n. 11; (Eretria Ptr, onos 1629), 142
Avanzo, 108; Funeral of St. Lucy, 109; Presentation, 109; St. George and Poison, 109

Bacon, Roger, 126, 127
Barberini, Card. Francesco, 48
Bartholomew, Abbot, 48
Bartolo, Taddeo di, 231 n. 45
Bellini, Jacopo, 146
Berlin, State Museums (Amphiaraos krater), 237; (Lippi), 184, 185; (Masaccio), 136, 138; (Piero), 189–90; (van Eyck), 225, n. 24
Béziers, 219 n. 3
Black Death, 230
Borgo San Sepolcro (Piero), 196–7, 199, 261
Boscoreale, Villa of Publius Fannius Sinistor, 258, 260, 265
Boston, Mass., Gardner Mus. (G. da Rimini), 38 n. 32; Museum of Fine Arts (Phoenix, Achilles amphora), 246–7
Botticelli, Sandro, 118
Bruges, Musée des Beaux Arts (van Eyck), 108, 225 n. 24
Brunelleschi, Filippo, 113–21, 122, 124, 125, 126 n. 43, 140, 202, 206, 212, 213; Piazza della Signoria, 117–20, 122, 126, 126 n. 42, 136, 202, 254; S. Giovanni and P. del Duomo, 114–16, 117, 118, 119, 120, 122, 136, 192, 202, 254; Viewpoint Theory, 114–21, 210. See also Persp.: Peepholes; Proportional Diminution; Vanishing Point; Viewing Distance; Visual Angle
Brussels, Bibl. Royale (Ms. 11060), 223 n. 13; Musée Royale (Hydria 3098), 242
Buddhist Art, 68
Byzantine Art, 26 n. 4, 28, 28 n. 10, 49, 66, 79, 82
Cambio, Arnolfo di, 48, 51 n. 51

Index

Index

Index

281

Index

275. See also Persp.: Distortion, Perspective; Foreshortening, Lateral; Foreshortening, Vertical; Optics; Peepholes; Vanishing Point; Visual Pyramid

Li Ch'eng, 69 n. 20

Limbourg Brothers, 223–4, 228, 230, 230 n. 44, 231; Très Riches Heures, 223–4— January, 224; June, 224; Mont St. Michel, 228; Plan of Rome, 231 n. 45; Presentation, 104, 231 n. 45

Lippi, Filippino, 138 n. 8

Lippi, Filippo, 104 n. 5, 170–87, 193, 194, 197; Barbidori Altarpiece, 170, 171–3, 174, 175; Berlin Adoration, 184, 185; Coronation, 173–5, 183; Empoli Madonna, 170, 171, 173; Florence Adoration, 184; Funeral of St. Stephen, 185–6; Funeral of St. Stephen Drawing, 186; Munich Annunciation, 180–2, 186; Pal. Venezia Annunciation, 180; Pitti Tondo, 182–4, 186, 197; S. Lorenzo Annunciation, 175–8, 180, 183, 186; Tarquinia Madonna, 173, 175. See also Persp.: Ambivalence; Archaisms, Exploitation of; Atmospheric Perspective; Foreshortening, Extreme; Framing; Interior, Development of; Orthogonal/Transversal Distinction; Vanishing Point

London:
British Museum: Manuscripts: Add. 18850, 228 n. 37, 228; Add. 35311, 230 n. 34; Br. M. (Leonardo), 213–14, 213 n. 34; Cotton Tib. B. VIII, 221 n. 8, 221; Harley 2897, 230 n. 44; Harley 4431, 224 n. 19, 224–5; Yates Thompson 27, 220 n. 6; Vases—Amphora B.194, 238; Amphora (Nr. Nikon Ptr.) E.302, 242; Hydria (Meidias) E.224, 247 n. 17; Hydria B.343, 237; Kylix (Euaichme Ptr.) E.86, 242 n. 10; Stamnos (Eupolis Ptr.) E.452, 242–3

National Gallery: (Castagno), 145; (Cosimo, P. di), 126 n. 43; (Duccio), 79–80; (Masaccio), 136; (Masolino), 143 n. 2; (Paolo, G. di), 103 n. 3; (Pollaiuolo), 145; (van Eyck), 225 n. 24

Victoria & Albert Museum (Donatello), 151–2, 154, 156, 164–5, 193; Ms. 18.3.91, 222 n. 11, 222–3

Lorenzetti, Ambrogio, 89 n. 3, 93–101, 108; Annunciation, 100; Allegory of Bad Government, 96–8, 99, 100; Allegory of Good Government, 93 n. 1, 96, 100; City of G. G., 93–6, 97, 98, 99, 100; Country of G. G., 93–6, 100; Landscape Panels, 93 n. 1; Madonna Enthroned, 100 n. 16; Presentation, 99; Synthetic Perspective Forerunners, 29, 91, 93–6, 121, 202, 204–5, 224, 230, 267. See also Persp.: Foreshortening, Lateral; Landscape, Development of; Lighting; Viewpoint, Implied

Lorenzetti, Pietro, 108; Birth of Virgin, 99–100, 100 n. 19, 109

Lucretius, 249, 258 n. 38; De Rerum Natura, 256–8

Luini, Aurelio, Codex Huygens, 214–15

Madrid, Prado (M. de Flémalle), 225 n. 24

Manetti, Antonio, Life of Brunelleschi, 113–121, 124, 192, 261; & Uccello, 207

Mantegna, Andrea, 40, 154 n. 6; Camera degli Sposi, 200; Eremitani, 193

Mantua, Camera degli Sposi, 200

Martini, Simone, 83–5, 99, 222 n. 12; Death of St. Martin, 83; B. Agostino Novello, 84; Guidoriccio, 85, 107 n. 11, 145; St. Louis, 83–4

Masaccio, 107, 126 n. 43, 135–40, 170, 174, 202, 214; Almsgiving, 135, 137; Birth Plate, 138; Crucifixion, 139; Crucifixion of St. Peter, 136; Lame Man & Tabitha, 137, 138; Pisa Altarpiece, 136, 139, 143 n. 2; Raising of King's Son, 138, 193; St. Nicholas' Story, 136; Shadow Healing, 135, 137; Tribute Money, 137–8; Trinity, 138–40, 149, 193, 196–7; & Donatello, 126 n. 43, 148, 149, 174; & Illusionism, 107, 135, 138–40, 193, 194, 196–7; & Masolino, 143 n. 2, 143, 145, 146, 146 n. 4. See also Persp.: Vanishing Point

Maso di Banco, 87–91, 107, 108, 125, 135, 179, 227; Dream of Constantine, 91; St. Sylvester & Baptism, 90; St. Sylvester & Bull, 89–90; St. Sylvester & Dragon, 88–9, 90, 91; Synthetic Perspective Forerunners, 88–91, 202, 204–5, 224, 230, 267. See also Persp.: Foreshortening, Lateral

Masolino, 36 n. 27, 138, 142–6, 148, 163, 180, 185, 194; Annunciation, 143; Assumption, 142; Crucifixion, 145–6; Death of St. Ambrose, 144; Decapitation, 144–5; Dispute,

282

Index

Index

Index

Index